*The Development Film
in the Americas*

The publisher and the University of California Press Foundation gratefully acknowledge the generous support of the Ben and A. Jess Shenson Endowment Fund in Visual and Performing Arts, established by a major gift from Fred M. Levin and Nancy Livingston, The Shenson Foundation.

The Development Film
in the Americas

Molly Geidel

UNIVERSITY OF CALIFORNIA PRESS

University of California Press
Oakland, California

© 2025 by Molly Geidel

Library of Congress Cataloging-in-Publication Data

Names: Geidel, Molly author
Title: The development film in the Americas / Molly Geidel.
Description: Oakland, California : University of California Press, [2025] |
 Includes bibliographical references and index.
Identifiers: LCCN 2025019638 (print) | LCCN 2025019639 (ebook) |
 ISBN 9780520416475 cloth | ISBN 9780520416482 paperback |
 ISBN 9780520416505 epub
Subjects: LCSH: Documentary films—America—20th century | Propaganda,
 Capitalist—America—20th century | Motion picture producers and
 directors—America—20th century | Motion pictures—America—
 20th century | Developing countries—In motion pictures
Classification: LCC PN1995.9.D6 G387 2025 (print) | LCC PN1995.9.D6 (ebook) |
 DDC 070.1/80973—dc23/eng/20250805
LC record available at https://lccn.loc.gov/2025019638
LC ebook record available at https://lccn.loc.gov/2025019639

Manufactured in the United States of America

GPSR Authorized Representative: Easy Access System Europe,
Mustamäe tee 50, 10621 Tallinn, Estonia, gpsr.requests@easproject.com

34 33 32 31 30 29 28 27 26 25
10 9 8 7 6 5 4 3 2 1

Contents

Figures

Acknowledgments

This book exists because of a few brilliant scholars. Judith Smith's film history course was formative for me; I was astonished to learn how much films meant, and how much it was possible to learn by studying their collaborative, historically conditioned production. Silvia Rivera Cusicanqui's Sociology of the Image course had a similar effect, changing and deepening the way I thought about the visual world. I am also eternally grateful to Marco Arnez for sharing Ruiz's films with me, and to him and Mercedes Bernabé for talking through many of the ideas in this book early on.

The research for this book has been supported by fellowships from the Charles Warren Center for Studies in American History, the Rockefeller Archive Center, and the Roosevelt Study Center. Many archivists shared their expertise with me; a few who deserve special mention are Michele Beckerman and Brent Philips at the Rockefeller Archive Center and Sandra Piñon at CREFAL. Thanks to the CREFAL archivists for providing the cover image. Thanks also to those at Syracuse University, UNC-Chapel Hill, University of Stirling, UCLA, Stanford, University of Virginia, University of Oregon, and the Wisconsin Center for Film and Theater Research for scanning and sending material. Thanks to Kristen Crase for assisting in my research, and to Peter, Kaija, Nate, and Henry,

and Heidi, Bob, Caleb, Elliot, and Juliet for graciously hosting me on research trips.

Thanks to all who invited me to speak and present papers from this project: Gary Gerstle at Cambridge; Simon Jackson and Mo Moulton at Birmingham; Daniel Bessner at University of Washington; Nick Witham and Mark Storey at Warwick; J. D. Schnepf at Groningen; Camila Gática Mizala at UCL; the International History Seminar group; Simon Fagour, Flores Giorgini, and the rest of the Fabriques AmeriLatines conference organizers; and finally Thomas Fisher and Luis Peña at ZILAS. Thanks to Jorge Coronado, John Pat Leary, Fernando Purcell, Nicole Pacino, Susana Romero Sánchez, Salomé Aguilera Skvirsky, David Wood, and Sonja García López for organizing panels where I presented this work, and to Catherine Benamou, George Ciccariello-Maher, Laura Gotkowitz, Kathleen Newman, and Kirsten Weld for astute commentary at the panels. Thanks also to Vanessa Freije and John Munro for especially useful feedback at these events.

I workshopped parts of this book many times. In Ithaca, special thanks to Rachel Weiss, Josh Savala, and Jennifer Jolly for particularly helpful suggestions. I learned so much from everyone in the amazing Cold War Camera project; I am particularly grateful to Thy Phu and the late Andrea Noble, as well as Ariella Azoulay, Ileana Selejan, Dot Tuer, and Laura Wexler. Thanks so much to Hugh Wilford, Giles Scott-Smith, Ken Osgood, and Simon Rofe for running an excellent SHAFR workshop in Leiden, and to the rest of that fantastic group. At the Warren Center I was part of a lovely cohort: thanks to Fred Logevall, Erez Manela, Joseph Fronczak, Gretchen Heefner, Kevin Kim, Saje Mathieu, Victor McFarland, Ken Osgood, and Jessica Wang for the generative workshops and fun dinners. Thanks also to David Ekbladh, Aaron Lecklider, and Drew Hannon for helpful feedback during that time. Thanks to Simon Toner and Shaul Mitelpunkt for hosting the productive Violence and the American Century workshop at Sheffield.

At the University of Manchester, I learned to be anti-work. Thanks to all my union comrades there who are still struggling for less and better work, and to reduce our complicity with militarism, genocide, and climate apocalypse. At Manchester I also benefited immensely from being part of a wonderful department. Thanks especially to David Alderson, Ingrid

Hanson, Ben Harker, Mike Sanders, Robert Spencer, Dave Brown, Doug Field, Michelle Coghlan, Andrew Fearnley, Peter Knight, Monica Pearl, Eithne Quinn, Ian Scott, and Natalie Zacek for reading and commenting on parts of the manuscript. Thanks to all at our Spectacle and Spectatorship conference, and to Kerry Pimblott, Tom Allcock, and Lessie Jo Frazier in particular. Thanks to Anna Strowe for the check-ins and neighborhood hangouts. Thanks to Iain Bailey and Rebecca Pohl for the intellectual camaraderie; to Eithne, Steve, Sean, and Des for being generous neighbors and lovely friends; and to Clara Dawson and Melissa Tanti for talking everything through. Thanks to Adrian Favell for the walks, books, and thoughts. Thanks to all in the Monday five a side game for the great matches and baffling questions.

Scholars in my new home of Dartmouth offered ideas and support toward the end of this project. I'm especially grateful to Mingwei Huang, Eng-Beng Lim, Jennifer Miller, Don Pease, Julia Rabig, and Pamela Voekel.

I'll be forever grateful to Richard Blue, who reached out to me to discuss his brother's films and life. We had a wonderful email exchange, but he died before I could send him a copy of this book; I tried to write a book he would've liked. Thanks also to George Stevens Jr. and Norman Miller for generously answering my questions, and to Elissa Kline for letting me use her father's photo.

Thanks to Raina Polivka for believing in this book and for all the thoughtful encouragement, and to Sam Warren for being so helpful. Thanks to my two anonymous readers at UC press for the incredibly detailed feedback. Earlier versions of parts of this book appeared in *American Quarterly* as "Petrodocumentary and the Remaking of New Deal Culture" and the *European Journal of American Studies* as "Cinemas and Spectators of International Development."

John Pat Leary and his smart students at UPenn helped me figure out the book's conclusion. The wonderful students in the Imágenes del Imperio class at the Tambo Colectivx in 2018 helped me gain new insights that shaped this book. Many classes of the University of Manchester students in Visual Culture of US Empire were also wonderful and helped me think through material.

Thanks to my parents, Nancy Braus and Rich Geidel, for teaching me to be a critic and a radical, and to my sisters, Jane and Laura Geidel, for all

the love and support. Thanks to Joey, Ben, and Allie Birchmore for putting me up for extended periods and being fantastic.

If the book could not have begun without wonderful scholars, it would have been equally impossible to finish without some others. Myka Tucker-Abramson, Ericka Beckman, and Christine Okoth are a dream writing group; I'm so lucky to be able to think with them. Thanks to Eithne, again, for the tough critiques and sustaining friendship. Thanks to J. D. Schnepf, Laliv Melamed, and Salomé Skvirsky for help and insight at the end. And finally, of course, thanks to Patricia Stuelke, always my first, last, and best reader.

Introduction

A typical development film opens on a tranquil rural village not yet awakened by the inexorable forces of modernity. An authoritative voice-over introduces the village as "untouched by time" and frozen outside of history, a place where there is no meaningful existence but "simply the passing of the years between birth and death."[1] Sometimes the film opens on a montage of several such villages, accompanied by musings like "everywhere in the world somehow, the face of poverty is the same."[2] This account of unproductive, meaningless life is often corroborated by an expert talking head, and often also by scenes of indigenous villagers: disheveled women laboring in cramped interior spaces, dirty half-dressed children lingering in shadowy doorways, similarly ragged children ravaged by illness and further antagonized by folk cures, and finally premature funerals and drunken despair. Never are these abject characters given the opportunity to characterize their own condition; the commentary about the difficulty and futility of their lives comes only nondiegetically, from above and outside.

Eventually, in the film, something changes. Often a white, well-dressed stranger comes to town and precipitates the change; according to the voice-over, however, this change originates in the hearts of the people themselves. The scenes of abjection with which the film began morph

Figure 1. Women and children signifying the disorder of underdevelopment, *Evil Wind Out* (dir. Blue, 1962)

Figure 2. "Today he has every chance of life, and for the first time in the memory of her people, he'll have something to live for," *United in Progress* (dir. Guggenheim and Heffron, 1963)

into triumphant sequences of clean, orderly men working comfortably alongside machines, building schools, spraying DDT, settling "underpopulated" areas, receiving diplomas, and engaging in inaudible democratic speech. Sometimes leaders are identified, generally young men, tasked by the voice-over with dragging their villages the rest of the way into the future. Women retreat to the margins as admiring audiences for the laboring, democratically inclined men; sometimes they sew happily, sometimes they are teachers in the new school. The voice-over tells audiences that villagers are "learning to think for themselves" and beginning to speak after centuries of silence.[3] Sometimes the film ends in the school, newly built by the villagers, with the camera panning over shyly smiling children; often it closes on a close-up of a boy, light shining on his face, signaling the modern future.[4] As the voice-over proclaims in one 1963 development film over a close-up of a child's inoculation, speaking generally of Central America: "Before now a mother could hope no more for her child than he live. Today he has every chance of life, and for the first time in the memory of her people, he'll have something to live for."[5]

This book tells the story of the mid-twentieth-century emergence, flourishing, and decline of the development film in the Americas. Made at the behest of charitable foundations, oil companies, governments, and the

new global governance organizations founded toward the end of World War II, development films were shown around the world in cinemas, but also in schools, in university classrooms, on television, and in mobile film units that toured rural Latin America. Individual development films are not particularly well remembered, although some were widely viewed, some won prizes at festivals, and many were reviewed by social scientists. However, it is the contention of this book that these films are so little remembered precisely because their aesthetic was quickly taken for, and seemed to become, reality. Despite being highly stylized and almost always scripted, development films quickly lost their status as contrived individual works of art and propaganda and became instead an accretive chronicle of ethnographic, scientific, and economic fact. Together development films created compelling images of underdevelopment and plausible narratives of the modernization process. Through an examination of the production, circulation, and reception of these films, this book explains how development as an image-world became ubiquitous and believable in the mid-twentieth century, in spite of evidence everywhere that lived cultural and economic relations could not be encompassed by the simple trajectory development posited.

Part of what made development films convincing was their social-realist visual beauty. The films' powerful depictions of abjection include close-ups of villagers smiling shyly and tracking shots navigating bustling outdoor markets, while the development sequences feature majestic montages of synchronized labor, in which men and machines fuse harmoniously. Rather than exoticizing their subjects, such scenes create intimacy between the objects of development interventions and their audiences; they emphasize underdeveloped and modernizing subjects' humanity as well as their capacity to live full lives and inhabit a mechanized, hygienic future. I argue here and throughout this book that development films' humanist and workerist aesthetics, which contrast starkly with their domineering voice-overs and simplistic sequencing, were shaped by the leftist artistic worlds in which the most influential development filmmakers were trained. In examining for the first time the rise and fall of the development film in the United States and Latin America, this book also offers a story of leftist aesthetics, both of their power and persistence and of their co-optation by militaristic liberal empire.

DEFINING DEVELOPMENT

Scholars have long been aware of the visual character of development. From James C. Scott's equation of modernization schemes with "seeing like a state," to Arturo Escobar's formulation that development entails training "machines of visibility" on poverty, peasants, and eventually women, to Nick Cullather's assertion that development projects "were designed for 'display,'" to the many descriptions, often drawing on official accounts, of particular areas as "showcases" for development, scholars often explain development in visual terms.[6] While these characterizations signal the importance of the visual to development's plans and assumptions, these scholars for the most part have asserted and assumed this visuality rather than dwelling on why or how it came to be, and they have generally used films to derive development's principles rather than studying them as vehicles for development in their own right.

For their part, film scholars have attended closely to films and their relationship to modernization and modernity, debating and refining what early film scholars refer to as the "modernity thesis." Asserted by Walter Benjamin and Siegfried Kracauer but also evident in audience responses to early films, the modernity thesis claims that cinema as an art form was both a product of and a response to the new sensory experience of industrial-capitalist urban modernity.[7] Scholars working on myriad aspects of early cinema have built on this core insight about movies and modern life, linking the advent of film to particular racial, ethnic, colonial, and national experiences of modernity.[8] This body of work linking early cinema and industrial modernities is useful to this book, helping to explain why modernization theorists often articulated their own prescriptive versions of the modernity thesis. However, film scholars generally stop before the mid-century period when state agencies, global organizations, and private foundations commissioned hundreds of films expressly to enact and promote capitalist modernization—or, as it was soon called, *development*.

What both these bodies of scholarship have overlooked, then, is how states and organizations attempted to use mid-twentieth-century cinema to effect a shift to a new form of global modernity. If interwar Hollywood assisted in the decline of European empires and the rise of US empire, the transition Lee Grieveson calls "the slow dissolve of one world system into

another," development films in the Cold War period facilitated aggressive US intervention in the global South, securing the shift to the hierarchical imperatives of development from the previously dominant paradigm of racial civilization.[9] These evidentiary film narratives, though never attaining the mass popularity of Hollywood films, found their most enthusiastic viewers in social scientists, their students, and development planners and workers, helping them imagine and justify development schemes. It is my contention that these films, and their visually compelling yet improbably simplistic dramatic renderings of economic and cultural change, were part of a successful cultural campaign, installing development as the new common sense, which persists even into the chaotic decades of the twenty-first century.

But what is this common sense? While some of development's tenets should be clear from the synopsis that opens this book, we still need to clarify its meaning. In the post–World War II era, development replaced racial civilization as the dominant way of both seeing the world and attempting to change it. Like the racial-civilizational colonial logic that preceded it, development's logic posits that some societies are "behind" others; this is what Johannes Fabian, making the simple observation that we are all living at the same time, calls "the denial of coevalness."[10] However, in a departure from the ideology of civilization, development emphasized national evolution rather than racial hierarchy and used the language of self-help in place of more overt paternalism: all nations, in development's worldview, move semiautonomously along a track to maturity. As dictated by modernization theory, the 1950s body of interdisciplinary, policy-oriented social science that undergirded US-led Cold War development interventions, nations would move predictably—though forcibly if necessary—in stages from "traditional" (poor, provincial, stagnant, superstitious) to "modern" (entrepreneurial, mobile, rational, nationalistic). The spread of capitalism into every area of life was a key feature of development; as Gilbert Rist observes, development fully conflated this spread of capitalism with the general idea of a better life.[11]

Two new ideas in particular made development's rise to dominance possible: economic growth and racial flexibility. Scholars trace the origin of economic growth as a concept to the late 1930s. Economists throughout the 1920s and 1930s debated statistical measures of quality of life,

considering metrics such as the average worker's purchasing power and the quality of food they were able to access. These debates lasted until the late 1930s, when US and European policymakers elevated national income above all other measures of quality of life; in the 1940s, these politicians and experts replaced income with gross national product (GNP) as their central metric.[12] By the early 1950s, this national "growth paradigm" dominated the study of even parts of the world that were still colonized, and US social scientists combined this devotion to "national" economic growth in the colonized world with sociological and psychological theories to form modernization theory.[13] When pre-eminent modernization theorist Walt Whitman Rostow, who advised successive US presidents in the 1960s, titled his classic 1960 treatise *The Stages of Economic Growth*, he obscured the novelty of economic growth as a marker of well-being by assuming it as both the key measure and the sole imperative of development.[14]

Development's naturalizing of national economic growth as the predominant measure of a good life meant that just at the historical moment when decolonization presented an opportunity to account for exploitative colonial dynamics, both histories of exploitation and future possibilities for downward economic redistribution disappeared from the many plans and programs being formulated by national governments and global governance organizations. By conflating growth with the improvement of life, global development experts pushed decolonizing governments to valorize only processes of enclosure, extraction, and exploitation: the conversion of everything, everywhere, into raw materials and commodities. These particular growth metrics were also gendered: in a double movement, postwar development planners classified work by men as "productive," excluding other work from GNP, and pushed women into devalued "unproductive" roles, deepening gendered labor divisions.

In formulating and promoting development with economic growth at its center, the United States and its allies were empowered by the changes to dominant racial thinking that characterized the decolonizing, post-Holocaust world. Following the shift initiated in the global North by maverick anthropologist Franz Boas and his students, but also adopting ideas from Latin American thinkers that imagined indigenous people in particular as racially improvable, postwar social scientists displaced hierarchies previously understood as biological and civilizational onto "culture,"

de-emphasizing race as a determinant of life chances.[15] However, rather than using this newfound sense of the insignificance of race to fight for the end of colonialism or celebrate cultural difference, US and European intellectuals such as those who convened to pronounce on race at the United Nations Education, Science and Culture Organization (UNESCO) emphasized the "ignorance" of indigenous and colonized people as a looming threat that needed urgent eradication. Such ignorance could be eliminated, these intellectuals argued, through educational programming, as well as through the more complete extension of capitalism into every area of indigenous and colonized people's lives.[16] This new concept of (flexible, adaptable) culture enabled modernizers to embark on massive, often violent social engineering projects, from "strategic hamlet" concentration camps in Vietnam to attempts to colonize the Amazon rainforest. Societies following socialist paths attempted similarly convulsive, growth-centered development schemes, at times with famously catastrophic results, rather than adopting alternative measures of well-being.[17]

Thus in its hegemonic postwar form, development created an intractable problem for the global South: namely, its singular focus on growth pushed governments to take natural resources for granted while making downward redistribution either among or within nations unthinkable. The limitations of development's conventional wisdom, as James Ferguson pithily points out, can be encapsulated in the proverb beloved in the development world: "Give a man a fish and he'll eat for a day; teach him to fish and he'll eat for a lifetime." Within development, as Ferguson explains, poverty and hunger stem from ineptitude on the part of the poor and hungry, work is unassailably good, and supplies of natural resources are inexhaustible.[18] Development cannot say, "You have a fish you're not going to eat, just give it to the hungry man!"[19] The central question for this book is how precisely such possibilities for justice became foreclosed: How were development's tenets universally adopted as common sense?

It is still something of a mystery how the imperative for all societies, everywhere, to modernize, as well as neologisms like "[national] underdevelopment," made sense so quickly in the postwar world. Many scholars have offered compelling accounts of the historical origins of development in South-North negotiations, tracing how it was imagined as both a way for colonial powers to grant concessions to their African and Asian

subjects and an opportunity for Latin American officials to make demands for help with infrastructure and better trade terms.[20] However, while these scholars are convincing on development's origins as a response to demands from the global South, their genealogies don't sufficiently account for the power of Cold War development's sharply dichotomous narrative— why and how it was able to convincingly reframe the world into categories of "developed" and "underdeveloped," position indigenous tradition as a villainous scourge to be vanquished, and make successful integration into the global capitalist economy the measure of a good life. To understand how the imperative to wipe out underdevelopment came to make sense in the popular imagination, we have to look to cultural and aesthetic genealogies rather than only to development's economic and infrastructural roots. The development film, this book contends, helped naturalize these new ways of thinking about the fictions of "race" and "the economy" in a way the many treatises of modernization theory alone could not. The propaganda films of the development era helped make development real, closing off possibilities for redistribution, justice, and envisioning a better collective life.

Scholars have begun to reconstruct this story of development's consolidation through film, particularly in Africa and Asia. Rosaleen Smyth details how the British empire experimented in the interwar years with "ideas about using mass media as a means of changing mindsets from 'traditional' to 'modern'" in its African colonies and intensified these efforts during and after the war, while Peter Sutoris explores the "visions of development" in Indian documentaries that remained fairly consistent before and after independence, only morphing into forms that admitted multivocality and questioning in the late 1960s.[21] This book, in contrast, focuses largely on the development films of and about Latin America, arguing that the region deserves special attention as a site of constant and widespread US intervention in the name of Cold War development. Film propaganda constituted a major facet of this intervention. During World War II, the United States constructed an enormous, far-reaching cultural apparatus for the production and screening of nonfictional films in Latin America; after the war, this apparatus was used by both US propaganda organizations and more eclectic internationalist and regional film ventures to spread cinematic visions of development.

Partly because of this cinema infrastructure, Latin America's development films, which have thus far received little scholarly attention, played a crucial role in the consolidation of the postwar development regime, providing an iconic visual and narrative repertoire that allowed the contested terms of development and modernity to harden into Manichean social-scientific truths.[22] In Latin America as in the rest of the global South, the enactment of allegedly natural development processes was often violent or failed or both: US-backed development projects advocated limited empowerment and land redistribution while also building up Latin American militaries, empowering soldiers to perform a broad range of "civic" tasks while conditioning aid on crackdowns on communism and labor militancy. These contradictory if thoroughgoing development interventions led to military coups, as in Bolivia in 1964, and massacres, as in Guatemala in the late 1970s, where indigenous peasants, having followed the advice of development workers in the 1960s to construct a village market and advocate for their own interests, took up arms to defend their market and were slaughtered by the US-backed army.[23] Development films, however, allowed a different story of development to circulate and congeal into social scientific truth. These films smoothed over the contradictions of Cold War development and erased the widespread violence it spurred, making development instead seem natural, orderly, logical, and desirable.

ASSEMBLING THE GENRE

As I have been describing, development's promise of freedom was contravened by the authoritarian force with which it was so often implemented. Perhaps even more fundamentally, development was an unpleasant process. While planners promised a good life for so-called underdeveloped populations, in practice development often delivered dispossession, cultural disintegration, and grueling and repetitive labor regimes. Development's counterintuitive equation of freedom with orderly hard work and capitalist expansion, rather than with having enough to eat or the right to territory or state-provided infrastructure, had to be envisioned before it could be explained in other ways.

My claim that the development film constitutes a genre stems partly from this unity of purpose: development films were made, first and foremost, to envision and promote development. However, I also call the development film a genre because of its formal properties, which cut across fictional and nonfictional forms to create a recognizable aesthetic.[24] Beginning in the 1940s, artists in the United States and Latin America, along with the state agencies and corporate entities that sponsored them, invented new visual and cinematic conventions for representing underdevelopment and development. To create these conventions, filmmakers amalgamated existing forms—namely ethnographic films, Griersonian and New Deal treatments of infrastructure and state planning, melodrama, and educational film—into something new.

In the 1940s, the decade when visual representations of underdevelopment and development began to solidify into recognizable clichés, documentary film was a new form whose boundaries and conventions were not yet clear. Scottish filmmaker John Grierson coined the term in 1926 in his review of Robert Flaherty and Frances Flaherty's sprawling Samoa film *Moana*, and the form was often, in its beginnings, associated with exoticizing ethnographic portrayals of cultures that were allegedly about to be wiped out by the forces of modernity.[25] Capitalist development and documentary thus had a symbiotic relationship from the start: the "preservation" in ethnography, which Fatimah Tobing Rony, following Donna Haraway, has labeled taxidermic in nature, assumed the inevitability of the destruction of "primitive" peoples and cultures while also creating fascination with filmically preserved accounts of them.[26]

Development films adopted ethnography's fascination with, and creation of, untouched traditional settings. However, development films diverged from ethnographic ones in important ways. Most importantly, they rendered traditional settings and peoples abject rather than sensuously or playfully exotic as the Flahertys had done. While beautiful landscapes often appear in the tranquil "before" scenes of development films, they are juxtaposed with dirty, despondent, and distressed villagers. "Traditional" practices, too, change in the transition from ethnographic film to development film; unlike ethnographic films, development films rarely if ever let their subjects complete a discrete task or act ingeniously, in accordance with their own customs.[27] Instead, these customs are depicted as both

arduous and ineffective and are eventually replaced with orderly, mechanized routines. Development is depicted through harmonious scenes of communal work often involving tractors, bulldozers, or other machinery used to grow chemical-assisted crops and to construct pipelines, shiny new schools, and health centers. Nourishing meals and comfortable housing, which would perhaps be the clearest indications of an improvement in quality of life, are almost never depicted in the "after" scenes of development films, deferred instead to beyond the space of the film—one film's voice-over assures viewers that "better housing comes later."[28]

In their sympathetic depictions of poverty and harmonious scenes of machine-assisted manual labor, development films drew on leftist documentary traditions. The US documentary artists who pioneered the development film were initially trained in a leftist artistic milieu that found economic support from the state-funded culture of the 1930s. In that decade, as David Ekbladh argues, intellectuals in and around FDR's government began to formulate the "grand plans" to "transform human perceptions" that would extend into the postwar development era.[29] These plans included the creation of public cultural programming agencies such as the Farm Security Administration, in which documentary artists were tasked with inspiring national sympathy for struggling, mainly rural, fellow Americans.[30] In the mid-1930s, leftist attempts to expose power and liberal attempts to create sympathy merged into what Michael Denning terms the *cultural front*, the artistic expression in the United States of the global Popular Front policies by which Communists embraced liberalism in order to defeat fascism.[31] As Bill Nichols argues, the documentary artists of the cultural front were deeply influenced by avant-garde and especially Soviet cinema, adopting the editing techniques invented by Dziga Vertov in order to make persuasive arguments and convey a sense of the historical importance of everyday life. However, they also muted the defamiliarizing and critical techniques they borrowed from the Soviets in order to make films that propped up the existing state rather than creating a new one.[32] In this way, these Popular Front artists produced patriotic celebrations of the American worker, as well as portraits of stoic poverty that, as Paula Rabinowitz argues, "inspire emotional reactions akin to classic melodrama."[33]

During and after the war, the development film adopted and internationalized Popular Front portrayals of suffering victims and dignified

muscular workers. But in doing so, they abandoned the complexity that often showed through in those films. Despite their support for the capitalist state, US Popular Front documentary culture was able, on occasion and often with irony, to implicate the rich in poverty, question uncritical adherence to technological progress, and formally incorporate multiple perspectives into films. These tendencies toward leftist analysis, complexity, and multivocality were lost in the transition to the development film, which was simpler and more straightforward. Development films unquestioningly celebrated "progress for the sake of progress" and were utterly devoid of the irony that had been present in some Popular Front juxtapositions of wealth and poverty; the form permitted only an authoritative voice-over and occasionally an expert talking head or two who would corroborate his assertions.

The resemblances to "classic melodrama" that Rabinowitz detects in 1930s Popular Front documentaries became more pronounced in postwar development films. While only a few development films, such as the 1958 Bolivian fictional drama *La vertiente*, fully commit to melodramatic storylines, many center suffering victims and adopt other melodramatic tropes. In line with Douglas Sirk's observation that melodrama happens "inside," development films focus on interiors and interiority in a way that ethnographic films, with their objectifying exoticizing outdoor scenes, and even most Popular Front films, with their focus on landscapes and workers, do not.[34] Not only do development films take viewers into cramped interiors, where women and children dwell uncomfortably, but they also focus on the imagined inner lives of the underdeveloped: on abjection that gives way (or does not) to forward-looking redemption. As the community becomes modern, the women move to the margins of the screen, illustrating Marisol de la Cadena's stark finding that "modernization has reinforced the Indianization of women" in the Andes.[35] Thus women occupy a strange role in development films: in the tradition of melodrama, their abject suffering provides an occasion for development, but they rarely become central actors in, or visible beneficiaries of, that development.

Finally, the development film stages a morally uncomplicated story that is also a racial one, as Linda Williams argues melodrama is uniquely positioned to do.[36] However, rather than casting its victim-heroes and villains according to stark racial types, as in the racial melodramas Williams

treats, development films mobilize melodramatic tropes to dramatize racial transformations—often, in the films under consideration in this book, from "Indian" to "*mestizo*." In these films, initial scenes of darkness, superstition, lethargy, and villainy give way to the throwing over of indigenous traditions. Some of these films begin by interspersing stills of ancient artifacts and ruins with shots of indigenous communities, with dissolves between the two signaling these communities' temporally suspended condition.[37] Early shots are dark, with their cramped and shadowy spaces emphasizing indigenous peoples' abjection as well as their racial difference from white or *mestizo* viewers. But as order arrives, so does light: later scenes of hard labor, democratic deliberation, and future-oriented observation and learning feature light-bathed, upturned faces. This lightening or whitening of indigenous characters' faces over the course of the film, only occasionally articulated explicitly in the voice-over, illustrates the racial flexibility as well as the persistent racial hierarchies (newly deemed "cultural") that characterize development thought.

While the development film borrows visual elements from melodrama to illustrate the new racial and gendered logics of development, much of the power and authority of the genre comes from its most recognizable common feature: a deep, authoritative, omniscient voice-over. Julianne Burton begins her influential 1990 essay on Latin American documentary voice by explaining that "from the inception of the social documentary movement in the mid-to-late fifties, Latin American filmmakers began experimenting with a broad range of strategies designed to eliminate, supplant, or subvert the standard documentary address: the anonymous, omniscient, ahistorical 'voice of god.'"[38] She does not elaborate, however, on this "omniscient, ahistorical" narrator of the "standard documentary": Who was he, what was he narrating, and why did filmmakers want so badly to supplant him? Burton is not alone; most scholarly treatments of Latin American cinema skip over this middle period or attribute rebellious filmmakers' will to "subvert or eliminate the authoritarian narrator" to the influence of European neorealism.[39]

But this anonymous, omniscient, authoritarian narrator filmmakers so wished to subvert and eliminate was not ahistorical; rather, this book argues, he was the voice of postwar development. He presided over the many propaganda films exported by the United States and screened in

Figure 3. Truck ballet, *La vertiente* (dir. Ruiz, 1958)

Figure 4. Democracy face, "So That Men Are Free" (dir. Van Dyke, 1962)

Latin America during World War II and the Cold War, as well as the documentaries made by international organizations and liberal Latin American governments. He commanded villagers to abandon their folk practices, to colonize the rainforest, to soak the earth with pesticides, to build schools, to build roads, to work harder, to embolden the military, to embrace foreign intervention; all this, he promised, would bring prosperity and happiness to these rural populations. He spoke both over and in the name of the people, narrating the vibrant political discussions development would usher in but never allowing the participants to speak for themselves and articulate their own demands. The development films in which this voice-over appeared, and the centers of production and circulation on which they relied, thus inspired reaction and revision from radical artists, but also informed their work in less oppositional ways. Venezuelan filmmaker Margot Benacerraf later reflected that she "became aware of a shared Latin American identity" while teaching filmmaking to trainee development workers at a UNESCO site in Mexico in 1954, and as Zoë Druick argues, UNESCO's screening infrastructure opened the way for alternative circuits of film distribution on which these radical filmmakers drew.[40]

If scholars of Latin American Cold War cinema have largely skipped over the mundane development films to which radical avant-garde filmmakers responded, there is a practical reason for this: the films were

difficult to find. In the most dramatic case, due to a Cold War prohibition on showing US propaganda domestically, development films made by the US Information Agency (USIA) were screened outside the United States but were unseen within the country, except by politicians and others who were granted special screenings. When the Cold War ended and the restrictions on domestic screenings of USIA films were lifted, the films were then consigned to the National Archives, which for many years was the only place they could be viewed, as copies of the films archived outside the United States still remain unavailable to the public. This massive archive of USIA films is to this day still being sorted through and digitized, which means that scholars have yet to fully explore the Cold War film output of the United States. The restrictions on domestic screenings of these films meant that scholars such as Burton, writing in 1990, had little if any access to the films circulated by USIA during the early Cold War, films which the militant avant-garde generation of Latin American filmmakers had not only seen but sometimes even worked on, and against which they had reacted. Indeed, these USIA films, along with other development films, many of which were circulated and screened by USIA, seem to have disappeared from the historical record when the Cold War ended, leaving a gap in film and diplomatic history alike. This book assists in the recovery projects of recent decades, as scholars continue to reckon with the scope, ideological work, and reverberations of US Cold War propaganda.[41]

If development films have largely been consigned to the archives since the 1990s, who watched these films when they did circulate? Why, how, and with what responses did mid-twentieth-century audiences watch these films? During the postwar period, development films undoubtedly fit broadly into the categories of both useful and educational cinema. However, development films rarely contained instruction in specific skills, and while they created a world in which national cultures evolved along clean trajectories, they did not primarily attempt to make their viewers into global citizens in the way scholars claim other educational films did.[42] Instead, nearly all of them conveyed the ideological assumptions of development in their entirety to "underdeveloped" audiences themselves as well as to modern, urban audiences. John Steinbeck articulated this duality of purpose when he instructed director Herbert Kline that their 1941 feature *The Forgotten Village* must work simultaneously "on one top level

for our peers, those who know as much as we like to think we know—and on another level to keep it simple and true for people with little or no education so they can understand and be moved by our story."[43] Part of the complexity evident in many development films stems from filmmakers' attempts to appeal to two distinct audiences whose levels of sophistication they imagined to be very different.

As part of its massive Good Neighbor propaganda campaign during World War II, the United States constructed new infrastructure in Latin America for the distribution and screening of films, particularly in remote rural communities. During the Cold War, USIA took over much of this film projection infrastructure, and expanded it to encompass much of the globe. They dispatched mobile units to rural areas in Latin America, as well as Africa and Asia, where they screened films in school buildings or outdoors at night on the sides of buildings or portable screens. These rural screenings often drew enormous audiences; in a 1950 USIA tour of Veracruz, Mexico, according to Seth Fein, "audiences varied in size from 4,500 to 200." Fein has found that early Cold War Mexican audiences of US educational, health, and propaganda films were largely enthusiastic about such screenings, which generally consisted of multiple short films in a row.[44] Fein's findings are echoed by the experience of Latin American educators at 1950s screenings of UNESCO-sponsored films around their adult education site in Pátzcuaro, Mexico (treated in chapter 3), where the teachers adapted films to particular communities and hosted postscreening discussions.

Other reports from Latin America, however, suggest that development films were not always audience favorites. Development films were often screened before dramatic features, along with newsreels, compilation reels, and other short productions. In the 1960s, USIA filmmakers found that Latin American audiences preferred comedy reels to even the most acclaimed of their films.[45] In 1950s Bolivia, where modern cinemas were constructed around the country to screen development films, the development melodrama *La vertiente* was wildly successful, running three times a day for six months at one theater in the lead actor's home city. However, other development films were less popular; there seems to have been a tradition of spectators arriving after the short development film but before the dramatic feature.[46] In these and other cases, development films

were seen by many Latin Americans but not exactly chosen by those viewers. Instead they formed the background to life, along with the multipage "development" section that cropped up in newspapers during those years.

The development film found a more unreservedly enthusiastic reception in the global North, particularly among scholars and planners. The postwar era in the United States, as Kirsten Ostherr describes, saw a shift in how nontheatrical films were screened: educational films ceased to be screened alongside Hollywood films and were instead shown "in a wide variety of settings, including churches, civic clubs, YMCAs, classrooms, and other locations whose primary purpose was not film exhibition."[47] Development films not made by USIA, similarly, were screened by US museums, churches, and other organizations, and many were shown in US university classrooms. Some reached even broader audiences: at least one USIA film in the 1950s overflowed large theaters in France, while a few, such as the 1953 UNESCO film *World Without End*, found mass viewerships in US and British schools and on television.[48] More commonly, development films found their way into academic and policy discussions; they were reviewed in anthropology and sociology journals and acquired by the libraries of universities, museums, and development organizations. Despite the simplifications they insisted on in their quest to propagandize the masses, development films were appreciated and taken seriously by experts—academics, teachers, development workers, and students—who most often interpreted the films credulously, as ethnographic evidence.

What this book suggests, then, is that development films perhaps were most influential on the development apparatus itself. Development films enabled a self-fulfilling feedback loop in which modernization theorists provided insights that shaped filmmakers' scripted development narratives. The modernization theorists then reviewed those same films, often treating them as unscripted evidentiary documents of underdevelopment and development. The theorists then drew on the visual and narrative structures and tropes from the films to support their theories and the policies they justified, and to craft curricular and training material for university students, soldiers, and development planners and workers. In this way, development films *were* mid-century development; they were the only place where the clean, orderly processes confidently sketched by economists, theorists, and planners could be found.

THE LABORING OF DEVELOPMENT DOCUMENTARY:
METHOD AND STRUCTURE OF THE BOOK

Many of the most prominent modernization theorists—Nils Gilman points out that they called themselves *modernists* and did not distinguish themselves sharply from the art world from which they borrowed the term—had lives that were intertwined with film.[49] Walt Rostow played piano accompaniment for silent movies as a teenager; wrote songs while studying at Oxford that he hoped would attract the attention of Hollywood producers; and dedicated *Stages of Economic Growth* to his close friend, screenwriter William Rose, who scripted *Guess Who's Coming to Dinner?*[50] Kennedy aide, historian, and modernizer Arthur Schlesinger Jr., a lifelong film enthusiast, hosted regular film screenings at the White House and reviewed films for *Vogue*, *Show*, and the *Saturday Review*.[51] Sometimes modernization theorists' interests in film converged more closely with their work: Edward Shils wrote essays in the 1950s defending mass culture from the Frankfurt school critique that it numbed the masses (he agreed but thought this was a good thing); David Apter supervised the making of development filmstrips at UNESCO while arguing in scholarly articles that "perception" rather than economic conditions determined African societies' development; and Daniel Lerner, Harold Lasswell, Lucian Pye, and Ithiel de Sola Pool all wrote both modernization theory and works approvingly theorizing mass communication.[52]

Lerner is perhaps the modernization theorist whose work makes the most of cinema as a modernizing force. In his 1958 book *The Passing of Traditional Society*, Lerner argues that mass media has spurred among Western audiences "a net increase in human imaginativeness" along with an "inhibition of overt active response," which he argues has been key to creating the "mobile personality" necessary for modernization. This inhibition of response, he explains, is "a learned behavior and a difficult one." In "the early days of movies," he notes, "persons strained beyond endurance" would "throw themselves or some object at the screen"; he frames such uninhibited responsiveness to cinematic images as a premodern impulse that Western audiences had to learn to overcome.[53] "The mass media," he argues, "have been great teachers of interior manipulation" and thus have "disciplined Western man in those empathic skills that might

spell modernity."[54] In *The Passing of Traditional Society*, Lerner's modern personalities love the cinema, while his traditional ones, doomed to pass into obscurity, are more fully integrated into village life. Lerner thus adopts a version of the modernity thesis, arguing that because cinema evolved with and helped audiences become accustomed to capitalist urban modernity, deploying cinema in traditional societies will inculcate this modern mindset in those audiences.

The origins of this book lay in my discovery of this interplay between modernization theory and cinema. However, as it became clear that the development film's visually arresting narratives were crucial to understanding how development became so believable and compelling to so many, development films and their production histories began to take up more and more space in the book. Examining the films' intimate workerist style as well as audience responses to them, I came to the conclusion that development films became compelling as something more than propaganda—as accounts of authentic cultural life, as plausible scientific truth—largely due to what we might call the "leftist aesthetic sensibility" shared by the hemispheric cohort of filmmakers who crafted them. Thus the life stories and work histories of the artists who made development films—many of them well-known documentary artists—are crucial to understanding the rise, fall, and visual work of the genre. While some of these filmmakers, as they moved from leftist to development scenes, were ardent believers in the international development mission, others were reluctant propagandists who negotiated the messages and style of their films with the government agencies, foundations, and organizations for whom they worked. These negotiations over setting, script, plot, and editing, while not uncommon in filmmaking, illuminate the ironies in the development films' common usage, in the classroom and development work, as reliable ethnographic social science.

The artists who made the most indelible and oft-repeated scenes of the development film genre were born in the first decades of the twentieth century and trained in radical and leftist documentary cultures, primarily the US New Deal. After the 1930s, when New Deal agencies began to disband, socially committed documentary artists began working for oil companies, private foundations, and the US government; in this capacity, they began to turn their cameras on Latin America and collaborate with

Latin American artists. The artists in this US cohort whose work and ideas I treat in depth—Jack Delano, Gordon Parks, John Steinbeck, and Willard Van Dyke—had lives that spanned the twentieth century. They were born in the early days of cinema and influenced by racial melodrama—Van Dyke, for example, recounts in his memoir being captivated when his elementary school class took a trip to see *Birth of a Nation*.[55] They lived through the Great Depression and the New Deal but also the Vietnam War and the dawn of the environmental movement, and most of them eventually became disillusioned with the development propaganda they helped create. The book's other main characters—British documentary film movement filmmaker Paul Rotha; Bolivian bourgeois revolutionaries Jorge Ruiz and Luis Ramiro Beltrán; France-trained USIA auteur James Blue; and exiled Brazilian feminist Helena Solberg—were trained in radical scenes, including in the cultural centers of the first two Latin American revolutions of the twentieth century. They were also conscripted to make films for US and global development agencies. The book chronicles both the political trajectories of these artists and the ends into which their radical, workerist, and experimental documentary artistic styles were channeled.

Approaching these films and the artists who created them biographically also brings labor back to the center of the development era. In their claim to produce natural ethnographic depictions, development films erased the labor that went into their own production: the labor of scripting and shooting, but also of acting. Thus in addition to tracing the political and artistic trajectories of the development filmmakers and the generic properties of the films they made, this book also uncovers the stories of key actor/subjects of the most paradigmatic and influential development films. Development films' schematic stories of personal and community awakening relied on the work of local "non-actors," who acted out scripted stories, understood and discussed their own artistry, and occasionally argued with the filmmakers over their visions for the films in which they acted and their sense of what fair compensation would be. These "non-actors" invited film crews into their homes and communities and sometimes maintained lifelong relationships with them. This is true of some of the most memorable protagonists of development films, particularly Sebastiana Kespi from Ruiz's 1953 film *Vuelve Sebastiana* and Flávio da Silva from Parks's 1964 short film *Flavio*, already famous from

multiple *Life* photo spreads. Both Kespi and da Silva gave indelible performances of underdevelopment as children and went on to live difficult lives, haunted by the promises of the development era as well as by periodic media attention evaluating their lives in relation to these promises. They in turn haunted the artists who told their stories, calling into question the utility and ethics of both development and documentary.

In recovering these multilayered stories, this book considers the consequences of development-film narratives for the objects of development and the actors portraying those objects, categories constantly conflated by viewers. By focusing on laboring "non-actors"—their contributions to development filmmaking, their offscreen personas, and their life trajectories—the book joins recent work that insists that film history is also always labor history.[56] Development film production stories reveal how state and corporate funders pushed left-liberal documentary auteurs to work in the service of militarized US hegemony despite their misgivings, but they also expose the complex relationship between these filmmakers, their worker-subjects, and the development narratives they collaboratively crafted. In development films, the designation of "non-actors" for those who invited the film crews into their villages and acted in scripted films reinforced the general assumption of ethnography, in Rony's words, that "the Ethnographic is without intellect."[57] This designation was also damaging in other ways: it exploited the creative labor of those "non-actors," who were in fact sometimes asked to give grueling performances, and it also led to a perception among credulous social scientists, film reviewers, and others that the films were in fact unscripted, naturalistic accounts of daily life. There was a bitter irony to this process: the more welcoming and accommodating these global Southern "non-actors" were, and the better they were able to take direction as *actors*, the more likely they were to be transformed into documentary evidence that their own villages and societies were stagnant, mistrustful, and in need of aggressive intervention.

This book's chronicle of the development film unfolds over six chapters. It begins by charting the creation of a cinematic vocabulary for underdevelopment in the 1940s, as filmmakers refigured isolated indigenous communities, which had been constructed by the Flahertys as objects of curious fascination and imperial nostalgia, as miserable and unproductive locations. Chapter 1 tracks the strategies by which Popular Front filmmakers

transformed the conventions of ethnographic film into a new aesthetic for development, focusing on Herbert Kline and John Steinbeck's Mexican family drama *The Forgotten Village* and Willard Van Dyke and Ben Maddow's extractivist travelogue *The Bridge*. As development filmmakers figured out how to construct scenes of abjection, they also began to experiment with how to envision the modernization process, and particularly how to depict the dislocations and hardships it augured as natural and benign. Following the trajectories of US Popular Front filmmakers, chapter 2 focuses on two different scenes of such experimentation: the US oil propaganda industry and Puerto Rico's Division of Community Education. In both scenes, filmmakers used fictional forms to infuse narratives of displacement with excitement. Chapter 3 similarly studies the many development films made at the UNESCO site in Pátzcuaro, Mexico, by both European filmmakers and Latin American filmmakers and educators; these films imagined a variety of incentives for indigenous audiences to increase their literacy, hygiene, and productivity.

In the late 1950s and early 1960s, filmmakers across the Americas collaboratively perfected the development film form, depicting with some regularity anachronistic and abject communities being ushered into the twentieth-century world, as one film proclaims, of "science, commerce, and cash."[58] Chapter 4 tracks the birth of Bolivian national cinema after that country's 1952 revolution, in which virtuoso director Jorge Ruiz eschewed depictions of revolution and political conflict and focused instead on making highly exportable development films about self-help, mechanization, and "colonization" of the rainforest. Chapter 5 treats Latin America more broadly, focusing on prominent 1960s documentary workers and the films they made to accompany the Alliance for Progress. The chapter charts first how these artists' iconoclastic sensibilities allowed them to retain in their development narratives a sense of novelty and hope, then moves on to treat how, in the mid- to late 1960s, these artists became disillusioned with development. By the late 1960s, this was a more general trend: optimism about development had given way to anxieties about population growth and horror at the destruction wrought by the US war in Vietnam. Development filmmakers in this period took up experimental feminist techniques, eschewing the authoritative, masculine visions of modernity that earlier films had featured. Chapter 6 closes with the story

of Helena Solberg's film *The Double Day*, a film that attempted a radical analysis of Latin American gender relations but retained a commitment to development's individualism and productivism.

By the mid-1970s moment of *The Double Day*, sponsored by a Nixon agency that combined private and public funding sources, state support for development and its propaganda was already in decline. In the years after that film, militarized austerity experiments dominated Latin America and then the world, with NGOs constituting a diminished and barely ameliorative "civil society"; meanwhile the privatized development communications industry took over the propaganda project once assumed by states, diminishing both its ambitions and its aesthetic power.[59] But while it is generally acknowledged that the heyday of development is long gone and that many societies have gone through several stages of deindustrialization or de-development (economists' new phrase to explain widespread deviation from modernization trajectories while still retaining faith in those trajectories seems to be "premature deindustrialization"), critiques of development as an ideology have not become common knowledge, in contrast with the critique of the racial civilization ideology that gave way to development.[60]

In other words, development is still the air most of us breathe. We recognize development as failing and failed, but we don't disbelieve its descriptive tenets or have a new paradigm to take its place. The shorthand of development thus lingers even in an era of chaos and de-development, structuring popular envisionings of everything from refugee crisis to environmental crisis to genocide: in 2024 a headline read, "Israel's War on Gaza Has Set Development Back by 69 Years," insisting on reading carpet-bombing and starving a population as a setback on its growth trajectory.[61] For this reason, it is necessary to understand the visual formation and circulation of development ideas, which have proven to be much more durable than the liberal imperialist welfare states that produced them. This task becomes even more urgent as climate change and economic stagnation shape global experiences of work and survival, and degrowth is at once inevitable and unimaginable. This book's attempt to understand how the development film helped growth imperatives become so stubbornly entangled with conceptions of a better life is meant as a contribution to the project of imagining something better.

1 From the Popular Front to the Modernization Mission

The Forgotten Village, a 1941 scripted documentary written by John Stein-beck and directed by Popular Front filmmaker Herbert Kline, contains a pivotal scene of a film within a film. Children in the fictional Mexican vil-lage of Santiago are falling ill from typhoid, and the townspeople have re-fused modern medicine, relying instead on the diabolical folk healer Trini to cure them. After a few children have died, enterprising teenager Juan Diego undertakes a new strategy: he will show the town an educational film. Over the mournful sounds of his fellow villagers praying outside, Juan Diego reverently unspools a film he has borrowed, with the help of a sym-pathetic teacher, "from the federal school of the neighboring market town." The voice-over, by renowned character actor Burgess Meredith, intones that the educational film "was a strange and wonderful object to them, and they planned to show the people of Santiago what caused the sickness, and how the children could be cured." Juan Diego and his teacher talk animatedly but inaudibly, their faces beautifully, starkly lit, their democratic impulses drowned out and summarized by the imposing voice-over. "They wrote a petition to the medical authorities in the distant capital," Meredith explains.

In its first moments, the screening seems successful: the camera pans over the reverent faces of the townspeople, then lingers on Juan Diego's

hopeful expression. But as the screen shows a close-up of a horse, with Meredith explaining, "Serum from an infected horse can cure the children," a man in the audience—"the landowner"—springs from his seat, breaking through the reverie of the viewers around him. "Horses' blood!" Meredith ventriloquizes. "Are we animals?" The teacher, also voiced by Meredith, implores the townspeople to stay—"The men of science work to help you"—but to no avail. The villagers chastise Juan Diego and abandon the screening, together asserting (again, through Meredith's voice-over) that they "do not like new things." The camera lingers on the mangled film reel on the floor, signaling the failure of both cosmopolitanism and science to move the hopelessly backward villagers, then cuts to another shadowy interior, where Trini is administering "a new cure" to Juan Diego's younger sister: she brandishes "a snakeskin, to draw the pain," and lays it over the child's stomach in a careful movement mirroring the unspooling of the film in the previous scene. The community's stubborn rejection of modernity causes Juan Diego to leave Santiago, walking "into a new world" to find a doctor and bring him back to the community. However, this effort too is unsuccessful (the women, under Trini's influence, slam their doors on the doctor as he begs for the chance to cure their children), and at the close of the film Juan Diego leaves the village behind for good. As he is spirited away by the doctor, light shining on his face as he hurtles forward in the otherwise dark space of the car, the voice-over speaks to him, informing him that he is on a modernizing path like children all over Mexico who will lead their country on its "long climb out of the darkness." Illustrating this claim is a montage of various regimented, uniformed young people learning in classrooms, science labs, factories, and operating theaters. In the closing moments of the film, back in the speeding car, Meredith's voice declares, "I am Juan Diego," as the boy gazes rapturously up into the light.

Forgotten Village, despite not being much remembered in popular and scholarly circles, marks the beginning of a new era in international development and documentary cinema. If the final scene echoes the moment in *Grapes of Wrath* of Tom Joad's separation from his family in order to achieve a more universal state of identificatory sentimentality—when Tom, in Michael Szalay's memorable phrase, "enters the impersonal ether of the New Deal public"—gone is both the ambivalence about technology and the attention to labor exploitation, however vague, that characterized

Figure 5. "I am Juan Diego," *The Forgotten Village* (dir. Kline, 1941)

Grapes and was even more pronounced in other New Deal and Popular Front culture.[1] Muted also is the salvage-ethnographic impulse from which the documentary form was born, the attempt to use film to preserve customs and cultures threatened by the encroachment of modernity: here, at least according to the voice-over and narrative action, there is nothing worthwhile to preserve.[2] Rather, in its representation of development as an all-or-nothing social process that can occur only after the personal transformation of backward "villagers," the film presages the modernization theory created in the universities and think tanks of the 1950s United States.[3] The film's aesthetic vocabulary suggests this desire for total transformation: its lack of color and synced sound, invoking an earlier era of film; its hopelessly "traditional" inhabitants who stubbornly reject all things modern; its forward-looking men mutely yet animatedly articulating their civic vision; and its closing moment when the camera lingers on the face of a boy, bathed in light, promising a better future and allowing audiences to share in it. Through such scenes, which stage the all-encompassing condition of underdevelopment as a challenge to overcome, *Forgotten Village* inaugurates the development film genre.

Forgotten Village's singular focus on what would soon be called *underdevelopment* is remarkable not just because the film appears well before the term was in broad circulation as a descriptor of societies and nations, but also because of how much it diverged from its filmmakers' original aims. Worried about the ascendancy of a right-wing political candidate in Mexico and wanting to secure Mexicans' position on the Allied side in the war,

Steinbeck and Kline planned to make an antifascist film that defended the Mexican Revolution. The finished film, however, makes no explicit reference to revolution, war, or fascism. Instead, it stylistically invokes the drama and urgency of these events, but entirely transposes the context of immediate, life-or-death struggle onto the opposition between tradition and modernity in one sleepy village. This transposition allows *Forgotten Village* to imagine poverty in a new way, abandoning the Popular Front's characterizations of the poor as stoic, laboring sufferers who have fallen on hard times. Despite the spartan structures and bedraggled characters who populate the film, the voice-over does not mention poverty; rather than taking center stage as a problem, the villagers' economic deprivation constitutes only a small part of the constellation of pathologies and deficiencies that make up underdevelopment, including isolation, illiteracy, lethargy, and superstition. In *Forgotten Village*, these ills appear not as misfortunes to be ameliorated but rather as evil scourges to be eradicated through the application of science and the destruction of indigenous lifeways.

By transposing the urgency of anti-fascist struggle onto the new project of eradicating "traditional societies," Steinbeck and Kline made *Forgotten Village* into the first development film. If Juan Diego's abortive screening reflexively suggests the difficulties of creating a cinematic form that can move the masses to development, the film itself signals a new era of technocratic optimism among experts and artists in Mexico and the United States alike, one that inspired them to experiment with film as a tool for propagating new ideas about deprivation and progress. Liberal and leftist artists who made up the anti-fascist Popular Front in the United States were among the first to sense the power of this anti-fascist rhetoric in lending urgency and intensity to wartime campaigns to further enmesh the hemisphere economically. Other renowned documentary artists followed *Forgotten Village* in using anti-fascist imagery and rhetoric along with ethnographic techniques to convey the (alleged) necessity of free trade and unfettered extractive capitalism in Latin America. Popular Front documentary artists thus played a key part in crafting a militarized and melodramatic visual vocabulary of underdevelopment and modernization, one that framed the spread of capitalism, the adherence to Western scientific principles, and the wiping out of indigenous cultures not just as improvements but as moral imperatives.

The first half of this chapter situates the story of the planning, production, and reception of *Forgotten Village* within the broader context of US artistic movements and cultural institutions from the 1930s through the early 1940s in order to chart both some reasons for the discursive shift to development it helped inaugurate and some of the many effects of this shift on the world, particularly on liberal intellectual and social-scientific thinking. As in the screening within the film, the main and most enthusiastic audience for *Forgotten Village* turned out not to be its intended audience of "villagers," but rather academics, social scientist policy advisers, and diplomats, who mistook the film's melodramatic simplifications for ethnographic fact. The second half of the chapter opens out from Steinbeck and Kline's film to consider work by Willard Van Dyke, another artist who got his start in the Popular Front milieu and transposed the antifascist aesthetics he learned therein onto Latin America's economies and populations. Van Dyke's World War II films turn the struggle to throw over tradition in South America into a dramatic battle, casting extractive modernization as a task that might save the continent and racially improve its people. Van Dyke's postwar films elaborate on this cinematic vocabulary as a means of visualizing abject underdevelopment and developmental striving, helping to shape the common sense of intellectuals and planners in government, universities, and private foundations. Tracking the cultural and aesthetic trajectories of Steinbeck, Van Dyke, and their collaborators from the New Deal to the Cold War can thus help us understand how the imperative to wipe out tradition became an urgent and realistic-seeming task for powerful US planners and politicians as well as ordinary people around the world.

INVENTING THE VILLAGE IN ORDER TO SAVE IT

In 1939, exhausted and overwhelmed from his rapid rise to fame after the publication of *The Grapes of Wrath*, Steinbeck wrote to his literary agent Elizabeth Otis about his frustration with the widespread "hysteria about the book," which included "fifty to seventy-five letters a day all wanting something," as well as "vilification . . . from the bankers and landowners." "There is one possibility," he concluded. "And that is that I go out of the

country."[4] He began planning a sailing expedition with his wife Carol and his friend Ed Ricketts. In the months leading up to the voyage, Steinbeck expressed confusion about the growing global political crisis, and he looked to science for answers. "There are things in the tide pools easier to understand than Stalinist, Hitlerite, Democrat, capitalist confusion, and voodoo," he wrote to a friend in November 1939:

> Communist, Fascist, Democrat may find that the real origin of the future lies on the microscope plates of obscure young men who, puzzled with order and disorder in quantum and neutron, build gradually a picture which will seep down until it is the fibre of the future. The point of all this is that I must make a new start. I've worked the novel—I know it as far as I can take it. I never did think much of it—a clumsy vehicle at best. And I don't know the form of the new but I know there is a new which will be adequate and shaped by the new thinking.... There is so much confusion now—emotional hysteria which passes for thought and blind faith which passes for analysis.[5]

Steinbeck's subsequent efforts, in both science and filmmaking, reflect this disillusionment with politics. He characterizes politics here as "emotional hysteria": this characterization conflates communism and fascism, anticipating the postwar popularization of the term *totalitarianism*, and also contrasts a feminized confused political subject with "obscure young men" who see the world clearly through their microscopes. *Forgotten Village* thus emerges from Steinbeck's temporary exhaustion with the novel as a form, but also from his more permanent estrangement from the political vocabularies of the Popular Front, which saw the struggles for democracy, workers' rights, racial equality, and anti-imperialism as one and the same.[6]

Despite Steinbeck's distaste for "politics," the origins of *Forgotten Village* lay in his and Kline's concerns about fascism. Kline, who had made films in 1938 and 1939 about the Spanish Civil War, the rise of the Nazis in Czechoslovakia, and the beginning of the war in Poland and England, initially contacted Steinbeck because he was worried about the fascist tendencies of 1940 Mexican presidential candidate Juan Andreu Almazán.[7] The film, however, eschews the context of the election that inspired it in order to imagine fascism, as Chris Vials argues the Euro-American liberal Left began to in the late 1930s, in "terms such as *barbaric, medieval*, and *primitive*" and "blood ritual," while disregarding what Vials characterizes

as the core of the understanding of fascism initially formulated by the 1930s Left: its fundamentally middle-class character, its ultranationalism and alliance with business, its reliance on a racism that often escaped the control of the business elite that had initially encouraged it, and its focus on spectacles of white masculinity.[8] Rather, in *Forgotten Village*, a feminized hysteria, along with an attachment to land and folk culture, embodies the fascist threat, against which not liberal-left redistribution but neutral science must be mobilized.

The film's argument that tradition rather than exploitation was the central problem plaguing the people of Mexico indicates Steinbeck's deliberate refusal to depict the class and land dynamics of the Mexican Revolution. His decision to shift the film's central conflict from revolutionary class struggle to the terrain of modernization is clear in his communication with Kline about the film. In Jackson J. Benson's account, Kline approached Steinbeck with the idea of making a film about "a family caught up in the turmoil of the Mexican revolution"; Steinbeck liked the idea but pushed back against the suggestion that the Revolution take center stage, proposing "that instead of revolution the conflict come out of the attempt to bring modern medicine to a backward area."[9] In a letter to Kline in late April 1940, Steinbeck nudges him in that direction, proposing that the film should be the story of three generations, of which "Grandpa was a peon on the hacienda, papa worked in an oil field, Juan Diego 3rd is an *ejidero*."[10] He suggests in that letter that "the story will be that of the process from hacienda to *ejido*, interrupted by a number of forces," such as "ignorance" and "disease."[11] However, neither hacienda nor oilfield appears in Steinbeck's final script, and the *ejido* is not identified as such in either the script or the film; the entire backdrop of revolutionary Mexico has fallen away, restored only briefly and partially at the film's end in the brief yet reverent montage of young people studying and learning. The idea of the Revolution as a struggle over land is nowhere in the film, except perhaps in the brief identification of "the landowner" as the one who stirs up trouble at the screening. Even the people's attachment to the land they work, which Steinbeck portrayed so powerfully in *Grapes*, is absent from the film, which is shot mostly in cramped interior spaces that emphasize the insularity of the village. The workerist aesthetics in which both Kline and Steinbeck were versed are thus transposed onto a scenario devoid of

class struggle, lending a populist-sentimental tone to a story about evil folk wisdom and the unassailable wisdom of technicians.

While many reviewers claimed that Steinbeck and Kline's idea for a story primarily about scientific progress emerged from their encounters with Mexican villagers, there is no evidence of these encounters; in fact, Kline complains in his diary from June 1940 that "so far, we haven't even found the 'forgotten village' the script calls for, though we have driven over 10,000 miles in search of it."[12] (The filmmakers finally settled on a "composite of several" towns in central Mexico.)[13] Steinbeck's extensive writings on his spring 1940 expeditions do not refer to any particularly recalcitrant or superstitious villagers. Instead, Steinbeck condemns "the white man" for bringing to indigenous people "industry and trade but no prosperity, riches but no ease."[14] His letters during the trip are equally unconcerned with reforming or otherwise changing indigenous communities, as when he writes to Otis, "[F]rom the simple good Indians on the shore to the invertebrates there is a truer thing than ideologies."[15] Whoever these "simple good Indians" were, Steinbeck seems mostly to have encountered Mexicans he recognized as modern; he wrote to Kline from a 1940 location-scouting trip that "most Mexicans [he has] talked to want . . . Fords and canned fruit and store clothes, want them intensely, want them more than ideas."[16]

Steinbeck's shift in the focus of *Forgotten Village* thus stemmed not from his interactions with Mexican villagers, but rather from his intensifying desire to participate in the war effort in the Americas, in particular his desire to create wartime propaganda that would be accessible to a broad swath of the Mexican public. While in Mexico in the spring of 1940 scouting locations for the film, he worried about the contentiously fought upcoming election and was especially alarmed at what he perceived as widespread support for right-wing presidential candidate Almazán, among the same Mexicans he observed wanting "Fords and canned fruit and store clothes."[17] Steinbeck was concerned enough at both the political conflict that seemed to be brewing and Almazán's fascist tendencies that he wrote to Franklin Roosevelt in June 1940 to express his concerns and to propose a "propaganda office, which, through radio and motion pictures, attempts to get this side of the world together."[18] Even after Roosevelt met with Steinbeck and established the Office of the Coordinator of Inter-American Affairs in August of that year, Steinbeck remained preoccupied

by the war; he pitched at least one more idea that summer to Roosevelt, that of scattering counterfeit German money over Europe, which Roosevelt vetoed.[19]

Though Steinbeck's fears about the Mexican political scene were ultimately not borne out, his interest in wartime propaganda and his worries about fascism and contentious Mexican politics shaped his decision to excise the historical context of the Mexican Revolution from his script in favor of a story about a war between tradition and modernization.[20] His commitment to working in a popularly accessible medium and form, and to uniting rather than dividing the hemisphere, seems to have compelled him to erase the contentious national politics he observed while scouting entirely from the frame of his film. The "political-minded people" that Kline observed during shooting also didn't make it into the script or the film: stills from the weeks of filming *Forgotten Village* show raucous crowds filling the central plaza on election day, with some townspeople holding homemade banners demonstrating their efforts to display themselves as literate, modern, politically involved citizens.[21] But the finished film depicts Santiago as quiet and insular, its inhabitants exhibiting no trace of the political engagement their real-life counterparts so ostentatiously displayed.

Steinbeck's solution to his wartime worries, then, seems to have been twofold: erasing the political conflict he observed from the picture in order to create a stark opposition between tradition and modernity and combatting the "emotional hysteria" of fascist and communist ideologies (here symbolized by Trini and her folk wisdom) with an absolute faith in science.[22] Despite Steinbeck having written in 1936, "I will not write about Mexico. I do not know enough about it,"[23] *Forgotten Village* adopts a slow, naturalistic, and authoritative style meant to convey social-scientific truths. This style, as well as the evacuation of modern technology and politics from Santiago, marks *Forgotten Village* as heir to the ethnographic film tradition established by Robert Flaherty and Frances Flaherty. The film's beginning offers what appears to be patient attention to the unfolding of events in a "traditional" society, a fabrication that obscures the filmmakers' extensive coaching of indigenous peoples through antiquated or exaggerated rituals and practices that they did not perform in their day-to-day lives.[24]

However, rather than continuing with such naturalistic scenes, *Forgotten Village* hews a new path that diverges from the ethnographic tradition, constructing a new kind of film—the development film—that condemns the traditional practices it initially tracks so sensitively. The film creates a new cinematic vocabulary of underdevelopment and development by suffusing its ethnographic elements with melodrama, a mode which, as Travis Workman explains in the context of Korean cinema, "uses pathos to provoke sympathy to give emotional authenticity to a Manichean moral world."[25] In *Forgotten Village*, the suffering women and dying children provide the pathos, and the stark opposition between tradition and modernity constitutes the Manichean moral world. The film also contains melodrama's characteristic moments of "too late" heroic action when repeated attempts to save the children fail; this lateness is forecast by the opening intertitle, which introduces the film as "the story of the boy Juan Diego, and of his people who live in the moment where the past slips reluctantly into the future." This framing assertion of temporal lag resonates with the "persistent sense of arriving too late" that Workman and other scholars identify as characteristic of melodrama.[26]

The film also adopts melodrama's conventions in other ways. The opening scene depicts Juan Diego leading his pregnant mother Esperanza to her checkup with Trini. Their slow walk along the clear, calm water establishes a sense of equilibrium, signaling the space of innocence from which melodramatic narrative begins. This sense of innocence at the start of the film, as Juan Diego and Esperanza journey to meet the ultimately nefarious Trini, is complemented by leftist composer Hanns Eisler's score, which features discordant, foreboding trills.[27] Through the film's tender, slow opening scenes the audience is drawn into the story of Esperanza, who gives birth with Trini's help in the "Aztec-style" birthing scene that the New York State board of censors would later attempt to excise. It is only when the baby becomes sick that Trini is revealed as the evil embodiment of underdevelopment, the force that is infecting the village and keeping it from modern science and technology. Thus the spectator first becomes identified with Juan Diego's family but is then encouraged to see them as Juan Diego begins to, as naïve victims tricked by Trini into slamming the door on the doctors who would save their children. This melodramatic scenario appears not only in the film's plot, but also in its

lighting: Trini and the women who listen to her are repeatedly shown in shadowy darkness, while Juan Diego is generally bathed in light. This is particularly true at the end of the film, when he is in the doctor's car: the light shining on his face suggests that it is the space of innocence in which melodrama, as Linda Williams argues, "wants to end," while the "I am Juan Diego" pronouncement with which the film closes proclaims that he, if not his family and community, has finally converged with the Anglo narrator and attained the modernity and timeliness he has sought.[28]

The incorporation of melodrama into *Forgotten Village* was the element Steinbeck identified as its innovation in the documentary form. In the companion photo book to the film, he boasts of the new form he has created, confident that the story structure will instill both knowledge and intimacy in viewers:

> A great many documentary films have used the generalized method, that is, the showing of a condition or an event as it affects a group of people. The audience can then have a personalized reaction from imagining one member of that group. . . . In *The Forgotten Village* we reversed the usual process. Our story centered on one family in a small village. We wished our audience to know the family well, and incidentally to like it, as we did. Then, from association with this little personalized group, the larger conclusion concerning the racial group could be drawn with something like participation.[29]

Steinbeck's confident explanation, his assertion of the fictional family drama and the elicitation of emotional participation as the film's real innovation, indicates the deliberateness with which he spliced family melodrama together with ethnographic realism, as well as his recognition that he was doing something new in the realm of documentary film. His explanation also indicates aspects of the new international development thinking that would become ubiquitous during the early Cold War. The process of audience identification Steinbeck describes is contradictory: viewers of *Forgotten Village* must "know" and "like" Juan Diego's family (and by extension, their "racial group") to participate, at least emotionally, in their fragmentation and destruction. Juan Diego, hurtling toward the city at the end of the film, has detached himself from his family and community: he embodies the rootless "mobile personality" modernization theorist Daniel Lerner later advocated constructing, primarily through mass

media, as the necessary first step in modernizing the world.[30] This contradictory way of imagining and attempting to assist traditional societies—identifying with them and recognizing them as equals, then attempting to help them by inciting them to destroy their own cultures, lifeways, and community structures—would soon become central to the imagined process and promise of development.

If Steinbeck's paring away of the historically grounded elements of his story in favor of a clear, melodramatic narrative of family tragedy and nationalistic modernization can be explained by his post-*Grapes* aversion to "politics," his decision to make Trini the central symbol and source of the village's ignorance cannot be explained so easily. Steinbeck's decision to make Trini the film's central figure—she appears alone on the theatrical poster, a glow emanating from her cupped palms as if she controls the cosmos—as well as its villain seems to have been a result of her very willingness to participate in the film, a decision that in turn shaped the script he wrote.[31] Kline wrote in his journal for August 1940, "The village curandera (Trini by name) is the first villager to agree to work with us. Once Trini broke the ice, quite a few villagers promised to work with us when we need them."[32] Kline identifies Trini as one of the film's "scene stealers," in contrast to the actor playing Juan Diego, who is "learning his way about." (In general, Kline was unhappy with the acting abilities of the villagers, whom he had to break "of the habit of mugging by having [assistant Carlos Castillo] mimic their posing, thus showing them how unnatural their 'acting' is.")[33] Photos of Trini talking with the crew and instructing other actors on set also indicate that her performance of hostility was an act.[34] Steinbeck's note, "Please ask Trini whether she knows either of the following words but do it casually: YEHYECAME: (this is the disease she is supposed to have been treating, in the Nahuatl language) and YEHYECATZITZIN (these are the little gods which are supposed to cause it)," similarly suggests that the film's depiction of Trini's recalcitrance and folk-medical ideas did not evolve naturally out of her interactions with the crew.[35] Ironically, then, Trini's positioning as the embodiment of recalcitrant evil in the film was partly a result of her obliging presence on set—of her very attempts to welcome the film crew into her village and cooperate as an actor. Trini's performance, however, was so convincing that she sold the film as an unembellished documentary: the *New York Times*

Figure 7. Trini on the set of *The Forgotten Village* (dir. Kline, 1941). Photo by Herbert Kline, courtesy of Elissa Kline.

Figure 6. Movie poster for *The Forgotten Village* (dir. Kline, 1941)

Book Review noted that "as the camera focuses on Trini . . . you feel the fear and suspicion of a thousand years of ignorance peering out of those heavy-lidded eyes."[36]

Released at the height of Steinbeck's fame, *Forgotten Village* was reviewed widely and was universally critically acclaimed. Despite the film's melodramatic script, reviewers mostly understood the film as a faithful document of Mexican village life, free of any artifice or shaping narrative. Philip K. Scheuer of the *Los Angeles Times* wrote authoritatively of the shooting, "Winning over the suspicious populace was a task requiring infinite patience and sometimes guile, but once convinced the gringos meant no harm the Indians went about their business of living as if the camera wasn't there."[37] Bosley Crowther of the *New York Times* likewise asserted that "this fine and sincere documentary of a modern conflict in a remote Mexican town is as innocent of ulterior motive or moral offense as the

Song of Ruth," and that "integrity is the distinctive quality that lends au-
thority to this handsome picture."[38] *Time* similarly designated the film "a
documentary film of integrity and beauty," while the *San Francisco Chron-
icle* explained, "They are humble natives of the village of Santiago, a tiny
spot of human existence lost in the mountains of Mexico. There do these
simple, child-like villagers live out their appointed days, sowing and reap-
ing the food they eat, weaving and sewing the clothes they wear, playing,
loving, and dying in serene ignorance of the march of science, industry
and commerce in the skyscraper cities lying beyond the farthest range."[39]

Perhaps more surprisingly, given its later obscurity, *Forgotten Village*
landed on several critics' "best of" lists for 1941; on the lists that combined
documentary and fiction, it fell behind *Citizen Kane* but well ahead of *Sul-
livan's Travels* and *The Maltese Falcon*.[40] That the film was on multiple
lists with these better-remembered films is remarkable, but also remark-
able is the contrast between them: the other three films, in different ways,
are all inflected by the anti-capitalist sensibility of the Depression years—
the knowledge that poverty is caused by capitalism, or at least the general
sense that some people are poor because others are rich. In its focus on
traditional folk culture and powerful women as the causes of its charac-
ters' misery, *Forgotten Village* signals the particular kind of forgetting that
would characterize development thinking, the severing of poverty from
class antagonism that James Ferguson has called the "anti-politics ma-
chine."[41] This line of thinking only became more central over the course
of the decade, and *Forgotten Village* garnered more acclaim, winning Best
Feature Documentary at the Brussels Film Festival in 1947.[42]

Prizes and critical praise, however, could not win the film a mass audi-
ence. Steinbeck had imagined the film reaching both mass and educated
audiences, advising Kline "to direct this, Herb, as I try to write—on one
top level for our peers, those who know as much as we like to think we
know—and on another level to keep it simple and true for people with
little or no education so they can understand and be moved by our story."[43]
The mass audience, however, did not materialize: although the film was
released in theaters across the United States, theater managers reported
big opening nights and dismal business thereafter; one theater manager
complained that "the week he played *Forgotten Village* was the all-time
low and that he cannot play the picture in Sacramento."[44] In Mexico even

fewer people saw the film. While politicians screened *Forgotten Village* privately—Kline reported in 1944 that he had screened the film for Mexican president Avila Camacho and received "a wonderful reception"—it never enjoyed mass distribution in the country where it was made.[45]

Social scientists and reformers, however, did see the film, and like the movie critics, they were impressed. Anthropologist Robert Redfield, whose studies of Mexico shaped postwar modernization theory, reviewed the film's accompanying photo book favorably for the *American Sociological Review*, impressed that "the presentation manages to treat the folk beliefs sympathetically and yet to be propaganda for science and progress. A work halfway between art and reporting, it is faithful to ethnological fact."[46] Alvin Johnson, an economist and one of the founders of the New School, wrote an indignant letter to the *New York Times* about the state's attempt to censor the film (an attempt that was ultimately overruled by the Board of Regents after Eleanor Roosevelt intervened on the film's behalf), arguing that "the picture is a singularly complete and penetrating account of the whole life of a primitive community," while also marveling that "[i]t is remarkable in these days of cynical depreciation of scientific progress to encounter a writer of the 'younger generation' who exhibits the intelligent zeal for scientific progress that made the Enlightenment the brightest page in modern history."[47] Eleanor Roosevelt also discussed the film in her *My Day* column as depicting a model for rural medical services that the United States could follow.[48]

The film also traveled in development circles: it was adapted for Puerto Rico's Division of Community Education (DIVEDCO), translated into Spanish as *Pueblito de Santiago*, and screened in England alongside the Colonial Film Unit's *Daybreak in Udi*.[49] It was also acquired in the early 1950s for the film library at the Center for Fundamental Education and Adult Learning (CREFAL) in Pátzcuaro, Mexico, one of the key UNESCO sites for their program of development through fundamental education, and particularly for the practice of adult education through interactive film screenings.[50] (The films made at these Puerto Rican and Mexican sites, which learned from *Forgotten Village*, are treated in the next two chapters.) The film also circulated among church and missionary groups around the United States.[51] Thus for all Steinbeck's worries about simplifying the story for the average uneducated viewer, development agencies and social

theorists seemed most taken with the film's narrative, even using it to support their assertions about "The Generic Folk Culture of Mexico," as one sociological article described it.[52] While the mass audiences Steinbeck had attempted to attract did not see the film, it was seen and appreciated by a small but influential class of liberal intellectuals, social scientists, and development workers (including cultural workers), who often understood it as a faithful ethnographic document.

Though US media accounts credulously attested to the accuracy of the film, a few journalists expressed doubts. Barker Fairley, from the *Canadian Forum*, praised the film but also noted that "it all seems not quite contemporary since this is not, for us, an acute phase of the social problem. On the whole—except for holes and corners—modern medicine has won out."[53] Ed Ricketts, with whom Steinbeck had sailed to Mexico, was one of the few critics who went a bit further. In fact, he wrote the beginnings of an "anti-script," "with a motif diametrically opposed to John's, but equally true and equally significant factually." Ricketts imagines that "the working-out of the script for the 'other side' might correspondingly be achieved through the figure of some wise and mellow old man who has long ago developed beyond the expediencies of wealth and power drives. . . . A wise old man, present during the time of building a high-speed road through a primitive community, appropriately might point out the evils of the encroaching mechanistic civilization to a young person."[54]

Perhaps the most revealing reaction in relation to both the melodramatic elements of the film and its reductive portrayal of the already-modernizing Mexican state was the mild critique leveled by medical doctor and Mexican ambassador to the United States Francisco Castillo Nájera. In a letter to distributor Arthur Mayer, Castillo Nájera conveys his aesthetic appreciation of the film, calling it "a masterpiece of art and of sympathetic understanding of the task which confronts the Mexican government in few of the very remote villages of my country." However, he continues:

I must say, nevertheless, that although its title brings out the fact that the environment which you represent in your film represents neither the normal nor the average social and sanitary conditions which prevail in most of our small communities, I am afraid that unintelligent audiences may derive that false impression. As a matter of fact, only in a few of the most insolated [*sic*]

regions in Mexico, children are brought into the world by the so-called "manteada" procedure, which is the climax of your film. I fear that some of the public in this and other countries, prone to be indiscriminating, might get an erroneous impression of Mexico as a whole.[55]

Castillo Nájera objects here not to the film's elision of the revolutionary Cardenist political landscape, but rather to its depiction of an archaic "forgotten" village and its customs, which he correctly identifies as largely eradicated by the Revolution's extant modernization programs.[56] However, he also understands the film's melodramatic moves:

> I am of the opinion that the privileged people of the world should be made to realize, more than they usually do, that there are many others, not so privileged and not so benefited by the blessings of a good social and exonomic [sic] education. This is the only way to arouse public sympathy, to create an expanding sense of responsibility towards our fellow human beings. Your "Forgotten Village," it seems to me, is to our generation what the famous "Tom Cabin" must have been to the generous reader of its time: they are both, democratic contributions to democratic countries."[57]

Castillo Nájera's reference to *Uncle Tom's Cabin* is perceptive: like Harriet Beecher Stowe's novel, *Forgotten Village* forges emotional connections with audiences by embellishing racial types, as well as by depicting and then rending family bonds. Like Stowe's novel and its many subsequent theatrical adaptations, *Forgotten Village* wielded its emotional story for a purpose: it deliberately constructed a melodramatic fiction that looked like ethnographic truth to make an argument for the urgency of eradicating underdevelopment. Kline knew the film's staging of the stark divide between "evil" Trini and modern medicine was a fictionalization of Mexican villagers' practices; he wrote in 1942 that, far from eschewing one or the other, "the peasants generally had more faith in *curanderas* than in doctors and would continue with Trini's herbs and magic at the same time as they were being treated by modern scientific methods."[58] However, at Steinbeck's behest, Kline created the illusion of unmediated reality, filming in the on-the-scene style he had developed in Europe "in a way that would make audiences feel that no camera crew had been present, that life had just unfolded on the screen."[59] Evacuating the political conflicts they had actually encountered in Mexico from this vision of unfolding "life"

and replacing them with a simpler tale of hostile tradition and benevolent modernity was a move imagined by Steinbeck and Kline as "democratic" and democratizing, as Castillo Nájera gleans. But like the emerging development regime it helped usher in, the film was democratic in impulse rather than substance: it attempted to elicit sympathy for isolated and impoverished people but also blamed them for their own woes and did not permit them to formulate their own stories or demands.

But if the film entirely missed the mass audience for which it was made, it was these very "democratic" impulses to oversimplification, naturalization, and melodrama that lent *Forgotten Village* currency among politicians, social scientists, and other filmmakers. Thus *Forgotten Village* assisted in making the remote, tradition-bound "villager" the credible ground on which modernization theory rested. As the earliest example of a development film, however, the film does not yet offer a fully worked-out vision of a path to modernization; it does not yet visualize the transformations in the subjectivities of the villagers through the application of pesticides and chemicals to their agriculture, or other such stock moments and shots that come to stand in for a general improvement of life in the modernization imaginary and later development films. Other filmmakers in the 1940s, however, were drawing on their experiences in New Deal documentary culture to develop this vocabulary.

ANOTHER WAR: WILLARD VAN DYKE'S GOOD NEIGHBOR FILMS

The sense of imminent hemispheric crisis Steinbeck conveyed to Roosevelt, as well as the imperative to transform "traditional" subjectivities that drives *Forgotten Village*, began to creep into the official hemispheric propaganda efforts that emerged at the same time Steinbeck was suggesting them. Darlene Sadlier has called the output of the 1940–1945 Office of the Coordinator of Inter-American Affairs (OCIAA) "the most fully developed and intensive use of soft power in U.S. history," and documentary film formed a large part of this "soft power" mobilization. By 1944, more than four hundred Good Neighbor educational documentaries were circulating in the Americas, including twenty-six travelogue-like "Latin America

films" directed by Julien Bryan, and many by Van Dyke, who worked for both the OCIAA and the Office of War Information.[60] These films had tremendous reach, moving beyond the middle classes to target urban workers and rural audiences.[61] In capturing a broad Latin American audience, their task was to bring the war to the Americas: to demonstrate that a conflict that seemed far away was actually encroaching on the hemisphere. These filmmakers' attempts to frame hemispheric cooperation as a life-or-death affair, a mobilization of resources that could make the difference between the victory or defeat of global fascism, meant that they began to gaze upon Latin America with a certain Manichean sensibility.

The ease with which wartime anti-fascism was transposed onto economic modernization efforts was partly due to the presence of young oil heir Nelson Rockefeller at the OCIAA's helm. After an unsuccessful attempt to get business leaders to agree to conduct themselves better in Latin America in the name of hemispheric solidarity, Rockefeller approached Roosevelt with a massive wartime economic plan for the hemisphere and a desire to assist with wartime economic planning.[62] The plan, which Rockefeller had formulated in collaboration with brain-truster economist Beardsley Ruml, included buying up surpluses of natural resources and "develop[ing] sources of raw materials," eliminating tariffs, and "refunding" Latin American debt in order to "obtain substantial sums available for local investment" and "to eliminate the bad atmosphere that will exist as long as the defaulted debts remain outstanding."[63] The president liked the plan but faced opposition from both his cabinet and domestic agricultural associations like the American Grange and could not implement it.[64] He ended up putting Rockefeller in charge of cultural programming, a position for which, as the director of the Museum of Modern Art who also had connections in the worlds of Hollywood and educational film, he perhaps seemed a bit more qualified. However, Rockefeller's interest in economic planning, in visualizing resource extraction and trade relations rather than counterposing fascism and democracy, was reflected in the orientation and output of the OCIAA.

If we can see the antipathy toward tradition that impels *Forgotten Village* in some of the OCIAA's films, most filmmakers also recognized that demanding the complete transformation of "traditional" culture was somewhat at odds with Roosevelt's Good Neighbor philosophy of "your

Americanism and mine."[65] While some US-produced World War II–era films highlight US dissemination of medicine and other technologies in Latin America, most tend to frame it in terms of hemispheric collaboration and the anti-fascist struggle, rather than an overarching modernization project. Though these films are somewhat preoccupied with tradition and modernity, generally the story is not the one modeled by *Forgotten Village*, of an isolated village facing staunch resistance to modernizing interventions. In the 1943 film *The Silent War* (dir. Van Dyke), for example, the people in a small Colombian town hear that a yellow fever vaccine, "the product of the genius of the combined Americas," has finally arrived. The villagers line up to receive their vaccines, without any superstitions being vanquished. *Silent War* mentions neither lethargy nor tradition, making it quite clear that the scourges to be eradicated are disease and fascism. In general, too, most Good Neighbor films display something more like uneven and combined development: because of the short-lived wartime imperative to imagine Latin American societies as equal to North American ones, many of the travelogues and other documentary films juxtapose bustling cities and a cosmopolitan class with scenes of poverty, isolation, and "underused" rural lands.[66]

Van Dyke, the filmmaker who made *Silent War*, was also the artist who began in his Good Neighbor films to venture into the starker territory of the development film. Van Dyke was an important figure in mid-twentieth-century documentary, one who helped to envision mid-century modernization's schematic ideas and make them compelling to ordinary and expert viewers alike. Van Dyke started his film career working on New Deal films *The River*, *The City*, and *Valley Town*; made World War II Good Neighbor films that introduced South America to US audiences; and then in the early 1960s made films for the Rockefeller Foundation dramatizing its agricultural projects. In his work making US and Rockefeller propaganda films, Van Dyke was influential. He mentored other filmmakers, including some in DIVEDCO (discussed in chapter 2), and worked with Jorge Ruiz, who founded and directed Bolivia's National Cinema Institute (whose output is treated in chapter 4). The dramatic social-realist sensibility he lent to his educational film assignments proved to be a blueprint for development film in the hemisphere. *The Bridge*, the OCIAA-distributed 1944 development film he made with leftist writer

Ben Maddow, was particularly important in this regard; a compellingly stark and dramatic catalog of Latin American underdevelopment, the film pioneered the use of melodramatic imagery rather than narrative in the service of the development goals of intensified resource extraction and economic integration.

What allowed Van Dyke to invent the vocabulary of the development film was precisely his training in the workerist and anti-fascist aesthetics of the Popular Front. Van Dyke embodies Michael Denning's account of how liberal artists became aligned with the Left in those years: while he maintained throughout his life that "Roosevelt was the savior of the country," and that he was "interested only in democratic change," the mid-1930s saw Van Dyke drifting leftward in his life and artistic commitments.[67] He had begun his career in California as an art photographer, where he formed the f/64 photography group with artists such as Edward Weston, Ansel Adams, and Imogen Cunningham, advocating together for photographing quotidian objects on the f/64 exposure, which allowed for maximum depth of field (it was perhaps this attention to clarity and framing that gained him the nickname "the shot" when he became a filmmaker).[68] However, seeing Dorothea Lange's photographs for the first time in 1934 made Van Dyke rethink his subject matter, if not his style. "I quit making pictures of gas tanks and smokestacks against the sky, symbols of a thriving industrial society, and began to search for decaying storefronts and makeshift shacks that marked the Depression," he recalls in his unfinished 1970s memoir.[69] After this realization spurred by Lange's evocative portraits of dust bowl migrants, Van Dyke moved east to New York City. There, with Maddow, he became a founding member of the Nykino film collective, a collective that produced among other things a left-wing newsreel called *The World Today*; Van Dyke was overjoyed at finding himself in a leftist milieu of young artists.[70]

While he never joined the Communist Party and seemingly never even considered it, Van Dyke did travel to the Soviet Union in 1935, in search of the great filmmakers Sergei Eisenstein and Alexander Dovzhenko. Once there, he was disappointed to learn that they were out of the country, and that in any case they were "no longer relying on foreign talent or guidance."[71] He was also disappointed with the Soviet culture he did encounter, and particularly disdainful of socialist realism (though he did enjoy

a trip to the ballet), and he returned home even more "disillusioned with the extreme left" than before.[72] Upon his return, Van Dyke took a job as the cinematographer for the New Deal film *The River*, working for fellow Roosevelt admirer Pare Lorentz on his poetic film. After filming *The River*, he recalls, "I was sure that I wanted to make films more than anything else, but I was also sure that I wanted to expand the documentary form beyond the boundaries set by Lorentz.... My youthful optimism was unbounded."[73] He began to imagine how he could draw on Bertolt Brecht and experimental theater techniques to imagine a filmic style more his own.

The apotheosis of Van Dyke's career as a filmmaker, the film he considered the height of his stylistic creativity and experimentation, was *Valley Town*, which he and Maddow made on behalf of the Alfred P. Sloan Foundation in 1940. An archrival of Roosevelt and the New Deal, General Motors head Alfred P. Sloan founded an educational film center at New York University as part of his foundation's overarching goal of "the promotion of wider knowledge of basic economic truths generally accepted by authorities of recognized standing and experience."[74] Alfred, together with his brother Harold, who served as the first director of the foundation, hired a Harvard economics PhD student to cowrite the films, hoping that the student could guide their stable of prominent filmmakers toward clear explanations of (laissez-faire) economic theory as applied to what Harold called "live social problems, such as the displacement of men by machines."[75] The tension created here by rabid anti–New Dealers employing Van Dyke, a Roosevelt-loving filmmaker interested in perfecting a workerist aesthetic and to some degree a solidarity politics, is apparent both in their struggles during the filmmaking and in the finished film itself.

Although Van Dyke had agreed to make a film illustrating "basic economic principles," reasoning that "now that the Great Depression was beginning to subside, it was only reasonable that its causes should be examined," his visit to Pittsburgh to meet displaced steelworkers changed his mind. "I was determined that my film would be no sterile explanation of economic theory," he remembers in his memoir. "The people were in trouble through no fault of their own."[76] The finished version of *Valley Town* reflects these concerns and commitments, examining the devastating effects of mechanization on workers and the environment while also

considering its benefits. Stylistically, the film features complicated, multi-vocal voice-over schemes, with characters breaking into song and a score by avant-garde composer Marc Blitzstein, who had written the music for the controversial Works Progress Administration labor musical *The Cradle Will Rock*.[77] Although the Sloans edited out about ten minutes of the bleaker, more avant-garde, and anti-corporate voices from Van Dyke's first draft of the film, he was still pleased with the final product, particularly with the feedback he received from leaders of the steelworkers' organizing committee: "One of the toughest looking men at the first showing, visibly moved, said 'It isn't exactly real but it's so *true*, so *true*.'"[78] It is true that despite Van Dyke's compromises with the Sloans, the film is a statement of sympathy with the displaced workers and an exploration of their fate. Van Dyke seems to have been satisfied with the collaboration; he immediately accepted another commission from the Sloans when, as he describes it, the foundation canceled its association with NYU and decided to make films for the Foreign Policy Association (FPA) about Latin America that "dealt with the complexities of foreign trade."[79]

The Sloan Foundation and FPA-sponsored film Van Dyke ended up making, again with Maddow as screenwriter, was *The Bridge*, an early development film that transposes the war against fascism in Europe onto "another war" between tradition and modernity, as well as a related struggle between isolation and "free trade," in South America. Distributed by both the NYU film library and the OCIAA, and praised by the Museum of Modern Art's Iris Barry as one of the few documentaries about Latin America that transcended the Good Neighbor formula of "amateurish and feeble travelogs," *The Bridge* draws on Popular Front stylistic and thematic preoccupations, particularly with laboring bodies and humanist, sympathetic depictions of poverty, but uses them to support the "basic economic truths" promoted by the Sloans.[80] Here the Sloans seem to win out: the film pays little attention to worker subjectivity and instead works as a prescription for overcoming poverty through the intensification of extraction, manufacturing, and US corporate power in the Americas. Presaging 1950s modernization theory, *The Bridge* reaches back into the past of the Americas to renarrate the history of "triangular trade" as a nonviolent teleological one only recently interrupted by nefarious fascists. Warning of the effects of trade disruption, it then posits "another war," this one

on tradition, reaching forward to imagine resource extraction and aviation as the forces that will finally liberate South America.

That the Sloan Foundation would sponsor Van Dyke and Maddow's attempt to make a hemispheric anti-fascist film for circulation by the Roosevelt administration was surprising, given Alfred P. Sloan's hatred of FDR and the New Deal and his reluctance to cooperate with the war effort in other ways. When Nelson Rockefeller had asked him in 1940 to sever GM's ties to pro-Nazi auto dealers in Latin America as part of a pre-OCIAA effort to improve US corporations' behavior in Latin America in the hopes of a united Allied front there, Sloan had not only refused but also expressed fury at the request. According to David Farber, he fumed to Walter Carpenter of Du Pont, suggesting, "rather than pick on some of these things which are more or less inconsequential in relation to the total in South America, that somebody might get busy putting in jail, or exporting, some of the Communists who are causing the many labor troubles in this country."[81] That Sloan agreed to finance Latin American filmmaking for the war effort at all demonstrates that Rockefeller's dream of uniting corporate leaders was at least partially realized, albeit around propaganda rather than reforming their own conduct. The Sloan Foundation did not micromanage *The Bridge* as much as they had *Valley Town*, although Harold Sloan had some suggestions for Van Dyke, including, "[H]ow about showing more clearly how we shall be benefited from a higher standard of living in South America?"[82] Sloan also commented that he "liked particularly the scene breaking up the jungle in preparation for oil wells."[83]

A departure from Van Dyke and Maddow's 1930s efforts that allowed their subjects to speak and evinced ambivalence about progress, *The Bridge* cuts together stark yet impersonal scenes mapping "the economy of South America" with close-ups of suffering women and children and alarmist commentary, infusing a melodramatic sense of urgency into what might otherwise be a dry tale of opportunities for hemispheric trade and connectivity in wartime.[84] The film opens on a calm seascape overhung by ominous clouds, as the voice-over proclaims: "The sun is rising over a battlefield. Over the Atlantic Ocean. Beyond the horizon lie other battlefields: Europe, and Asia. The sun moves west, toward the two Americas." Having designated the entire, ostensibly calm ocean a battleground, the

film implicitly extends the battle to the Americas as well as Europe. At the end of the opening sequence is a scene of the ruins at Machu Picchu, where the camera lingers on a pair of indigenous men walking away from the camera while the voice-over proclaims: "The new civilization of South America lives and works and trades with the rest of the world. Turning her back on these symbols of the past, she looks to Europe and North America." In this deft initial substitution, then, the film depicts Latin America as a "battlefield," using the battle against fascism to introduce a new Manichean battle, between the (indigenous) past and the (European and North American) future.

As the indigenous men disappear into the ruins, the scene dissolves into a hand-drawn map of the Atlantic region, while the voice-over explains the history and importance of trade relationships with Europe and North America, asserting, "Before the war the trade of South America with Europe was nearly a billion dollars a year." The authoritative voice-over continues, accompanied by drawings, first a thick white triangle connecting the three continents, then cartoon ships gliding over the lines, then products that pop up from each region as they are named, extracted from the land as if by magic. The voice-over reiterates the sense that the land has magically produced, extracted, and packaged the raw materials on view: "This three-cornered relationship was not a simple one. The variety of climate and resources produced a variety of trade. The Caribbean area, largely tropical, produced coffee, sugar, chewing gum, and bananas. Fifty percent of the trade of this area was with the United States. The west coast area, mountainous and dry, produced cotton, cacao, and minerals." The litany of products and their paths continues until World War II, which the narrator announces as a decisive break, the moment when "[t]he guns of destroyers and the torpedoes of submarines struck at this triangle of trade until it broke, until the broken ends coiled back on South America to strangle it with the death of trade."[85] Here the history of the global slave trade is both effaced and implicitly counterposed to European fascism. "Death" and "strangulation" describe not the experience of people during the middle passage or on plantations, but the isolation that might happen *without* further extraction or exploitation. Likewise, the industrial "death" Maddow observes in his journal of their spring 1942 travels—a smelter in Peru that had "poisoned the vegetation of this area and killed the cattle,"

a "dirty" hydroelectric plant in Chile, a "cyanide accident" and "two men killed" at a rubber plant in Brazil—appears nowhere in the film.[86]

According to Van Dyke, *The Bridge*'s narrative of smooth "triangular trade" interrupted by fascism was a result of the increasing US involvement in the war. Before the attack on Pearl Harbor, Van Dyke and Maddow had planned to make a film about the "classically colonial" economic relations between Latin America and the global North, but as had happened with Steinbeck and Kline in *Forgotten Village*, the exigencies of the war pushed them to abandon their initial, more historically grounded idea.[87] This interruption of the smooth and peaceful triangular trade is framed as the central problem of the film, which offers industrialization, air travel, and the colonization of the Amazon rainforest as solutions for the economic integration of South America.

This setting aside of a story of "essentially colonial" trade relations in favor of imagining intensified international capitalist flows as desirable for all enabled Van Dyke to create a new aesthetic of modernization in *The Bridge*, one that focuses on ordinary impoverished people only to reframe them as disconnected from "the economy" and bind their improvement insistently to large-scale extractive ventures. Van Dyke's tracking shots with a handheld camera in a Colombian market, of which he was very proud, exemplify this new logic: his camera follows market goers with some curiosity but ultimately recasts them as generic, improvable "villagers."[88] As the film cuts away from a roaring smelter to an aerial view of a crowded town square, the voice-over proclaims that "there is no war boom here. There is only one road into this town. There is only a market. Nine out of ten South Americans live near towns like this. Nine out of ten have never seen a mine or an oil field." These pronouncements are illustrated by eye-level shots of men struggling with heavy burdens, as well as others who seem to be socializing happily, while the voice-over connects the difficulty of the people's lives with their stagnation and local identities: "They live by the earth, and by the labor of their hands. Their lives have always been hard. Nothing changes here but the faces on the coins." The camera lingers on a few women, seemingly merchants, smiling, and the voice-over stems any assessment of their joy by reminding audiences that their "beauty" is "marred by disease." We also see lovely shots of potatoes, and later of flour being ground, but the voice-over again cautions viewers

that "in this market, the cheapest food is still the food of the Indians . . . and being poor, this is what most South Americans eat." Throughout the scene, what might be a warm and appreciative depiction of sociability and nourishment is framed by the voice-over to emphasize the deficiency and improvability of the population.

The landscape, too, often looks beautiful and tranquil in the film, but it is recontextualized by the narration as remote, closed off, and infinitely improvable. As the camera pans over a lone hut in the middle of the tranquil rainforest, the voice-over warns that the "unused" area is "not easy to use," covered in "stubborn jungle" and "too much water." A close-up of a leaf crawling with caterpillars is likewise accompanied by a warning that the region is "crawling with life and with the enemies of life," offering viewers a melodramatic biopolitics that also ushers in the era of both pesticides and disastrous attempts at rainforest colonization, paving the way for the deforestation and megaprojects that followed.[89] To illustrate such possibilities, the film shows some scenes of massive trees being felled and land being bulldozed before arriving at the Ford Motor Company's Fordlandia plant, panning over its rows of rubber trees and proclaiming that "science can make the jungle straight" and that another remote Amazon village "can become a city."

The persistent contrast in *The Bridge* between the imperious voice-over and Van Dyke's sympathetic camerawork reflects the central tension of the film's production: Harold Sloan seems to have pressured Van Dyke and Maddow to impose a narrative of isolation and stagnation on the people and places they encountered on their long road trip, in order to proclaim the urgent need for their modernization. While Van Dyke and Maddow seem to have implemented Sloan's suggestions without much trouble, it was nonetheless Van Dyke's social documentary sensibility, the sensibility that drew him to depict impoverished and laboring people, that made his schematic visions of modernization so compelling, drawing Iris Barry's attention as well as that of the Rockefeller Foundation. In *The Bridge*, Van Dyke's tendency to move toward human relations and away from industrial and resource-extraction scenes at times threatens to undermine the Sloans' designs, as in the rainforest sequence where the camera lingers on a smiling child with a monkey. The music swells for a moment before the voice-over decries the sparse population and the overly abundant water of

the area, undermining but not erasing the calm, lush beauty of the scene. However, if moments like these demonstrate how the film does not evince a total commitment to the eradication of tradition and the extension of modernity everywhere, *The Bridge* is still able, through its language of war and enemies and stark scenes of innocent suffering, to convert the antifascist imperatives of wartime institutions into a melodramatic scenario pitting the malevolent past against the moral modern future.

The melodramatic cinematic vocabulary Van Dyke and Maddow invent in *The Bridge* for representing both underdevelopment and the beginnings of development has a long afterlife. Shots and scenes from *The Bridge* recur frequently in later development films of the 1950s and 1960s, eventually congealing into the clichés of the genre. *The Bridge* pioneers, for example, the visual logic of solving the problem of feminized poverty with intensified resource extraction. It features a close-up of a tiny girl standing in a doorway, body smudged with dirt, wearing only a T-shirt, hair disheveled, as the voice-over intones, "Everywhere in the world somehow the face of poverty is the same. How will this girl grow up? Into what kind of South America?," before cutting to an aerial view of a lush overgrown mountainous landscape and then to a map of the continent. "Perhaps the answer is here, in the continent itself," the voice-over posits, as the narrator points out "unused" areas that include the whole of the Amazon rainforest. The map then dissolves into a scene of the "unused agricultural lands" of the rainforest. It is here that a certain shorthand becomes clear: the disheveled, half-dressed girl stands in for poverty, and the potential for her improved life can be seen only in the aerial view of land that has not been sufficiently mapped, mined, and farmed; the editing binds the girl's individual future to the productivity of the land but also to "the economy" the film is conjuring into being. By zooming out from the girl, the scene ties her fate to regional growth, helping the downward redistribution of resources become unimaginable.

In keeping with the OCIAA's preferred model of partnering with corporations and private foundations, *The Bridge* was distributed and then later made available in educational catalogs with OCIAA-produced films. While the title of the film turns out to refer a bit awkwardly to cargo planes, ultimately arguing that airplanes are the solution that will bridge the "five hundred years" of distance between the American republics, the

Figure 8. "Everywhere in the world somehow the face of poverty is the same," *The Bridge* (dir. Van Dyke, 1944)

titular bridge seems more appropriate, and multivalent, with the benefit of hindsight. Beyond the bridging function of intercultural understanding that is the second intended meaning the title carries, the film also can now be seen as a bridge between the New Deal–era films its creators made at the start of their careers and the Cold War films some of them, like Van Dyke, would soon begin making. The film also serves as an ideological bridge, between the conservative corporate interests of the Sloan Foundation and the New Deal liberal-left politics of the artists who made it. We might even say it presents an early vision of what many have understood as the postwar liberal consensus, in which limited workers' rights and a welfare state at home accompanied an aggressive foreign policy agenda that secured raw materials and markets around the world.[90]

In the early postwar years, Van Dyke and his new production company, Association Films, tried their best to participate in the new foreign policy film world. He made a USIA film in 1950, *Years of Change*, that he conceived of as an illustration of Harry Truman's 1949 inaugural address, in which Truman introduced the term *underdevelopment* into popular circulation. The film, shot mainly in Bolivia by Richard Leacock, who would go on to have a storied career in 1960s direct cinema, echoes *The Bridge* in its tender market scenes. But *Years of Change* is ultimately more meditative, asking how "the changer must change" as development workers attempt to convince people that their ways are best. Of his USIA filmmaking Van Dyke writes, "We hoped that the meager efforts of the United States could have some effect in solving the enormous problems. We were not very optimistic and time has confirmed our fears, but we knew that

the effort must be made."[91] Van Dyke's desire to assist the US government and his lack of interest in communism did not save him from falling under suspicion during the McCarthy years, seemingly for his trip to the Soviet Union. While he was not fully blacklisted, a fate that Eisler (who was also deported in 1948), Kline, Maddow, and other more openly leftist artists suffered, Van Dyke was graylisted, which meant a less thorough but still consequential suspicion and snubbing that he found infinitely frustrating; for years he was "reduced to making dull educational films and the occasional industrial."[92]

In the early 1960s, Van Dyke was still mainly excluded from USIA projects. He did, however, make two of the Rockefeller Foundation's most important films, *Harvest* (1961) and *Rice* (1964), depicting the enormous agricultural projects they were undertaking in Mexico and Asia as part of their Green Revolution efforts. These films mixed an interest in accurately documenting the activities of the foundation's agricultural program with a will to conform to a developmental narrative that led from stagnation to striving and agricultural bounty. Van Dyke was brought in first on *Harvest* to update and ever-so-slightly stylize the film's accounts of the Rockefeller Foundation's agricultural projects, which had been documented more prosaically throughout the 1950s. We can see this will to melodramatic style in both the production of *Harvest* and the final product: on the original script, someone from the Rockefeller Foundation penciled in the line that Mexican people were "chained to the soil by a primitive agriculture," a line that stayed in the film. The beginning of the film, much like that of *The Bridge*, shows viewers Aztec statues and a Diego Rivera mural, while the voice-over intones that corn "nourished ancient civilization." Lingering on the Rivera mural, the voice-over conveys the somewhat incongruously sanguine historical narrative: "In the time of the Spanish conquistadores, the magic grain became a holy grain. Where once there was Aztec sacrifice, today there is festival."

Perhaps most remarkable in *Harvest* are two scenes that exactly mimic the 1940s films discussed earlier. In the pre-credits sequence of *Harvest*, we see a medium close-up of a disheveled and dirty young child, while the voice-over queries, in a near-identical move to *The Bridge*, "What will her future be? Part of the answer will come from the land." After the credits, the camera then cuts to land being tilled, exactly the transitional move

used in *The Bridge* after its own, identical questioning of its young girl's future. While it is perhaps not surprising that Van Dyke borrowed a dramatic transition from his earlier film, the end of the film bears an even more remarkable similarity to the close of *Forgotten Village*. Cutting away from the wheat and corn fields where much of the film is set, *Harvest* ends in a domed space, a Mexico City operating theater packed with young white-coated spectators nearly identical to the one featured in the montage at the end of *Forgotten Village*. As in *Forgotten Village*, the camera pans over the reverent faces of the students looking down at the surgery. The voice-over intones that "in this land, many young people were once chained to the soil. Today, many can move on to other tasks, of industry, in the professions, in the arts and sciences." Zeroing in on several intent students, the voice-over asserts: "These are the descendants of a revolution that overthrew the conquistadores"—development has successfully decontextualized the Mexican Revolution, collapsing it with the struggles for independence—"Today they are part of an even greater revolution: against the tyranny of poverty, hunger, and disease." The last moment of the film is a close-up of a male student about Juan Diego's age, face lit from above and full of anticipation, while the voice-over intones: "today, on the land or in the town, his freedom can be fulfilled." The music swells. The otherwise prosaic film's stylishness thus consists of bringing together two of the visual clichés from these earlier films: the small disheveled girl as symbol of underdevelopment, for whose future the bulldozers bulldoze, and the young teenage boy as transitional (and for the audience, identificatory) figure who can finally break through to modernity, which, despite how regimented it looks, promises freedom.

Harvest was one of the featured listings in the *New York Times* anticipatory writeup of "the finals of the American Film Festival." Even among "a mammoth display of the best non-theatrical film fare of 1961" in "the biggest, best-organized and most influential 16-mm conclave in the world," *Harvest* stood out as what reviewer Howard Thompson calls "a towering documentary, scholarly, enlightening, and entertaining, which succinctly records the Rockefeller Foundation's long-range program of assistance in Latin America."[93] It circulated to university libraries all over the United States, USIA bureaus in Africa and Asia, and Australia's agricultural bureau, and it was used to train Peace Corps volunteers at Latin American

training sites; it also seems to have been screened frequently on television. The Rockefeller Foundation considered it extremely successful.[94] However, after some initial criticism by Mexican agricultural planners, the foundation decided not to circulate the film in Mexico beyond their closest collaborators. Throughout the 1960s, they refused requests for prints of the film from Latin America, citing "distribution arrangements" stipulating that the film could not be sent internationally, despite the foundation's willingness to send multiple copies to an Oklahoma State University project housed at "three locations in Ethiopia."[95]

Rice, too, was shown widely in educational settings and on television and mostly acclaimed, though it was criticized for its disparaging of traditional cultivation methods.[96] Reviewer Eugene Knez complained that the narration constantly criticized indigenous practices, arguing that "except for some excellent footage showing the rice terraces of the Ifugao, there is no mention of the impressive folk sophistication regarding rice cultivation."[97] The film's lack of attention to ingenious indigenous practices, of course, made it perfect for development circles: Rockefeller Foundation biologist Paul Mangelsdorf showed it to his students at Harvard, who in postfilm questionnaires mostly found it accurate and educational.[98] These later Rockefeller Foundation projects suggest that *Forgotten Village*'s accidental audience of mainly North American technicians and political figures was more deliberately replicated in later development films. Over time, the films' aspirations to educate the masses seem to have been curtailed: their slow pace, stark visual binaries, and generalized claims about poverty and progress seemed to work best on the highly educated few.

CONCLUSION: WORKERISM WITHOUT WORKERS

By considering these particular 1940s films about Latin America and their lasting effects on the social science and documentary film world, this chapter has shown how work by artists on the Popular Front spectrum, ranging from Steinbeck in the New Deal center to Van Dyke on the center Left to Kline and Eisler on the Left, together created early development films that embodied a shifting and narrowing definition of fascism and its increasingly commonsense corollary of indigenous tradition as a scourge

that needed to be eradicated. The Manichean, melodramatic urgency of *Forgotten Village* and *The Bridge*—the sense, above all, of the war on "the past" and indigenous tradition (and on the pristine land itself) as "another war" equivalent to the one on fascism—would shape many more development films of the 1950s and 1960s. However, these later films would often, as in *Harvest*, forgo the extensive staging of scenarios of underdevelopment and instead establish it through a shorthand of shots of disheveled women and children as well as folk medical practice, a shorthand rooted in the imagery and scenarios that *Forgotten Village* and *The Bridge* had established a decade earlier.

Marked by the identificatory intimacy and the workerist aesthetics of New Deal and Popular Front documentary, as well as by an urgent anti-fascism that allowed them to transpose the European battleground onto the villages of Latin America, *Forgotten Village* and *The Bridge* use both melodramatic identificatory techniques and anti-fascism to fabricate the need for the rapid transformation of everyone, everywhere (and all land, everywhere), a fantasy that marks the development era. This easy slippage between anti-fascism and developmentalism, ironic as it is given the sources and technologies of mid-century fascism, is perhaps partly a consequence of the Popular Front's abandonment of anti-capitalist revolution (and largely of its anti-imperialist program) in its quest to defeat fascism. If, as Denning writes, the US Popular Front entailed a certain "laboring" of American culture, a new centering of work and workers, this "laboring" morphed rather quickly into a celebration of hard work, and even entrepreneurial work, that development necessitated, particularly when the filmmakers turned their cameras on racial others already imagined to be "behind."[99]

Even as these films celebrate physical labor, however, they elide the perspective of the laborer taken by much Popular Front culture. This trend follows, perhaps, from the continued appeal to social scientists and mass audiences in the capitalist world of workerist aesthetics that lingered on after dreams of communist revolution had been quashed. *The Bridge*, in particular, erases the history of unfree labor that made industrialization possible, but also begins to erase the exploitative histories of waged labor that Van Dyke had documented so poignantly in *Valley Town*. In the scene of oil extraction that Harold Sloan especially liked, the camera

pans dramatically over muscular workers and oil rigs, but the voice-over disregards the workers entirely. The workers drift to the edges of the shot over the course of the scene; eventually they disappear, the camera fore-grounding instead the "rich oil" depicted surging out from and onto the "virgin land" as if by magic: "Under the soil lie pools of high-grade oil. New wells go down night and day: wells to supply new oil to American fighters. The new well begins to pump. At first there is nothing. Only the yellow mud that smells of kerosene. But in half an hour there's oil. Rich oil, prospected and drilled and pumped out of the virgin jungle of East-ern Venezuela." This erasure of the workers in *The Bridge* is only remark-able in that it comes so quickly on the heels of Van Dyke and Maddow's sympathetic portrayal of workers' plight in *Valley Town*. The forgetting of workers' concerns about mechanization happens quickly, and develop-ment films thereafter only depict machines as equally triumphant protag-onists in their own right, or as triumphantly aiding workers, who are often filmed so that they meld seamlessly with the machines they operate. This vision of man-machine melding solidifies in films directly sponsored by the oil industry, as we shall see in the next chapter.

Both *The Bridge* and *The Forgotten Village* also minimize the labor of their actors. "The people in this film are not actors" opens the intertitles of both films. In the case of *Forgotten Village*, this claim is absurd, par-ticularly when read alongside the film's drive to represent scripted and staged melodramatic scenarios as natural and unscripted. Trini's stud-ied interpretation of scripted scenarios, Juan Diego's struggle to learn to act "natural," and of course the less strenuous labor of the many actors-turned-villagers who worked to get their affect right in particular scenes—all of these efforts are doubly disparaged. They are erased, first, by the film's claim to be a naturalistic recording of ethnographic truth, and then second, by social scientists and other reviewers' use of the film to imagine "underdeveloped" people generally as habitually stagnant, suspicious, and lethargic.[100] This insistence by global North filmmakers and audiences that people in the global South laboring as actors were nonetheless "non-actors" thus allowed for their direct exploitation in the name of lower film budgets. It also shaped the perception, necessary for the development mission, that global Southerners' work ethic was deficient or nonexistent, and that working for development would thus be liberating and necessary.

2 Dispossession as Development in US Information Agency Propaganda, Petrodocumentary, and Puerto Rican Community Education Filmmaking

By the early 1940s, documentary films had established an iconography of underdevelopment. Well before 1949, when Harry Truman designated more than half the world the "underdeveloped areas," Herbert Kline and John Steinbeck's docudrama *The Forgotten Village* and Willard Van Dyke and Ben Maddow's wartime travelogue *The Bridge* had displayed underdevelopment for viewers. Those films went to great lengths to depict untouched "traditional" villages, characterized by abjection, isolation, deprivation, and superstition. The films eschewed both the identificatory sympathy that had shaped the filmmakers' prior artistic output and the sensuality and playfulness with which "primitive" worlds were depicted in ethnographic documentaries. Instead they adopted a melodramatic and moralizing tone that created Third World underdevelopment as an absolute and easily identifiable condition, clear in statements like "poverty looks the same everywhere" and scenes of ragged children and dark interiors.

Yet even as they were amassing a visual repertoire for depicting racialized abjection, development films of the early 1940s could not quite fully imagine what a thoroughgoing capitalist transformation of these traditional societies might look like, much less make it appealing to viewers.

While their few scenes of modernity (the orderly university students peering into microscopes at the end of *Forgotten Village*, the inferno-like smelters and mine blasts that punctuate the tranquility of *The Bridge*) suggest that regimented urban life would be better than an abject rural existence, and that mechanized extraction might be better than laborious manual farming, these films do not depict the transformation of the rural, untouched villages that are their main subject. The scenes of extractive modernity in *The Bridge*, furthermore, look dirty and often dangerous, while the scenes of underdevelopment in both films (the laughing child holding a monkey in the lush rainforest, Juan Diego and his mother walking their donkey along the crystal-clear lake) look too beautiful to be convincing as depictions of abjection. This difficulty selling development is articulated in the United Nations Department of Social and Economic Affairs's 1951 warning that "rapid economic progress is impossible without painful adjustments" and thus that "very few communities are willing to pay the full price of economic progress."[1] These admissions that development would be painful at the community level, however, largely disappear over the course of the 1950s, helped along by images depicting it as a joyous and manifestly desired process.

Thus in the early 1950s one of the central challenges for the project of depicting development was how to make its imperatives look both possible and beautiful. This chapter traces how development films from the late 1940s through the mid-1950s began to piece together historical narratives that constituted a usable past for development, as well as how they reimagined present-day processes of displacement, mechanization, and mass urbanization as natural and appealing. These films were commissioned by institutions, each of which in the 1950s happened to be working out a specific piece of the development story: the USIA aimed to secure allegiance to the United States during the early Cold War by offering the US past as a model for the Third World; the oil industry sought to promote oil drilling and naturalize the increased use of petroleum products; and Puerto Rico's DIVEDCO was tasked with reimagining the island as democratic despite its commonwealth status and its concurrent quashing of an independence movement. Cinematic development narratives became key to each of these institutional projects. Particularly in the latter cases of oil companies and DIVEDCO, filmmakers marshaled

development's emergent visual tropes and created new ones to depict forms of violent displacement as pedagogical opportunities and natural steps toward progress. The films they made, for purposes connected to but not entirely congruent with international development, ended up contributing new visual and narrative tropes to the burgeoning development film form.

The first part of the chapter considers USIA's 1950s depictions of US history, charting how these films attempted to mobilize historical narratives that would inspire Third World nations to follow the United States in its allegedly peaceful and free route through mechanization into wealth and productivity. These films, however, because of their inability to suppress fully either the dullness of mechanized labor or the oppressive, racialized labor dynamics in the histories they recounted, failed to convince test audiences of the wisdom and replicability of US history as a model. The chapter then moves to the documentary works sponsored by Standard Oil and the American Petroleum Institute and created mainly by artists who'd gotten their start in the Farm Security Administration (FSA) and other New Deal art programs, arguing that these works were far more effective than USIA films in envisioning beautiful and painless development stories. These photographs and films transpose the rugged settler histories that New Deal art had already animated onto the present-day context of oil companies seeking leases. The oil films, as a kind of by-product of companies' attempts to sanitize and romanticize the convulsive changes caused in the present by oil drilling, succeed in both obscuring histories of dispossession and slavery and making the case for the United States as at once exemplary and a replicable model for the Third World. The chapter ends by considering the films produced by Puerto Rico's DIVEDCO, the other destination for New Deal documentary artists during the late 1940s and into the mid-1950s. Faced with the rapid, large-scale urbanization, industrialization, and US corporate encroachment brought about by Operation Bootstrap, along with Puerto Rico's suppression of its burgeoning independence movements, DIVEDCO's films focused on the rural local worlds that were disappearing, spinning tales of intimate social conflict and local triumphs over avaricious middlemen. These films' idyllic scenes of schoolroom education and democratic deliberation became staples of the development film genre.

USIA AND THE FAILURE OF HISTORY FILMS

The modernization theory produced by US social scientists in the 1950s depended on a vision of the United States, and to a lesser degree Britain and the rest of Europe, as both the pinnacle of modernity and a nation in whose historical footsteps any other nation could follow. As Andre Gunder Frank, Walter Rodney, and many others have explained, positing that "underdeveloped" societies were moving steadily along the path already trod by "developed" ones and intervening politically to attempt to help them do so necessitated concealing the extractive interdependent relationships by which some nations and empires had underdeveloped other societies and enriched themselves.[2] If, as Cedric Robinson reflected in 1987, "the dominant rationales for the exercise of American power in Africa, Central America, Latin America and Asia are the generic permutations of bourgeois historiography," we might add that some of this historiography was crafted deliberately by modernization theorists over the course of the 1950s and into the 1960s. As Robinson suggests, those theorists aimed to fashion a historical narrative that would allow for the maximal exercise of US power in the Third World, largely by erasing the violent processes of accumulation through which the United States had attained its power in the first place.[3]

Modernization theory's attempt to position the United States as an example for the world was connected to the 1950s project of consensus history, a school of historiography that argued for the United States as a nation uniquely "born free." Its contention was that the country's lack of experience throwing over feudalism had led to a tendency toward incremental change rather than class struggle.[4] As Nils Gilman points out, however, the modernization theorists could not follow the exact line espoused by consensus historians; their desire to depict US history as both "benign" and paradigmatic, as well as replicable for Third World nations, meant that they had to reject the idea of the United States's unique origins.[5] Modernization theorists thus spent a lot of time retelling US history, particularly the story of its industrialization in the nineteenth century. These retellings minimized the role genocide and slavery played in US industrial expansion and even the exceptionally abundant natural resources that had played a significant role in US attainment of hegemonic power.[6]

Even before modernization theorists had grappled with these problems and produced influential accounts of historical transformations in the United States, however, USIA was screening films that explicitly attempted to resolve the same questions, proffering US history to the world as an attainable and ideal trajectory that any independent nation could follow. As one United States International Information and Educational Exchange Program (USIE, which would become USIA in 1953) representative, working in Turkey, explained in a State Department publication in 1949:

> These films serve a dual purpose. They not only tell other countries about the United States so that their peoples can visualize Americans at home, at work, and at play, but at the same time direct their attention to their own potentialities as individuals and nations. The United States is portrayed as an example of what an independent people can become and can have through the will to work, and recognition of the individual's responsibilities to his country. A large proportion of USIE films are exhibited with the express purpose of bringing home to under-developed countries that within themselves—the people—they hold the key to their destiny. Such films seek to provide an incentive to development at the source, and to promote a willingness to make the same sacrifice and apply the same hard work that have been responsible for every phase of America's growth.[7]

The idea of American "independence" and "the will to work" as the unique yet replicable American qualities anyone in the world could follow if they realized "their own potentialities" comprised a partial solution to this conceptual dilemma of the necessity and limits of US exceptionalism. However, the references to "sacrifice" and difficulty, and the sense that peoples of the Third World might not be willing to make the necessary sacrifices, signal USIA's knowledge that the modernization process would not be an easy or pleasurable one and hint that it might not always be voluntary.

While USIA's film section would become renowned in the Kennedy era for its sophisticated documentaries and its on-the-scene depictions of development, particularly in Latin America (a story told in chapter 4), the films USIA circulated in the 1950s were didactic and clunky. There were a few early exceptions, such as the two biographical films about contemporary artists USIA commissioned in the late 1940s: Van Dyke's *The Photographer*, which follows photographer Edward Weston on a tour of the stark California coast, and Henwar Rodakiewicz's *Land of Enchantment: USA*

Southwest, which similarly celebrates the southwestern landscape as seen through the eyes of Georgia O'Keeffe and unnamed Navajo ceramic artists. These meditative films, through their stark natural imagery and slow depiction of various artistic endeavors, constituted a more subtle form of propaganda, attempting to impress viewers with the beauty of the United States and its art rather than impart lessons about prosperity and progress. However, USIA soon jettisoned Van Dyke and Rodakiewicz for their past brushes with leftism, and then devoted the 1950s to what Kenneth Osgood calls the agency's "total Cold War": a massive and unsubtle propaganda offensive that argued for US superiority mainly on economic grounds.[8]

By the 1950s, USIA had thus largely left on-location artistic documentaries behind. Instead the agency commissioned short travel films of state visits; it also amassed educational films made by private companies and adapted slightly for USIA audiences, often filled with still images and stock footage, many of which told the story of the nation's history.[9] Because of their very clunkiness, however, these films provide a close index of what USIA officials imagined as usable pasts for the United States, pasts that might translate into possible futures for the Third World. Surveys of target audiences of "foreign national" students and professionals indicate that USIA circulated these history films with a clear purpose, one that supplemented the agency's more covert and coercive endeavors such as laying the groundwork for the 1954 US-backed coup in Guatemala.[10] Namely, the films were meant to present the history of US industrial capitalism as an appealing and imaginable future for the Third World. Even the most straightforward, prosaic films about US industrialization, however, are haunted by the very histories of unfree labor they suppress.

Productivity: Key to Plenty, a twenty-one-minute, 16 mm film scripted by economist J. Frederic Dewhurst for Encyclopedia Britannica Films in 1949, is one of these prosaic films. USIA showed *Productivity* widely in the early 1950s.[11] An audience of more than two thousand people packed the Normandy Theater in Paris for the 1951 French premiere of the film; *Productivity,* with adapted French narration, was the main feature alongside three other technical films. After the premiere, the film continued to play to crowded theaters throughout France.[12] In its attempt to depict US history as imitable and mechanization as liberatory and achievable by all, *Productivity* retells the story of US industrialization as one that began in the supposedly

unmechanized, unindustrialized frontier America of 1850. Hints of the pre-1850 industrial and slave economy pervade the film, however, suggesting that the history modernization theorists were working out was not able to avoid questions about slavery in its account of economic "takeoff."

As a prelude to its historical narrative, the film opens by extolling the marvels of American prosperity and buying power through sumptuous scenes of suburban life, private cars, and weekend relaxation. "But do you really think all this just happened?" asks the narrator, offering a statistical interlude comparing US, European, and Russian workers' buying power before providing the partial answer that "this [prosperity] happened" because "we've learned to use machines!" The film launches into montages of men and machines (along with the occasional woman in front of a typewriter or sewing machine), in medium close-up, then embarks on the historical narrative meant to demonstrate that this did not, in fact, "just happen." The camera cuts to a watermill and a covered bridge, accompanied by quieter orchestral music. "The year," proclaims the voice-over, "was 1850." A new type of music begins: this time, distinctly, the banjo-and-flute melody of renowned plantation-nostalgia composer Stephen Foster's famous gold rush anthem "Oh! Susanna." As the images and the voice-over tell of "slow, laborious, costly" craft labor including "a blacksmith with his hand tools and hand-operated forge," the blackface minstrel tune continues, betraying the unuttered truth that despite the ongoing litany of craft labor varieties, enslaved people also existed and labored. The contrast between music and image hints as well at the interdependence of Northern craft and creative economies and Southern slave ones, an interdependence the voice-over narrative pointedly does not explain. The year 1850, then, becomes in the film's account of US history the point of origin for mechanized mass production, with only the accompanying music hinting of the Southern plantations and Northern mills that had industrialized decades before; it was these mills' workers who performed in blackface, their minstrel songs and skits becoming the predominant popular cultural form of the Jacksonian era.[13]

The film's illustration of the growth of both machine power and productivity is also troubled by unfree labor. Like *The Bridge*, *Productivity* lapses into cartoons to depict "the economy"; this time the cartoon depicts a horse, a silhouetted man with an axe, and an upright machine with

a wheel and a bell on it. In 1850, the voice-over explains, animal power drove 50 percent of all the work completed, man power 20 percent, and machine power 30 percent. A bar graph appears behind each, illustrating its proportion of "power." Then animal, man, and machine suddenly dissolve and reconstitute themselves as the figure of a muscular, shirtless white man, his skin noticeably a few shades lighter than that of the bent-over laborer. This man holds a tray of shiny coins, representing "output per hour . . . measured in present-day buying power." In a bit of ostentatious animation, the figure with the coins is propelled forward into a close-up and then back again, shiny coins glinting at his waist. This pattern of statistical illustration; the categorization of labor into "animal, man, and machine"; and then their reconstitution into the shirtless, whitened man with ever more strobing gold coins, is repeated for 1900 and "today" (1949). This strange graphic morphing, like "Oh! Susanna" in the frontier scenes, seems to undercut the "1850" cartoon's attempt to erase the slave economy and depict a country made up entirely of rugged pioneer smallholders. If the question of enslaved people being treated like humans, machines, animals, or some fraction or combination of the three is almost asked by the tripartite graphic, it is then answered by their reconstitution into the white man with the gold coins. As illustrated through the strobing graphic, the white man incorporates "power" from machines, animals, and implicitly other unwaged beings to enrich himself.

The film, in its fetishization of labor both domestic and waged, includes only one depiction of a nonwhite worker: the closing montage about increasing productivity on all fronts includes a Black child of about ten in overalls picking cotton. He is the only child seen working in the film. His image is accompanied by a voiced promise: "If there's an improved method of picking cotton, to increase the output per man per hour, we must use that improved method." The film then cuts away from the child to a mechanical harvester, and his presence, the presence of a Black child laborer (departing from the man, animal, or machine schema), is not remarked upon. But the close-up seems to invite sympathy for the child and thus to encourage audiences to imagine the magic of mechanized agriculture (rather than wars of liberation) as the means to his freedom.

In 1954, USIA commissioned test screenings to evaluate the efficacy of *Productivity*'s messages about US history as a workable model for

Figure 9. "Output per hour . . . measured in present-day buying power," *Productivity: Key to Plenty* (dir. Dewhurst, 1949)

Figure 10. "If there's an improved method of picking cotton . . . we must use that improved method," *Productivity: Key to Plenty* (dir. Dewhurst, 1949)

decolonizing regions. The film was reviewed by "a panel of ten nationals of foreign countries" hailing from Ecuador, Colombia, Pakistan, Belgium, Finland, and elsewhere, all of whom had resided for a short time in the United States. The USIA survey was particularly interested in whether viewers understood correctly the "reasons for high productivity in the US," "reasons for high standard of living," and "desire for machine methods." Answers were divided into two groups, separating respondents into "moderately agrarian" and "mainly agrarian" countries.[14] The questionnaire's insistence that the panelists understand "machine methods" as the reason for US purchasing power suggests that modernization theory's dictates were being pressed by USIA, even if not in the most compelling fashion, before they were even schematized in theorists' tracts. Despite being composed of nine men and one woman, the panel reported "that the motion picture lacked feminine appeal," a complaint that indicated the film's relentless focus on men's productive capacity, as well as perhaps intuiting the systematic and complete exclusion of women from USIA at every level.[15] The panel's objections to the film's "lack of feminine appeal" also signaled that modern life as depicted in *Productivity* was generally unappealing; some in the test audience complained that the film "made mass production methods seem too mechanical and too unpleasant."[16]

The report notes that "one previewer was curious about the meaning of the rapid expansion and contraction in size of the man carrying the trays of money. No previewer was able to attach any logical meaning to this symbolism."[17]

USIA officials asked similar questions in other test screenings, where they also focused on the equation of nineteenth-century US history with the present of decolonizing nations. In 1953, another US history film, *A Nation Sets Its Course*, made by USIA as part of its Scenes from American History series, was screened for "fifteen foreign subjects, ten of them Asian," living in the United States. The film charts US history from 1783 through 1830; after viewing, the "foreign subjects" were asked what USIA called "simple factual" questions, including "Andrew Jackson was a hero of the West: true or false."[18] As with *Productivity*, the overarching objective of the film, according to the USIA questionnaire, was to convince the audience that the early United States "faced many problems like their home countries now face." The USIA report crowed at the "exact comprehension" of this objective by both an Iraqi viewer, who remarked that "the history of the USA resembles, to a high degree, the history of every young nation trying to stand on its feet," and an Indian viewer, who said "the American people are giving an idea that only through hardships and problems we can gain freedom and democracy."[19] The audience was not entirely approving of the film—viewers were unhappy with the scenes that relied on still photography rather than on filmed action—but in general the audience found the film "not propagandistic" while also receiving the message that the early United States was exceptionally hard-working, exceptionally free, and a model that their nations should follow, even if it entailed hardships.

If the "Third World nationals" who served as USIA's test-screening subjects could understand that the films were promising that hard work and sacrifice could propel their countries along America's path to industrialization, they remained unsure that the sacrifice would be worth it. By the early 1960s, USIA would change tactics, employing skilled documentary filmmakers to depict small-scale stories of mainly Latin American development. Those later USIA films would draw on the aesthetic vocabulary of early development films fostered elsewhere in the 1950s. Two key locations for the elaboration of this development film vocabulary were the

US oil industry's well-funded documentary endeavors and Puerto Rico's DIVEDCO. Both locations were places at which New Deal and Popular Front artists found work when wartime propaganda agencies (briefly, it turned out) were shuttered. In both milieus, participating artists were relatively free to create their own visions of industrial and rural life, even as they masked the convulsive transformations being undergone in the communities they selectively depicted.

MEN, MACHINES, AND FRONTIERS IN PETRODOCUMENTARY CULTURE

In their roles at the FSA and elsewhere, New Deal documentary artists had already worked to promote the transformation of the United States into a petroleum-fueled society. As Matthew Huber writes, "New Deal policies did not declare a new national energy policy; rather, they proposed new imaginaries of living life . . . [that] encompassed a whole set of practices and geographies that locked in ways of consuming energy—energy that was assumed as available."[20] What this meant for US artists was that the Popular Front culture sponsored by New Deal institutions, supported by the Communist Party and the liberal-left coalition they were part of, created an imaginary that facilitated the suburbanization of the United States. New Deal art, through both its celebration of an expansive American past and its depiction of rural and suburban spaces as cleaner and more livable than urban ones, paved the way for the postwar explosion of highway construction and private homeownership. Thus even as the New Deal was for the first time allowing working-class Americans to become cultural workers, it compelled them to make culture that supported the construction of new private and suburban worlds rather than preserving and enlivening the public, urban, communal spaces that had nurtured them as artists. After World War II, as what remained of the New Deal was placed fully in the service of the homeownership, automobility, and class ascension of white men, many of its cultural workers became more directly beholden to the oil industry.

It was thus not a great leap for artists to move from the soft public petro-advocacy of the New Deal state into positions working directly for

oil companies. These oil companies, much disliked during World War II for their suspected collaboration with German corporations, were looking to rehabilitate their image. Standard Oil New Jersey (SONJ) as well as the American Petroleum Institute (API), the main trade organization for the US oil industry, hired renowned documentary artists in this period to make original photographs and films that promoted not so much particular oil companies as what Timothy Mitchell calls "both energy and the forms of life that were increasingly dependent on that energy."[21] These petrodocumentary works recast both oil exploration and the dizzying array of new products it could make as consonant with US frontier history. From the mid-1940s, when SONJ hired famed FSA director Roy Stryker to head up its photography section, through 1956, when the API abandoned its documentary film productions to focus on television, the oil industry recruited renowned documentary workers to burnish the image of oil and the large companies that extracted and sold it. The artists made photographs and films that celebrated, and integrated oil into, the American frontier.

Popular Front documentary artists brought, but also adapted, their frontier-rural and workerist sensibilities to the project of making oil propaganda. The artists had to sanitize the dustier reality they had animated for 1930s government aid projects, when their central task was twofold: bringing wealthier Americans into sympathy and identification with the victims of the Great Depression, victims portrayed as temporarily downtrodden but stoic and dignified, and creating a nostalgic frontier imaginary that was meant to help marshal support for expanding public infrastructure. For the oil companies, artists had to create more straightforward, triumphalist narratives of progress. The photographs and especially the films they made retold the story of US history as one of seamless progress to, and beyond, efficient agrarianism. The films represented indigeneity through artifacts and antiquated practices, while also taking up the New Deal–era preoccupation of celebrating the incorporation of white "others" (Cajuns, Scandinavian immigrants) into the nation. This incorporation culminated in the leasing of one's land to oil companies, a transaction carefully framed as voluntary displacement in exchange for a higher, petroleum-product-saturated standard of living. Thus as they facilitated the US transition into what Huber calls "the postwar period of

naïve petro-capitalism," oil industry photography and films also retold US history as a story of the freely chosen hard work of pioneer men and the freely ceded land of indigenous people, as well as of the beautiful melding of men and machines.[22] Oil photographers—and even more, oil filmmakers—succeeded where USIA's economists had failed in reframing the displacement and extraction that characterized US history as a beautiful story of free, if risky, frontier life. The sense of past and present frontier freedom conveyed by petrodocumentary was important both for naturalizing oil leasing in the present and retelling the US narrative of modernization in a way that erased the theft and dispossession that, because of its interest in a stable postwar order, the United States could not encourage most other nations to replicate.

This sustained propaganda offensive on behalf of oil and petroleum consumption began with SONJ's massive photography campaign, launched in 1943 to burnish SONJ's image amid widespread accusations it was collaborating with the German conglomerate IG Farben.[23] SONJ's polls showed that it was not just the working classes but educated "opinion leaders" who disliked and mistrusted the company, and it was this latter group they sought to win over with their photography project.[24] By 1950, the SONJ project had produced almost eighty thousand images and sent photographers to "the company's largest oil-producing, refining, and consuming states," along with Venezuela, Saudi Arabia, Colombia, Peru, France, and Belgium.[25] These photos were distributed to mainstream magazines and exhibited at museums and universities throughout the United States, while SONJ affiliates throughout Latin America and Europe were sent one hundred prints each to exhibit as they saw fit.[26]

Although he was initially reluctant when SONJ asked him to run their photography division, remembering his Populist father's hatred for the company, Stryker was convinced by SONJ's offer of artistic freedom and opportunities to continue photographing everyday life and economic activity.[27] In a 1965 interview, Stryker called SONJ's sensibility "strangely similar" to that of the FSA, and this similarity was enough to convince many other FSA photographers to sign on to make oil propaganda.[28] A photo published by former FSA photographer Esther Bubley in *Coronet* magazine (in a photo essay that gave no indication of Bubley's affiliation

with Standard Oil) illuminates some of these similarities.[29] The photo is a long shot of a farm with an oil derrick integrated into the rest of the buildings, surrounded by orderly fields and overhung by stark low clouds. The caption reads: "[P]unctuating the green and fertile prairies of Texas are the symbols of America's wealth—growing food, and derricks raising oil," a caption which, as Michael Poindexter points out, made the connection between oil drilling and farming seem like a natural one.[30] Wallace Scot MacFarlane, in his study of oil in East Texas, has found that this link between "growing food" and "raising oil" was commonplace: although the oil boom largely hurt the interests of farmers and "accelerated the decline of East Texas's farming economy," the language of oil "seeds" and "farming" pervaded petroleum industry media and advertising accounts, along with the idea that oil capital was creating untold benefits for farmers.[31] This idea was compounded by work such as Bubley's, whose photos helped incorporate oil naturally into the "green and fertile" landscape, while also signaling the myriad ways that oil was coming to replace natural material in everyday products.[32] This association of oil with agriculture, which Fernando Coronil also finds in Venezuelan state rhetoric of the same historical moment, deployed in order to conjure images of "collective fecundity," here extends the FSA's mission of bringing professionals into sympathy with the deserving downtrodden to bring audiences into sympathy with oil towns, oil fields, and even oil companies.[33]

The experience and documentary work of Gordon Parks, who would later make both development documentary and commercially successful Hollywood cinema, starkly demonstrate the change in sensibility between the documentary cultures of the FSA and SONJ. Parks got his start as the only Black photographer on staff at the FSA, but assumed that he would not be able to follow Stryker to SONJ in 1943, knowing that "the only blacks this huge conglomerate hired, at the time, were either messengers or janitors."[34] However, after Southern congressmen blocked him at the last minute from an assignment documenting Black pilots in the war, and after he received several rejections from fashion magazines when initially enthusiastic editors met him in person, Parks was desperate for work. When Stryker invited him to join the SONJ project, Parks's relief outweighed any compunctions he might have had about working for a racist

oil company. "I never quite understood the real purpose of that Standard Oil file," Parks recalls in one of his many memoirs. "I can only assume that it was meant to improve the company's image. But since my bank account was also suffering it made no difference."[35]

Relieved that he was able to support himself, Parks made beautiful photographs for Standard Oil, including some of mostly white workers in various New York City settings: a light-bathed foreman straddling girders at the Structural Steel Company; commuters thronging the Staten Island Ferry, seen from above as a patchwork of hats. While these images already depart from the less orderly scenes of Parks's FSA photos, the changes in his style are most evident in his rural images. Parks had made his name as a photographer with Stryker and the FSA with his remarkable ironic restaging of Grant Wood's *American Gothic* painting, portraying DC office cleaner Ella Watson with a mop and broom in front of the American flag in a stance both parodic and accusatory. By contrast, Parks's Standard Oil farmer photographs, taken largely in rural New England, de-ironize the American Gothic imagery he played with at the FSA, emphasizing the abundance and industriousness of rural life: in one photograph an older white farm couple gazes into the camera, looking solemn yet contented. Parks's street scenes, too, seem overflowing with energy and nourishment. One image of Springfield, Massachusetts, depicts a particularly bustling crowd scene. This hustle and bustle is reflected by the billboards hovering above the crowd: "WORKERS are needed," "PUBLIC MARKET," "CLEAR WEAVE," "BEAUTY SCHOOL." Gone are the ironic juxtapositions of New Deal documentary photography, where billboards promising luxury loom above tableaus of people suffering. In the Standard Oil archive, the billboards can only be read straight.

Despite the beauty of Parks's photos from this period, the Standard Oil frame constrained him; his photographs and films before and after this period are sharper in their commentary and better remembered. Other photographers, however, warmed to the assignment of making petro-modernization beautiful and documenting the cultural changes it wrought. John Collier Jr. thrived at Standard Oil, understanding his broad remit from the company as an opportunity to undertake his own social science research into culture and development. In fact Collier's experiences working for Standard Oil led him to establish the field of visual

anthropology. In a 1965 interview he recalls that "Roy [Stryker] sent me to Colombia on a three months project to do a lot of working on better relations with the Tropical Oil Company." However, "three months stretched out into two years," and Collier "ended up by making a pinpointed geographic-sociological file on every part of Colombia as a preparation vehicle for better cross-cultural understanding."[36] Collier's Colombia and Venezuela photographs reflect this interest in depicting culture and sociality. While SONJ South America photos by his colleagues depict derricks and palm trees on windswept Lake Maracaibo, Collier's images capture human scenes: a child sneaking a snack at the Bogotá market, men making plans in the oil camp.

Collier's *Visual Anthropology* textbook, first published in 1967, builds on the work he did for SONJ in Latin America, deploying oil propaganda photography to put forth a new method for the visual interpretation of culture. Collier's method indicates how the abundant economic scenes SONJ encouraged its photographers to envision also formed the basis for Cold War ethnographic and development knowledge. The book intersperses photographs from Collier's Standard Oil and FSA assignments with photographs of indigenous Peruvians from his 1950s documentation of Cornell University's Vicos experiment, in which Cornell anthropologists bought a town and attempted to develop its people.[37] Traces of its oil propaganda origins pervade the book's descriptions but are also erased from the text, which focuses instead on reading material objects as an expression of cultural values. The section on "photography as a tool for mapping," for example, explains in an extended metaphor that "potential oil fields are examined first with aerial photographs taken when the sun is at the proper angle that reveal subsurface geology the same way they reveal Viking tombs in the heaths of England." Describing in detail the jobs of the "petroleum geologist" and "field geologist," Collier slowly reveals that the "subsurface geology" is an analogy for his method of understanding cultural groups: for measuring the religion, "cultural vitality," "psychological levels," and "signposts of well-being" in a particular community.[38]

Here, and elsewhere in the textbook, Collier performs an erasure of capitalist extraction even as he describes it, using the scene of the oil camp to make what he sees as a larger point about "culture" that he imagines to exist independently of these extractive systems. This evacuation of natural

resources from discussions of the "levels" of cultures and societies, even as they are used as a metaphor to imagine those levels, is a key feature of modernization ideology and propaganda, as indicated by USIA's deliberate efforts to draw viewers' attention away from the United States's vast territory as an explanatory factor in its wealth accumulation. But Collier's erasure of fossil fuels as factors that might contribute to (someone's) prosperity is more convincing than USIA's because of his insistent production of visual evidence to support his assertions about the importance of "human capital." His photographs produce a vision of the "economy" that Mitchell argues could only exist in the petroleum era; the invisibility of the petroleum itself in these images produces the economy as an entity dependent on the ingenuity, skill, and technological proficiency of workers.[39] For Collier, oil exists, but not as a variable with discernible effects on quality of life, which is instead determined by cultural factors. Another photograph in the textbook, taken on Collier's Standard Oil trip to the Canadian Arctic, features an oil worker sitting up in bed, reading a Steinbeck novel. The caption reads: "[H]ome away from home in the Canadian Arctic. Each bunk in the oil camp was a reflection of the inhabitant."[40] This claim seems nearly nonsensical: that each bunk constructed for housing extractive workers is "a reflection of the inhabitant" rather than of either the materials from which it is made or the wishes of the company that had it built. However, this idea of objects as manifestations of "culture" rather than the resources from which they are constructed is key to Collier's visual method, as it is to mid-century social science thinking more generally and development ideology in particular.

If oil industry photography helped naturalize a society with "a drop of oil in everything," as Stryker put it, subtly connecting these incursions of petroleum to the alleged eradication of scarcity, oil industry films helped ease the transition to oil leasing as a way of life.[41] This visual integration of what were in fact antithetical pursuits (farming or hunting and trapping and large-scale oil drilling) was an important achievement of oil films; development filmmakers would later draw on these scenes of harmonious integration to help viewers imagine development as something other than the violent eradication of indigenous cultures and lifeways. The best-known oil industry film, and the most highly acclaimed propaganda for SONJ of all time, was Robert Flaherty and Frances Flaherty's 1948 film

Louisiana Story. The Flahertys, legendary ethnographic filmmakers by the late 1940s, made the feature-length film for SONJ; SONJ paid the Flahertys in advance and gave them creative control over the film, with the stipulation that Standard Oil not be named or credited.[42] *Louisiana Story* tells the story of a Cajun family leasing their swampland to an oil company in order to mythologize the early days of offshore drilling in Louisiana. Beginning in 1938, as Michael Watts explains, Louisiana's "inner and outer continental shelf [became] the forcing house for the development of deepwater and ultra-deepwater oil and gas production"; he argues that places like the Louisiana swampland and Gulf Coast should be understood as oil frontiers, "not so much as zones of pioneer settlement and crucibles of democratic values forged by the battle between wilderness and rugged individualism (the canonical view of frontiers derived from Frederick Turner), but rather as particularly dense sorts of spaces—at once political, economic, cultural, and social—in which the conditions for a new phase of (extractive) accumulation are being put in place."[43] *Louisiana Story* artfully fuses these two senses of the frontier, reimagining the beginnings of what would become deepwater oil drilling as a beautiful adventure in male bonding and oil extraction through harmonious tableaux of men and machines melding. Such sequences became key components of the development film genre as it continued to evolve throughout the 1950s and 1960s, central to the films' vision of how audiences might imagine the appeal of development.

In preparation for filming the beautiful drilling scenes in *Louisiana Story*, the Flahertys explored oil country and fell in love with oil. Frances writes that they "went to the Texas and Oklahoma oilfields and saw the powerful working of our own economic system." Seeing the "regiments of oil derricks" that "marched over the plains and bristled in the cities," and "a derrick rising out of the yard of the governor's mansion," she writes: "Here was the symbol of America's vast production, her leadership in oil, that had come out of the American way of life, out of private property, free enterprise, and all the heady ferment of capitalism."[44] The Flahertys were partially mistaken in their assessment: although Frances's martial language was prescient, given the oil wars the United States would fight at the end of the twentieth century, there was nothing free or truly competitive about oil-drilling markets at that moment, when the government

was desperately trying to keep prices high.[45] But *Louisiana Story* makes the conceptual connection between the "free enterprise" of oil drilling and "the cypress swamps teeming with wild life," imagining a wild union of magical swamp with magical oil.[46] This connection is convincing and powerful in part because it is made through the symbols and iconography of rugged frontier life; almost in passing, the film paints Louisiana and its residents as historically free-spirited and freely laboring.

The film's celebratory frontier ethos is made clear through the persona and story of its main character. Played by local "non-actor" J. C. Boudreaux, the protagonist is named Alexander Napoleon Ulysses Latour, a name that foretells his encounter with oil as an epic adventure. At the film's outset, the camera follows Alexander in his boat as he paddles through the magnificent bayou, through giant lily pads and around beautiful birds, shielding his pet raccoon from the alligator, who becomes the film's "emblem of primordiality," a device Ross Barrett argues Standard Oil used earlier in the century to imagine oil exploration as natural and timeless.[47] Following Alexander as he gently glides, the voice-over asserts his belief in mermaids and werewolves, creatures made all the more believable by the magical-seeming animals and plants that part to let him through. The film depicts Alexander's slow, shy, beautiful union with the oil derrick; as with the "raising oil" photographic trope, the derrick becomes one more natural curiosity in Alexander's world, integrated fully into the swamp. The boy climbs aboard it easily, and he and the oil workers smile shyly at each other. The film ends with the crew bringing in oil and then leaving; for Alexander and viewers alike, as the film's editor Helen Van Dongen writes, the film conjures a "phantasmagoric of oil world-like dream-world, where nothing is impossible."[48] This is, in Stephanie LeMenager's terms, a moment of "loving oil"; such moments, she argues, have "a great deal to do with loving media dependent on fossil fuels or petroleum feedstock from the early-to-mid twentieth century," media which of course include film.[49] *Louisiana Story*, then, is a love story between a boy and an oil rig, which is shaped and made convincing by the Flahertys' characteristic focus on the "magic" of supposedly disappearing cultures.

While Standard Oil representatives supervised the film's production, even visiting the bayou shooting location, they do not seem to have significantly altered the Flahertys' artistic vision. Instead, the most interesting

conflicts over representation in *Louisiana Story* seem to have been between editor Van Dongen and the Flahertys, who collaborated (along with cinematographer Richard Leacock and sound engineer Benji Doniger) to create *Louisiana Story*'s lush mood but also clashed over the script as well as the treatment of the film's "non-actor" subjects. Van Dongen was younger than the Flahertys and was trained in a leftist social documentary milieu, having studied with Sergei Eisenstein and Dziga Vertov in the Soviet Union. She objected to how the Flahertys pushed Alexander's father to speak pidgin English, as well as to Robert's insistence on closing the film with a broken-English letter from Alexander's father to the oil scout.[50] While Van Dongen thought the film did not do justice to the intelligence and business savvy of the Cajun people she encountered, and connected this falsity to the Flahertys' previous stagings of "native" wonder at modernity, she also objected on aesthetic grounds; she did not like the stilted dialogue in an early scene of Alexander's father signing the contract granting the oil company permission to drill on his land or in the letter at the end.[51] Van Dongen is right that the contract and letter slow down the action, bookending the film as they do. However, they play an important ideological role, linking the nature-machine love story of the film with the free-market capitalism symbolized by the oil derricks. They suggest, in other words, that the contractual rules of capitalism are what make possible the wildness and beauty of frontier life.

As Leacock reports, Robert Flaherty decided to reshoot the film's drilling scenes at night, even though it was a tremendous amount of work, because he felt that the daytime drilling scenes lacked beauty. Leacock recalls him saying, "[W]hen I see them working at night there is magic and what we have does not have magic; we see too much, the grime, the tools left lying around."[52] But Flaherty's ingenious nighttime filming disappeared both the "grime" and the "tools" of extraction. This beautification project worked. Released in a moment when the majority of Americans disapproved of Standard Oil, the film used its combination of beauty and imagined evidentiary veracity to win over an educated, expert class; leftist artists and intellectuals, from Simone de Beauvoir to Charlie Chaplin, were impressed and charmed.[53] The film's story of the oil rig's smooth integration into its environment created a sense of the unquestionable goodness of SONJ and its new offshore drilling apparatus.

In 1948, the same year *Louisiana Story* provided propaganda for SONJ's offshore oil-drilling projects, the API began its less subtle Oil Industry Information Committee (OIIC) initiative. The initiative poured funds into various propaganda efforts, including, as Gregory Waller observes, "a major film production annually between 1949 and 1956." [54] According to Waller, these films "were rolled out with much fanfare" during the API's Oil Progress Week, an annual festival of oil celebrated in forty-four hundred US towns throughout the 1950s.[55] Many of the OIIC films were concerned with retelling US history, sometimes in cadences borrowed from the Popular Front: the 1951 cartoon *Man on the Land* features a low operatic Robeson-esque voice singing a song extolling the titular "man on the land" and embarking on an extended triumphalist historical journey enumerating innovations in agriculture and extraction. Other films looked to Westerns for visual cues. *Born in Freedom: The Story of Colonel Drake*, a technicolor biopic set in the late 1850s, starred famous horror villain Vincent Price as Edwin L. Drake, the man who invented the mechanics of oil drilling; the story emphasizes over and over the American "freedom" that, in 1859, led Drake to be able to extract oil. But while many OIIC films reimagine frontier life and (a bit defensively) depict the nineteenth-century United States as fully and uniquely free, Willard Van Dyke's 1953 short film *American Frontier* stands out from the others. As Waller observes, it was the only one of the OIIC films that could have been called a "masterful documentary," as it was by *Business Screen. American Frontier* succeeded the way *Louisiana Story* before it had: by poetically celebrating oil drilling and envisioning its smooth integration into the existing landscape.[56]

Van Dyke's participation in oil propaganda was dictated by the changing political climate: he turned to corporate filmmaking in the early 1950s after his graylisting by the McCarthy-era US government left him ineligible to make State Department films. However, he already had some experience: his most famous film of the New Deal era, *The City*, was already something of an oil film. Made in collaboration with Ralph Steiner and urban theorist Lewis Mumford to promote the abortive greenbelt towns initiative, the film exhibits a hostility toward technological progress rare in New Deal documentary output. As we watch an overwhelming montage of smoke billowing and sparks flying from iron and steel mills, the

voice-over delivers a frantic yet also caustically mocking account of sense-less, endless industrialization, decrying "the steam and steel. The iron men. The giants. . . . Pillars of smoke by day, pillars of fire by night, pillars of progress, machines to make machines, production to expand production." This bitter denunciation of the recursive brutality of progress is rare in of-ficial documentary output. However, although the film denounces freight train and coal-based industrialization, it stays silent about oil, envisioning a "cleaner" suburban life implicitly powered by petroleum. Oddly, given the comparatively low population density of US cities, the film depicts and de-nounces a claustrophobic and irredeemable urban present.[57] The film's an-swer to its manufactured problem of urban density, as Vojislava Filipcevic explains, is "a garden suburb, offering a small-scale communal democracy to middle-class white citizens"; the film's showing at the 1939 World's Fair alongside General Motors's futurama exhibit confirms its compatibility with car culture.[58] While the questioning of progress for its own sake and the related valorization of public planning found in *The City* are unimag-inable by the 1953 release of *American Frontier*, the celebration of idyllic, pastoral, petroleum-fueled worlds remains consistent between the films.

Though it does not match the beauty of *Louisiana Story*, *American Frontier* echoes the Flaherty film in many ways. Both feature camerawork by Leacock, who in the 1960s would become a prominent figure in the direct cinema movement, and in these films too the camerawork has an observational style, seeming to catch natural, unforced moments. Like *Louisiana Story*, *American Frontier* portrays a fictional family, focusing on Nils Halverson, a young "wheat farmer and schoolteacher" in North Dakota thinking about leasing his farmland for oil exploration. As in *Lou-isiana Story*, oil representatives circle cautiously, and much is made over the discussion and eventual contract-signing scene at the kitchen table. "I want you to feel right about it," the Citadel Oil representative tells the family when they say they'll think over his offer. Like *Louisiana Story*, the film tells the story of the family's growing affection for oil-drilling in-frastructure. Although Nils narrates much of *American Frontier*, it is his wife, Barbara, who encourages the family's embrace of the oil company; she is the one whose face lights up with hope during the discussions of pos-sible strikes, as Nils acknowledges: "In the evenings after that I watched Barbara. I could see she had visions of an oil rig out in the middle of our

wheatfield, new wallpaper in the parlor, and a college fund for the kids we hope to have someday." This imagining of feminized consumer desires hints at the changes that oil drilling was bringing to gender relations; as MacFarlane explains, oil economies led to the abandonment of "shared farm labor," creating a stark division between the all-male world of the oil rig and a new women's sphere of service jobs (as well as perpetually unseen, uncompensated household labor).[59]

Despite these aspirations to middle-class comforts, the film spends quite a bit of time establishing the family's closeness to the earth, their folk wisdom about the crops and the trees, their love for the land, and their intrepid survival in hard times. After establishing these ties, the film depicts the slow encroachment of oil infrastructure, linking it to the history and landscape of the frontier. "It was like watching a little town take shape," Nils reflects on the oil rig when he and Barbara finally go to see it, implicitly connecting it back to the pioneer construction of towns and admiring the men "working with numbed feet and icy fingers." Later Nils, watching the oilmen admiringly, describes them as "a rugged, proud independent breed, ready to pull up stakes wherever there's oil to be found." From its opening, *American Frontier* makes such analogizing moves, celebrating the presence of the oil rigs as a reopening of the frontier. At the film's opening, before the narration is turned over to Nils, an unnamed, deep-voiced narrator gives a poetic account of frontier life, with a litany of names that echoes that of *The River*, the New Deal film on which Van Dyke got his start as a cinematographer:

> The wind sings like a wild bird across the northern states coming at last to this place, this sweep of America over stark, empty, snowy vistas. . . . [N]ot so long ago this was frontier. Listen closely and you will hear the old ghost echo of covered wagons, the phantom shadows of pioneers, fighting for their lives against the wilderness. Lean men hard as hickory. Lonely women wearing their dreams like a bit of bright calico. They began with nothing, with their bare hands and a bucket of hope. Breaking the land with freedom's plow. Planting towns with names American as a banjo tune. Fargo, Stampede, Bluegrass, Beaver Lodge, Lincoln Valley, Williston.

The Native American presence on this frontier, past or present, is nearly erased. The exception is one scene on the oil rig: when Citadel Oil's representative is discussing the risks and potential profits of drilling, he pulls an

arrowhead from his pocket, and the camera zooms in on it. "Indian arrow-head?" asks Nils, and the oilman explains: "I found it right over there, right where we put the rig. It's for luck. We're gonna need it." The film thus not only enacts the settler dream of replacing the Native peoples on the land, but also positions the settlers, authorized by talismanic objects like the arrowhead, as more savvy than the original inhabitants—only they are ingenious enough to know when they should, in turn, sign away the land they have acquired. In a later scene, watching the riggers, Nils picks up the arrowhead again and remarks that the Native Americans were the "first homesteaders" but lacked "the tools, the skill, the freedom" to harness the petroleum bubbling under their feet.

Through its repeated use of the talismanic arrowhead and its compari-son of the Scandinavian settlers with the Native American "homestead-ers," along with its treaty-signing scenes, *American Frontier* invokes the long history of Native North Americans signing away their land. Such rit-uals of treaty signing, as María Josefina Saldaña-Portillo explains, char-acterized even the most coercive landgrabs during the conquest of what is now the United States; it was crucial to Anglo-American mythologies, she argues, that Native Americans be given the freedom to sign away their land.[60] Here these rituals are rewritten as rituals of freedom and abun-dance, culminating on the final day, when the drilling stops and everyone gathers around the "thin pipe," waiting. "Will it gush forth the white foam that means oil?" asks the narrator, and the foam soon spurts wildly from the pipe, intercut with the celebrations of Nils, Barbara, and the rest of the townspeople.

From there ensue hustle and bustle and more competition for leases for "drilling wells across 10,000 square miles of North Dakota and Montana." Nils ends by celebrating the labor of extraction, musing that "the cease-less pounding of work was like a heartbeat, pouring energy out through the veins of America." The original deep-voiced narrator returns, over a scene of a swiftly flowing stream: "But there is a new song in the air. Win-ter will come again but it will never be the same. For this land is more than wheat now, and life is no longer at the mercy of the seasons. Now in this place a new frontier is born. A new breed of pioneers work to bring forth the riches of the land. The pounding temple rising from this prairie is the heartbeat of a great nation, forever seeking a new American frontier." As

Figure 11. "Will it gush forth the
white foam that means oil?"
American Frontier (dir. Van Dyke,
1953)

the narrator speaks the last line, the camera pans up from the stream to
a long shot of the prairie, punctuated evenly by oil derricks, now fully in-
tegrated into the landscape. If the narrator's final pronouncement that
"winter . . . will never be the same," heard in retrospect, eerily augurs the
current climate catastrophe, the immediate effect of *American Frontier*
was to recast what were in fact dirty, dangerous processes that caused con-
vulsive upheaval as smooth, natural developments, helped along by tech-
nology, that would unequivocally enhance life. Like older depictions of
the frontier as a struggle between (or a smooth integration of) man and
machine, *American Frontier* handily erases the dispossession and geno-
cide of native peoples, allowing white settlers to replace them as dwellers
with rights to the land and even to handle and exchange their artifacts. Oil
films thus not only told stories of the present as calm and peaceful, mak-
ing oil itself seem glorious, clean, and powerful, able to enhance rather
than pollute or destroy the natural and agricultural worlds around it. They
also staged the male bonding, contract-signing rituals of drilling as natu-
ral episodes in a history they retold as a story of freedom on the frontier.
Later development filmmakers would draw on these films' techniques for
melding past and present visions of modernization, using them to create
utopian visions of mechanized progress that recast dispossession, work
speedup, and air and water pollution as rugged expressions of freedom.

Oil filmmakers thus created scenes that downplayed the dislocation
that came with having one's land turned into an oil well, naturalizing it
as just one more episode in wild and free frontier life. But the pioneers
whom filmmakers imagined overspreading the North American continent

in the past and leasing their land to oil companies in the present did not, in the films, need instruction or prodding; rather, as the films made clear, they could simply draw on their adventurous pioneer-entrepreneurial instincts, which would tell them to invite in the oil companies and embrace convulsive change. But what of those characters who did not have this pioneer sensibility? In Puerto Rico's DIVEDCO, the last case study in this chapter, filmmakers attempted to imagine and enact a program of education by which rural Puerto Ricans might practice local democracy, triumph over greedy middlemen, and enhance their lives in other small ways. Ignoring the authoritarian nature of the modernization initiatives rapidly transforming the Puerto Rican countryside, filmmakers imagined a world in which community education would lead to a deeply democratic, freely chosen modernity.

COMMUNITY FILMMAKING AND THE DEVELOPMENT PASTORAL AT DIVEDCO

The changes Puerto Rico was undergoing in the 1950s, though different than those the oil industry was visiting on the mainland United States, were no less convulsive. Operation Bootstrap, supported by the United States and orchestrated by Senator, then Governor, Luis Muñoz Marín beginning in 1947, was a massive modernization program that improved roads and other infrastructure; eliminated corporate taxes; and spurred a mass exodus from the countryside, to both Puerto Rican cities and the mainland. In order to empower US corporations in Puerto Rico, Muñoz Marín outlawed the Puerto Rican independence movement, which up until then had been a significant force in the island's mainstream political life; his 1948 Gag Law outlawed displaying the Puerto Rican flag, speaking against the United States, and speaking or printing materials in favor of independence. That year the Puerto Rican police established their Internal Security Unit, which worked closely with the FBI to surveil and repress the independence movement, putting down an insurrection in 1950 by strafing the mountain town the nationalists were holding.[61]

DIVEDCO, which Muñoz Marín founded in 1949, drew attention away from these dramatic battles, as well as from the rapid economic upheaval

the island was undergoing. DIVEDCO's films and other artistic output focused on documenting and celebrating the culture of rural, largely white Puerto Rican subsistence farmers (*jíbaros*), the very culture that was quickly disappearing with mass urbanization. As Rafael Cabrera Collazo writes, DIVEDCO films' central goal was "to preserve a past redefined by the *jíbaro*, but without the *jíbaro* being the true architect of this redefinition."[62] The destruction of Puerto Rican rural livelihoods and lifeways is reimagined in the films as a smooth integration of rural-pastoral life with modern machines and ideas, an integration which never took place outside the films. Thus, although DIVEDCO's films looked different than USIA's history films or SONJ and API oil films, they shared with those films the task of pastoralizing and beautifying displacement, social upheaval, and violence.

Unlike many development films, DIVEDCO's often fictional films do not depict Puerto Rican rural life as abject or isolated. Instead, they combine visions of the beauty and abundance of the countryside with social problem scenarios that often involve exploitation by middlemen or other greedy middle-class figures (though rarely landlords). They also, with some frequency, depict women's discontent and gender conflict, and characters often have intense discussions about these problems. In their ability to depict some degree of social conflict and exploitation, and in their commitment to staging conflict and multivocality rather than letting a dominant voice-over describe their characters, DIVEDCO films look more like New Deal films than the development films that increasingly appeared in other sites during the 1950s. The films' ambivalent relation to the emerging genre of the development film stems in part from the fact that the rural world depicted in Puerto Rico was already disappearing, and thus, as Cabrera Collazo argues, the films' critiques were not particularly controversial or even relevant to the new concerns of the ruling classes. Those classes were more interested in supporting Muñoz Marín's brutal suppression of Puerto Rico's independence movement, which DIVEDCO films never mention.

The politics of DIVEDCO's filmmaking division were influenced by prominent New Deal artists who went to Puerto Rico after stints with wartime propaganda agencies or the oil industry. The agency was initially headed by FSA veterans Edwin Rosskam, Jack Delano, and Irene

Delano, under the advisement of Muñoz Marín, whom Rosskam knew well. Jack Delano, the founder and first head of DIVEDCO's film program, was a particularly important figure in shaping the aesthetics and politics of DIVEDCO's films. Born Jacob Ovcharov in Ukraine, Delano adopted FDR's middle name as his surname as an adult, in a show of patriotism. After getting a grant in 1939 for a project photographing coal miners in Pennsylvania, Delano sent his coal-mine photos to Stryker, who invited him to work for the FSA. He and Irene, a fellow artist he had met at art school, traveled together taking photographs; she wielded the flash, helping him make the images of complex interior spaces for which he would become known. During the war Jack enlisted, while Irene went with Stryker to SONJ, where she designed exhibitions and worked on stories for its corporate publication *Photo Memo*.[63] The Delanos' first trip to Puerto Rico was in December 1941. Sent on a short-term assignment by the FSA, they were stranded on the island after the Japanese attack on the US base at Pearl Harbor. They decided to travel around Puerto Rico and take photographs for three months; in that time, in their telling, they fell in love with the island's people and culture.[64] They returned to Puerto Rico in 1946 and stayed for the rest of their lives, founding DIVEDCO and then moving on to work on other projects in 1952; while Jack worked on the films, Irene, a graphic artist, made many of DIVEDCO's distinctive film posters.

From the beginning of his life in Puerto Rico, Jack was aware of its status as a colony, and he noted the Anglicizing dictates that intensified after the war. In a letter to Stryker from the late 1940s, as he was setting up the film program, Jack recounts a visit to an elementary school, noting that "[e]ach of the changes in policy toward the teaching of English has only served to confuse teachers more than ever," since classes were in Spanish but all textbooks were in English. He then recounts a melancholic anecdote about a Puerto Rican friend who remembered reading a story in school called "The Last Class," about the World War I German conquest of Alsace-Lorraine, in which a schoolteacher tells his students that the book they are reading will be the last one they read in French.[65] Although all learning will henceforth take place in German, the teacher tells the students to guard their French heritage proudly, "and when he is through," Jack writes, "the class spontaneously begins to sing the Marseillaise," and then the Germans come in and arrest the teacher. Jack concludes

the anecdote by connecting it back to Puerto Rico's own clampdown on Spanish: "Imagine a Puerto Rican child, of Spanish speaking parents and of intensely nationalistic tradition, having to read such a story—and in ENGLISH!"[66] These frustrations over the imposition of English, and the struggles he witnessed over language and culture, do not appear in the films Jack directed for DIVEDCO. However, DIVEDCO films themselves are narrated and acted in Spanish, and they draw almost exclusively on local culture and music. Jack established for himself a role somewhere between the heroic schoolteacher he admired and the occupiers who horrified him, making intimate films on behalf of the US government and the colonial Puerto Rican government that attempted to preserve Puerto Rican culture and educate audiences in their native language while ignoring the contentious politics of the present.

Other New Deal artists and oil filmmakers followed the Delanos and the Rosskams to DIVEDCO over the course of the 1950s, including Benji Doniger, who had been in charge of the sound for *Louisiana Story*, and Van Dyke. Most of the DIVEDCO films made by these US filmmakers, if they do not eschew entirely the filmic vocabulary that was becoming associated with development, have plots that move beyond development's formulaic narratives. Doniger, for example, directed *Modesta* in 1955, a thirty-five-minute film that won a prize at the Venice Film Festival. Written by celebrated Puerto Rican author René Marqués, *Modesta* tells the story of an abused and exploited woman who unites with other women to demand better working conditions. Written and directed by men in 1955, the film cannot quite think feminism; the resolution it imagines is mutual appreciation for men's and women's work rather than a more equal and less gendered sharing of that work. But this film also dramatizes "the resolution of conflict through dialogue," a storyline Cati Marsh Kennerley points out is one of the most common in DIVEDCO films.[67] The talkiness of these films, their commitment to democratic dialogue that often involves characters speaking over one another, seems like a denial of the authoritarian colonial modernization regime under which Puerto Ricans were living, challenging that authoritarianism only in the most subtle allegorical ways. Yet despite their silence on the issues of the day beyond allegory, these films imagined that range of topics that might be discussed in the allegedly democratic spaces of development and at least attempted

to enact democratic discussion. Such lively, synced scenes of dialogue disappear in development films made elsewhere in the late 1950s and early 1960s, which tend to depict such scenes silently, with the dialogue drowned out by a voice-over describing the speech as democratic.

Van Dyke, who made more formulaic development films before and after this period, commented in the 1970s that DIVEDCO's films "were socially useful films . . . made with the same kind of fervor that documentary films had been made in England in the early days, and then in Canada, and so on."[68] Van Dyke's DIVEDCO films similarly break from the conventions of development media he had been cultivating in his previous films. His brief film *Mayo florido* is a symphony of close-ups of flowers accompanied by folk songs, and his short drama *El de los cabos blancos* is a drama about a lucky and avaricious middleman (the titular "white shanks" signify his good luck), whose exploitation of tobacco farmers is finally undone when they form a cooperative. Despite its theme of exploitation, *Cabos blancos* is not interested in depicting abjection: its opening shots of children romping through the oversized tobacco leaves recall the beautiful abundance and similar opening of the Flahertys' *Moana*. Van Dyke called the experience of making *Cabos blancos* "both frustrating and satisfying. The result is quite good, but I really am not fluent enough in Spanish to do the job of directing as thoroughly as I have done it in English."[69] For the film, Van Dyke's "less thorough" job meant that it strayed from the development clichés he was in the process of formulating in order to tell a more politically complex story. While other DIVEDCO films do contain standard sequences such as collective building projects, even those distinguish themselves from other development films in their lack of abjection: "traditional" rural Puerto Ricans, even if they struggle with money, are brightly lit and sometimes cheerful.

Jack Delano, the most successful of the New Deal filmmakers at collaborating with and training local filmmakers, also produced films with an ambivalent relationship to development. His 1949 short hygiene film *Una gota de agua* uses modernization rhetoric, but that rhetoric is wrapped up in an exuberant and somewhat experimental film. The voice-over, by young DIVEDCO-trained filmmaker Amilcar Tirado, trips over itself with enthusiasm about a microscope's ability to amplify a drop of water four hundred times; a nurse speaks directly to the camera, calling childhood

preventable illness "a crime and a shame," after which Tirado reiterates, "if the people could only see the water they were drinking." After boiling the water they look again—"let's see what has happened to the horrible creatures"—and find, triumphantly, that the water is now calm and safe.

Likewise, Delano's 1951 feature drama *Los peloteros* (*The Ballplayers*), inspired by one of Tirado's stories about his childhood, contains camera-work that becomes central to the later development films, but mainly tells the untrustworthy-middleman story common to DIVEDCO films. Told in flashback (framed by a group of urban young men reminiscing) about a rural baseball team and their slippery manager, the film luxuriates in scenes of boys playing, lounging, and talking over each other. As Marsh Kennerley explains, *Los peloteros* established a set of conventions for subsequent DIVEDCO films: "The camera focused on faces that later films would frame in the windows of rural houses as 'the Puerto Rican face.'"[70] These same shots of rural subjects framed by windows and doorways also became a staple of "before" scenes in later development films. But in its flashback format, *Los peloteros* is also one of the most honest of the DIVEDCO films about the changes sweeping the island; it is one of the only films from the division that acknowledges that the rural life being both celebrated and improved in the films is rapidly disappearing.

The Puerto Rican filmmakers trained by Jack Delano at DIVEDCO made films that, like *Los peloteros*, both iconically envisioned develop-ment and engaged ambivalently with Puerto Rico's rapid modernization. The films directed by Tirado in particular feature sequences that recur in later development films. The 1952 short drama *Una voz en la montaña* (*A Voice in the Mountain*), with a poetic voice-over by Marqués celebrating the natural beauty of the countryside, tells the story of Juan, an illiterate young laborer who organizes a night literacy class for himself and other workers. The class is difficult to organize, but he finally succeeds, draw-ing in skeptical friends and ultimately learning to read. Juan's literacy in turn helps him win over his love interest, María, who has been to school and is thus more "sure of herself"; before starting classes, the voice-over tells us, he "cannot find the words" to tell her his feelings, and others in the community mock him. At the opening and close of the film, the cam-era moves from face to shining happy face of the adult learners in the school; nearly identical scenes, though more often of children, become

central to many later development films. In most of the subsequent development films, however, triumphant schoolroom scenes follow dramatizations of the community's abjection, lethargy, and misery. *Una voz*, by contrast, imagines Juan as a hard worker from the beginning (that is why he cannot attend school in the daytime) and depicts a town where there is already a school, which can be used at night. Thus, as with *Los peloteros*, *Una voz* presents visual elements that will be adopted in subsequent development films while not yet presenting the totalizing world created in these later films.

Tirado and Luis Maisonet, in collaboration with Marqués, went on to make films that engaged more directly—seemingly as directly as they could—with the rapid industrialization of Puerto Rico under Operation Bootstrap. These filmmakers attempted to respond to what Cabrera Collazo identifies as the mismatch between the pastoral vision and hyperlocal problems that had been the focus of early DIVEDCO films and the powerful geopolitical forces that were simultaneously transforming rural Puerto Rico, bringing into view what he calls the "new and persuasive forms of power framed by North American investment."[71] Particularly Tirado's *El santero* (1956) and Maisonet's *Juan sin seso* (*Witless Juan*, 1959) began to directly confront the erosion of rural Puerto Rican culture by plastic and mass-produced mainland US cultural products. In the film, the titular Juan is a literate and educated man who was once at the top of his class; however, he now "does not analyze" and "accepts everything," and thus cannot see the negative sides to technology and sped-up, mechanized, consumerist life. After an extended scene of a Coca-Cola assembly line, the voice-over comments that people shopping and commuting in urban environments resemble machines, and that "even enjoying himself, a man looks like a machine" (this said as sped-up rock and roll blares from the record player and couples dance mechanically).

Juan sin seso, written by Marqués, feels like a more pessimistic sequel to *Una voz de la montaña*. Marqués himself reflects that over time the DIVEDCO filmmakers realized they "were underestimating our adult rural population in terms of readability, understanding, sensitivity and imagination" and that "drama with a realistic ending could be more effective educationally than drama with an artificial happy end."[72] Yet for all its perceptive skepticism, *Juan sin seso* is one of the rare DIVEDCO films

told entirely in didactic voice-over. Juan is urged to think, and to speak, for himself, but is not given the opportunity to do so within the film. Furthermore, in contrast with the many times DIVEDCO film *jíbaros* band together to confront untrustworthy middlemen, Juan is all alone as he confronts a society flooded with mass-produced commodities and culture from the mainland; the film suggests that he should use his independent judgment to decide which modern conventions to adopt and which to reject. Despite DIVEDCO's emphasis on discussion and collective organizing, the filmmakers can only imagine (or, given the existence of the Gag Law, are only permitted to imagine) "thinking for oneself" as the solution to the onslaught of mass-produced goods and new industries, including culture industries. Within the space of the film, community action cannot be mobilized against these forces, much less the nationalism that remained a force on the island despite more than a decade of repression.

CONCLUSION: CLEARING THE WAY
FOR THE DEVELOPMENT ERA

This chapter has moved from USIA's 1950s "history films," which attempted to position US history as an imitable and desirable path for the decolonizing world yet failed with test audiences; to the petrodocumentary of the late 1940s and early 1950s, which succeeded spectacularly at the task of beautifying both the current wave of domestic US oil exploration and previous waves of frontier conquest and displacement; to the DIVEDCO films that experimented with depictions of local democracy as Puerto Rico's neocolonial status was being cemented. By the mid-1950s, the former New Deal filmmakers in the latter two scenes had developed reliable formulae for depicting development as a nonviolent and sometimes joyous process. If USIA's rosy portrayals of the US nineteenth-century past were not quite credible to test audiences, documentary's evidentiary power helped produce convincing depictions of both the incursion of oil drilling into rural communities and the community education of rural Puerto Ricans. These development films alternately erased and beautified the upheaval their documentary subjects were experiencing: the pollution of land and water, the danger of oil rig work, and the difficulty of

farming in an oil boom in the first case; and the convulsive industrialization and urbanization of Puerto Rico along with the brutal suppression of the Puerto Rican independence movement in the second. Oil industry cinema evacuated dirt and pollution, integrated oil derricks visually into the natural landscape, brandished contracts and Native American artifacts as evidence of free consent, and integrated men comfortably with machines, all in service of helping oil companies sell their encroachments as natural and painless. Meanwhile, DIVEDCO's films, with their focus on communal democracy and small triumphs over husbands, middlemen, and groupthink in the countryside, helped Muñoz Marín's government imagine itself as democratic as it ceded control to corporations and enacted repressive measures. These depictions of modernization, particularly in their emphasis on freedom, reimagined what were highly coercive and convulsive processes as idealized and voluntary ones. In so doing they created a portable visual repertoire that left behind the roaring fires and filth of industrial processes in favor of hopeful schoolroom scenes, triumphant sequences of men and machines, and instantly recognizable portrayals of hyperlocal deliberative democracy.

DIVEDCO's films and filmmaking techniques were not restricted to Puerto Rico. Luis Beltrán of Bolivia was one of many filmmakers who took classes there; Beltrán took a film production class with Doniger at DIVEDCO in 1953, then returned to Bolivia and worked on several development films before eventually becoming a distinguished scholar of development communications.[73] Many of DIVEDCO's films were shared with and adapted by UNESCO for its fundamental education campaigns of the early to mid-1950s, which are the subject of the next chapter. Fundamental education was put into practice, or at least attempted, at CREFAL in Pátzcuaro, Mexico, starting in 1951, where educators screened, adapted, and imitated the techniques of DIVEDCO films. CREFAL, like DIVEDCO, was a vibrant scene that welcomed a variety of filmmakers and approaches. While the films made and screened there focused broadly on promoting the self-help tenets of development, they sometimes did so using creative and playful techniques and moods. This meant that the films made at CREFAL, like those at DIVEDCO, invented clichés that would be repeated in future development films but also created alternative visions that represented creative roads not taken for the genre.

3 Experiments in Fundamental Education Filmmaking and Latin American Regionalism at Pátzcuaro

The 1949 film *That All May Learn*, commissioned by UNESCO and produced by the United Nations Film Board, presents a clear impetus for mass education. The film tells the story of a rich businessman who steals the land of a group of illiterate Mexican farmers, tricking them into signing away their plots by telling them the document they are signing is a contract for work in the city. When the farmers realize what has happened with help from the literate son of the protagonist, they advance on the businessman's home with pitchforks, menacing him until he agrees to return the land. Directed by Carlos Jiménez and written by Hans Burger, who had previously made anti-fascist documentaries with Herbert Kline and Billy Wilder, *That All May Learn* tells its story through gauzy close-ups of the lead actors' expressive faces, accompanied by swelling music, in a style that resembles Mexican melodrama.[1] The film intercuts its dramatic story of the immediate benefits of education with documentary footage of Chinese, Indian, and Russian literacy campaigns. As Suzanne Langlois writes, this inclusion of the Soviets and newly communist China as exemplary in their literacy efforts reflects the "the [temporal] gap between the commissioning and making of films, the rapid deterioration of international relations, but also a will to open the film experiment up to differing options of internationalism."[2]

Indeed, as UN cultural and educational programming caught up with capitalist Cold War imperatives, it was not only friendliness toward the USSR and China that disappeared from its films and images. The straightforward motive for education, too, vanished from the agency's films and other productions. Rather than being a way to keep devious land-grabbers in check, UNESCO positioned literacy, and education more generally, as a step along the path toward the more nebulous goals of enlightenment and world community. Typical in this regard is a 1951 drawing in the *UNESCO Courier*, accompanying an article on literacy, of a globe spinning in a pitch-dark sky, stamped with the word "IGNORANCE" and illuminated by a beam of light projected by UNESCO's logo, in which the letters in its acronym form the columns in a classical, Parthenon-like structure, visually equating the agency's purview of "education, science, and culture" with a Western civilizational lineage. The image bears the title "FUNDAMENTAL EDUCATION" and is accompanied by a headline meant to cause alarm: "1,000 Million Illiterates: HALF THE WORLD IS IN DARKNESS."[3] This attempt to conjure anxiety at the natural condition of the earth vis-à-vis the sun signals the affinity of the new global fundamental education project to the general mission of development: its promise to allow humans everywhere to triumph over natural and even cosmic forces. The positioning of UNESCO as both Western-civilizational edifice and film projector also illustrates the organization's conviction that fundamental education through film was the way out of the unfortunate condition of illiteracy, which the image conflates with the general condition of ignorance. Documentary film, which managed to be education, science, and culture all at once, was particularly well suited to UNESCO's mission.

These promises to illuminate the world through film, along with a nebulous sense of both the "ignorance" of the people of the global South and what kind of education might lift them out of it, defined UNESCO's fundamental education mission. One of the most important locations for the production of the films that might educate the world was CREFAL in Pátzcuaro, Mexico. If fundamental education constituted what Glenda Sluga calls UNESCO's "ambitious flagship contribution to the creation of One World" from 1945 until 1958, bringing together progressive educators and colonial administrators in an effort to educate "backward" indigenous peoples, the Mexican CREFAL headquarters exemplified how UNESCO

imagined film as a way to avoid specifying what were actually quite vague educational aims. Unable to come up with a clear curriculum or method for education that would lead reliably to self-help and economic growth, experts at UNESCO and students at their Mexico training center learned, and taught others, to dramatize education-for-development, helping its trainees imagine that development would happen through the overcoming of "ignorance" by teaching them to create cinematic scenarios in which this occurred. The story of CREFAL's intense focus on making and screening development films points to development's elusiveness and the difficulty of encountering successful self-help endeavors offscreen; at CREFAL, films were the place where a credible version of development, inflected by both the late-colonial internationalism of the expert teachers and the experimental spirit of the Latin American trainees, could be found.

After tracing the rise to prominence of fundamental education at UNESCO in relation to late-imperial and development logics, this chapter examines the development films made at and around the CREFAL site by both the European and North American professional filmmakers who worked at and visited the site and Latin American student-teacher teams studying there. In prioritizing education and modest visions of self-help that retreated from wartime dreams of international planning and land redistribution that might eliminate hunger and deprivation, CREFAL's films were crucial to the evolution of the development film genre. In these films, the straightforward rationale for education in *That All May Learn*, which not only made sense at the level of plot but also alluded to the long history in the Americas of the usurpation of nonliterate indigenous people's land, never returned; instead the development films at CREFAL made vague promises that education would bring with it infrastructural modernization, entrepreneurial wealth, and social harmony.[4] However, the films, particularly those made by CREFAL's Latin American trainees, use a variety of strategies to advocate for education, experimenting with playful rationales and techniques to make learning seem appealing and enjoyable. While the professional filmmakers at CREFAL helped establish the omniscient perspective, "global village" iconography, and preoccupation with education that would become central to later development films, they also, for a variety of reasons related to both their late-colonial racial and geopolitical perspective and Pátzcuaro's status as a picturesque

training site, made films that did not quite render global South societies abject and could not quite convincingly call for transformative modernizing interventions. Latin American trainees at Pátzcuaro, for their part, made films that were even less interested in plotting modernization trajectories, disregarding UNESCO's advice about indigenous people's inability to understand film language and playing with genre in ways that demonstrated respect for their subjects and audiences.

FUNDAMENTAL EDUCATION ON FILM AT PÁTZCUARO

If UNESCO during the Cold War conveyed only a hazy sense of why educational programming on a massive scale was necessary, it justified this far-reaching educational mission by mobilizing new definitions of race that emphasized universal educability. The thinking on race that UNESCO had recently codified, which eschewed the strict racial determinism of the pre-war years, constituted an adjustment to the post-Holocaust, slowly decolonizing world that also demonstrated what Denise Ferreira da Silva calls "the racial's resistance to moral banishment."[5] Such a moral banishment almost seemed possible at the moment of UNESCO's 1950 Statement on Race, drafted by eight preeminent anthropologists and sociologists, which declared race "not so much a biological phenomenon as a social myth," argued for "educability, plasticity" as "a species character of homo sapiens," and strongly denied any racial differences in intelligence or temperament.[6] However, UNESCO backpedaled in 1951; after consulting with "physical anthropologists and geneticists," the organization released a new statement that opposed racial prejudice but refused to relinquish the idea of innate racial differences, in intelligence in particular.[7]

While the second statement conceded much to the biologists and physical anthropologists who insisted, despite all evidence, on the possibility that racial difference shaped "innate capacity," both statements emphasized that "educability" was far more important than biology in determining the conditions under which individuals and their societies would exist, and that education could and should be used to utterly transform the "illiterate societies." Julian Huxley was one of the most prominent advocates at UNESCO of this logic, guiding the organization toward ideas of

evolutionary racial improvability. A zoologist and biologist by training, he was also the great-nephew of imperialist poet and cultural theorist Matthew Arnold, as well as a committed eugenicist, albeit of a less genocidal variety than some. Horrified at the Nazi project, Huxley instead imagined that scientific insights and the technological and educational interventions they undergirded could create "a single world culture."[8] As Sluga and Zoe Druick demonstrate, Huxley's general view that "underdeveloped intelligence stemmed from cultural and environmental rather than biological deficiencies" allowed for an emphasis in UNESCO on education that would lift these "deficient" populations toward a world community that was always guided by Europe and the West more generally.[9]

Fundamental education was thus undergirded by convoluted eugenic-humanist racial thinking, but was also shaped by the various educational specialists and progressive thinkers who along with Huxley made up UNESCO's Education Committee. This group, which included Margaret Mead, literary critic I. A. Richards, and Mexican educational administrator Elena Cuellar Torres, agreed that fundamental education should learn from British late-colonial education but had trouble agreeing on what the nature of that education should be. Instead, they produced ponderous documents asserting that education should facilitate world peace and that educators should "develop the curriculum out of the materials of children's present social life."[10] Unable to reach consensus on the knowledge that might make up a fundamental education, though certain that indigenous and rural people in the global South did not already possess it, education committee planners glossed over their differences, resolving "that fundamental education would be an ongoing process from a new global point of view" and encouraging UNESCO to appoint a panel to both gather information on fundamental education and present that information through audiovisual and other means so that countries might sign on to UNESCO's program. In practice, the vagueness of the committee's idea of fundamental education meant that the disinterested, omniscient expert's "global point of view" remained paramount to UNESCO's fundamental education projects, but also that those projects would be sites of experimentation rather than opportunities for the dissemination of a particular educational program. The committee from the beginning signaled that audiovisual media would be key for sharing knowledge about

the experiments in fundamental education it envisioned UNESCO undertaking, and that audiovisual media would play a key role in educating illiterate populations.

If early fundamental education planners left questions unanswered about what constituted a fundamental education, there was no doubt that these planners were centrally preoccupied with the struggle between modernization and cultural preservation. The 1949 book that attempted to give fundamental education a "description and program" refused to define education exactly, but rather made assertions that were somewhat contradictory in its attempts to support students' adjustment to modernity while also preserving their cultural traditions: "The aim of all education is to help men and women to live fuller and happier lives in adjustment with their own changing environment, to develop the best elements in their own culture, and to achieve the social and economic progress which will enable them to take their place in the modern world and to live together in peace."[11] Although this definition of education seemed to apply universally, fundamental education's focus on indigenous people and peasants is made clear elsewhere in the *Description and Programme*. "The peasant or tribal peoples who provide the world with all-important primary products are engaged in a ceaseless struggle with their physical environment," the pamphlet asserts, and "are often constrained by the prevailing social and economic system and usually lack the scientific knowledge and the skills which would give them access to a fuller and more productive life." Fundamental education, then, could facilitate "agricultural improvement and the betterment of social conditions" in a way that would "contribute to world prosperity and peace."[12]

While it promises that fundamental education will improve the lives of these "peasant and tribal peoples," the *Description and Programme* also insistently calls for cultural preservation, arguing that "people who are technologically backward may possess personal qualities, values and traditions of a higher order than those found among more industrialized groups.[13] This claim, while still implicitly designating Westerners the arbiters of which values and traditions might be "of a higher order," left room for the preservation of "technologically backward" communities' values and traditions, as well as unique cultural paths that contrasted with the uniform development trajectories proposed by the modernization theory

formulated in the 1950s United States. But this impetus to educational intervention for both improvement and preservation would prove difficult to put into practice, though these imperatives would be easier to integrate in the imaginary space of the documentary film.

The difficulties with putting UNESCO's educational programming ideas into practice became apparent during its abortive fundamental education pilot project in Haiti's Marbial Valley. There the assessment of local problems, undertaken by renowned French anthropologist Alfred Métraux, was completed after limited resources (from UNESCO, the Haitian government, and the Rockefeller Foundation) had already been pledged to the project. Métraux suggested that the problems in the Marbial Valley, which included isolation and poor agricultural conditions as well as low literacy rates, had been underestimated, but it was too late to request more money. Facing both underfunding and local resistance, UNESCO yanked all funding from the Marbial Valley project in 1953. Despite some progress in eradicating yaws disease and developing educational materials for children and adults in both Haitian Creole and French (experts argued over which language should be used for education), the general consensus was that the project had been a failure.[14] UNESCO then concluded that it was not equipped to directly host its own development projects, especially since wealthier member nations (primarily the United States) were reluctant to finance such projects when they could sponsor bilateral projects directly and thus cement their own humanitarian reputations.

After abandoning the Haiti project and with it the idea of administering its own large-scale educational programs, UNESCO established a new model of regional training centers. These centers were imagined as sites that would educate teams of educational specialists and then send them back to their home countries, equipped with new pedagogical techniques and training in making and screening audiovisual materials. This focus on training education leaders and on the production of audiovisual materials meant that the UNESCO centers did not have to worry about envisioning or measuring educational outcomes; the centers would simply produce ideal visions of development and rural education to be viewed and exported. For western European and North American intellectuals and planners, CREFAL was a place to test out and consolidate the roles of the international official, which Anabella Abarzua Cutroni argues was a "special kind of

expert," who had emerged after the war; CREFAL in particular accommo-
dated not only experts in the natural and social sciences but also artists and
arts-related technicians from Hollywood, the publishing industry, and the
art film world. It was imagined as a place to transfer knowledge and skills to
educators and civic leaders in the region so that they might localize a funda-
mental (and fundamentally Western) education model.[15]

Founded in 1951 in Pátzcuaro, Mexico, CREFAL was the first regional
fundamental education center and UNESCO's flagship education project.
The choice of Mexico was linked to Jaime Torres Bodet, who succeeded
Huxley as UNESCO's director general in 1948. Choosing a Mexican direc-
tor general was significant for UNESCO, signaling that it recognized the
by then institutionalized and developmentalist Mexican Revolution as an
important model for what it might do around the world. Torres Bodet had
been Mexico's secretary of education during the 1940s and had overseen
a rural education process that attempted to undo the radicalization of
the education campaigns of the 1930s Cárdenas regime. Torres Bodet an-
nulled socialist education from the constitution, led a campaign to revise
textbooks, called for educators to instill in their students a cross-class ca-
maraderie and a love of country that would replace class struggle, resegre-
gated students by gender, and posited literacy as a path to world peace and
universal brotherhood.[16] Inspired by Torres Bodet's example, UNESCO
officials studied the Mexican cultural missions, which integrated mobile
education centers with health and infrastructure projects in rural areas,
as they attempted to plan their own fundamental education programs. A
UNESCO-commissioned book on the Mexican cultural missions, written
by CREFAL's soon-to-be deputy director Lloyd Hughes in 1951, comments
that the rural missions have made indigenous Mexican peasants "better
producers and consumers" and lauds their educational film program,
which was brought to villages through both "mobile mission" trucks and
eight "cinematographic missions" that transported films on pack mules to
more isolated indigenous communities, screening educational films for
thousands of people at a time.[17]

Films were thus a solution to the problem of educating the masses on
the cheap, but CREFAL's planners argued that they were also optimal
for teaching. CREFAL's statement of philosophy insists upon "the psy-
chological fact that what one learns through sight and hearing is better

understood and remembered than what is learned through other mental channels."[18] The emphasis on film as educational medium at CREFAL was perfectly suited to the location of Pátzcuaro, which had been the iconic center of the Cárdenas regime's nation-building efforts and the site of many iconic Mexican films in the 1930s and 1940s.[19] This meant the indigenous communities there had experience working with film crews, and that the Mexican workers on those film crews could draw on a romantic visual vocabulary that imagined indigenous worlds untouched by modernity. For planners and administrators, the twenty-two indigenous communities around Pátzcuaro constituted a "zone of influence" where the "future leaders of fundamental education" from around Latin America who trained at CREFAL undertook extended fieldwork. These fieldwork stints, in which each trainee worked for six months in a particular community in the zone of influence, were meant to prepare them to return to their own countries and run rural education programs where they would train local educators and other "fieldworkers." Throughout the training program, including in its fieldwork, CREFAL emphasized producing and exhibiting audiovisual educational media to "traditional" communities in the service of their development.[20] Hughes explained that the combination of media production and experiments in CREFAL's training program was meant to "endow its graduates with certain specialised skills in communication and methods of work, plus an understanding of how all the specialised areas of community development fit together."[21]

Hughes's reference to "specialized skills" and the lengthy statements justifying CREFAL's use of film reflect the significant role filmmakers and artists played at CREFAL. If they could not entirely figure out the content or method of the center's community development endeavors, CREFAL administrators had an easier time identifying technical and often artistic skills in the realm of art and media production. It was not only the film instructors—led initially by Danish filmmaker Hagen Hasselbach and joined in the mid-1950s by documentary luminaries such as Venezuela's Margot Benacerraf—but also other artists such as Richard Kent Jones, an animator with Hollywood experience, whose technical skills were valued there. These experts imparted their technical knowledge to the "future leaders" sent to CREFAL from around Latin America; Jones, for example, invented and taught his CREFAL students "a method of lettering which

required only a ruler, a compass, and a pencil," enabling them to make reproducible visual materials for the communities they were working with in Pátzcuaro, but also to go back to their home countries and train other educators.[22] Benacerraf, for her part, taught filmmaking for five or six months in 1954; she recalled in a 1992 interview her frustration with UNESCO's bureaucracy but also that at CREFAL she "first became aware of a shared Latin American identity."[23]

If it inspired Latin American fellowship, the film program at CREFAL was inspired by European filmmakers, particularly British ones, who were already well versed in using documentary film to manage the decline of their own empire. Julian Huxley himself had in 1929 overseen what Tom Rice calls "the first coordinated experiment to present nonfiction films to African audiences" when he brought three Empire Marketing Board films to schools in East Africa in the hopes of using the films to make colonial subjects more productive.[24] During and after the war, colonial film production increased if anything, as the British used cinema, and depictions of development in particular, to both slow down the cession of their territories and help naturalize their ongoing economic power after the end of formal empire.[25] Huxley was responsible for bringing preeminent British documentary filmmaker John Grierson into UNESCO, where Grierson served as the first director of mass communication and public information. While he aspired to train local filmmakers, Grierson brought to UNESCO both a catalog of films from the Colonial Film Unit and a network of western European filmmakers and administrators with experience in colonial cinema.[26] As Rosaleen Smyth notes, Grierson's dual roles at UNESCO and at Britain's Central Office of Information, which oversaw colonial educational films, allowed him to meld "the high and the low," supervising the production of films that combined the poetic-creative state propaganda he was known for with the more straightforward style to which colonial educational films adhered.[27] This Griersonian template, in which symphonies celebrating state infrastructure met simple how-to and morality tales about rural peasant life, was frequently adopted by filmmakers to depict development in the late colonial era, including by the British documentary filmmakers who worked for UNESCO.

Paul Rotha, who had also made films for the British empire, produced the best-known documentary depiction of CREFAL in 1953, in the form

of half of the UNESCO development film *World Without End*; the other half was filmed in Thailand by fellow British documentary luminary Basil Wright. Rotha was perhaps the most left-wing major figure in the British documentary film movement, which, as Tim Boon writes, "became possible in Britain in the interwar period through a historically contingent linking of issues of citizenship with the rise of public relations."[28] Rotha came of age as a documentary filmmaker in a way that parallels Willard Van Dyke's story, although, like the other key figures in the British movement, he was from a more middle-class background than most of the New Deal/Popular Front artists who were his US counterparts. Born in 1907, Rotha published his first book of film history, *The Film till Now*, at age twenty-two, having fallen in love with the poetic realism of Soviet filmmakers Sergei Eisenstein, Vsevolod Pudovkin, and Aleksandr Dovzhenko. In 1931 he met Grierson and began working for him at the Empire Film Board, and from then on he was committed to the documentary mode.

Unlike Grierson, Rotha was a self-proclaimed Marxist in his approach to both film and the copious film criticism he authored, although his understanding of Marxism was mainly gleaned through the Soviet filmmakers he loved. In his 1935 film *The Face of Britain*, Rotha takes up, as Boon writes, "Eisenstein's commitment to dialectic, as a mode of historical account, and as a mode of film construction," and depicts the industrial revolution "as both aesthetic and social catastrophe," positing state planning as the only way to avert "the chaos of the Victorian era."[29] Also in 1935, Rotha formed the Associated Realist Film Producers, an organization that connected documentary filmmakers with clients in both government agencies and private industry, and invited Huxley to be on the ARFP's panel of advisers. In 1946, after Rotha had become frustrated with inefficiency at the British postwar Central Office of Information and dissolved his affiliated film program, he drew on his connection with Huxley to become the official adviser of the British government to UNESCO. Thus he was already known by UNESCO in 1952, when they commissioned him to make *World Without End* at CREFAL. Rotha had no qualms about working for the British empire and seemingly no qualms about colonialism generally.

Rotha's politics, then, seemed to consist of this complacency toward empire alongside a leftism that consisted of self-professed Marxism; advocacy

for global redistributive mechanisms that would temper capitalism, as evidenced in his 1940s documentaries *World of Plenty* (1943) and *The World Is Rich* (1947); and ties in the 1940s and 1950s to a global documentary-artist Left. In holding these contradictory politics, Rotha is representative of both the late-colonial intellectuals who ran UNESCO and the British Left more generally. As Charlotte Lydia Riley writes, these leftists took an "accommodatory approach to imperialism":[30] supporting colonial development allowed them to be vaguely anti-imperialist without calling for an immediate end to empire, as development thought encompassed "a belief that the future was defined by looser bonds, and greater liberty, but not independence as such."[31] *World Without End* constitutes one attempt to imagine this greater liberty, while also revealing the contours of the relationship between these "colonial development" efforts and the more aggressive postwar US-led development project. Rotha's description of how and why he made *World Without End* repeats the anodyne developmentalist line of the film's voice-over: "We wanted to show how, by providing expert advice and materials, it is possible to help people help themselves."[32] However, the film itself, as well as the writing Rotha produced as he was filming, betrays both an ambivalence about the international development enterprise, particularly in its US-dominated postwar phase, and an awareness of the possibilities it obscured.

EUROPEANS AT CREFAL: THE "ONE WORLD" FILM

World Without End (1953), directed simultaneously in Pátzcuaro and Thailand by British documentary film movement veterans Rotha and Wright, opens on an animated Earth spinning in darkness, over swelling music. The solemn authoritative voice-over announces, "I am a man myself, and I think that everything that has something to do with other humans has something to do with me too." The swelling music, by English composer Elizabeth Luytens, who had recently scored films for the British Gold Coast film unit, continues, over a long dissolve in which the spinning Earth morphs into a lush landscape.[33] The camera pans across the horizon, eventually settling on wispy clouds above elegantly hanging fishing nets, then pans again down to ground level in order to follow a fisherman

and a tiny, smiling boy as they climb into a boat. The voice-over, written
by Rex Warner, an English intellectual whom Druick pithily identifies as
"a classicist with a penchant for universal platitudes," intones that "we are
looking at human beings and we are seeing something of two countries
where they live."[34]

The scene cuts to an equally lush landscape in Thailand, where a man
dressed similarly to the Mexican man, in work clothes and a sun hat, is
riding an elephant. The voice-over continues as the camera follows the
young man skillfully balancing on the elephant: "[D]ifferent languages;
different religions; different animals, trees and flowers. Yet in both places
people get their living from the earth and from the water; in both places
people feel pain and hunger, and people enjoy health and the good things
of life. They have enemies and they have friends. They have children and
they want them to be happy." We return to more shots of the lovely Mexi-
can lake, followed by lively market scenes; the voice-over informs viewers
of the "great Tarascan Empire" and of the Indians who "still live here" and
"retain their old love for music and for singing," at which point a mournful
traditional song begins. It is only after these various scenes and assertions
that the film begins to venture into UNESCO's work in each place, depict-
ing teacher trainees "learning how people live" before they begin to cure
their yaws and teach them about embroidery and DDT. The final scene
again juxtaposes the local and the global, superimposing a globe onto the
head of a Thai baby.

Scholars have indicated *World Without End*'s affinity with newly dom-
inant modernization ideas, demonstrating how the film reduces the po-
litical complexities and conflicts Rotha and Wright depicted in their prior
films to straightforward narratives of progress.[35] Contemporary reviews
of the film confirm how new and jarring these logics of modernization
and development seemed, at least to British moviegoing audiences. In the
Saturday Review, reviewer Cecile Starr calls the film "vibrant and em-
phatic" and praises the "unsurpassed beauty" of its "every face and form,"
but she is also perplexed by *World Without End*'s developmentalist as-
sumptions. Apart from (and despite) its slowness, she notes that it "leaps
like a wild animal from Mexico to Thailand and back and forth, giving
the bewildering impression that people and problems are somewhat alike
all round the globe." She also notes that in the film, "problems are all

contiguous—illiteracy, disease, poor land, fear, isolation, despondency run into each other without our being able to see exactly where one begins or where another ends," whereas "we in this country tend to want everything condensed and arranged geographically in separate subject categories for our convenience."[36] This conflation of global South societies across widely disparate geographies and the blurring of disparate problems would soon congeal, in both US-led modernization theory and the global imagination, into the commonsense temporal categories of "underdevelopment" and "traditional societies." The fact that these characterizations are "bewildering" to Starr (and by implication at least some of the British viewers for whom she speaks) in 1954 is an indication of how important film was in making otherwise nonsensical modernization ideas cohere in this period.

However, if *World Without End* expresses development's oversimplifications and anti-political tenets, it is also true that the film does not make the case for modernization very urgently. As another contemporary review states, "[A]t heart this is a sociological film, meant to awaken our consciences to the need to do something for our 'under-privileged' fellows in Siam or Mexico, but it seems to lack force." This reviewer cites the "diffuse" stories and the "lyrical and romantic" camerawork as contributing to the film's lackluster call for change and concludes by pronouncing the film "less effective" than *Forgotten Village* or the British Colonial Film Unit's *Daybreak in Udi*.[37] Film critic and theorist Siegfried Kracauer, in his appraisal of the film, also notes that the "cutting on resemblances, elemental needs, and humanitarian efforts does not level all exotic charms and cultural differences" and that "Wright and Rotha seem to have fallen in love with the people they picture."[38] Recent scholarly appraisals similarly note the film's affection and respect for its subjects, despite its aspirations to transform them: Richard MacDonald notes that the film "presents its heroes as sensitive and humble and its victims are dignified and relieved rather than wretched and suffering," while David Wood notes that the Mexico portion "repeatedly incites the viewer to stand in awe at the visual appeal of the location and the richness of its inhabitants' cultural traditions."[39]

One clue to what sets *World Without End* apart from earlier and later development films is the motif of the spinning globe that opens and closes the film. Seemingly because of their relentless attempts to project spatial

differences onto a temporal axis, development films generally avoid depictions of globes and even maps. *World Without End*'s opening on the globe, and thus the global, seems both to symbolize UNESCO's "one world" cosmopolitan vision and to recall the dream of rationally managed global production and distribution that had driven Rotha's earlier "world" films.

However, *World Without End*'s greatest difference from other development films is its respectful approach to the cultural practices of its "traditional" subjects. It is in this lack of abjection positioned anterior to modernizing transformation, its insistence on both the beauty of "traditional" life and the idea that the action is all taking place (and we are thus all living) at the same time, that *World Without End*'s internationalism differs slightly from that of the US-dominated Cold War modernization project that was concurrently taking shape. Rather than primarily attempting to make abject global Southerners available as objects of transformative intervention, the film seems to first and foremost be assuring Europeans, perhaps not least the filmmakers themselves, of their shared humanity.

The humanizing and even reverent quality of *World Without End* emerges not only from Carlos Carbajal's romantic cinematography—Wood argues that Carbajal's experience on Mexican melodramatic feature films influenced the sweeping, awe-inspiring scenes—but also from the circumstances under which the film, particularly the Mexico portion, was commissioned and made. This is not to say that Rotha himself revered the indigenous people around Lake Pátzcuaro; his writings show that in fact he did not. But his correspondence while filming in Mexico demonstrates that both the situation at CREFAL he was asked to depict and his own antimodern, socialist, and anti-American but also racist worldview allowed him to produce a film that by turns romanticized and dignified its indigenous subjects—a film that could only half-heartedly insist that they needed modernizing. That this widely viewed film could not quite make the case for modernization illustrates much about the British colonial vision of development and how it was elaborated through cultural and educational efforts at the United Nations. Despite their indebtedness to Griersonian traditions of state-building documentary, British and North American filmmakers at CREFAL could not quite imagine the joyous scenes of cultural upheaval and grueling labor that would constitute the recognizable iconography of development in the Americas by the end of the 1950s.

In seeking approval from CREFAL and the Mexican government, Rotha described the film as "a Unesco film based on the theme 'living in a world community.'"[40] Initially, too, the film was called *The World Is a Village*, invoking the all-important village that was a discovery of early Cold War development, and the film indeed goes a long way toward universalizing the traditional villager immortalized in the Kline and Steinbeck film *Forgotten Village* (see chapter 1). In preparation for filming, Rotha described the process of "going out day by day with various teams, rejecting various villages for such reasons as difficult for transport or lack of cooperation from local people."[41] Eventually he settled on the community of the island of Yunuén, explaining that it had "a very keen Crefal team of students, and has problems which can be visually explained. It will take time to get the confidence of the Indians in the approved Flaherty manner, but this can be done."[42] Robert Flaherty, here and elsewhere, looms large for Rotha as a white filmmaker who gained the trust (or at least captured intimate footage) of indigenous people.[43]

Rotha did experience difficulties as he attempted to find a place to film, not least (he reported) because villagers were annoyed that CREFAL educator teams did not do much to raise their standard of living. He wrote: "[O]ne must remember that Crefal's main job is to train students to go back to their own countries equipped to work there, and that the raising of conditions in the villages round here is a secondary task, however critical the local villagers may be about Crefal." He also described a dilemma: while "the farmer types [the crew encountered] were either dull or uncooperative, . . . [t]he headache is that Crefal does nothing to help the fishery problems, which are many."[44] This problem, Rotha wrote, could be fudged by having the CREFAL team assist the fishing community with health and other non-fishing-related problems.[45] Thus despite Rotha being tasked with making a film about CREFAL's development interventions, much of the world Rotha filmed was bypassed by those interventions, which were in any case very limited in scope. These circumstances doubtless contributed to the film's unconvincing modernization plots, as Rotha's film often alludes to development interventions that were not in fact occurring.

Hints of the criticism and "lack of cooperation" Rotha encountered in some communities can be found in a 1951 letter from the indigenous

authorities of the communities around the lake, who assert that "with some frequency, film companies realize their works in this zone, particularly in this area, granting some gratifications to some people or groups of people but without leaving any material works that effectively benefit the community." The community authorities go on to demand, in exchange for the next film made on their land, improvements to the local library and municipal tenancy offices and more medicines for the local health center, noting that "your help will also serve as an example for other institutions that only use these areas to satisfy their own needs, without leaving behind any works."[46] This cutting commentary by the indigenous authorities lays bare the disconnect between the improvements they wanted and expected—generally basic goods and services—and development's insistence on education and self-help before (and often in place of) concrete infrastructural improvements. It also reveals a conflict in framing: the indigenous authorities argue that they are being used for others' gratification and deserve compensation in the form of public works, while Rotha and UNESCO frame their film as itself a humanitarian work. The film's lack of interest in depicting communities in need of, or undergoing, transformation was partly a result of UNESCO's limited budget, but it also seems to have stemmed from fundamental disagreements about how that transformation should take place.

Claiming *World Without End* as a public or humanitarian venture allowed the filmmakers to pay their workers less. While film crews in Mexico were governed by union rules, Rotha was able to exempt his film from some of them (such as minimum technician numbers and overtime for some crew members) by explaining to the union the film's "official UN status."[47] Despite these concessions, which ultimately allowed him to finish the film under budget, Rotha repeatedly clashed with members of the film crew, including two who "gave false figures for their overtime," and most notably Lupe Mayer, his translator and guide, with whom Kline had put him in touch.[48] After initially noting that Mayer was efficient and well liked, Rotha began to complain that she "spent a lot of money on food, on tips for Indians to do things"; he later accused her of skimming money and fired her.[49] He also received advice from CREFAL film program director Hasselbach to pay his actors little to nothing, revealing practices that substantiated the indigenous authorities' complaints about CREFAL: "If you

cannot avoid it, pay your actors 5 pesos for half a day and 10 for a whole, but do not call it tips or salary, just say that to stimulate their interest, you can to [*sic*] reimburse what they lose by leaving their daily work. And *don't* pay them just for being shot; don't pay them unless they do a real job they wouldn't have done otherwise. . . . I am unreservedly delighted with the poor Mexicans and I'm sure you will get the cooperation you need."[50]

Rotha did not seem to notice that the politics of his film's production mirrored the nonredistributive politics of the film. He did note, however, that *World Without End*'s politics were significantly less radical than those of his earlier documentaries, in musings that were occasioned by a screening of his 1947 film *The World Is Rich* at CREFAL. After rewatching the film with the *World Without End* crew and "various people from Crefal," he wrote that the screening "made a deep impression, left them rather stunned. Seeing it again after a long time, I am amazed today that we were ever able to make it. How world events and public opinion have changed since then, in only five years. All the things we hoped for in that film, they have vanished."[51] Rotha thus recognized how the "great world plan" set out in *The World Is Rich*—a plan that would have entrusted the Food and Agriculture Organization (FAO) to manage global food production and storage in a way that would feed the world and "put politics and economics on the road to world prosperity and world peace"—had been destroyed and superseded by what Amalia Ribi Forclaz calls "a focus on short-term technical assistance" and an "increase of bureaucracy and expertocracy."[52] The Cold War development order let the rich off the hook and ignored the economic complexities of food distribution in order to tout increased capitalist production as the only solution to world hunger. Rotha's acknowledgment of his own capitulation to the anti-political logic of the 1950s both contrasts with the sweeping idealism of *World Without End* and explains why its beautiful landscapes visually undermine its own assertions that Pátzcuaro villagers must change their ways.

Rotha's awareness of the loss of a more redistributive internationalist economic vision went hand in hand with his disdain for rising American hegemony, as well as an anti-modern sentiment that crept into the film. While filming he wrote, "Fifty years ago, Pátzcuaro must've been wonderful. Today, it has not escaped its coca-cola signs, juke boxes and American streamlined taxis. The American way of life creeps and attacks

everywhere. Only Yunuén had no American advertisements, no juke box, to date."[53] Later he denounced an FAO representative as "one of those smooth-faced American types you can tell stink a mile off."[54] Rotha's anti-American and anti-modern sensibility dovetails with his repeated references to Flaherty; the film captures "untouched" Yunuén life not, as in *Forgotten Village*, to render it abject and dangerous, but rather, as in Flaherty's films, to preserve it against what Rotha worried was the encroaching crassness of American modernity.

While Rotha's anti-modern sentiments may have contributed to the sense that *World Without End* respected its subjects, he also, like his model Flaherty, approached those subjects with a racist gaze. Some of this racism was expressed affectionately, as when he wrote, "The little boys on the island are all my firm friends by now. They are like golliwogs, with their sticky-out black hair (filled with nits)," and "so bright and alert, with the most bewitching smiles."[55] Of the Yunuén, he wrote, "These Indians are mostly fishermen and are all extremely musical."[56] However, Rotha also readily attributed forgetfulness and duplicity to the race of his collaborators. "I now know that no Mexican, Tarascan Indian or what have you," he wrote, "remembers one thing from one day to the next. It doesn't matter how carefully you plan the shooting requirements for tomorrow, when tomorrow comes it is all forgotten."[57] (This racial attribution is contravened by evidence Rotha himself provides: he repeatedly accused his compatriot Shaw-Jones of "shocking forgetfulness" but did not racialize the accusations, and also wrote, "One person whom I exempt from all of this is Carlos, the cameraman, who I am sure is completely honest and a nice guy.")[58] Later when he was accusing Lupe of embezzlement, Rotha wrote: "[F]or all she is married to a New York Jew she is very Indian and Mexican just underneath the skin."[59] Rotha's repeated racist assertions suggest who the audience might be for the "one world" philosophy that *World Without End* attempted to propagate: the film's main goal seems to be to counter the racism that is presumed to be the viewer's baseline condition; the film is shot as if answering an unheard racist interlocutor, insisting both that some aspects of Purépecha culture are worth preserving and that human beings are interconnected.

World Without End, despite its lack of "strength" in promoting development, won acclaim at film festivals and influence as a documentary,

globally but also at CREFAL. Subsequent documentaries filmed at Pátz-cuaro, particularly those by professional filmmaker-instructors there, took up its visual and conceptual theme of the tensions between tradition and modernization.[60] As the 1950s wore on, however, CREFAL filmmakers found ways to resolve these tensions instead of presenting them visually to viewers. They would use two related intellectual arguments to maintain a sense that culture could be preserved in the face of modernizing inter-ventions. The first positioned Spanish colonization as the moment of in-digenous people's slide into stagnation, imagining precolonial indigenous civilizations in the Americas as embodiments of greatness and energy that might be reawakened and harnessed by development. The second imag-ined the entrepreneurial mass production and commodification of indig-enous art to be the ideal solution to the problem of how to both preserve and modernize indigenous culture.

A notable example of a film committed to both restoring and commodi-fying indigenous cultures is *Tzintzuntzan*, directed by Canadian publisher and journalist Lucien Parizeau and UNESCO filmmaker Francine Vande Wiele. The film celebrates the inhabitants of the eponymous community while showcasing a development program that allows them to improve their techniques for weaving and making ceramics. After leading viewers through an arduous yet beautiful day in the life of Tzintzuntzan residents, extolling their communitarian ethos while questioning the efficiency of their fishing and food preparation practices, the narrator asks, "[B]ut what is the new element that can modify the life of the community?" The answer turns out to be CREFAL experts, who believe they can make Tzintzuntzan's handicraft production more efficient. In a scene nearly identical to the one in which the doctor in *Forgotten Village* attempts to reach the suspicious villagers, the film shows the CREFAL representative walking through town attempting to impart his handicraft methods. The narrator claims, "He doesn't feel sad when many neighbors . . ." and then trails off, as we see three different house doors opening a crack, then shutting again into dark-ness. But where in *Forgotten Village* the door-closing scene is pivotal and serious, in *Tzintzuntzan* the narration is playful. "He knows some would have to be interested," the voice-over continues, cutting to a smiling white-haired man. "Here is an important villager, inclined to accept CREFAL's services. And then, since he has a lot of influence in town, not much time

passes before his fellow villagers follow his example." After this scene, other villagers spill out of their homes and follow the influential man down the street in a joyous, slightly silly parade.

The parade eventually dissolves into an assembly line of artisanal pots and weavings. The narrator explains that by partnering with the International Labor Organization to create modern weaving workshops, and with the state to give oil-burning kilns to the potters of Tzintzuntzan and two thousand other towns in Mexico, CREFAL has allowed the potters to rediscover the artistic qualities that characterized the ceramic output of their ancestors. As men work triumphantly, assembly-line style, making bricks, the narrator intones, "Nothing is impossible for men if, throwing off the weight of routine, they revive their cultural heritage, to find within it the admirable qualities of their race. . . . Tzintzuntzan is no longer the sleeping village of times past . . . the inhabitants have broken definitively with the isolation to explore the world of collective labor." Thus while the film reiterates the clichés of *Forgotten Village*—depicting the village as sleepy and isolated until "awakened" by experts, not allowing its subjects to speak on camera—the process of development feels slightly different. "Tarascan" cultural heritage is not eliminated at the end, but rather revived and subjected to the assembly line. These celebratory scenes in which the "culture" of the parade morphs into the assembly-line commodities are supported by the idea that this commodification draws on and even honors the indigenous past of Tzintzuntzan.

Parizeau and Vande Wiele's film demonstrates how films made at Pátzcuaro, as both pedagogical tools and narratives of a pedagogical process, spoke to multiple audiences. Parizeau himself touted the superiority of audiovisual educational tools, writing that "essentially, audiovisual education is the recognition of the fact that concrete experience, as opposed to symbolic experience through the use of words, is the foundation of knowledge."[61] However, if in theory Parizeau imagined films as synonymous with or representing "concrete experience," the trainees he taught at CREFAL had other ideas. Perhaps recognizing the Pátzcuaro indigenous communities' familiarity with, and interest in, various types of genre films, or perhaps simply making films that reflected their own preferences, student-teachers used tropes from horror and romance genres to construct a compelling impetus for literacy and development education.

CREFAL'S TRAINEES: INDIGENOUS KNOWLEDGE AND
THE PLEASURE OF SPECTATORSHIP

Despite film's widespread use in educational projects at CREFAL, some educators there doubted its utility in education. Colombian education specialist Gabriel Anzola Gómez wrote in his account of his experience teaching there, "It must be said that despite the zeal of the cinema service experts, the result [of CREFAL's film program] was very modest and its educational performance debatable."[62] He claimed that the films CREFAL borrowed from the Mexican state did not interest the local peasants in the area because the films "demanded a higher level of comprehension on their part," and noted that he was not impressed with the capacity of the CREFAL student teachers to introduce and explicate the educational films sufficiently. He noted that commercial films, though lacking educational value, "constitute[d] a center of interest."[63]

Much of the doubt about indigenous people's ability to understand film was inherited by UNESCO from the colonial film projects on which many of its founding members had worked. In Julian Huxley's sojourn showing films to Africans, he had noted the "childlike delight" of his audiences (who in this case were actual children), but had also observed his audiences' ability, despite some of them having no film viewing experience, to grasp "difficult subjects, such as speeded-up films."[64] But as Rice writes, Huxley was "whistling in the wind"; already deeply ingrained in British colonial filmmaking was the idea that indigenous people, and particularly Africans, simply could not understand film language and thus could not follow sophisticated cuts and rapid action or understand unfamiliar scenes and close-ups. UNESCO's 1949 guide *The Use of Mobile Cinema and Radio Vans in Fundamental Education* reiterates this conventional wisdom, sharing advice from a UNESCO official in the Belgian Congo: "The best programme for illiterate audiences should be made up of films with a simple script, the running time of which does not exceed thirty minutes, and which do not require of the audience much concentrated attention."[65]

The most ostensibly damning indictment of indigenous people's comprehension in the *Mobile Cinema Vans* book is the story of a failed screening in the Americas, to which an appendix of the book is devoted. The

failed film was Willard Van Dyke and Ben Maddow's 1943 short film *The Silent War*, shown to "an audience of about a hundred illiterate Mexican Indians"; the book explains that "the audience was utterly impervious to what appeared in Western eyes to be an excellent film." The problem, as the description acknowledges, was that the beginning of the film depicted a rapid military deployment, with troops amassing across land and water, traversing jungles and mountains with guns at the ready. Massive troop invasions, common features of American wartime films, became confusing and even scary when shown to an indigenous community that was not experiencing war. UNESCO's conclusions, however, were sweeping and did not point to the general fear that might be inspired by a film that opened on scenes of armies rapidly advancing from all sides. Instead, UNESCO claimed that "the idiomatic technique and rapid episode changes of western 'documentaries' are unsuited to unsophisticated minds. It remains for applied research to discover how quickly such minds will attune themselves to the new idiom, or whether it is essential for all films designed for such audiences to be made in a slower tempo for a long time to come."[66]

While evidence from other CREFAL screenings suggests that UNESCO and Anzola, like many in the Colonial Film Unit, underestimated the viewing comprehension of local audiences, Anzola nonetheless points to a difficulty encountered by CREFAL staff: the benefits of educational films were not always clear, while the entertainment value of narrative films was undeniable. Students at CREFAL, who were mostly young educators from all around Latin America, noted the Pátzcuaro communities' enjoyment of cinema: films, whatever their subject, drew a crowd, and technical complexity did not seem to be a barrier to enjoyment. If they were aware of UNESCO's general advice about the inability of "Indians" to grasp "idiomatic technique," the student filmmakers at CREFAL seem to have disregarded it. In response to their sense of the communities' enjoyment of cinema, students at CREFAL crafted films of their own that drew on audiences' experiences of and pleasure in fictional genre films, using tropes from horror and romance to make the case for education as a worthwhile pursuit. They also evaluated and adapted educational films from around the world, generally pushing back against a framework that emphasized indigenous communities' "cultural level" to consider instead the usefulness of the film given audiences' life experiences.

El primer paso (*The First Step*), a collaborative project by five students during a short course in filmmaking with Parizeau in the summer of 1957 (Vande Wiele also spent a week helping with the editing), exemplifies CREFAL students' play with genre in the service of educational aims.[67] The film begins as a horror film of classroom humiliation. Indigenous twentysomething adult protagonist Luis enters a terrifying, cavelike classroom, accompanied by ominous, discordant music. He attempts, haltingly, to write on the board as his teacher and various business-suited men gleefully, terrifyingly, mock him. The music continues to screech along as the camera cuts from terrified Luis, still attempting to move the chalk across the board, to the mocking men's open mouths, their ominous laughter suddenly synced. The teacher gestures at him, seemingly banishing him from the classroom, and he retreats, hands raised, into the dark, as cries of "stupid!" fill the air. The men's laughing mouths return, and the screen begins to distort; the camera cuts faster and faster between the mouths as they pronounce vowel sounds, depicting the horror of language's overwhelming complexity and variation. Luis, shaking, clasps his head in his hands, and the film suddenly cuts to a well-lit scene of him sitting on a bench, his head similarly in his hands. A well-dressed man, presumably his teacher, clasps his shoulder, saying, "Hello Luis. *This* is reality." He takes Luis's arm and leads him toward the schoolroom door, assuring him that "no one laughs at you, Luis, not your friends, nor your neighbors, nor your teacher."

The second half of the film takes the form of a romance. In the class, Luis and the camera immediately notice fellow adult learner Lupe, sitting beside him. Over swelling, melodic music, their mutual affection grows: they watch each other answer questions at the board, laugh at the lighthearted lessons, and hold up the same letter at the same time; the camera cuts between them as they look at each other tentatively. The film closes on Lupe and Luis lingering too long in the classroom; the teacher has to remind them that the class is over. As they gather up their things, Luis unfurls a slip of paper that reads "me ama?" ("do you love me?") and Lupe smiles: the literacy classroom, it turns out, is not a space of horror but a venue and avenue for love.

Parizeau was impressed with the film, and CREFAL continued to show it in its classes. "The First Step, as a combined training and production

Figure 12. Horror aesthetics, *El primer paso* (dir. CREFAL trainees under the supervision of Parizeau, 1957)

Figure 13. Romance in literacy class, *El primer paso* (dir. CREFAL trainees under the supervision of Parizeau, 1957)

venture," Parizeau explained, "proved invaluable in bringing home to the students the complexities of filmmaking and in stressing the patience and skill which sub-standard production require[s] at every step."[68] Parizeau noted that two of the Latin American educators who had worked on *El primer paso* "had already turned out films for government agencies in their own countries" but "did not suspect that 16mm films are more difficult to produce than 35mm films of comparable scope and quality." While Parizeau stressed that the student-teachers had "acquired a sum of practical knowledge" from both their theoretical classes and especially the trial-and-error process of filming scenes, he concluded that "the production of films with beginners and novice filmmakers is an onerous task which, in our opinion, should not be attempted again in short-course training."[69] Parizeau's account, and his caution against film production with beginners, suggests that even when UNESCO centers set for themselves what seemed like the modest goal of training teachers in the production of audiovisual materials for development, they struggled to have the time and resources to meet this goal.

Another CREFAL film, *La decisión de José*, the thesis project of Ecuadorean student Enrique Betancourt, also demonstrates the conflicted ambitions of the fundamental education project, while experimenting with tactics for making literacy appealing. *La decisión de José* adopts the

structure of other development docudramas in which a character played by an amateur actor acts out a fictional scenario as an authoritative voice narrates his story; like *Forgotten Village*, it tells the story of a character being inaugurated into modernity without ever speaking. José is a timid farmer living in a small village, a good man who like his fellow villagers desires progress and a better life. He would like a loan from the bank to buy new farm equipment, but he cannot read, and literacy is a requirement for the loan. José, knowing that "it's never too late to learn," decides to learn to read, finds a CREFAL teacher, and begins taking lessons. After working very hard at his lessons (according to the voice-over, though the film rushes through the lessons without depicting them as particularly arduous), José learns to read. He then obtains a loan, fertilizers, and insecticides; he reads books and, taking the books' advice, begins raising chickens; he also starts reading the newspaper and learning about what is happening throughout Mexico. "Little by little, José's life changes," the narrator reports. These changes are represented visually by shots that became the standard vocabulary of the development film in the following years: triumphant sprays of DDT and Jose's anticipatory, upturned face.

La decisión de José, however, diverges from the melodramatic formulas of other development films. As a man laden with baskets walks into the frame, the voice-over introduces the town of San Pedro, describing it as a "small, calm, peaceful place, with hardworking sons and a desire for progress" and thus indicating that this will not be a conversion story from stagnant, superstitious, underdevelopment to forward-looking development. For his part, José is "a good man," hardworking and curious from the beginning; superstition, tradition, and lethargy are not factors keeping him from literacy, technology, or national consciousness. Despite its title, then, the film does not depict an existential choice between past and future orientations; rather, José hears about opportunities and avails himself of them. The reading lessons, depicted as "two friends" working together in an idyllic outdoor setting, represent the realization of a dream rather than a painful sacrifice or a brave leap into the unknown. Non-narrative films by CREFAL students seem equally uninvested in denigrating indigenous life: *Eres libre* (*You are Free*), a short film by Guatemalan trainee Jorge Ramiro Girón, features a voice-over reciting points of the UN's Universal Declaration of Human Rights over scenes of indigenous people exercising those rights.

While CREFAL student teachers made more films of their own, they adapted many more films from outside agencies, adapting many Puerto Rican DIVEDCO films in particular, as well as films from the United States, Canada, Bolivia, and around the world. When CREFAL teacher trainees evaluated and adapted films, they did not generally evaluate the level of sophistieation of the film's techniques, perhaps because they themselves were not professional filmmakers. Instead, they evaluated the audience's capacity for understanding based on whether the themes of the film were likely to speak to its experience. For example, Central American trainees worried that a US film about an agricultural fair would not resonate with the people in their countries; landless peasants, they asserted, would not have the opportunity to present livestock to a state fair for judgment and awards. They also vetoed a film that recommended regular trips to the dentist, again worrying that viewers would not have the resources to comply with the film's imperative.[70]

When staffers' evaluations of the films were positive, filmmaking teams showed them to local communities, making changes to the films before further exhibition.[71] In contextualizing the screenings as well as adapting them, CREFAL emphasized the "importance of two-way traffic between the materials-production centre on the one hand, and the village community on the other."[72] In practice, this meant that instructional films underwent significant adaptation as educators attempted to modernize local populations. CREFAL's commentary for *The King's X*, a short American film about credit unions, adds an introduction to the film that did not exist in the original—"This is a film about a very common problem"—and then contextualizes the opening scene in seventeenth-century London. When the film moves to the present day, rather than directly translating the dialogue on which the film opens, the narrator instead describes the state of mind of the protagonist. CREFAL commentators thus often not only added context and information to films produced elsewhere but also freely reframed the situation ("this is a common problem") in a way they thought would speak to their audiences.

In a 1953 program of weekly screenings, one of CREFAL's trainees, J. Ernesto Rosales Urbino, showed three films, two USIA films made in Puerto Rico and one English film. For one of the Puerto Rican films, *Desde las nubes (From the Clouds)*, despite its production by the similarly

education-oriented DIVEDCO (discussed in chapter 2), CREFAL's film section wrote a script adapted to local farmers; Rosales noted that the new narration "perfectly fit the film."[73] Rosales reported that the attendees were local farmers, *mestizos* who spoke good Spanish, with "medium cultural preparation" and "good maturity of perception." According to Rosales, the farmers were very enthusiastic about the films, and between fifty and eighty-five "farmers" came, in addition to "women and children," who also attended in great numbers; he also noted that the men in these audiences outnumbered the fifty-six *ejiditarios* who lived in the community, suggesting that community members had brought their sons and other relatives who lived elsewhere. He observed that despite the agricultural content of the films, the women and children "conducted themselves very sensibly." Rosales prefaced the films with a motivational speech and stopped them at important moments to emphasize the connection between the audience's problems and the solutions depicted. He wrote that a farmer in one screening said, "We too can do this, we just have to overcome our laziness, but if we make an effort, we'll have a better life!" Each screening was followed by a more extensive discussion, in which Rosales collected the farmers' impressions. He noted that the screenings had made the farmers enthusiastic about using herbicides, and that they would begin using new fertilizer in order to plant wheat and then rice in the plots where corn was now growing. He concluded that "presenting films with a well-designed, well-executed program can put farmers in the mood to think hard and act to improve their economic conditions through new modes of labor. If it doesn't require great sacrifice, they can be motivated to do it."[74]

The principles of modernization and development Rosales relied on in his report seem familiar: the ranking of the community's "maturity of perception" and the emphasis on motivation, accepting change, working harder, and technological fixes like herbicides. However, the care with which the screening was planned suggests an attentiveness to local conditions that is lost in the universalizing propositions of modernization theory, as well as later imaginings of development workers as interchangeable embodiments of modern values. Furthermore, Rosales's sunny platitudes about motivation were qualified by his caution about sacrifice, which was at odds with the formulations of US modernization theorists, who imagined that rapid development, although necessary, would exact a

high price from "traditional" communities. The experiences of the adaptation and screenings by CREFAL educators suggest a more interactive, locally situated, and listening-focused mode for development than that which the United States and international organizations would pursue in the following decades.

Florita Botts, a photographer from the United States whose work at CREFAL led her to become a photographer for the United Nations, serves as an exceptional case that proves the rule; her attempts to resist the film-screening orthodoxy at CREFAL help to make clear what that orthodoxy was. In her twenties, Botts worked as a book editor in New York, then traveled to Mexico to volunteer for the American Friends Service Committee. In the early 1950s she ended up at CREFAL, later recalling that it was a place where "I felt I could use my background in literature and art."[75] Botts reports that the communities "were familiar with gangster films and westerns," but that she "wanted to show great films" in the communities, particularly after returning from an inspiring trip to Puerto Rico, where she witnessed the "truly creative production of films" by DIVEDCO. Upon her return, Botts arranged a screening of Luis Buñuel's Mexico City crime drama *Los olvidados*. She recalls proudly her experience of the screening, that the "whole village came to the showing, and they were deeply moved. They understood the message immediately and our discussion went right to the heart of the film." The experience confirmed Botts's belief "that you can use with rural people what we might call a work of art. It can be used with a guide and with proper presentation to let people know that the experience they are going to have will be educational and not entertainment; that this film is being shown for a reason."[76]

It is this sharp distinction between "education," "art," and "entertainment" that separates Botts's outlook from that of the other CREFAL trainee filmmakers and teachers, who attempted to merge these categories in the films they made and screened. This use of popular genres to make development narratives appealing reached its apogee in Bolivia in 1958 with Jorge Ruiz's full-length development romance *La vertiente* (*The Spring*), which successfully stitched together a love plot patterned on Mexican Golden Age melodramas with an extended documentary sequence of joyful collective labor. Though Ruiz's many other films do not feature fully elaborated melodramas, they do attempt to merge these three

purposes, combining educational films that might model change for "underdeveloped" audiences, lively engagements with melodrama and other genres that might simultaneously entertain these audiences, and sensitively filmed documentary accounts of these modernization projects for other viewers.

CONCLUSION: THE END OF FUNDAMENTAL EDUCATION

Despite international interest in the fundamental education model proposed by international experts and worked out by CREFAL's teachers and students, by the early 1960s the carefully built fundamental education model and practice at Pátzcuaro was in decline. UNESCO abandoned the idea of fundamental education in 1958, arguing that the term "led to confusion."[77] In response, CREFAL began to reorient itself around the new buzzword *community development*. This meant the end of CREFAL's commitment to training documentary filmmakers, as well as the slow decline of its attempt to place documentary and educational practice at the center of its development efforts. The demise of these efforts was hastened by UNESCO's 1961 decision to cut CREFAL's budget; artists there continued to experiment with filmmaking throughout the early 1960s, but many did not have the resources to finish their films.[78] The early 1960s was also the moment of both US escalation of development programming and a change in USIA's filmmaking strategies, which meant that the US agency took on much of the work of selling development to the world. The documentaries made at USIA were clearly influenced by CREFAL: in the 1950s USIA had looked to CREFAL for inspiration, asking for materials and producing publications about their process for creating development media, and some of the scenes (of triumphant education, of luxuriant DDT spray) worked out at CREFAL made their way into the USIA documentaries of the 1960s.[79]

At the same time, the USIA development films of the 1960s, and even the Bolivian films of the 1950s, imagined intensive development projects only hinted at by CREFAL. Perhaps because they were implicitly informed by the impending demise of the colonial world, CREFAL films sometimes strayed into imagining a generalized freedom not defined by the strict tenets

of development. The resulting films were successful both at making a visual argument about the similarity of "villages" the world over and at putting intimate scenes of person-to-person education of indigenous people (where the content mattered less than who was doing the educating) at the center of the vision and project of development. However, films like *World Without End* and *Tzintzuntzan* could not, and did not, depict the development era as one of dramatic transformation, in which education would lead to full integration into capitalism. CREFAL's films were meant to make both the British colonial role in managing the decline of its empire and UNESCO's role in educating the world seem more deliberate and perhaps a bit more transformative than they were. But aside from the ubiquity of DDT and the half-hearted proposal of entrepreneurial schemes, CREFAL films did not envision that traditional peoples would inhabit significantly different worlds than they had before. As previously hinted, it would take the liberal-revolutionary society of Bolivia after 1952 to produce more aggressive and complete visions of development, with films that depicted their subjects moving from poverty, isolation, and debility into education, democracy, and man-machine harmony.

4 Perfecting the Development Film Form in Revolutionary Bolivia

In the aftermath of the 1952 Bolivian National Revolution, in which an alliance of workers, indigenous peasants, and the urban middle class wrested power from the landed oligarchy and tin barons who had controlled the country's resources, Revolutionary Nationalist Movement (MNR) leader Victor Paz Estenssoro returned to Bolivia to claim the presidency, to which he had been elected in a landslide from exile the previous year. The day after he arrived in La Paz, even as fighting persisted in some neighborhoods of the city, he agreed to sit down for an interview in English, to be sent to NBC, with three of Bolivia's prominent young filmmakers: Jorge Ruiz, Augusto Roca, and Gonzalo Sánchez de Lozada (nicknamed "Goni"). President Paz spoke little English, so Goni, whose father was Paz's friend and political comrade, sent for a chalkboard and used it to coach the new president in the pronunciation of English words. "There was the president of the country and leader of one of the most important social revolutions in Latin America," Ruiz later recalled in an interview, "and Goni was treating him like a student." Ruiz notes that the "interview was very successful," and that "the success benefited President Paz Estenssoro because he explained in the interview, which was written by Goni, that it was not a communist revolution, that it was a nationalist revolution."[1]

This story of the "successful" English-language interview scripted by young Bolivian filmmakers that allayed the fears of the US Cold War empire even as fighting still raged in the streets indicates how much Bolivia's national revolution was, from its start, mediated (both tempered and filtered) for the United States. If there was always tension within the Bolivian revolution between what James Malloy calls the "pragmatic nationalist center" of the MNR, the young professional-class men who made revolution reluctantly and on procedural grounds because the country's three tin barons kept overthrowing their democratically elected governments, and the workers and indigenous peasants who pushed for a dramatic reorganization of Bolivian society, this tension was exacerbated by the imperative to perform the revolution, from its beginnings and in English, as moderate and innocuous.[2] The story also demonstrates the importance of film, dating from the revolution's early moments, to both the Bolivian national project and a more global project, led by the United States, of envisioning a path toward capitalist modernization for the Third World. Indeed, along with the partial nationalization of resources and a land reform program, Paz's government in 1953 founded the Bolivian Film Institute (ICB), which enabled domestic film production for the first time. This intertwining of cinema and national revolution in Bolivia is well known to scholars: film historian Carlos Mesa writes that the country's filmmaking tradition, including the radical films by the Ukamau Group that would become globally recognized in the late 1960s, is "not explicable without understanding the meaning of 1952 in the political, social and economic spheres as well as in what we can say today was the opening of a new cultural route that has expanded and enriched our perspectives."[3] Mesa would come to have firsthand knowledge of Bolivia's political sphere: he himself became Bolivia's president from 2003 to 2005 after serving as vice president to none other than Goni, the former filmmaker who had coached Paz through his 1952 interview. Both were ousted by popular uprisings.[4]

This intimacy of Bolivian filmmakers and film critics alike with the country's national political scene was a question of both class and scale: an uncommonly small *mestizo* middle class, even after the partial leveling brought about by the revolution, both constituted the new government and shaped the nation's fledgling culture industries. But it also indicates the power of filmmakers, perhaps as much as presidents, to tame the

liberatory aspirations of Bolivian indigenous and working-class peoples. In the early days of Bolivia's revolution, some officials in the labor-left faction of the revolutionary MNR party compared their country hopefully to Iran and Guatemala, citing approvingly the expropriation of resources by the leftist governments in those countries.[5] However, the tide soon turned: in 1953 and 1954 the increasingly bold Central Intelligence Agency (CIA) led ousters of those leftist governments, which served as warnings against other redistributive projects in the global South, and the more moderate faction of the MNR gained power in Bolivia's government. This faction, continuing the work of Paz in his Goni-scripted interview, was most concerned with moderating the revolution's aims—curbing miners' labor militancy and indigenous peoples' demands for land after their temporary alignment with these groups during the revolution—and assuring the US government of this moderation. These assurances secured Bolivia the highest level of per capita US development aid on the continent in the period between 1954 and 1963, as well as an extremely high concentration of foreign development workers, such that Bolivia was routinely labeled a showcase for Cold War development.[6] This showcasing happened in part through the ICB's films, which were almost entirely devoted to dramatizing development plans and projects.

Scholarly accounts of the films of revolutionary Bolivia have often argued that they played a role in forging national unity. This can be seen, these accounts argue, in their triumphant modernization tales and their allegorical unification of the western highlands, characterized by the US and MNR governments alike as "overcrowded" and rife with political tensions, with the tropical eastern lowlands imagined as empty spaces whose "colonization" might create national unity and build Bolivians' pioneer spirit. Scholars thus generally read these films as twentieth-century versions of the cross-regional romances Doris Sommer theorizes as constituting the national-allegorical "foundational fictions" of Latin American nineteenth-century literature.[7] While multiple 1950s Bolivian films do stage romances that bridge the country's geographical divides, this chapter departs from these scholarly interpretations, emphasizing instead how half-heartedly the ICB's films participate in the project of national consolidation and political subject formation. In stark contrast to the films that emerged in the wake of the earlier Mexican and Russian Revolutions or

the subsequent Cuban Revolution, and in contrast with other government publications whose circulation was exclusively domestic, the ICB films of Bolivia's early revolutionary years make no explicit reference to the revolution and contain little in the way of crowds, flags, newspapers, pageantry, or other national symbols; the national symbols and civic rituals the films do depict are disrupted and undermined by the narrative action.[8] If Bolivia's film traditions are impossible to imagine without the national revolution, the national revolution all but disappears from its official revolutionary films, which turn away from the project of national subject formation in favor of picturing generic, abject underdevelopment, melodramatic awakening, joyous self-help, and natural resource extraction, visions that could be easily exported in the Cold War era.

This chapter charts how Bolivia's national-revolutionary films, like Paz in the scripted 1952 press conference, attempted to depoliticize Bolivia's revolutionary subjects. I posit that these films' retreats from more clearly political spaces and national rituals are intertwined with the imperatives of the modernization era, in which class and anti-colonial grievances must be reframed as technical problems. Through their attempts to temper the militant nationalism of the revolutionary years, Bolivian filmmakers created iconic development films. ICB films drew on the energy of Bolivia's revolution, particularly the insurgent potential of its indigenous and mineworker base, while simultaneously containing and redirecting that potential into self-help projects. These films visually and narratively foreclose projects of national subject formation and social solidarity, substituting instead joyous depictions of the willing and uncompensated work speedup that, along with the destruction of indigenous lifeways, constituted the core imperative of development. In this way, ICB films came to illustrate perfectly the schematic modernization theory that was simultaneously being created in the think tanks and universities of the global North.

To explain the cinematic crafting of this visual and narrative vocabulary of development, this chapter reconsiders the biographies of the founding protagonists of Bolivia's revolutionary film institute. Attending to but also looking beyond the central, virtuosic figure of Jorge Ruiz, it chronicles how a cohort of *mestizo* elite men with extraordinarily close ties to Bolivia's post-1952 national government together consolidated a vision of development as a top-down endeavor that would transform Bolivia's people,

turning their attention away from political engagement and toward participation in a nationally and internationally integrated capitalist economy. These filmmakers were able to channel the energy of Bolivia's 1952 revolution into formulaic development narratives by melding together an array of existing transnational genres and forms: they drew on ethnography, industrial film, workerist documentary, and melodrama in order to produce archetypal visions of development. This chapter traces the ICB filmmakers' artistic and scholarly influences, as it was the fusing of international forms and influences that allowed these filmmakers to view their own national scene as one of generic underdevelopment that could be remedied by technological fixes. This anti-political vision of development made Bolivian films of the ICB era exportable, allowing Bolivian filmmakers to aid in a variety of modernization projects in the Americas, from advertising the expansion of the Ecuadorian police, to touting colonization projects for Guatemala's right-wing government, to documenting modernization test projects in Peru, to developing internationally renowned theories of development communications.[9]

The project of post-1952 Bolivian cinema can be divided into three eras: the ethnographic era, in which films by Bolivia's preeminent filmmakers adopt an anthropological gaze in order to circumscribe indigenous participation in the national modernizing project; the melodramatic era, in which these same filmmakers repurpose sentimental scenarios from Mexican and New Deal feature melodramas in order to imagine compelling rationales for community self-help in the face of a contracting welfare state; and the postmelodramatic era, during which rationales for development disappear, replaced by a cinematic shorthand that positions development as a recursively framed end-in-itself but also a safety-valve solution for the political conflict that had by then engulfed the state. The archetypal films in each of these eras contain a hinge point, a moment when the central characters turn away from nationalist demands and rituals and toward economically productive labor. These films thus dramatize how development visually reordered the world in the decolonization era, as they experiment with narratives and images that might convince the masses that development rather than land seizure and anti-imperialist nation building looked like freedom. But development looks different in each of these eras: in the mid-1950s, ICB filmmakers advance a vision that

locates both indigenous peoples and highland miners in the past in favor of industrialization in the bountiful lowlands; after 1956, development looks like community self-help and further colonization of the lowlands with assistance primarily from the newly empowered military rather than the pared-back welfare state; and by the early 1960s, the ideal of community self-help has faded to make way for more hierarchical visions of lone "colonizers" being guided by military leaders and teachers.

The three phases of Bolivian development cinema are characterized by an evolving understanding of development as a gendered project. While test audiences complained that the USIA films of the 1950s lacked "feminine appeal," ICB films of the same decade featured prominent women characters. These films support Silvia Rivera Cusicanqui's argument that "women and Indians" served a crucial yet ornamental function for the revolutionary Bolivian state. In early 1950s films, indigenous women and girls serve as emblems of stalwart tradition, while *mestizas* in the films of the later 1950s are positioned equally ornamentally, as prizes for those who venture out to develop the eastern lowlands or as beautiful, suffering catalysts who spur sluggish communities to undertake self-help ventures. In the ICB development films of the early 1960s, women disappear entirely, written out as development imperatives and visions became more and more ubiquitous. During a time of increasing conflict between miners and the government in reaction to brutal US-imposed austerity measures, these early 1960s films imagine a harmonious and hierarchical world of men and machines that might liberate the nation from political conflict.

Understanding the cultural work of these films that fall somewhere between documentary, entertainment, and propaganda means keeping multiple audiences in mind: international audiences, often made up of university students and development workers, and local audiences in cinemas across Bolivia, where screening ICB films was mandated. As Jeffrey Himpele notes, the ICB years were "the only period in which Bolivian filmmakers were well funded and continuously occupied as the gears of the state and cinema fully enmeshed."[10] This included the construction of cinemas: by 1954, the ICB counted 146 cinemas in the country, with many in small towns and 18 in mining areas.[11] Development films were also screened in plazas and parks in city centers, so even theatrical distribution numbers underestimate the possible viewers of any one film.[12]

However, late arrivals seem to have been fairly common in Bolivian cinemas, suggesting that viewers regularly skipped over the development film and appeared only just in time for the feature.[13] If these ICB films imagined a modern future for Bolivians, they, like so many other development films, seem to have worked best, or at least most straightforwardly, on technicians and others outside Bolivia.

VUELVE SEBASTIANA AND THE PREVENTION OF INDIGENOUS SOLIDARITY

In order to craft development films, Ruiz and his collaborators drew on the cultural energy of Bolivia's indigenous rural communities. However, theirs was a selective form of affirmation: Ruiz and company's films celebrated an allegedly timeless indigenous culture but also excluded it from the processes of national consolidation taking place during and after the revolution. The first issue of the ICB's short-lived film magazine *Wara Wara* clearly articulates this relationship to indigeneity. The 1954 editorial by founding ICB director Waldo Cerruto, brother-in-law of President Paz Estenssoro, thanks Paz for "helping us realize a great dream: of our cinema, piercing the skies with its objective message of the new Bolivian reality, and of the new national cinema as a living force, fermented in the Indian entrails of the young heart of America."[14] This tortured metaphor implies a teleology for revolutionary Bolivia: the dream of an "objective message" demonstrates the prominence of a developmentalist and documentary approach, but one that relies on a "living force" that comes from Bolivia's "Indian entrails." Indigenous Bolivians, necessary to make the country's cinema a "living force," must also be relegated to the role of incubators and their forms of social organization eradicated to make way for the "objective" future the films will imagine.

Even before the founding of the ICB, cinema had become an important arena for *mestizo* middle-class Bolivians, with US support and guidance, to work out the proper relationship between the new national culture they were attempting to create and the indigenous peoples who constituted the majority of the country. Ruiz recalls in his memoir that in the late 1940s he and Roca made a few ten-minute 8 mm films and

showed them to Kenneth Wasson, a US embassy functionary who in 1947 founded Bolivia's first film production company, Bolivia Films. Ruiz, in his characteristically flowery style, describes Wasson as having "the enormous hands of a prosperous farmer, and his gaze was always suspended in astonishment, like a cowboy ripped from the desert."[15] Wasson, aghast at the low-quality materials Ruiz and Roca were using, gave them a 16 mm Bolex camera and "a few little rolls of celluloid."[16] Ruiz and Roca then began traveling to indigenous community festivals and filming them; Ruiz recalled that they fancied themselves "disciples of Robert Flaherty and John Grierson in Andean lands."[17] While many scholars have noted Ruiz's citation of Grierson as an influence, his reference to Robert Flaherty is revealing here; Ruiz and Roca seem to have absorbed the Flahertys' drive to cinematically preserve cultures that they imagined were imminently threatened by the inexorable advance of civilization.[18] With these goals in mind Wasson soon set up a laboratory, and Ruiz and Roca produced Bolivia's first sound film, *Virgen india*, which they successfully screened at La Paz's Tesla Theater.[19]

With Wasson's supervision and sponsorship, Ruiz and Roca made films throughout the late 1940s and early 1950s about highland indigenous populations; Goni joined them at Bolivia Films in 1951 before setting up his own film company, Telecine, in 1954.[20] These prerevolution ethnographic films take an ambivalent stance toward indigenous peoples and lifeways, using an authoritative ethnographic style to both reckon with and circumscribe the coevalness of Bolivia's indigenous communities. The ten-minute 1948 film *Donde nació un imperio* (*Where an Empire Was Born*) looks back nostalgically to the Incas' greatness but also celebrates the "agricultural wisdom" passed down to their descendant community on storied Isla del Sol; the camera pans over the lush terraced farmland on the island, giving every indication that the community is thriving. The 1951 film *Los Urus* likewise vacillates between a sense that the Urus are disappearing and a sense that they are flourishing. Ruiz recalls that Wasson, having learned about the Urus from his friend, French anthropologist Jean Vellard, asked him, "Why don't we go film them, before those five men (in the Uru tribe) are lost to us forever?," notably including Ruiz among the spectator/collectors to whom indigenous Bolivians would be lost.[21]

The landmark 1953 documentary (Ruiz calls it a "docu-fiction") *Vuelve Sebastiana* (*Come Back Sebastiana*), the first Bolivian film to win awards at international film festivals, both established Jorge Ruiz as a nationally and internationally renowned documentary artist and initiated his transition from ethnographic to development filmmaking.[22] *Vuelve Sebastiana* garnered international acclaim throughout the 1950s, including the praise of preeminent documentary filmmaker John Grierson, who pronounced Ruiz one of the six most important documentary filmmakers in the world.[23] While the filming and subsequent scripting of *Vuelve Sebastiana* predate the ICB's founding, *Vuelve Sebastiana*'s success made Ruiz the obvious choice to succeed Cerruto as head of the institute in 1956, allowing him and his like-minded cohort to set the ICB's agenda. Although it ostensibly tells a simple story of highland Chipaya ten-year-old Sebastiana's journey away from her village and back, Vuelve Sebastiana also clears the way for the development stories on which the ICB would subsequently concentrate.

Vuelve Sebastiana's script was written by Luis Ramiro Beltrán, who in 1953 was a young journalist. Beltrán recalls in his memoir that he was coaxed by Goni and Ruiz into becoming a screenwriter over the course of their regular chats in a café in central La Paz.[24] Yielding to their entreaties would change the course of Beltrán's life: he studied filmmaking and educational film-screening techniques in Puerto Rico with various filmmakers in their community education division (discussed in chapter 2), went on to study agricultural development and audiovisual media at multiple mainland US universities, then returned to work on several more development films.[25] Beltrán, in fact, would devote the rest of his life to the scholarly field of development communication, becoming well known by the 1970s.

Beltrán wrote Sebastiana's story at a significant remove from her community. Despite having grown up quite close to the territory of the Chipayas in the city of Oruro, Beltrán had not set foot in Chipaya territory when he wrote the script; instead, he read the works of anthropologist Vellard and his mentor Alfred Métraux to understand the Chipayas.[26] Métraux's account of Chipaya life was decades old by 1953, and its mix of mythic pronouncements about the Chipaya with revelations of his personal distaste for them lent it the tone of an archaic travelogue. He opines that "the man who inhabits this strange and almost unreal environment,

at the center of this wild, magnificent, and extravagant universe, inspires more revulsion and antipathy than piety. The Chipayas are devoid of almost everything that confers dignity on man."[27] Beltrán based the film's story not just on his newfound anthropological knowledge but also more directly on a story from the Chipaya community, yet the opinionated anthropological perspectives he absorbed from Métraux and Vellard inflect the film, particularly its distinctive voice-over.[28]

In the film Sebastiana, a shepherd girl from an isolated and deprived Chipaya highland community, wanders away from her village and befriends Jesús, a child and fellow shepherd from a wealthier Aymara community nearby; Jesús shares his food with Sebastiana and invites her to visit the market in his village. The camera registers Sebastiana's delight and wonder at her adventure, with close-ups luxuriating in her budding friendship with Jesús and the delicious food they eat together, until her grandfather abruptly appears at the market and commands her to return home with him. At the moment of Sebastiana's parting from Jesús, the voice-over abruptly assumes a hectoring tone, reminding her of the many customs and traditions in the Chipaya world. At this point the film moves into flashback, demonstrating beautifully, though not quite as comprehensively as in *Los Urus*, the Chipaya techniques for house building, hair braiding, quinoa growing, and other specific labors. The voice-over urges Sebastiana to remember the better days the Chipayas have seen, exhorting her again to return to her community. She reluctantly agrees, but on the way home her grandfather dies, seemingly to punish her for her joyful outing. The last scene is at the funeral, where the voice-over again addresses Sebastiana, pronouncing, "Your suffering has made you a woman."

With its shifting, opinionated voice-over and attempt to dramatize relations between highland indigenous groups, *Vuelve Sebastiana* is complex and humane compared with many ethnographic and early development films. The film does not force its indigenous subjects to reenact long-abandoned practices, as the Flahertys' ethnographic films and Steinbeck and Kline's *Forgotten Village* do, and some scholars understand *Vuelve Sebastiana*'s sensitivity to difference among indigenous groups as a realistic and progressive element of the film.[29] But the film's timing makes it disjunctive: *Vuelve Sebastiana* was filmed over the course of 1953, during the immediate aftermath of Bolivia's national revolution, at a time when

Figure 14. Sebastiana and Jesús, *Vuelve Sebastiana* (dir. Ruiz, 1953)

indigenous rural Bolivians were forcing the government through both vi-
olence and legal petitions to carry out and extend the land reform it had
promised.[30] The bourgeois MNR government responded with a program
of limited land reform, but also one of indigenous assimilation through
development: indigenous Bolivians could express themselves democrat-
ically, but through new MNR-formed peasant unions rather than their
existing forms of social organization, and were more generally pushed
to abandon their ways of life and integrate into the modernizing state.[31]
The idea of a nation controlled by its majority indigenous population,
which had seemed possible in the lead-up to and during the revolution,
was countered by the *mestizo* minority's insistence on developmentalist
assimilation into their liberal-capitalist social systems. The government
also attempted to break up politicized indigenous and mining areas by en-
couraging those highland groups to "colonize" the eastern lowlands. The
focus of these assimilationist efforts was mainly on the Aymara and Que-
chua highland populations, which made up by far the largest indigenous
groups in the country.

Read against this backdrop, *Vuelve Sebastiana*'s thwarted-friendship
narrative—its sensitive depiction of the budding friendship between

Chipaya and Aymara children, followed by its sharp interruption by the commanding narrator—works allegorically to curtail the possibilities, forged in the indigenous congresses and then the prisons of the 1940s leading up to the revolution, of flattening Bolivia's racial and social hierarchies and even of creating a nation made up of indigenous collectivities or nations.[32] The abrupt interruption of the slow, tentative construction of solidarity (the sharing of food and space, the building of trust) between Sebastiana and Jesús ostentatiously forecloses the project of Bolivian indigenous solidarity in favor of ethnic segregation and the constant, unchanging labors to which Sebastiana must return. The film performs this work self-consciously: while the lovely shots of the shy smiles between her and her Aymara counterpart suggest that indigenous collectivity could be attained quite easily, the voice-over exhorts Sebastiana to stay in her community.

Meanwhile, the narrator leaves Jesús alone, implicitly allowing him the opportunity to move forward along the path of assimilation. This is clarified by *Juanito sabe leer* (*Juanito Can Read*), a short development film made the following year by Ruiz, Goni, and Roca and sponsored by USIA, which tells the story of an Aymara boy Jesús's (and Sebastiana's) age who is the first in his farming family to go to school. Employing a hectoring voice-over similar to *Vuelve Sebastiana*'s, the film follows Juanito on his meandering route to school with school-construction and education scenes in which US assistance is repeatedly, obsequiously invoked; *Juanito sabe leer* closes by proclaiming Juanito to be "the new Indian": his community is no longer "a lost race" because "light and knowledge will set [them] free." The contrast with Sebastiana, barred from the capitalist nationalist future that Aymara children can access, could not be starker.

There is a gendered resonance, too, to the contrast between Sebastiana, who must go back to her sedentary and timeless existence, and Jesús, who is implicitly if conditionally allowed to assimilate into the new Bolivian nation. As Rivera makes clear in her work on representations of indigenous Bolivians in the wake of the revolution, indigenous women in particular are constantly represented as both left behind by the modernizing nation ("more Indian," as Marisol de la Cadena has theorized) and at the same time made into ornamental symbols of the nation's static past.[33] As Rivera also points out, this attempt to position indigenous women as

static and non-coeval ignores their historical mobility, their roles as both merchants and domestic servants. This mobility, Rivera notes, is explicitly elided by the territorial conception of rights enshrined in Bolivia's 1952 revolution and the 1953 land reform.[34] In *Vuelve Sebastiana*, Sebastiana must go back to her Chipaya community in order to preserve a land-based and necessarily patriarchal apportioning of limited indigenous rights consistent with the 1952 directives.

The opening of the film also illuminates the gendered character of Sebastiana's non-coeval status. In this scene, the camera pans around a mummified body as the narrator tells of the mythical Chullpas (ancient gods who existed before the sun), at which point the figure dissolves into a shot of Sebastiana, as if the mummified girl has been given life by what Fatimah Tobing Rony calls "the taxidermic gaze" of ethnographic film.[35] This scene echoes that of Mexican director Emilio Fernández's 1944 indigenist melodrama *María Candelaria*, in which an Aztec ceramic mask dissolves into the titular character's nearly identical living face. *María Candelaria* is told from the point of view of an urban bourgeois Mexican painter, who sadly recalls the story of how his obsession with painting María nude, because he saw her as the essence of a true Mexican Indian, led to her murder at the hands of her scandalized indigenous community.[36] *Vuelve Sebastiana*'s resonance with the earlier film suggests that its filmmakers might be aware, if only in the most inchoate of ways, that Sebastiana is the sacrifice who must remain frozen in time, as a stable origin point from which orderly national progress advances. The film's rationale for sending her "back" is not about any benefit for her or her people, but rather because someone must embody the national past. Therefore the narrator commanding her to "go back," though he acknowledges that the return will cause her suffering, also deems it necessary in order for development to unfold elsewhere. This is one way to make sense of the film's disjointed voice-over: the grave, observational voice-over of the first half of the film is that of taxidermic ethnography, whereas the aggressive, commanding voice-over of the second half heralds the coming of development and the working out of the development film's orientation.

Vuelve Sebastiana's attempt to fracture indigenous solidarity and selectively isolate indigenous communities (and indigenous women in

particular), locating them in the past at the very moment of the twentieth-century high point of mass indigenous militancy in Bolivia, was meant to counter the insurgent impulses awakened by the revolution while also conveying to the United States that this militancy was contained. It also had lasting consequences for its star. Sebastiana Kespi, periodically honored for her performance, remained in her Chipaya community until she died in 2019. Ruiz recalls in his testimonial autobiography that Kespi came to La Paz twenty years after the film, now a distinguished community leader, to ask him for help after a flood; he recalls that though he "did not have the strength of the characters who populate Werner Herzog films," he did what he could "to settle accounts with the past," contacting "people of influence" and organizing a solidarity campaign to help the community; the two appeared on television together to raise money, inspiring an outpouring of support.[37] "Sebastiana returned to her community, this time with a smiling family," recounts Ruiz. However, as in the film, this return and the sedentary life that followed were not entirely her choice. Buoyed by the international attention to her performance in *Vuelve Sebastiana*, she aspired to act again, as she indicates in a 2009 discussion with journalist Manuel Chaparro Escudero:

> "I am an actress, I worked with Jorge Ruiz, but there's no payment left. How long will I be in these fields, I want to work as an actress, I want to go to Spain, why don't they take me? I can sing, I can make films, I'm Come Back Sebastiana." Tears are visible in her eyes. She walks through the field with a light step, guiding the sheep with a hiss that her granddaughter imitates. She acts for the camera. She moves in short and rapid steps, once in a while kicking up clods of dirt so that the sheep don't escape.[38]

Referring to herself as "Come Back Sebastiana," Kespi expresses her need for, and sense that she deserves, payment as the film continues to circulate and receive acclaim.[39] Perhaps more surprisingly, she also indicates her thwarted desire to resume the vocation for which she had gained international fame more than fifty years earlier. Kespi demonstrates here the wide gulf between the ethnographic accounts of the stagnant and insular Chipaya and their own ideas of who, and how modern, they might be. Her declaration "I can make films" makes clear her certainty that her work in *Vuelve Sebastiana* was work—a well-executed performance and a crucial

one to the film's success—despite the inability of audiences to see her as anything other than charming ethnographic source material.[40]

A NEW DEAL FOR BOLIVIA? *LA VERTIENTE* AND THE DEVELOPMENT MELODRAMA

Vuelve Sebastiana and even *Juanito sabe leer*, despite their fictional plots and bossy voice-overs, still contain elements of ethnographic curiosity, patiently following their child-protagonists on journeys and introducing indigenous customs to viewers. However, future Ruiz and ICB films abandon this curiosity, instead embracing New Deal and Griersonian styles, which they must significantly adapt for the Bolivian context of the state's ever-diminishing welfare and infrastructure provision. In an oft-quoted moment in his autobiography, Ruiz identifies as major influences Fernández, Grierson, Grierson's collaborator Harry Watt, and Willard Van Dyke, crediting them together with convincing him that "cinema can accompany social development" and "constructive cinema can be more useful than protest cinema."[41] This merging of melodrama and "constructive" documentary cinema is most fully expressed in Ruiz's ICB drama *La vertiente* (*The Spring*), one of the two full-length features he made in his career. By deliberately stitching together melodramatic tropes with extended scenes of collective labor reminiscent of New Deal narrative cinema, Ruiz and screenwriter Oscar Soria created a compelling development film, one that downplayed the Bolivian national context in order to spur communities to engage in the arduous and unpaid labor of development.

While *La vertiente* expresses a particular "constructive" ethos in favor of "social development," it does so, by 1958, in a way suited to a state that had been stripped of its ability to provide for its citizens. In late 1956, Bolivia began following an austerity plan authored by US banker George Jackson Eder. Tasked by the US government with stabilizing Bolivia's currency and reducing inflation, Eder authored a fifty-step plan for a "moral revolution" in Bolivia that shared many features with the economic shock therapy of the neoliberal era and was couched in equally zealous terms, imagining food subsidies and other hard-won benefits for mining communities in particular as profligacy that needed to be curbed. Using the

leverage of both aid money and control of global tin prices, the United States compelled the MNR's then president Hernán Siles Zuazo to freeze wages and cut welfare benefits for miners, privatize state-run industries, and pay out millions of dollars to the mining tycoons from whom they had expropriated the tin mines after the revolution.[42] As Kevin Young chronicles, this US-authored turn toward austerity and crackdowns increased inequality, coincided with a "remilitarization" of Bolivia, and inhibited state infrastructure projects, since so much money was flowing out of government coffers.[43]

ICB-cohort films register both the mid-1950s state investment in infrastructure projects and the abrupt 1960s turn away from them. Although Ruiz looked to Grierson, Watt, and Van Dyke as role models for his "constructive" films, the state's brief and inadequate forays into welfare provision and public works construction meant he could not realistically create paeans to state planning like Grierson and Watt's Night Mail or Van Dyke's The City. The closest he came to a celebration of state investment was Un poquito de diversificación económica (A Little Bit of Economic Diversification), a 1955 film produced for USIA by Telecine, the production company Goni had founded in 1954. That film experiments with what Anne McClintock calls the "porno-tropic tradition," eroticizing and equating lowland women and territory in a way that might spur colonization but also charts a path of import substitution industrialization that might create a better life for workers and lead to Bolivia's economic self-sufficiency.[44] The film begins in a mine in the cold, windswept mountains with scenes of tin miners' difficult and dangerous blasting work. One miner on his lunch break reads aloud a letter from his brother-in-law Santos, who has decided to venture east, toward the tropical lowlands. Santos's journey has a rocky start—some men get him drunk in a bar and then leave him to stumble home—but he soon acquires land for sugar production. He also finds a "sweet" lowland woman who eventually becomes his wife; the film repeatedly equates her with the land and the sugar crop. Linked to Santos's increasing skill at mastering the plenty of the east is the industrial development of that region: a sugar processing plant symbolizes Bolivia's aspiration to domestic production, indicating the MNR's aspiration to the liberal program of building up manufacturing to reduce Bolivia's economic dependency.

Although infrastructure like the sugar processing plant upon which *Un poquito* focuses ultimately benefited large growers much more than small landholders, the film's framing of domestic crop production as significant for small farmers represents Ruiz and Sánchez de Lozada's attempt to lionize, and seek support for, a planned economy that would allow Bolivia some degree of economic independence.[45] The film's sympathetic portrayal of the beleaguered yet chatty miners likewise endeavors to include them in the national picture, if only to tempt them away from life in the highlands. But even this mild emphasis on state planning and services, along with the appeals to miners, faded from the ICB's representations of Bolivian development during the post-1956 austerity years. Perhaps the most remarkable aspect of *La vertiente* is the film's inability, by 1958, to imagine that the revolutionary state might have some responsibility for the provision of clean water. *La vertiente* also undermines nationalist sentiment, particularly what Young terms "resource nationalism," in favor of a vision of bottom-up community self-sufficiency, with assistance coming from the military only when the self-help project is already underway.

La vertiente tells the story of Teresa, a schoolteacher from La Paz who goes to work in the lowland region of Rurrenabaque. After her favorite young pupil, Luchito, dies from drinking dirty water, she attempts to spur the sleepy townspeople to action, including Luchito's brother Lorgio, a carefree crocodile hunter who ultimately wins her heart by taking a leadership role in the pipeline-building project. Like *Vuelve Sebastiana, La vertiente* contains a hinge point in the middle: the first half of the film tells the slow-building story of Teresa getting to know the townspeople, charming the children, and verbally sparring with Lorgio, while the second half consists of a quasi-processual montage sequence of the townspeople building the pipeline while Teresa lies in bed injured and ill, then depicts them joyfully testing it out and celebrating its completion. The extended digging sequence features some of the new visual tropes that would become characteristic of the development film over the course of the 1960s. It first depicts the village men springing from lethargy into action, then moves to extended scenes of rhythmic digging, then slowly incorporates mechanized technology into the pipeline-building process, including a lovely truck ballet sequence on a beach featuring military vehicles in shifting formation. The pipeline-building sequence also depicts

the villager-laborers talking animatedly but inaudibly, drowned out by the swelling music, attempting to solve problems together in a way that looks vaguely civic and participatory; unusually for a development film, women are included in these "democracy-face" sequences. At the end of the film, after the pipeline is finished, Teresa finally awakens, gives a tearful speech to the assembled townspeople, and collapses into Lorgio's arms. Reflecting on the film, Ruiz recalls that "the central story was that of aesthetic aridity, and of collective sweat; for its part, the romance had to cover this central story like a bejeweled cloak, like a tempting apple."[46]

The "bejeweled cloak/tempting apple" here consists of melodrama. The Good Neighbor apparatus in Latin America, as we saw in chapter 1, initially made space for these melodramatic narratives and modes, transposing the anti-fascist struggle onto underdevelopment in order to imagine poor rural women and children as virtuous, suffering victim-heroes; to position tradition and its guardians as nefarious villains; and to call for the drastic cultural change that might come either "in the nick of time" or "too late," to use the terms of melodrama scholars.[47] In crafting their own melodramatic plot that would become the tempting vehicle for the development aesthetic in which at least Ruiz was more interested, Ruiz and Soria drew from Mexican golden age cinema. *La vertiente* particularly echoes Fernández's 1948 film *Río escondido* (*Hidden River*), in which schoolteacher Rosaura is sent by Mexico's president to a rural backwater community, where she fights a losing battle with the town's corrupt political boss to educate its people and eventually dies of a heart attack. The film thus mobilizes the figure of the heroic/tragic schoolteacher to bind peasants and workers to what Seth Fein calls "the benevolent centralized authority of the State."[48]

Examining *La vertiente*'s adoption of *Río escondido*'s basic plot alongside its rejection of some of its elements is instructive. In a real-life imitation of *Río escondido*, President Hernán Siles Zuazo personally financed *La vertiente*; Soria recalls that the president "gave his full and rapid support, above all because the film's theme coincided with the government's promotion of self-help."[49] In a significant revision of *Río escondido*, however, Siles Zuazo does not appear in *La vertiente* (nor does any political figure certify Teresa as representative of "benevolent centralized authority"), and the film generally downplays and undermines symbols of national unity. The cross-regional romance between Teresa and Lorgio,

barely begun, is soon forgotten in the rush of pipeline construction, with only a half-hearted reference to it at the end: a tearful Teresa finally staggers from her sickbed, makes a barely coherent speech professing her love and gratitude for the assembled crowd, and collapses into Lorgio's arms, looking more exhausted than enamored. The film's only overt moment of nationalism, a school pageant Teresa organizes, is also interrupted. After a berobed student on stage patriotically laments Bolivia's loss of its seacoast (in an 1879 war with Chile that is well remembered and much lamented in Bolivia), and another student in a soldier costume pledges to fight to regain it, Lorgio interrupts and ruins the pageant by stumbling in, drunk and devastated at Luchito's illness. A brawl ensues, and the children's performance is forgotten; the robed student, seemingly representing the nation, runs offstage and into the night. The film's one articulation of a national-political demand is interrupted, undermined, and ultimately subordinated to the economic self-help imperative.

Ruiz and Soria's other revisions of the *Río escondido* plot are telling. Unlike Rosaura, Teresa does not fight corrupt bosses, in a significant erasure of the recent revolution and the landowner class it had toppled. *La vertiente* also lacks the tragic element of the Fernández film: in a hopeful rewriting of Rosaura's defeat and death, Teresa's tearful collapse inspires the villagers to awake from their stupor of underdevelopment and begin to build the pipeline. The village men spend the first half of the movie drinking lethargically in the local bar, shrugging off Teresa's exhortations to "do something" with fatalistic pronouncements that things will never change. Even the melodramatic "too late" death of the charming and intelligent Luchito is initially not enough to motivate the town. It is only Teresa's own sickness (after taking her students out to construct a pipeline, incompetently felling a tree, and being bitten by ants) that impels the town to action. The turning point of the film is an extended, soft-focus close-up of Teresa's beautiful teary face; slowly, waterfalls begin to appear over it, with cascading orchestral music. The scene finally dissolves into a man with a bullhorn, exhorting the town's men to self-help: "Now is the time for our people to move toward progress! In this moment our women and children have already gone out to work! The young men cannot be less! We must go to work!" Awakened by this public challenge to their collective masculinity, the residents file out of their houses and begin building. The rest of

Figure 15. Teresa's suffering, or the hinge scene, *La vertiente* (dir. Ruiz, 1958)

the film is devoted to a montage, over swelling music, of the townspeople constructing the pipeline, with eventual help from the Bolivian army.

As the preceding should make clear, the transition between the two halves of the film is not explained by the film's diegesis: the townspeople are not pictured visiting the ill Teresa, and they of course do not see the waterfalls superimposed over her face. This moment of inexplicable reversal fits with the tendency toward unrealistic plots that Ben Singer terms melodrama's "nonclassical narrative structure" but also recalls the abrupt shift halfway through *Vuelve Sebastiana*, when the slowly unfolding friendship must likewise be cut short, also for external national-historical as opposed to diegetic reasons.[50] The visual spectacle of Teresa's teary face overlaid with waterfalls—the spectacle, in other words, of film itself—is what magically but somehow inevitably moves the townspeople to action. It also constitutes an implicit meditation on the source of motivation for development: how to move people to speed up their labor and

undertake the almost superhuman collective task of constructing a pipeline from a mountain down into a valley. The film posits that the look of film melodrama—the beautiful tearful woman, her tears amplified by the superimposed waterfall—will be understood as a spur to action and will spur audiences to action as well.

After the magical awakening of the townspeople, *La vertiente*'s tone changes, presenting joyous, musically accompanied montage scenes that for Ruiz constitute the true heart of the film. These scenes closely resemble, while also revising, the collective pipeline-building sequence from King Vidor's 1934 Great Depression/New Deal film *Our Daily Bread*. In *Our Daily Bread*, the protagonist couple John and Mary, down on their luck and unemployed, decide to establish a communal farm on which the men and their (almost unseen) families trade services and skills. In *Our Daily Bread*'s final scene, after almost running away with the urbane outlaw Sally, John realizes that they can irrigate their drought-starved crops and save the farm by constructing a pipeline from a far-off water source. He rallies the discouraged men to band together and dig the pipeline. The second half of *La vertiente* closely echoes, but also extends considerably, the series of communal pipeline-digging scenes with which *Our Daily Bread* ends.

La vertiente's elaboration on *Our Daily Bread*'s New Deal aesthetics perhaps signals Bolivian leaders' desire for the kinds of social support the US government provided for its own people in the 1930s, rather than the austerity imposed on Bolivia's workers and indigenous people by 1958. Bolivia's political leaders saw welfare provision as a model for containing dissent through state planning; they attempted to convince the US government that this model, rather than the pay freezes and food-subsidy cuts initiated by the Eder Plan, would work best for Bolivian development.[51] Bolivian Ambassador to the United States Enrique Sánchez de Lozada (Goni's father) remarked to an American audience in 1963 that "the advocates and principal leaders of the deeprooted transformation that has been under way in my country since April 1952 could not remain indifferent to the great social changes that took place in the United States in the decade of the thirties, and that is why I venture to state that to a certain extent and in a certain way, the structural changes now in process in my country have drawn their inspiration from that source, among others."[52]

If Bolivian revolutionaries had more directly imagined the Mexican revolutionary state, particularly in its technocratic iterations, as a model for their own, Sánchez de Lozada here demonstrates that they were aware of the irony of the United States demanding austerity measures from Bolivia while maintaining its own social safety net.[53]

If its echo of *Our Daily Bread* expresses a desire for a New Deal or at least some of the social safety net it provided, *La vertiente*'s revisions of the earlier film reveal that the developmental state is both less visible and less supportive than the New Deal state. Both films depict self-help in a moment of economic crisis, but *La vertiente* is not allowed to depict the national economic crisis its circumstances imply. While *Our Daily Bread* places societal economic collapse at the center of the community's attempt to rebuild itself, *La vertiente* is unable to depict the lack of clean water as a failure of the state-in-retreat, instead only implicating the local men's laziness and fatalism. *Our Daily Bread*'s domestic melodrama is clearly spurred by the economic crisis of the 1930s: protagonist John runs off with the urbane Sally because he can't stand the pressure of failing to be a good provider for Mary and his community; the collective crisis (of the crops needing water) becomes a clear impetus for action.[54] Ruiz and Soria's task in *La vertiente* is perhaps harder: to find an aesthetic mode that will instill in audiences a sense of their own underdevelopment and convince them to desire a different life, while also convincing them that making demands on the state is not warranted or possible.

La vertiente's attempt to construct a new relationship between the domestic spectator and the weakened state works allegorically through the character of Teresa, its emissary. *Our Daily Bread* links the state's successes and failures to women's embodiment: Mary's industrious body, constantly in motion, is the moral center of the film; John's return to her after rejecting the urbane, languid Sally signifies his embrace of the antimodern pioneer ethos and invigorates him to lead the pipeline project. Likewise in *Río escondido*, Rosaura's bodily actions and secretions give emotional resonance to the state-building process: her tears, her fainting, her blindness, and her eventual death are what make nationalist progress legible as a melodramatic struggle. Although Teresa's body, hidden in the first shot of *La vertiente* and often thereafter, never conveys the intensity of affect that Mary's or Rosaura's does, it still operates as the focal point of the film, representing the Bolivian state as it ails in response to lackluster

community spirit and then heals with the help of the development project. The waterfalls cascading over Teresa in her sickbed, which finally inspire the townspeople to build the pipeline, signal her symbolic role in the film: as the emissary sent by the state, she represents it here, in her beauty as well as in her utter incapacity. While Teresa may inspire the development mission, she is too weak to aid in it; she is central to inspiring the process, but sidelined as soon as it gets underway. Her fiery rhetoric combined with her physical weakness spurs viewers to imagine a circumscribed role for activist states in the global South: the communal transformation from feminine passivity to masculine agency, the film suggests, might be inspired by the state, but must occur without much help from it.

Even though *La vertiente* normalized and valorized the US-sponsored austerity regime, its filmmakers were reluctant to explicitly connect it to US development plans and programs. While most Bolivian films enriched the ICB by making money at the box office, *La vertiente*'s production proved expensive. According to Ruiz and Soria, US technicians agreed to finance the completion of the film if US sponsorship could be emblazoned on the pipes the villagers were assembling during the prolonged construction scene.[55] The ICB filmmakers refused and found the money elsewhere. Nonetheless, US development organizations were pleased with the film: a 1960 ICA memo reports that "technicians" reviewed it and agreed that it was "an excellent production [that] could be useful in practically all Latin American countries," in part because of its setting in "a non-Indian area of Bolivia."[56] While the ICA's assessment, like the film, erases the indigenous people who call the Rurrenabaque area home, it also suggests the perhaps-unintended consequences of Ruiz refusing to put US-supplied Point Four labels on the pipes: refusing to acknowledge "outside" help ended up emphasizing self-help in a way that made the film even more generically useful to the US modernization mission and increased its distance from a vision that included state support for basic infrastructure and services.

LAS MONTAÑAS NO CAMBIAN AND THE ENCODING OF MELODRAMA

Of the numerous development films Ruiz and his ICB cohort made, *La vertiente* was the first and last scripted full-length melodrama. Later ICB

films retain melodramatic elements—Manichean contrasts between tradition and modernity, dramatic use of light and darkness, the vanquishing of superstition by virtue and hard work—but their melodramatic content is much less explicit. In later ICB films, and in the various films made by Ruiz and the ICB cohort for USIA and other Latin American governments, melodrama inheres in visual shorthand rather than in the fully realized characters of suffering victim-heroes. One ICB film that eschews melodramatic plots—and with them, women's roles—while retaining melodramatic imagery and symbols, is the 1962 short film *Las montañas no cambian* (*The Mountains Never Change*), which Ruiz later described as "a filmic cocktail of fiction and reality" and which won multiple prizes at European film festivals.[57]

Las montañas no cambian is an anniversary film, made ten years after the revolution to celebrate its achievements. Its celebratory tone contrasts with the state's increasing violence against workers: Paz Estenssoro, who had returned to power in 1960, began escalating this anti-worker violence, first declaring a ninety-day state of siege in response to a 1961 teachers' strike and then, with funding, arms, and guidance from the United States and West Germany, initiating a series of "crackdowns" on miners that included layoffs and the detention of labor leaders in camps in the eastern jungle.[58] In the midst of these assaults on workers and the Left, Paz personally agreed to finance *Las montañas* on the conditions that the filmmakers complete the film in time for the April anniversary of the revolution and that the film celebrate the revolution's achievements. Ruiz himself made the decision to focus not on "the holy trinity of the revolution: universal vote, nationalization of the mines, agrarian reform," but rather on "the changes from the point of view of the peasant, the worker and the miner," although miners are in fact absent from the film.[59] The revolution, too, is barely mentioned, except in the film's final moments when, with the camera zooming in on the reverent faces of indigenous highland men and the music swelling, the voice-over narrates the change it claims the revolutionary state has spurred over the past decade: "When they were not citizens, they defended their territorial integrity. Now, as men incorporated into civic and economic life, they revere the symbols of their homeland. The rivers, the lakes, the mountains do not change. What does change is man. The Bolivian Revolution in ten years has achieved the greatest

conquest: the conquest of man himself." The "symbols of the homeland" to which the final voice-over refers, however, are scarce in the film.

Like *Vuelve Sebastiana* and *La vertiente*, *Las montañas* abruptly turns away from civic and patriotic rituals, instead literally enacting over and over Ruiz's commitment to "constructive cinema" in its focus on the people and machines physically transforming the land. But in focusing on its three men protagonists, incessantly reiterating their full names and insisting on (if not fully depicting the arcs of) their individual journeys to development, *Las montañas* revises previous MNR films by imagining development as more individualistic and hierarchical than communal. This vision supported the MNR government's position in the early 1960s, as it poured resources into breaking strikes, funding "colonization," and otherwise breaking up the highland communities it imagined as hotbeds of communism and "politics" more generally. The highlands, in the film, appear as the only location of political bodies and discussions. But while the film depicts these political spaces positively yet vaguely, it ultimately advocates leaving them behind for the apolitical, spacious "new" lowland areas.

Las montañas appears, at the beginning, to be about two indigenous men. The first, Gabino Apaza, has remained isolated with his sheep- and llama-herding family, Rip Van Winkle–like. Gabino is depicted, as Claudia Arteaga observes, in enclosed spaces with children who are unnamed and unrecognized by the voice-over.[60] His brother-in-law Eulogio Condori, in contrast, has participated in post-1952 society and so is able to embody a possible future of the highlands. The voice-over argues that Eulogio has transformed from being a voiceless serf, though it never says whom he served, to being able to raise his voice in the local assembly of the peasant unions that the MNR formed after the revolution. At one such meeting, Eulogio and Gabino reencounter one another. Ruiz's portrayal of the peasants' political assembly is an example of democracy-face, a particular type of muted civic scene that was becoming a staple of development films across the continent. The camera pans over the stoic, well-lit faces of men in the meeting talking animatedly yet inaudibly, while the narrator informs viewers that they are debating whether to construct a building or a road. This question keeps the meeting centered firmly in the realm of technical self-help rather than on the more contentious questions of land reform that Bolivia's peasant unions in those years were still pressing the

government to address, and about which the film says nothing. As Marco Arnez notes, the trappings of highland indigenous leadership (the poncho, the staff) are nowhere to be seen among these peasant leaders, illustrating the attempts by the postrevolutionary Bolivian state to destroy indigenous lifeways.[61] The demographics of the meeting also reinforce how the revolution's reconfiguration of indigenous governance structures weakened indigenous women's power; whereas power in communities had rested with an elder heterosexual couple, women now sit around the edges of the meeting, watching the men debate. In the argument over infrastructure, the voice-over asserts that representatives of both sides have argued well and explains that "the strength of their decision is reinforced with a vote" while keeping the result of the vote a secret.

Even the modest civic ritual of the peasant union meeting, however, is soon interrupted by a shift in perspective that constitutes the first of two hinge moments in the film. Permanently leaving behind the story of Gabino and Eulogio's reunion, the film shifts to an inventory of the economic changes in the highlands. The camera pans over sewing machines, glass, and cement, while the voice-over proclaims that the peasants "have understood that the economy is the base of their well-being." The film next approvingly describes the many schools built "with silent and humble daily work" by the peasants, illustrated by poetic shots of silhouetted men constructing a school, brick by brick, then raising the Bolivian flag atop it, then jumps forward to the children learning in one of the recently constructed school buildings. The teacher, a smiling young man, taps a map, reminding them that "Bolivia is not just the Altiplano." The film then makes a second turn away from national symbols to what it imagines to be the more productive terrain of infrastructure construction and other economic activity, cutting from the faces of the boys in school looking at a map of the eastern lowlands to the well-lit, shining face of a boy about the same age who is sitting in the dirt, gazing down upon bulldozers constructing a road across the country.

The film uses this sweeping segue to introduce a third character: a man in the lowlands, Oswaldo Melgar, going on "a day of adventure" with his son Eliseo. As Arteaga notes, the light-skinned, lowland dweller Eliseo, unlike Gabino's children, is recognized and named by the voice-over, indicating that he is the true heir to Bolivia's future. In the lowlands, the film

Figure 16. The community builds a school, *Las montañas no cambian* (dir. Ruiz, 1962)

abandons political symbols and situations in favor of vistas depicting pure economics: oil, sugar, and rice are all depicted as the new hope for "economic integration." In its attempts to represent the joyful economic integration of Bolivia, led by the increased exploitation of the lowlands, the film echoes *Un poquito de diversificación económica.* But if the 1955 film points toward a vision of domestic industrial production, focusing on how it might enrich the lives of ordinary peasants turned settlers, *Las montañas* promises less to its characters. By abandoning its three protagonists and their storylines as soon as they begin, the film, like *Vuelve Sebastiana* and *La vertiente*, becomes a divided, genre-melding text. Moving from a narrative to a geographical logic, it morphs twice from an individual and potentially political story into what Arnez calls "a symphony of progress," triumphantly tracing the country's new and prospective economic geography. In the lowland plot, the camera follows Oswaldo and Eliseo for a short while, then shifts focus to the road at which

they have been gazing. The film then abandons the father and son pair, following the road into oil-drilling territory and down an oil shaft; another road appears and the camera tracks some cattle nearby toward a line of tractors spraying pesticides. As the scene continues to shift from one location of frenetic extraction or production to another, the camera and swelling music, obedient workers, and awed spectators within the film luxuriate in the constant motion of pistons, wheels, drills, and bulldozers.

The most physically striking moment of the film, however, is not one of industrial production, but rather an extended shot of shining faces of settlers, staring out into the rainforests: the narrator identifies them as *kollas* (highlanders), "putting their mountains, their history" behind them, ready to descend into the allegedly untouched and unpopulated lowland. Soldiers help the settlers, then instruct them, then break up the forest with machetes, after which the film abruptly cuts to a story of rice cultivation, then cuts back to Oswaldo's watchful face (without resuming his story) to shift to a narrative of Bolivia's sugar production. The film reimagines the brutal-looking gears of the sugar mill as a showcase of power and strength; muscular men pile up enormous stacks of sugar as the voice-over intones, "This is the opportunity of our age." Oswaldo's "day of adventure" thus serves as a thin veneer for the film's tour through lowland Bolivia's new industries, agricultural technologies, and restored military might.

Although the character arcs in *Las montañas* are quickly abandoned in favor of montages of extraction, production, and trade, the film does still insist that it depicts the transformation of men, and in so doing imagines development as an entirely masculine activity. While *Vuelve Sebastiana* and *La vertiente* focus on the efforts of a central woman character, and even *Un poquito de diversificación económica* gives a name (Pilar) to the lowland woman who will become Santos's wife and prize for relocating, women characters are almost completely absent from *Las montañas*, only occasionally filling in group scenes. The line "what changes, perhaps, is man" at the beginning and the end of the film seems to be explicitly and exclusively descriptive of men. Women are also usurped, more completely than in *La vertiente*, by the military and the central role it has begun to play in education and other development endeavors. In a poetic scene of settlers on the beach embracing soldiers who have just emerged from a boat, *Las montañas* proclaims, "[H]ere they encounter their first friend:

the soldier. He will be their guide, and he will be their teacher." This signals the foreclosure of the symbolic role, and a usurpation of the concrete work, of teachers like Teresa, whose real-life counterparts were striking regularly in the early 1960s.[62] A later scene in which soldiers teach literacy classes outdoors makes even clearer how they have taken over the roles of the potentially disruptive civilian teachers. The final sequence in the highlands, in which children climb the rocky hillside to the famed progressive Andean Warisata school, does feature civilian teachers, but they too, like the initial teacher in the schoolhouse, are nearly all men.

Ruiz considered *Las montañas* "the last film [he] gave to the revolution." In his memoir he remembers it as a "tremendous success," recalling the premiere with "Paz Estenssoro, ministers of state, diplomats and journalists." The film, he recalls, "offended no one ideologically."[63] Ruiz's skill at making development films and at offending no one meant that his films traveled—*La vertiente*, in particular, as a self-help film featuring almost nothing in the way of national markers, was distributed around Latin America as well as in communist bloc countries.[64] Ruiz himself, however, would make several anti-communist films, including "So That Men Are Free" with Willard Van Dyke, a film about military development in Peru, and most notably *Los Ximul* in Guatemala. For this latter film, which Ruiz conceived of after reading an article about the "reform" of overthrown leftist Jacobo Árbenz's land reform, he received US financing and reunited with the *Vuelve Sebastiana* team of Augusto Roca and Luis Beltrán, who was working on development communications in Costa Rica. Together they made a film about a family settling on a government-leased coastal plot. The film touted the path to private landownership through the right-wing regime of Carlos Ydígoras Fuentes, explicitly contrasting the regime's carefully constructed colonization scheme with the redistributive policies of the Árbenz years, which the narrator argues gave peasants land "indiscriminately." Over swelling music and shots of bulldozers felling trees, the voice-over explains that the government has chosen the land with the best soil to give to the specially selected families who have applied for plots.

With its condemnation of the inefficiency of the Árbenz plans and its focus on colonization rather than redistribution, *Los Ximul* became a weapon in the ideological battle to define land reform during the 1960s. The film was exhibited at the Punta del Este conference in August 1961,

a conference at which the United States set out its goals for the Alliance for Progress, the development program for Latin America it offered under the guise of multilateralism. The Alliance's vision for land reform deemphasized questions of redistribution and justice by framing the issue as self-evidently one of net agricultural productivity and by pushing for the clearing and colonization of forested or peripheral lands. This intense focus on productivity allowed corporate interests to take control of land reform processes; as a result, many smallholders lost land due to Alliance reforms that purported to empower them.[65] With *Los Ximul*, Ruiz, Roca, and Beltrán not only made what Ben Nobbs-Thiessen calls "a dramatic endorsement of a reactionary regime," but also cemented a particular vision of land reform that emphasized farmers' merit and productivity rather than their right to control the land they worked.[66] Land reform was one important arena where the Alliance for Progress absorbed while also distorting the leftist redistributive visions that also proliferated in the 1960s. The next chapter explores these co-optations and distortions, focusing particularly on how the filmmakers enlisted by the Alliance drew on old and new leftist aesthetic traditions to make even brutal modernization measures seem to emanate from, and fulfill, the desires of "underdeveloped" communities.

CONCLUSION: THE AFTERMATH OF THE DEVELOPMENT MELODRAMA

The 1963 photo spread in *Life* celebrating "The Universal Magic of the Movies" features two Bolivian women dressed in the shawl and petticoats of urban indigenous *cholas* standing in front of a *Tarzan* poster. "Aimara Indian women become cosmopolites for an afternoon," proclaims the caption, "seeing the American *Tarzan the Magnificent* and a Mexican version of *Little Red Riding Hood*."[67] This caption misunderstands the women's social status, as their garments already signal their more sustained "cosmopolite" aspirations; it also misses the national significance of cinema for Bolivians by 1963.[68] Cinema in Bolivia was by then not particularly foreign or cosmopolitan, but rather was both widespread and intertwined with the country's aspirations to development. The country's burgeoning

national film program, as we have seen, initially assimilated ethnographic conventions with melodramatic tropes, mixing in a New Deal workerist aesthetic. In so doing, Bolivian filmmakers made some of the earliest fully realized development films, whose tropes would be repeated in US and global educational films throughout the 1960s. While CREFAL, USIA, and the Rockefeller Foundation did not always make compelling and coherent development films in the 1950s, Bolivia's ICB did construct a coherent vision of development, crafting compelling melodramatic rationales for self-help along with absorbing scenes of synchronized communal and machine-assisted labor. Its films, as well as some of its filmmakers, became more powerful advocates for US empire than the often-failed on-the-ground development projects the United States attempted.[69]

Bolivia's development films also framed conversations about social change in Bolivia, helping to shape the national sense of what had changed after the revolution while also placing development at the center of popular discussions about poverty and national liberation. The films' general impact on Bolivian spectators might be gleaned from the more legible and notorious mass reactions to the militant cinema of the 1960s. The head of the ICB who succeeded Ruiz, Jorge Sanjinés, had none of the aversion to "politics" his predecessor professed. With former Ruiz scriptwriter Óscar Soria, he made increasingly militant films, denouncing racism and corruption until his 1966 film *Ukamau* (*That's the Way It Is*) led the government to disband the ICB. *Ukamau*, by depicting a corrupt and exploitative *mestizo* class, broke the cardinal rule of the development film, in which the wealthy are never the antagonists of the poor. But while it dramatically breaks from one of the central conventions of the genre, *Ukamau* returns to the melodramatic frame of *La vertiente*, combining its use of a suffering woman as impetus for action with an impressionistic style to depict an indigenous man who must avenge his wife's rape and murder at the hands of a local authority. The film climaxes in a drawn-out struggle on the desolate plain between the protagonist and his wife's killer. Flashbacks of his wife's smiling face in close-up spur the protagonist to kill the *mestizo* rapist with a rock; the film clearly endorses indigenous resistance and revenge.

This militancy is carried even further, to more dramatic effect, in the 1969 film *Yawar Mallku* (*Blood of the Condor*), a film by ICB alums Óscar

Soria and Jorge Sanjinés that depicts "Progress Corps" volunteers sterilizing indigenous highland women; this act, in the film, allegorizes all development interventions and equates them with cultural genocide. When the government tried to suppress *Yawar Mallku*, Bolivians demonstrated in the streets and then proceeded to riot, kidnapping Peace Corps volunteers and protesting until the Peace Corps was expelled from the country in 1971; Bolivians continued to harass Peace Corps volunteers and steal their belongings as they were leaving the country. The enthusiastic reception of *Yawar Mallku* suggests that the tropes and images of development, on film as in the world around them, were familiar but not entirely convincing to many Bolivians. While *La vertiente* might have conveyed to audiences the necessity of communal self-help action in the face of women's suffering, *Yawar Mallku* persuasively subverts the visual tropes in that film to suggest that development interventions themselves cause women's suffering and the death of indigenous communities.[70]

The central yet uneasy place of women in revolutionary and development films alike foreshadows the story in the last chapter of this book. That chapter tells the story of the 1970s centering of women's voices and stories in development films. However, these women's voices and stories emerged in the context of what for development experts were confounding fears of overpopulation. These fears vexed development's promise of boundless growth, while also returning women to the center of melodramatic narrative, as they had been in the 1950s. But if women were previously imagined as catalysts for men's infrastructure-building action, here it was their reproductive activity that at once needed to be venerated and controlled, clearly explained and euphemistically represented. Thus the centering of women, and specifically the attempt to give them voice while controlling their reproductive capacity, led to new problems for the development film genre.

5 Brutal Pedagogy
in the Kennedy Years

School at Rincon Santo, an award-winning 1962 short film directed by
James Blue for USIA, opens on a celebration. A priest's blessing, fireworks,
crowds, and speeches are accompanied by slow guitar music. Then the
music speeds up, celebratory horns come in, and the solemn voice-over in-
tones: "For over a year, the people of the Colombian village Rincón Santo
had struggled to build a school. Now, it was finished. Never has a one-
room schoolhouse meant more than the new school at Rincón Santo." This
pronouncement is punctuated by a firework, set off by a jubilant man, and
then the festive scene gives way to a quieter, mistier one, as the loud music
cedes to a child's plaintive song. A boy, presumably the same one singing,
walks through a lush meadow, then several other boys join him, and they
frolic through the field and down a road. The scene then shifts again to
disheveled women cleaning and cooking, by then recognizable shorthand
for underdevelopment, as the narrator pronounces, "[F]or a hundred
years, people had lived in Rincón Santo without much change." As the
women in cramped interior spaces go about their unpleasant duties, the
narrator continues detailing the poverty, illiteracy, isolation, large fami-
lies ("at least seven children"), and other conditions of underdevelopment
that have characterized the community, ending by asserting that despite

their resignation to their circumstances, the people of Rincón Santo "have always wanted a school." A woman's voice attests that she wants a school for her sons, then children's voices chime in explaining that they spend their days playing (the camera returns to the boys in the meadow, offering close-ups of them making silly faces and playing a raucous game), but that what they really want is to go to school—one says he wants to study "to be an aviator so I can fly like the birds."

The triumphant close of the film, after the community has finally constructed its own school with materials but no other assistance from the government, presents a vision of education that bears little resemblance to the soaring freedom imagined by the daydreaming boys. The community puts the finishing touches on the school, joyously setting up the desks and sweeping the floor. Small children wait outside in a delightfully disorderly line. When the teacher gives them the go-ahead, the children, squealing with delight, crowd into the classroom, congregating at the front. In what is the film's extended climactic scene, the teacher begins addressing them by name, telling each child to move to a particular seat. She is quite forceful, telling several children "allí no!" (not there!), making hurried motions with her hands, and sighing with exasperation; she tells one child to move to the back of the room, and then almost immediately orders him to return to the front. Neither the teacher nor the film gives any reason for this vehement rearranging; the children are not organized by age, height, or any other discernible characteristic. All of them follow the teacher's instructions dutifully, some smiling for the camera, some with anxious or annoyed expressions. Throughout this senseless ordering of the children's bodies, the villagers press themselves against the classroom windows, looking lovingly at the children, their weathered faces lighting up with shy smiles. They continue to observe proudly as the teacher, finally satisfied with the children's placement, pronounces, "we're going to learn the alphabet," and commands them to repeat each letter of the ABC's. When they finish, she orders them to repeat, and they start again at the beginning. As the children recite the alphabet for the second time, the scene shifts from close-ups of the obedient children, the commanding teacher, and the smiling onlookers to an extreme long shot of the school building nestled in the mountains. "This is a part of the spirit of the Alliance for Progress," the narrator pronounces. "People helping themselves."

Figure 17. "We're going to learn the alphabet," *The School at Rincon Santo* (dir. Blue, 1962)

Figure 18. Children in rows, *The School at Rincon Santo* (dir. Blue, 1962)

Figure 19. Villagers peer through the schoolhouse window, *The School at Rincon Santo* (dir. Blue, 1962)

In its insistence not only on self-help but also on unquestioning obedience to an arbitrary disciplinary and classificatory process, *School at Rincon Santo* captures quite a lot about the convoluted spirit of the Alliance for Progress. Despite the collaboration its name suggested, the Alliance was a US program, initiated by John F. Kennedy's administration to prioritize Latin America in the wake of the 1959 Cuban Revolution, that promised Latin American governments aid and loans for development projects in exchange for eschewing communism (often by crushing leftists and unions) and implementing economic policies that favored the United States. Insisting on both democracy and stability, compelling governments to both assist the poor and brutally suppress the Left, and demanding austerity measures while promoting expanded public programs and even land reform (albeit, as we shall see, a particular version that drew on frontier myths and productivity goals more than redistributive ideals), the Alliance pursued contradictory aims, aims historians argue doomed it to failure.[1] However, the films of this era were able, for a time, to make those contradictory goals seem coherent, benevolent, and even beautiful. Although the Alliance coincided with the high point of USIA filmmaking and thus was supported by many filmmakers, this chapter focuses on three of its greatest propagandists: Willard Van Dyke, Gordon Parks, and James Blue. All three filmmakers drew on various radical aesthetic traditions to make films (and in Parks's case, photographs as well) during the Kennedy era that convinced global audiences of the wisdom of Alliance aims and the success of its programs. Though they may not have saved the Alliance, they refined the narrative and visual repertoire of the development film, convincingly depicting development as a simple, linear process in which previously lethargic, squalid communities, pushed by benevolent technicians to desire more, mobilized for change. However, by the mid-1960s, as other filmmakers adopted their stylistic models, all three artists worried about the development mission they had so compellingly propagandized. This chapter also tells the story of this growing disillusionment, tracking the filmmakers' journeys as they worried about the desires they had awakened and, particularly as the United States escalated its war in Vietnam, the militarized development regime they had bolstered.

For Van Dyke, Parks, and Blue, as in the Alliance for Progress and community development programming more generally, the school was the

iconic location of change.[2] Development's core tenet that change must come from the individual "heart" first—that a person, generally a boy or man, must be open to abandoning his old ways before economies and societies might be restructured—meant that the school took on paramount importance as a place where desire and discipline could be simultaneously learned so that modern subjects might be forged. The school is also a place of classification, and the United States framed Latin America as particularly "mixed up" in its racial and geographic makeup, in need of the sort of classificatory certainty on display in *School at Rincon Santo*. In many of the films, too, development is intertwined with militarization, as it was in the Alliance for Progress; as recent scholarly studies have shown, the Alliance's Civic Action military development programs built up militarized states, a buildup that in some countries led to military takeovers.[3] This taxonomizing and militarizing drive was made benign in development films even when its consequences in the lives of the films' subjects were less so.

WILLARD VAN DYKE AND
THE ALLIANCE MEDIA APPARATUS

While USIA was a particularly powerful source of the visions of US-guided Latin American development that proliferated during the Kennedy years, it was not the only media organization promoting the Alliance for Progress. Television networks, educational films, private foundations, and Henry Luce's *Time-Life* empire assisted the Alliance by promoting its personal side, in the form of constant, fawning coverage of Kennedy speeches and small-scale development ventures. With a reach even beyond the transnational ventures explored in the previous chapters, the US-based media apparatus of the 1960s worked to disseminate globally the development ideas that had been formulated by filmmakers and social theorists about untouched "traditional" societies and their anticipated breakdown, racial flexibility, and the inevitable yet urgent project of extending capitalism throughout the world. In the films, these assumptions were communicated through various stock scenes: "before" sequences of dirty and disheveled women and children, often crammed into doorways or small rooms; "after" scenes of clean, neatly dressed men looking proud,

inexplicably lined up in formation; scenes of collective outdoor labor that feature the seamless melding of men and machines; "democracy face" scenes in which men talk animatedly accompanied by a voice-over explaining that they are finally democratically participating in their own society; close-ups of thriving crops accompanied by scenes of DDT streams; and hopeful scenes of the future, generally symbolized by the well-lit face of a young boy.

Willard Van Dyke's 1962 film "So That Men Are Free" crystallizes this development vocabulary. With cinematography by Bolivian virtuoso filmmaker Jorge Ruiz, who had befriended Van Dyke in New York through USIA filmmaker Leo Seltzer, with whom he had worked in La Paz, the film was part of the acclaimed CBS docuseries *The Twentieth Century*; it was also distributed by McGraw-Hill and shown widely in US classrooms.[4] "So That Men Are Free" touts the success of the Carnegie Corporation–sponsored Vicos project, led by Cornell University anthropologist Allan Holmberg, who bought and, over a decade, attempted to transform and closely monitor the rural highland village of Vicos, Peru. This "experiment" at Vicos occurred partly due to the Bolivian revolution and the dramatic land seizures and institutionalized land reform that accompanied it, which are not mentioned in the film. Instead, the transfer of land to the indigenous peasant farmers is staged as a gradual process that must be mediated by technocratic experts, who gradually prepare the villagers (who, the film asserts, disregarding a history of labor struggles at Vicos, have been "sitting in their mountains" for centuries, "waiting for history to begin") to both make the land profitable and improve themselves to the point where they might be able to buy back and manage their own ancestral land.

The film's narration by Walter Cronkite introduces viewers to "Peruvian Indians, descendants of the once all-powerful Inca, whose forebears created a civilization rivaling that of ancient Egypt."[5] Cronkite then contrasts that history with more recent scenes of disheveled children, drunken festivals, folk-medical practices, and women cowering in fear, with his voice-over repeatedly pronouncing that the Vicos residents do not truly live but rather "starve slowly." Over the course of the film, these scenes of "sixteenth-century serfdom" morph slowly into sequences of proud, orderly men receiving diplomas, constructing a school, and spraying triumphant

Figure 20. Jorge Ruiz and Willard Van Dyke on the set of "So That Men Are Free" (Vicos, Peru, 1962)

Figure 21. Spraying pesticides, "So That Men Are Free" (dir. Van Dyke, 1962)

arcs of DDT. As the camera looks down on joyful villagers dancing in an alcohol-free festival celebrating their purchase of the town, Cronkite further explains the change that has taken place, characterizing it not only as an "earth shaking" leap forward but also as a specifically racial transformation: "Mestizos, townspeople, even joined in the dancing. Before this, they despised Indians. The truth is, being Mestizo in Peru is not so much race as place. The Indian in modern clothes, speaking Spanish, thinking like a modern Peruvian, becomes Mestizo as European immigrants became American." The narration, accompanying the aerial view of the villagers with its *mestizo* perspective on "the Indians," lays out unusually explicitly the analogy to the US past that underlay modernization theory. If the comparison to European migrants is a bit odd, given that the Vicosinos are indigenous people on their own land, it also reveals the transformation into settler consciousness that must occur in development. Land reform must become *settling*, which means that people indigenous to a particular area cannot reclaim it as rightfully theirs but rather must earn it by proving themselves to be modern settlers with modern thoughts. The film insists on this idea of racial improvement, making constant connections between the neatening and Westernizing of the villagers and the straightening out and increased productivity of their land. In the "after" scenes, the villagers' faces shine bright as they receive their diplomas, and the potatoes they now grow with "better seed, fertilizer and pesticides" also gleam a blinding

white. Workerist aesthetics make this story of improvement compelling: Ruiz shoots the men constructing the school from striking angles, capturing their energy and stolid determination and making compelling their alleged transition from beleaguered serfdom to self-directed, dignified, grateful laborer status. ("Now, more out of gratitude to the gringos who had helped them than out of any deep desire for education, they built a school.") The indigenous peasants' repossession of their land, convincingly downplayed and reframed in the terms of development, is not an endpoint but a middle step in the struggle to improve both land and people.

As in countless other development films made in the Kennedy years, the objects of development rarely speak audibly in "So That Men Are Free." In one instance of "democracy face," men sit around a table speaking animatedly but inaudibly while the voice-over explains that the Vicos project has reawakened the Indians' voices, previously "stilled by ages of submission," in a town "seminar" created by Cornell. "Slowly, words came out of startled hearts: grievances, questions, then ideas. After centuries, the Indians were talking freely," promises the voice-over, and the men's faces indeed look engaged. However, given the inaudibility of their "grievances, questions, and ideas," as well as the specific prescriptions for development that bookend these democracy-face moments ("better housing comes later, Holmberg says, as it did in our own history"), the film makes clear that the democratic participation dramatized in such scenes is highly circumscribed: the economy and infrastructure of Vicos are determined in advance by development's dictates. One of the only moments when an indigenous person speaks in the film confirms this contradictory vision of freedom in development. A boy in the classroom stands up, nervous and dignified, clutching his desk, in response to a teacher's question; the other children also peer seriously and anxiously at the teacher. The boy, reciting what the voice-over has identified as "the geometry of the future," identifies "the vertical line." The teacher asks, "Why is it called the vertical line?" and the boy gives a tautological answer—"because all those lines are pointing in the direction of the plumb line"—that viewers are meant to celebrate as a sign of "the change from unequal to equal." Here as elsewhere, Ruiz's cinematography, which captures the earnest striving of the boys, makes an otherwise underwhelming pedagogical moment seem consequential and perhaps even liberatory.

 The dramatic transformation the film depicts was not suggested by re-
porter Charles Kuralt's first impressions of Vicos. Sent to Peru by *Twen-
tieth Century* producer Burton Benjamin, who was "interested in doing
something on the Alliance for Progress, but didn't know how," Kuralt wor-
ried that "at first glance, the Indians of Vicos are indistinguishable from
the rest—they are tattered and ignorant and ill-fed," and that the Vicos
program was "a very, very small effort in a vast area with an almost in-
soluble problem."[6] The visual starkness of Vicos's transformation in the
film seems all the more remarkable given how invisible it was to Kuralt.
Van Dyke and Ruiz's ability to make viewers believe in the development
story of Vicos won the program praise: Benjamin was "delighted" with the
result, and *Show* magazine called it "one of the most moving and signifi-
cant programs of 'The Twentieth Century.'"[7] It won awards from the Ohio
State Film Festival and the Overseas Press Club and was distributed by
McGraw-Hill and widely shown in schools.[8]
 Van Dyke's experience crafting a workerist patriotic aesthetic in the
New Deal era enabled him to make compelling development films that
humanized the subjects of intrusive social engineering programs at Vicos.
However, even Van Dyke's patriotic-developmentalist leftism made him
too radical for USIA's liking. In 1963 he attempted to make a civil rights
film for USIA; scripted by radical Black journalist and civil rights activist
Louis Lomax and directed by English filmmaker Graeme Ferguson, it was
originally called *Progress of the American Negro*. The film depicted sit-
ins and activists discussing them; Ferguson told *Variety* it was to be told
"90% from the Negro point of view, via interviews and on-the-spot foot-
age, made, of course, by a fully integrated crew." The film, however, was
"quietly shelved" by USIA, as *Variety* reported. After initially commission-
ing the film, USIA's film and television section head George Stevens Jr.
told *Variety* that it "doesn't fit our situation," explaining "that USIA is es-
sentially a propaganda organization and is not required 'to go out and pub-
licize our problems.'"[9] Van Dyke was perturbed by USIA's treatment of the
film. In 1971 he wrote to scholar Richard Dyer McCann, after reading the
manuscript of his history of US government films, that the book should be
more critical of Stevens's leadership at USIA, promising to tell McCann a
story of USIA's "destruction of a film [he] made about Negroes": "It is a
shameful story indeed."[10]

While his experience making a civil rights film disillusioned him, Van Dyke's ultimate break with development filmmaking occurred in conjunction with the US war in Vietnam. Vietnam represented far and away USAID's biggest single-country investment in the 1960s, as well as the most important laboratory for US experts' ideas about modernization and development. However, these programs often failed; Vietnamese people were not much interested in forcible modernization, especially accompanied by war. As scholars such as Michael Latham show, US officials, when they acknowledged these failures at all, blamed the South Vietnamese regime they were propping up rather than questioning their own ideas. This meant they maintained their faith in modernization principles and development efforts in Vietnam, alongside ever-escalating military intervention, through the early 1970s.[11] However, politicians, journalists, and many others, including Van Dyke, began to question both the ethics and the strategic wisdom of destroying "traditional" societies in order to forcibly impose on them the benefits of modernity.

In the 1965 episode that caused him to abandon filmmaking, Van Dyke was outraged to find himself bolstering deceitful propaganda efforts for the war and its alleged development successes, efforts that extended well beyond official government bodies. After the success of "So That Men Are Free," CBS asked Van Dyke to go to Laos to make a film about "Pop" Buell, a retired Indiana farmer who had allegedly "offered his services to the Agency for International Development" to "help other farmers in underdeveloped countries." When Van Dyke arrived, however, he found that "[t]he farmer had no knowledge of the agriculture in the area, in fact there was none. . . . He could barely speak English, much less any foreign language. Our evenings were spent around a fire at one end of the warehouse while our farmer and the CIA men discussed why we should bomb Hanoi."[12] Van Dyke left Laos early and reported to CBS that the visit had been a failure. However, in early 1965 *The Twentieth Century* cobbled together his footage and aired the film anyway, calling it "Pop Buell: Hoosier at the Front" and casting Buell as a wise, folksy farmer and beloved hero of the Laotians. This betrayal left Van Dyke angry and disillusioned. After "Pop Buell," he stopped making films altogether. He took a job as head film librarian at the Museum of Modern Art and, in his spare time, used

his new letterhead to write anti-war letters to the liberal politicians whose policies he had advertised in the previous decades.[13]

Even beyond his "Pop Buell" experience, the Vietnam War shook Van Dyke's faith in social documentary. In a 1973 interview, Van Dyke's response to a question about the turn to individualism in documentary film reveals his sense that he had failed at his vocation, as well as his worries about both the war and environmental issues:

> Let me throw out a possible thing. If you, as a filmmaker, saw that, in spite of all the things that have been said, written, and filmed about society, nothing very much had changed, except for the worse, might you not then begin to explore the nature of an individual or individuals, in order to try to find some clue to why, in spite of all the things that we know, all the best will in the world, nice young American boys will go out and shoot men, women, and children down in cold blood—and that we continue to pollute our land, that our soil erosion continues to be a problem. There's something about the human being we don't know, and maybe the artist is trying to use, the film artist is trying to use his medium to get at some of the inner secrets that make us behave the way we do.[14]

Van Dyke's laments about Vietnam and pollution suggest that he had abandoned the pedagogical certainties of the development era. If he was not ready to reflect on his own role in making compelling development and oil propaganda, he was fed up with a society that pursues violent and rapacious ends. Van Dyke's declension narrative also reflects his lifelong love for his time in the 1930s Left, his sense that he had been the freest then and made the best work of his life. "There was ferment in the air," he recalled in 1965, "and we were part of it."[15]

Van Dyke's work in the 1960s for both CBS and the Rockefeller Foundation, detailed in chapter 1, marks the codification of New Deal aesthetics into the stock vocabulary of development in this decade, aesthetics that were then adopted by many filmmakers in USIA and beyond. However, Van Dyke's commitment to a Popular Front ethos, which kept him from embracing the virulent anti-communism of the Kennedy era, also kept him at the margins of the development filmmaking scene. Gordon Parks and James Blue were less connected to this Old Left milieu and were thus able to operate more comfortably amid the anti-communism of the development propaganda world. But as the 1960s wore on, they too began

to feel less comfortable espousing the liberal developmentalist line and began to drift toward leftist scenes and politics.

GORDON PARKS AND FLÁVIO DA SILVA: A "MIXED UP INHERITANCE" AND THWARTED DESIRES

In June 1961, sandwiched between an editorial asking "Are We Wasting Women?" and a feature story wondering "Can the Dolphin Learn to Talk?," *Life* magazine published a sweeping photo essay on Latin America, featuring photographs illustrating the region's racial "mixed-up inheritance" and "rich resources—poorly put to use."[16] The photo essay, above the headline "Prisoners of Our Geography" and the subheading "The Races and the Terrain: A Mixed-up Inheritance," features four mug-shot-like photos of these "prisoners"—"Indian, white, Negro, *mestizo*"—scowling and dressed alike in white shirts, with identically patterned tapestries behind them, demonstrating Latin America's "bewildering diversity." While the tapestries, whose intricate patterns resemble topographical maps, indicate that the men's "prison" is cultural as much as racial and geographical, the text argues that the land—"the ill-balanced geographical inheritances bestowed on Latin Americans"—bears primary blame for "the backwardness, the diversity, the political and commercial disunity which contrast so sharply with the U.S.," making Latin America "an astonishing place to visit, but a difficult area to adapt for commercial growth."[17] The region's racial diversity here becomes a difficult but not insurmountable problem, a problem that will be solved as modernizing projects and development workers find new ways to transform the "difficult" terrain of underdeveloped subjectivities into more orderly modern ones; the cultivation of a more orderly racial schema becomes analogous to, but also the precondition for, physical improvements to the land and infrastructure.

The "Mixed-Up Inheritance" photo essay, with its colorful images and sweeping program for Latin American development, was the last in a five-part Crisis in Latin America series meant to bolster support for the Alliance for Progress, a series which began with, and was haunted by, "the messianic eyes of Fidel Castro."[18] While most of the photo essays in the series point to areas of particular concern for the United States, the final

one is most explicit in diagnosing the problems of the area and promoting the Alliance as the solution. Its photos are accompanied by a lengthy essay by *Life* staff writer Robert Coughlan, in which he lays out a strategy for "full-on psychological warfare" in Latin America.[19] Coughlan argues that discreetly backing non-communist leaders while avoiding "even the appearance of an old-fashioned 'intervention'" is the only way to stave off more revolutions like Cuba's; toward the end of the essay, he reveals that the policies he has been describing and recommending make up the Alliance for Progress.[20] "The Alliance needs vigorous action and concrete, vivid results," warns Coughlin in conclusion, signaling *Life*'s support for the administration's Cold War policies, but also the magazine's intention to push the administration to be more aggressive and "vigorous" in pursuing them.[21]

Far and away the best-known photo essay from the Crisis in Latin America series, however, was a less overtly ideological one, which presented not a broad diagnosis of underdevelopment but an intimate portrayal of a boy and his family. That essay, the second in the series, was by Gordon Parks, titled "Poverty: Freedom's Fearful Foe"; it featured a young, severely asthmatic Brazilian boy, Flávio da Silva, who lived in the Catacumba favela, a neighborhood of ramshackle houses in the hills of Rio de Janeiro.[22] The photo spread, directly enabled by the exigencies of the Alliance, garnered a tremendous number of responses within weeks of its publication, many of them donations to help Flávio and his family. The donations allowed both a renovation of Catacumba and Flávio's transfer to a special school in the United States for children with asthma. However, Flávio was returned to Brazil after two years after his low IQ scores suggested to his teachers and benefactors that he was not as exceptional as they had initially thought. Both Parks's initial photo spread and the film he made about Flávio, the first in his pathbreaking film career, demonstrate his faith in the Alliance's vision of classificatory education and exceptionalism, his sense that he might identify and educate Flávio as an exceptional leader who could propel his entire society toward modernity. However, the aftermath of these productions haunted Parks later in his life and made him question these tenets. The classificatory zeal that allowed for Parks's original intervention, the need to reorder Latin America's "mixed-up inheritance" and identify the exceptional personality

worthy of salvation (as opposed to the masses "starving slowly"), also produced the results that deemed Flávio mediocre, undermining Parks's experiential sense of his young friend's charisma and competence and leaving Flávio hurt and confused.

By the time of the *Life* photo spread, Parks was a well-known photographer, working regularly for *Life* as well as *Vogue* and other fashion magazines. His background was not so different from Flávio's own: born in 1912 in Kansas, the youngest of fifteen children, he lived on the streets as a teenager after his mother died, working at various busboy and porter jobs before buying a camera at a pawnshop and securing a Julius Rosenwald fellowship to work at Roy Stryker's FSA.[23] He subsequently worked for Stryker at SONJ's photography section and then became a staff photographer for *Life*, developing a documentary style that forged intimacy with his subjects.[24] That he was tasked with finding a Cold War story in Brazil was predictable; Henry Luce, *Life*'s publisher, was an aggressive Cold Warrior. Although he had supported Richard Nixon over Kennedy in the 1960 election, Luce quickly began to work closely with the Kennedy administration, while also attempting through his publications to push its policy toward an even harder anti-communist, anti-accommodationist Cold War line.[25]

Despite his many experiences with American racism and his close relationships with Black Power leaders who took a more critical view of US foreign policy, Parks's views on the Cold War and development were not appreciably different from those promoted by *Life*. As he recounts in his 1978 memoir *Flavio*, "The poor [in Rio] were a large part of those already ripening for the sharpest danger facing the Western Hemisphere, a Communist take-over."[26] He explains that "the ratio of increased income against population growth was the sorriest in the world—worse even than Africa," indicating his distance from the recent wave of African decolonization struggles by characterizing the continent as uniformly abject.[27] Parks goes on to explain that "President Kennedy, in a historic effort to cure these ills and counter the threat of political exploitation, had initiated the Alliance for Progress. It was his explicit answer to Teddy Roosevelt's 'Speak Softly and Carry a Big Stick.' He was offering, instead, liberty and free economic development as a way for backward countries to help themselves."[28] Parks thus saw the logic in his March 1961 assignment from *Life*,

which instructed him to "[f]ind an impoverished father with a family of eight or ten children. Show how he earns a living, the amount he earns in a year. Is he a communist or about to become one?"[29]

Parks's reasons for straying from the dictates of his *Life* assignment were primarily aesthetic; in twelve-year-old Flávio, he found a better symbol of Cold War misery and vulnerability to communism than the "impoverished father" he was meant to find. Parks first glimpsed Flávio as he was walking up the steep pathway to his home, "breathing hard, a five-gallon tin of water rocking on his head," "horribly thin" and coughing. "Death was all over him," Parks writes in a memoir entirely devoted to his relationship with Flávio.[30] He and Rio *Time-Life* business manager José Gallo, who acted as his interpreter, might have passed the boy by until "suddenly, with the jerky movement of a mechanical toy, his head twisted sideways to us and he smiled."[31] Parks and Gallo followed Flávio, who invited them into his home, introduced them to his many younger siblings, and began to perform arduous household duties: cooking, sweeping, washing, caring for the younger children. Closely observing him on the first visit, accompanied by Gallo, Parks glimpsed something special in Flávio: "By now José and I could see that he was the one who kept the family going. In the closed world of the shack, tormented by the needs and bitterness of his hungry sisters and brothers, he was waging a hopeless battle against savagery and death. . . . [S]omething, perhaps his calm, set him significantly apart."[32] After this glimpse of Flávio and his family, Parks stayed five weeks in Rio, spending every day photographing and writing about the da Silva family; he shot over fifty rolls of film there and formed a bond with the family and especially Flávio. When he returned to New York, he presented the photos as a twelve-page spread with the cover, reasoning that "Flávio deserved it."[33] While acknowledging that Parks had produced wrenching pictures of Flávio, his parents, and his siblings, *Life*'s editors initially decided to publish only one of the Flávio photos, making Parks so angry he wrote a letter of resignation to *Life* in response to the downsizing of his essay. However, he was saved in the nick of time by a *New York Times* story reporting comments by Secretary of State Dean Rusk, in which Rusk called poverty "the real issue" in the Western hemisphere.[34] *Life*'s editors, ever responsive to shifting political developments, changed their minds and allowed Parks to publish an eight-page photo spread, though not the

cover story he wanted. The photo essay juxtaposes images of the favela ("a Hillside of Filth and Pain") that emphasize its disarray with photos of the interior of Flávio's home depicting pain, violence, and sacrifice; perhaps the most famous depicts a sickly and emaciated Flávio, his face smudged with dirt, lying in bed in a Christlike pose, an image juxtaposed with one of the corpse of his neighbor, but also with the famous Christ statue that looms over the city. If the editorial text reminds readers of the Cold War, reprising the terrain metaphor to warn that "the teeming poor are a ripe field for Castroist and Communist political exploitation," the images and captions focus on Flávio, allowing audiences to see him as industrious, hopeful, dreamy, and tragic.[35]

In extending his assignment and insisting on publishing the many photos of the da Silvas and Flávio in particular, Parks defied some of the aesthetic parameters imposed on him by *Life* in a way that ultimately enhanced the effectiveness of his Alliance propaganda. "Freedom's Fearful Foe" provoked one of the biggest reader reactions in *Life*'s history. Within a few weeks, readers sent in over $30,000 to help Flávio, *Life* was inundated with letters and pleas to help him, and an institute for children with asthma offered to take him in and cure him. *Life* embarked on an extraordinary undertaking, whisking Flávio away to the United States less than a month after the publication of Parks's photo essay, taking charge of his destiny. They used half the donations to bring Flávio to the asthma institute, and the other half to renovate Catacumba and move the Da Silva family to a house in a nicer neighborhood, as well as establishing a trust for Flávio that they kept secret even from his parents.[36] Disorientingly quickly, Flávio was flown to Colorado, examined, and resettled; *Life* controlled his travel and schooling and made unilateral decisions about his suddenly public existence.[37] Parks returned to Rio to take Flávio back to the United States and rehouse his family, photographing their new life, as well as Flávio's journey to the United States, for a second *Life* photo essay, this time a cover story.[38] For the story, Parks documented Flávio's tearful farewell to his mother and the family's descent down the hillside to their new home (though not the woman Parks recalls grabbing his shoulder on the way down and asking, "What about us? All the rest of us stay here to die!," for whom he had no answer), as well as Flávio's arrival in Colorado, his doctor's visit, his new saddle shoes, his attempts to play basketball and

baseball, and his newfound friendship with a blond boy. The cover depicts him in a big white bed on a fluffy pillow, wearing clean white pajamas and joyfully clutching a stuffed animal, while the first two photographs of the article contrast the Christlike image of him in bed with an image of him joyfully swinging on a swing.[39]

Parks seems to have made his short film *Flavio* on his second trip to Brazil in July 1961, as he was preparing to take Flávio away and show his family their new home. With narration written by Parks in Flávio's voice, the film depicts him as Parks first saw him, conveying some of the beauty and magic of their initial encounter while contrasting it with the brutality and suffering of his everyday life. The film opens by panning across a still image of the stark, falling-down favela before following Flávio walking up the steep hill of Catacumba, his tiny body straining under the weight of a barrel of water he carries on his head, his ribs painfully visible. But despite these signs of suffering and strain, Flávio's walk is given a magical look by the fog that seems to follow him up the hill, accompanied by slow flute music and his voiced observation that "the fog tickles my ankles and toes and wakes up my legs." After this moment of whimsical detail, the film returns to establishing the classic "before" shots of the development film, repeatedly contrasting Flávio's buckling body, made all the more ominous by a child-sized coffin being borne down the mountain in his path, with the birds soaring in the air overhead. The camera again pans over still images, this time of Flávio's exhausted parents, with his voice-over introducing them: "[T]hat's Papa. He says God forgot us, but he still goes to church. Mama never smiles." The camera then tracks Flávio's morning routine, following him as he makes a fire, brews coffee, and expertly cooks breakfast for his nine siblings, cutting periodically back to the birds above.

Brief and dreamlike, the film manages to convey both the squalor in which Flávio lives and the magic of development that may liberate him. This is Parks's second attempt to capture his encounter with Flávio; as Jay Prosser points out, such attempts became compulsive over the course of Parks's life, betraying how Flávio continued to haunt him.[40] The film does not seem to have been screened much, apart from occasionally in retrospectives of Parks's work, and Parks is oddly silent about the film in his voluminous corpus of memoirs; he mentions buying a motion picture

camera "to convince those who just couldn't believe such poverty existed" but says nothing about the shooting experience, his opinion of the result, or his plan for distributing the film to the skeptics he mentions. However, the film is important because it marks the beginning of what will become a highly successful and pathbreaking filmmaking career for Parks. It was Parks's bond with Flávio, and his related desire to show the world both the ravages of underdevelopment and Flávio's potential to overcome it, that inspired Parks to pick up a movie camera.

For Flávio, however, the better life he and Parks dreamed of was never realized. Early assessments predicted his success far beyond the completion of treatment for his asthma: a July 1961 psychological evaluation predicted that Flávio's "intellectual functioning will show marked gains in the next several years."[41] Similarly, the director of the Asthma Institute reported in 1961 that *Life* employee and Flávio's sometime caregiver Ruth Goncalves "describes Flávio as an intelligent lad whose learning abilities and processes she characterizes as 'dry soil.'"[42] This characterization echoes the "races and the terrain" analogy from the "Prisoners of Geography" *Life* photo essay; the comparison with "dry soil" suggests that Flávio, transplanted, has finally overcome the barrenness of his home. During his two-year stay in Colorado, Flávio did in fact adapt and excel: he learned to speak excellent English, became literate in both English and Portuguese, began to respect the private property of the other children, improved his table manners (which were a constant preoccupation of his various *Life* guardians), and made friends. After two years, however, the limits of *Life*'s benevolence became clear, and Flávio was sent home again. Part of the reason for Flávio's return, Parks writes in his memoir, is that his IQ scores did not improve enough to justify continuing his education in the United States. "The major problem" writes Parks, "was that Flávio was below average, a problem that many at the Institute, having been caught up in his charm and social amenities, were reluctant to accept."[43] On the eve of his return to Brazil, Flávio, reunited with Parks, cornered him multiple times, begging Parks to adopt him or otherwise help him stay in America. Flávio's feeling that he belonged in America persisted when he was returned to Brazil and placed in a boarding school. "America is the only place to be," he told José Gallo, shortly before his expulsion from the school. "Brazilians are awful and this school is awful."[44]

As Prosser observes, "ultimately what Parks' photographs 'take' from Flávio is Brazil"; he never feels at home there again. Flávio da Silva, now in his seventies, has articulated this permanent sense of dislocation ("I felt that everything had been stolen from me") whenever he has been interviewed: to José Gallo in 1961, to Parks in 1976, then again in periodic exhibitions that feature Parks's photos of him, well beyond Parks's death in 2006.[45] In 2016, when da Silva was interviewed for yet another art exhibit of Parks's photos of his malnourished childhood, this time at the Getty Museum, he was still bewildered at the course his life had taken: "Yes, I wished to stay," da Silva tells the interviewers, in English, in front of the run-down, two-room house in Rio where he ended up. "If I could have run away I would have." Asked about why he was not allowed to stay, he gives a halting answer: "I think so many times about the situation. I just can't say much because . . . I passed most of the time thinking, after I know that the people weren't for my staying and . . . I start to think, why they not do it, why they not give the permission for it?"[46] Da Silva's continual bewilderment reflects the schema of modernization inculcated in him; told over and over as a child that he was special, that he would be saved, that the place he came from was a no-place where people were "living out their days" and "starving slowly," from which he must strive to escape, he began to believe these stories. Then he was told, equally forcefully, that he had reached his potential and that he would be returned to the no-place he had been taught to disdain. This is the feeling James Ferguson describes, in his study *Expectations of Modernity*, as one of being "thrown out of the circle of full humanity"; Ferguson's focus is on the Zambian copperbelt, where the modernization its workers were promised never arrived.[47] Da Silva's account suggests just how brutally traumatic the effects can be of the betrayed project of modernization on those who were told, and believed, that the comforts of modernity would be theirs with enough striving.

For Parks, doubts about the enterprise of saving Flávio were present from the beginning. On the first trip he wrote in his diary, as he watched Flávio daydreaming and plotted a trip down the hill to Copacabana beach, which Flávio had never visited: "Maybe one trip outside will, if he lives, give him the incentive to get out of this. I may create a longing impossible to fulfill, but I think it is worth the gamble."[48] At the beginning of the 1978 book, however, Parks recognizes that maybe the gamble was not worth

taking after all, that he has, in fact, "created a longing impossible to fulfill." He writes on the first page of *Flavio*, "[A]s a photojournalist I have on occasion done stories that have seriously altered human lives. In hindsight, I sometimes wonder if it might not have been wiser to have left those lives untouched, to have let them grind out their time as fate intended."[49] This insight seems to be why he wrote the 1978 book, which ends with his optimism that Flávio's young son might have a better life, having "escaped to the top rung of an invisible ladder leading up from the mire of poverty and misery."[50] But Flávio's last words to Parks at the airport at the end of the 1976 trip demonstrate his persistent pain and longing, undermining the hopeful conclusion and bringing back the ambivalence with which the book begins. "I think almost every day about going to America, Gordon," Flávio says. "Please Gordon, see if you can get me back there."[51]

Parks's most successful film is one in which he departs most fully from, and even mocks, the liberal tenets to which he ambivalently adheres in his various works about Flávio. That film is *Shaft*, which with its 1971 release helped to touch off the diverse creative Black cinema movement that would be labeled "blaxploitation." *Shaft*'s eponymous protagonist is a Black Power noir hero who derides the liberal establishment, staring down police and gangsters and collaborating with Black Panthers. One of Shaft's sharpest lines of the film, in response to the police lieutenant's query about why he is going to see the white mafia boss, is, "I just want to find out his views on urban renewal." This line, delivered with derision by Richard Roundtree, ironizes the whole liberal project of the postwar era, the "renewal" of terrain that is meant to show concern for the racialized poor while actually displacing them, pointing them toward self-help through hard work and discipline while simultaneously destroying their homes and communities. But while *Shaft* depicts a triumph over the liberal forces of order—demonstrated not only by the "urban renewal" line, but also by Shaft's mocking final retort to the lieutenant's request that he close the case, telling the lieutenant to "close it [him]self"—Parks never achieved such success in his attempts to assist Flávio. In 1970, as Parks was filming *Shaft*, the Brazilian government was demolishing Catacumba; when Parks returned in 1976, the favela was entirely gone, the residents relocated around the city, the material effects of the *Life*-funded self-help projects entirely obliterated.

In the end, Flávio's story is a typical narrative of development, one that reveals the frustrations of its objects when development inevitably falls short of its promises. Flávio embodies and makes specific the plight of the anonymous boys filmed poetically by Blue and Van Dyke, the ones dreaming of flight in *Rincon Santo* and reciting "the geometry of the future" in "So That Men Are Free." As Parks knew, Flávio's expectations were deliberately, disorientingly raised in the development moment of the Kennedy years; he became, for a time, a symbol of this moment and the hope it briefly contained for Catacumba and all of Brazil. Flávio's abrupt disqualification from the status of improvable object of development happened partly because Brazilian public opinion became less important to the United States: over the course of 1963 US policy became less supportive of the country's liberal-left president and more supportive of the military that would take over in a coup the following year. But Flávio's disqualification also stemmed from the IQ test, the sense that Parks and his other *Life* benefactors had misclassified him. "The truth was inescapable: we had dreams for Flávio da Silva that were hopelessly beyond his reach," writes Parks. "It was as if we expected abundant fruit from a sapling already gone barren."[52] This repetition of the assertions of "barrenness" alongside Parks's accounts of Flávio's superhuman ability to care for his siblings, his quick absorption of language, and his ceaseless longing for a better life—the evidence, in other words, of his desire and potential to flourish—demonstrate the damaging and unjust character of *Life*'s, and development's, desire to classify everyone according to criteria they themselves have set. But they also point to the more fundamental brutality of development's individualism, the idea that Flávio either possesses untapped potential that allows him to deserve and get more than his fellow favela dwellers, or does not and is thus deserving, with the rest of them, of nothing.

JAMES BLUE AND USIA

While Gordon Parks had only a tangential relationship to USIA, and Van Dyke had a contentious relationship to it, a new generation of filmmakers felt at home there. The younger generation of USIA filmmakers were

enthralled by French and Italian rather than Soviet cinema and were generally less connected with socialism and more comfortable, at least for a time, with Cold War liberalism. The most celebrated among this younger cohort of USIA filmmakers was James Blue. Guided by the avant-garde stylistic training he had learned in France, but not by the leftism of his teachers there, Blue refined the vocabulary of the development film as it was beginning to harden into cliché, bringing a self-consciousness to development's stock scenes and voice-overs, not to critique development but to make it new. USIA was able to capitalize on Blue's desire for both stylistic freshness and a connection with his subjects. Eventually, however, Blue turned his self-conscious skepticism on USIA and the policies it helped shape, questioning both US development objectives and the uses of his own films in achieving those objectives.

USIA's role in the government expanded considerably during the 1960s. The Kennedy administration invited USIA officials to attend high-level planning meetings, where they helped to formulate policies rather than simply promoting them.[53] Kennedy's USIA, headed by journalist Edward R. Murrow, also changed its messaging strategy, adopting a new "soft sell" approach that stepped back from obvious propagandizing in favor of subtler tactics that focused on both artistry and intimacy. This change was particularly pronounced in the motion picture division, headed in those years by Hollywood producer George Stevens Jr., whose father had directed acclaimed 1950s films such as *Shane* and *Giant*. In an effort to "revive the government's documentary tradition," Stevens recruited at least eighteen mostly young (and all white and male) documentary filmmakers, including Blue; Bruce Herschensohn, who later became head of USIA's film division; Charles Guggenheim, who won an Academy Award for his 1964 USIA film *Nine from Little Rock* and went on to have a distinguished documentary career; and Leo Seltzer, who was part of Van Dyke's New Deal–era group and made popular films for the USIA about John Kennedy and Jackie Kennedy's state visits.[54] Stevens invited legendary documentary filmmaker John Grierson for a visit to advise these filmmakers on their craft, asserting that USIA films would be judged on their "general tone, style and attitude," their "very *personality*" as much as their political content.[55] He gave his filmmakers autonomy, asking only that they keep in mind, however subtly, USIA's five major themes of Berlin, disarmament,

free choice, modernization, and the United Nations.[56] The films, as Nicholas Cull writes, "typically showed the human side of one of these issues."[57]

The new orientation of USIA films toward documentary artistry and "the human side" of geopolitics was particularly congenial to the modernization theme. From its beginnings in the 1950s, USIA had been committed to furthering US modernization and development goals.[58] However, USIA's 1960s films moved away from the old strategies of touting the supremely modern systems that characterized the United States and retelling the origin story of its industrial development as an object lesson for new and "underdeveloped" nations, a strategy that, as chapter 2 demonstrates, had not worked particularly well with audiences. Even those USIA Alliance-supporting films that show less documentary artistry, such as the 1962 Alliance film *Land and People*, feature close-ups of farmers rather than stock shots of gnashing machinery. Touting land reform as both a productivity measure and a fulfillment of "the age-old longing of farmers for their own land," *Land and People* focuses on the faces of peasant farmers, whom it often calls "settlers," rather than on the specifics of land distribution and colonization programs. Other early 1960s development films also attempt to show this "human side," notably *Bridges of the Barrios*, Herschensohn's 1963 film. Narrated by Paul Newman, *Bridges* is focused on Civic Action, the Alliance military modernization program, in Ecuador. But the film shows very little footage of soldiers and their development work, depicting instead the close-up faces of barrio dwellers, mostly young boys, as they carry water, laugh together, sit in the classroom, and dream of a better life. Guggenheim's 1963 film *United in Progress*, narrated by John Huston, is less intimate than *Bridges* but employs spectacular workerist imagery, intercutting scenes of Kennedy addressing crowds in Latin America with scenes of content factory workers, including children, surrounded by machinery framing their faces with the angular stark beauty of futurist art.

James Blue was a perfect fit for Stevens's film program. Born in 1930, Blue was considerably younger than Parks, Van Dyke, and the rest of the New Deal cohort who went on to make development films. He was affected by the Depression (his family lost their home in Oklahoma and moved to Oregon, where he grew up), but rather than learning his craft in the New Deal milieu, he learned it in Paris; after early experiments

making comic films at the University of Oregon, he became one of the only North Americans (among many Latin American and European film-makers) to study at the Institut des hautes études cinématographiques in Paris, enrolling in 1956. His stylistic influences were drawn from Italian neorealism and the French New Wave, especially the experimental film-makers Jean Rouch and Chris Marker. Despite an interest in the radical-ism of the filmmakers he learned from, however, Blue was a liberal. His parents were conservative, and he defied them to support the civil rights movement, but he remained moderate throughout his life, a believer in democracy and diversity rather than the Marxism of many of his French mentors.[59]

Blue's moderate politics suffuse his first and only fictional feature film, *The Olive Trees of Justice* (1962). Based on Jean Pélégri's novel about the Algerian struggle for decolonization, *Olive Trees* is a naturalistic, med-itative story in which French settler/landowners and Algerian work-ers alike are treated sympathetically. The film is told from the point of view of young *pied-noir* Jean; in a style that echoes Italian neorealism, a handheld camera follows Jean as he walks the streets of Algiers. The film features flashbacks to Jean's childhood: he plays harmoniously with Al-gerian boys in his father's vineyard but also sees Muslim vineyard work-ers being harassed. Blue trusted viewers to understand these scenes as particularly, poignantly unfair since Muslims did not even drink the wine from the grapes they cultivated. The film, however, does not explicitly sig-nal this harassment as unjust, a move Blue argued would have "defeated its purpose as poetry."[60] The film received the Critics Prize at the 1962 Cannes Film Festival, a rare achievement for a US filmmaker in those years; French reviewers called it a "drama of conscience" and a "drama of hope."[61] Although the film's liberal-colonial perspective did not age well after Algerian independence (Blue had trouble finding a distributor and complained that both the "extreme Left" and the Right rejected it for its evenhandedness), it did get Blue his USIA job. Stevens was at Cannes, and *Olive Trees* deeply impressed him; upon meeting Blue, he recalls in his memoir, Stevens "knew immediately he was the kind of filmmaker we needed at USIA."[62]

Blue soon became a USIA star, charting the way for its new "soft-sell" approach; his cinematic style absorbed the naturalistic look and attention

to injustice of neorealist and New Wave films while jettisoning the radical politics of those traditions. For *School at Rincon Santo*, he recorded the voice-over himself, working hard on the voice tracks to establish what he called the "hushed respectful approach of someone who does not want to interfere."[63] This stance of "noninterference" worked on multiple levels: by showing himself not to intervene in either his subjects' experiences of development or his audiences' experiences of viewing that development, Blue conveyed a sense of both the sophistication of US culture (the "personality" Stevens sought) and the imagined noninterventionist nature of the Alliance. The two other short films Blue made in Colombia, *Evil Wind Out* and *A Letter from Colombia*, also in summer 1962, were similarly styled as "non-interventions"; they emphasized the human side of development by representing the joys of witnessing an experiential sense of order. All three films created worlds in which this strict hierarchical ordering could sit alongside joyful, collaborative crowd scenes that suggested democratic awakening.

Ironically, given the emphasis on democratic participation in Blue's Alliance films, Colombia was a country viewed by the United States as particularly congenial to its policy interventions during the Alliance years precisely because of its lack of substantive democracy. Due to a 1958 governmental arrangement that guaranteed power sharing between its two major political parties, if not an end to the waves of political violence known simply as *la violencia*, Colombia distinguished itself in the 1960s as a stable anti-leftist country where the United States could showcase its development initiatives in a way that would not depend on election cycles.[64] As Jeffrey Taffet points out, Colombia was the only country to receive large amounts of Alliance aid that was not tied to the threat of an ascendant Left; rather, the US government chose Colombia as a "laboratory" where it could demonstrate the validity of its policy prescriptions and development projects.[65] Murrow wrote excitedly to Kennedy aide Chester Bowles in August 1962, as Blue was making his films there, to affirm enthusiastically Bowles's suggestion that "Colombia serve as the spearhead for the Alliance for Progress."[66] Despite economic difficulties due to falling coffee prices during the 1960s, the United States convinced Colombia to follow its demands for currency devaluation and trade liberalization and rewarded successive governments with development aid,

amounting to the second highest level of US aid for any Latin American country over the decade.

In contrast with *The Olive Trees of Justice*, in which violence is rarely overt but constantly simmers beneath the surface of everyday inter-actions, Blue's Colombia films contain very little conflict: there is no trace of *la violencia*, nor even of the Cold War, in his quiet stories of remote communities embarking on self-help projects with a nudge from infal-lible visiting experts. *Evil Wind Out* is the only one of the three films that contains even interpersonal conflict. In this film, a young boy, because of an eye problem diagnosed as "evil wind," is menaced by the folk healer—in an early scene, the healer holds a candle near the boy's head and the boy cries out and falls—and shunned by the other villagers. However, this conflict quickly dissipates (and the folk healer disappears) when the boy agrees to see a visiting doctor, who quickly cures him; the eye problem is due to a vitamin deficiency, though the film is much more concerned with hygiene than with how the boy will get proper nutrition. After the boy has been healed and the town has expressed its happiness and grati-tude by constructing a new health center, villagers crowd around the health center window, jostling to see the clean white equipment. The climac-tic scene is similar to the climax of *Rincon Santo*, with the villagers lov-ingly, spontaneously uniting to gaze at a spectacle of modernity. More than *Rincon Santo*, though, *Evil Wind Out* cleverly reveals its own ar-tifice, accompanying early "before" scenes of "underdeveloped" laboring women and disheveled children with the assertion in the voice-over that "four months before these films were made, in this small Colombian vil-lage, seven children were dying every week." But despite cluing the viewer in on the fact that the scenes of lackluster labor at the beginning of the film and those of jubilant regimentation at the end were actually filmed during the same period (rather than before and after the transformation of the community), the film's imagery recounts a stark and simple de-velopment narrative, powerfully depicting a progression from dusty and despondent underdevelopment to joyful and clean modernity under the watchful eye of the doctor.

A Letter from Colombia approaches the form of the development film with even more self-consciousness than *Evil Wind Out*, indicating that a certain kind of filmic depiction of modernization had already crystallized

into cliché by 1962. As Katherine Jackson and Blue himself note, the film pays homage to Chris Marker's 1957 film *Letter from Siberia*, which plays with conventions of Soviet and US propaganda as well as "objective" reporting by, among other playful experiments, repeating the same sequence of Siberian scenes accompanied by different voice-overs.[67] Blue's *Letter*, however, sidesteps the political and formal questions of Marker's film and eschews its sometimes absurd humor; instead, *Letter* uses its self-conscious voice-over to restore a fresh earnestness to the development mission and the development film alike. After a gauzy beginning in which the camera pans over mountains, makeshift shacks, and running children, the letter-writer narrator confesses, "I have come here to make one of those films about progress that you see from time to time. . . . Progress with a big P that you can measure in tons of bricks and miles of road." However, Blue quickly assures the viewer of the film's sincerity, using this self-conscious jibe at progress to differentiate his good-faith attempt to make a development film from other, clumsier and more universalizing efforts: "This is about my search for that progress, what I found, and where I looked to find it," the narrator confesses, as the film shifts to indoor space, into a room with a woman stacking and polishing coffins. "Here there was much to be done," the narrator intones, "in this land where death was accepted as a part of daily life." The film's rejection of "progress with a capital P," it soon becomes apparent, signals Blue's rejection not of large-scale interventions like dam building (which were encouraged by the Alliance for Progress and appear in the Cauca Valley section of the same film), but rather of them as compelling subjects for film treatment. Instead, Blue's film posits that inspiring personal stories of learning and transformation can sell the Alliance's interventions more effectively than films that attempt to depict and explain large-scale changes in agricultural techniques or economic policy.

A Letter from Colombia, like *Rincon Santo*, focuses on school as a key location where development takes place, but *Letter*'s experimental narration allows the film to expand its vision of Colombia's students beyond the small boys who are the protagonists of so many development films. First, over a series of close-ups of boys at an agricultural school, the voice-over explains that "these are the sons of campesinos. Upon the faces in this school, a look of intense learning. Remember that look, we'll find it later

somewhere else." "That look" is found again fairly quickly in the film, in an episode of a development worker, presumably a graduate of the agricultural school, teaching a farmer an unspecified new chicken-farming technique. As the camera zooms in on the farmer's wrinkled, inquisitive face, the narrator concludes: "And suddenly, a sign of progress. Not machines, nor factories, nor steam-driven turbines, but a spark of interest in an old man's eyes. The look of a student learning, you remember, when he thought there was nothing more he might learn. A kind of miracle in a chicken coop." By interpreting the chain of close-ups as straightforward "looks of learning," asserting that the transmission of knowledge happens in only one direction (that the old farmer cannot impart any of his own chicken-farming wisdom to a younger trainee), the narration uses the experimental essay-film form pioneered more playfully by Marker to close off rather than open up ideas about development and progress.

Blue's Colombia trilogy was celebrated by US and global spectators. USIA officials were impressed; Stevens began to show *Rincon Santo* in screenings to US government officials and reported that all were impressed by the film, that "people laugh at each appropriate moment and are moved when they should be moved."[68] The films also won several European film festival prizes: *Rincon Santo* and *Letter from Colombia* won prizes at the Venice International Documentary Film Festival (*Letter from Colombia* won two), and *Rincon Santo* won Best Documentary at Balboa and Amsterdam festivals. The films were shown at US universities and screened widely around the world. Not many complained about them, though Van Dyke did write to the *New York Times* (in support of its film critic's plea for USIA films to be screened in the United States) that while *Rincon Santo* was "very skillfully made," "one begins to wonder how the foreign audience (especially Colombian) would react." "Surely they know that a new building is of limited value without a change in the curriculum and an increase in the number of trained teachers, and very few of them are aware of the fact that wealthy Colombians pay no income taxes to support such changes. Are we living up to our responsibilities to suggest, as we do in such films, that we will underwrite all the reforms that are so essential?"[69]

Apart from Van Dyke's mildly dissenting voice, Blue's Alliance films were a resounding success. A May 1963 memo reported that USIA posts in twenty-eight countries had ordered 322 16 mm prints of the three films

for nontheatrical showings, and 53 for theaters, and described favorable reactions from audiences in Ethiopia, Pakistan, India, Israel, Rhodesia, and Togo.[70] The films not only impressed viewers but also sold them on the Alliance: Stevens boasted of a study on *School at Rincon Santo* involving five hundred people, in which there was an 18 percent rise in approval of the Alliance for Progress after seeing it.[71] While Blue's brief films impressed audiences around the world with the beauty of person-to-person development, they generally did so with the help of Hollywood cinema: Stevan Larner, Blue's collaborator, recalled in 1980, "On my first trip to Latin America I asked the USIS people what sort of film went over best with their audiences. The answer, without exception, was *The Golden Age of Comedy*, a '30-minute compilation of silent-movie comic greats,' which USIA would generally show before 'the freight' (the film with the message they wanted)."[72]

As much as their sincere content, the impact of these films on the public approval of the Alliance casts doubt on subsequent critics' attempts to read their playful lyricism as a critique of development or even a gentle subversion of the Alliance's aims.[73] Blue's writings, the films' sense of wonder at community self-help ventures, and audiences' positive reactions to the films all point to Blue's complete commitment to, and successful selling of, Alliance for Progress interventions. Blue's films, in fact, represent the most successful output of the Alliance, advancing narratives of development, of local deficiency and the overcoming of poverty through education and self-help, that retained their power long after most in Latin America had lost faith in the Alliance's ability to support those aims in a meaningful way.

Blue's most famous film for USIA, *The March*, was also the one that made him begin to doubt the organization's aims. Filmed in Blue's intimate, offbeat style, *The March* is an account of the 1963 March on Washington. The film includes not only scenes of Martin Luther King Jr.'s "I Have a Dream" speech and crowd reactions to it, but also the preparation the day before of "80,000 cheese sandwiches," bus rides into Washington, the crowds on the hopeful day, and the marchers sleeping peacefully on the bus home, dreaming of freedom. The film, which Stevens commissioned Blue to make after the civil rights film by Van Dyke, Ferguson, and Lomax was shelved, is a departure from Blue's self-referential, clever

Alliance documentaries. It provides only spare narration (again by Blue himself) and gleans its drama from the excited, diverse faces of ordinary marchers and their singing, chanting, and commentary. Unlike the Colombia trilogy, it allows its subjects to speak, luxuriating in their impassioned improvisations as they chant, sing, shout, and joke together. The film shows neither white supremacist violence nor a particularly militant set of marchers, and Blue even changed the title of the film from *The Time Is Now* to the less confrontational *The March*.[74]

Even with its less confrontational title, Blue's depiction of crowds collectively demanding "freedom now" upset government officials. Presidential adviser Clark Mollenhoff worried that the film would confirm to African audiences that Black Americans were "under colonial rule"; Attorney General Robert F. Kennedy was angry that it didn't mention him or his brother; and he and Lyndon Johnson were both upset at the inclusion of an interracial couple on the bus, though Johnson and Senator Richard Russell agreed that they were glad the film did not show protestors "lying down on the road."[75] Blue was forced to appear before the President's Advisory Committee on Information, where he defended *The March* as "a democratic and American film."[76] In the end USIA decided to show the film internationally, but with a disclaimer at the start by incoming USIA director Carl Rowan; Rowan cited JFK and Johnson's approval of the march and touted it as "a profound example of the procedures unfettered men use to broaden the horizons of freedom and deepen the meaning of personal liberty."[77] Despite these concessions, the film's hands-off method, as well as its attention to the spontaneous passion of the marchers, creates a sense of simmering excitement. Meanwhile, Blue's experience defending *The March* seems to have led him into a period of questioning; on a Ford Foundation grant, he began a project interviewing directors about their work with nonprofessional actors. Stevens was dismayed at Blue's hiatus from filmmaking, remarking that "for some reason, he went in another direction," which Stevens saw as an abandonment of "his great strength—his humanity and vitality of expression and insight."[78]

Blue, like Van Dyke, had his faith in US foreign policy and its propaganda further shaken by the Vietnam War, though he never quite said so publicly. He worked anonymously on stories in *Film Comment* critical of USIA's work in Vietnam, but he also returned to USIA filmmaking briefly

Figure 22. "These children, at a time when the world is not growing enough food, look beyond the images in this dark box and begin to dream of a better life," *A Few Notes on Our Food Problem* (dir. Blue, 1968)

in the late 1960s.[79] The films he made in this period do not break completely with the US modernizing agenda, but they do gently question its notions of unassailable expertise, and the usefulness of US propaganda, in a way his Alliance films do not. His 1968 Academy Award–nominated USIA documentary, *A Few Notes on Our Food Problem*, while aligned with mainstream ideas about food scarcity and population growth, questions the cinematic project of creating desire in spectators. The film, which I discuss more fully in the next chapter, contains an early scene of a roving film projector in urban India, thronged with children, their expectant eyes peering through the peepholes. "These children, at a time when the world is not growing enough food, look beyond the images in this dark box and begin to dream of a better life. Their dreams are a force that can change the world," warns the voice-over. Taking as its starting point the

child-subjects of development upon whom Blue's earlier films also focus, *A Few Notes* asks what it means to create new desires and expectations in people when the resources (at least in his telling) to satisfy them do not exist. Blue thus argues here for cinema's immense power to reorganize the subjectivities and desires of spectators. But he also begins to worry about the consequences of this power; having made people dream of a better life, he contends, now film must account for a world that cannot support their dreams.

In other ways, too, *A Few Notes* constitutes a break from the certainties of the previous decades of development. Even by allowing farmers to speak for themselves, often to explain the reasons they are not producing more, Blue's film formally breaks with development film conventions. But while it accommodates this questioning, the film still imagines that any change will have to be initiated by experts; as Blue explained in a note to USIA's Washington office: "Goal of film to show farmer's perspective to influentials."[80] Blue would abandon his trust in experts and move in a more participatory direction in the 1970s, turning away from US propaganda to make documentaries for local Houston television: *Invisible City* (with Adele Santos) and *Who Killed the Fourth Ward?* In these later films, as Peter Lunenfeld argues, Blue moved beyond "constructing merely a 'self-reflexive' look, concentrating on the relationship of the work to its audience, incorporating interactive feedback, and reflecting these processes through the construction of whole episodes rather than simply at the level of the composition of the shots."[81] This cinematic style is of course markedly different from the Colombia films, which, like the Alliance itself, forged intimacy with their subjects without inviting any real participation from them.

A Few Notes on Our Food Problem partially perceives one of the key dangers of the modernization and development frameworks that dictated so much Cold War policy: experts can be, and often are, wrong. Development planners compel mass migration to cities, then decide that increasing rural production is more important; tempt farmers to abandon ancient farming methods and use pesticides, then in the next decade instruct them to take up sustainable agriculture; preach male supremacy and getting women out of the fields, then bestow gender equality on those same communities. *A Few Notes* sensitively explores this push and pull,

capturing how non-Western communities have been incited to desire a Western lifestyle and then informed that they are straining the world's resource capacity. These conflicts in development around food and population, together with the utter failure of the forced modernization projects of the Vietnam War, led to a crisis of representation for USIA: Nixon's USIA, led by conservative director Frank Shakespeare, began to rethink its commitment to development. Indeed, while USIA did exhibit some development films in the 1970s, they were made by other organizations; the era of both optimistic "nation building" and documentaries that conveyed the "American personality" was coming to an end.[82]

CONCLUSION: COLD WAR DEVELOPMENT'S OTHERS

In a 1967 review of Walt Rostow's *Stages of Economic Growth*, dependency theorist Andre Gunder Frank claimed trenchantly that "it is impossible, without closing one's eyes, to find in the world today any country or society which has the characteristics of Rostow's first, the traditional stage."[83] But as this chapter has demonstrated, one need not have closed one's eyes in the 1960s to see these isolated societies: rather, they appeared on screens everywhere, in documentary films about unchanging villages being awakened by the inexorable forces of modernity. If the ethnographic film had created the "untouched" village, the development film rendered it abject and malleable.

This chapter has told the story of three liberal American artists who, in the 1960s, mobilized different radical aesthetic traditions to help solidify and popularize a cinematic vocabulary of development. Van Dyke, Parks, and Blue dramatized the pedagogical imperatives of the Alliance for Progress, translating them from a national level—as the United States pressed Latin American governments to remove trade barriers and subsidies, build up their militaries, colonize "unused" lands, and write well-organized grant proposals for infrastructure projects—to an intimate, personal scale. For all these artists, the hopes for the Alliance were encapsulated by the upturned, sunlit face of a young boy, whether carrying a bucket of water, in a classroom learning "the geometry of the future," or in a field dreaming of freedom. The images of these boys, their promise of

a more orderly yet freer future, for a time could cover up the anti-leftist militarism that was the only consistent aim and result of the Alliance for Progress, as well as banish the contradictions in a liberalism that insisted education would bring "revolution" while maintaining highly unequal existing social structures. As Flávio's story shows, the weight of these hopes was hard to bear for those who embodied development's failed promises.

But what of the others in these stories? What of the women who have "too many children," who linger in doorways and fold clothes in cramped indoor spaces, who crowd around the edges of so many of the development cinematic experiments? What of the woman who demanded of Parks "What about us?" as he spirited Flávio and his family away from the favela? The next chapter charts the beginnings of women's emergence as the subjects of development cinema, and the central subjects of development, in experts' growing concerns about population growth and population-focused development films. These films, of which *A Few Notes on Our Food Problem* is an example, depart from earlier development films in their new worries about excessively fertile rather than dramatically barren land and people. However, the development regime and its films quickly assimilated feminist critiques of the population thinking on display in *A Few Notes*, adapting to but also shaping shifting gender norms. But just as it learned to incorporate liberal feminism, the development film went into decline, as states abandoned and privatized their development projects.

6 Women in Development and the New Experiential Documentary

James Blue's Oscar-nominated film *A Few Notes on Our Food Problem*, released in 1968, registers a shift in modernization thinking. Throughout the thirty-five-minute film, Blue uses his characteristic self-reflexive style to question the conventional wisdom that farmers are not producing enough food for the world out of laziness or a lack of entrepreneurial spirit. Unlike previous development films, it contains drawn-out interviews with farmers in Kenya and India about the difficulties of selling the food they produce. The film also presents population growth as a problem in a way earlier development films had not: in the opening scene the screen fills up ominously with flapping ducks, then moves to urban crowds in India who "begin to dream of a better life," represented by mobile cinema vans and the worlds depicted in the films screened inside.

If the film's sensitivity toward farmers and its worries about the desires awakened by previous waves of development communication are new, its stolidly patriarchal ideas are familiar. While women are depicted engaging in a variety of agricultural tasks, it is the male "farmer" who is interviewed, whom the film celebrates, and with whom the voice-over encourages viewers to identify. Proposing an identification between the viewer and "the farmer," the voice-over posits that "you send your wife to a nearby market"

as the camera captures the woman walking away. The film's final scene objectifies women more spectacularly, cutting between grain being unloaded from a giant ship and a woman giving birth in order to emphasize the necessity of maintaining a balance between the two processes. Through this contrast between the silent laboring women who serve as symbols of over-population and the always-male farmer who at last speaks for himself and with whom audiences are made to identify, the film recapitulates the standard gendered logics of the development film with a participatory twist.

By the mid-1970s, however, Blue was working on films that not only disavowed patriarchal logic like that on display in *A Few Notes* but painted that logic as entirely foreign to development circles. *Women in a Changing World*, a 1975 documentary to which Blue contributed, opens with a montage featuring a Chinese woman sweeping, an Afghan burqa-clad woman holding a child, and a Kenyan woman milking a cow with a baby on her back. A female voice-over proclaims that "the legal position of women in many countries makes her a second-class citizen." The 1974 film in the same series, *Andean Women*, rebukes patriarchal ideas more subtly, depicting Bolivian Aymara women engaged first in the back-breaking labor of hand tilling the soil and planting potatoes while men assist, then sitting in a circle shucking corn while some also hold and nurse babies. As they engage in constant activity, the women assert, "Men work a lot . . . women don't," and otherwise devalue their own labor, which is clearly on display in the film. Documenting these contradictions without comment, the film serves as both a naturalistic portrayal of the women's everyday lives and a feminist critique of the oppression they experience. More precisely, as the ad copy proclaims, the film argues implicitly that the women "express agreement with the dominant Hispanic ideal that women should be subservient to men and assigned to tasks appropriate to their limited strength and intelligence." *Women in a Changing World* expresses the same sentiment directly, with the voice-over offering a definition as Andean women labor onscreen: "machismo: the Latin American male attitude of being the privileged ruler of the family." The extent to which development institutions had until very recently shared this attitude and imposed it on rural societies is erased here; the undervaluing of women's labor, newly visible as a problem in development, was quickly projected onto Latin American culture.

Figure 23. "Men work a lot . . . women don't," *Andean Women* (dir. Miller, 1974)

With the understanding that stylistically cutting-edge development films were key locations where shifts in development logics were enacted, this chapter pieces together a new account of the complex transitional period for development that was the 1970s, a time characterized by scholars as alternately liberal-left and redistributionist, feminist, aggressively interventionist, and brutally neoliberal in its installation of market logic everywhere and its hyperexploitation of particularly global South women workers.[1] The first half of the chapter explores the shifts in the ideology and image of development between 1968 and 1975. The rapid move to center women in development is first signaled by population-focused development films like *A Few Notes*, which warp development's hopeful orientation, infusing it with a horror-like atmosphere by counterposing women's monstrously reproductive bodies against underproductive fields. These films register how development experts reached for the "population problem," and implicitly women, as a cause of the failures of

the modernization initiatives of the 1960s. But population control measures in the late 1960s were also seen as a failure, both because there was little evidence that family planning programs inspired people to use contraception and because the global Third World Left as well as the burgeoning global feminist movement criticized these efforts as attempts at racist cultural genocide (for the former group) and for ignoring women's desires and health concerns (for the latter).

Development films from 1968 through the early 1970s tell the story of how these confrontations with feminists and the global Left resulted in women's voices suddenly mattering in development, as well as how lingering population ideas shaped development's visions of women and their work. The films show how in their efforts to center and value women, development experts attempted to separate their potentially remunerated "productive" labor (to be encouraged) from their reproductive labor (to be discounted or limited, but not shared or collectivized). The films also tell the story of the inverse movement: how development institutions and ideas shaped feminism from its beginnings, particularly feminist frames for understanding international labor dynamics. The last part of the chapter examines Helena Solberg's 1975 feminist development film *The Double Day*, which premiered at the International Women's Year Conference in Mexico City that year, in order to consider how individualistic ideas of voice, as well as a newer focus on increasing women's "productivity," structured feminist documentary culture as well as even the most radical development thinking in those years.

FORMULATING THE PROBLEM

Population control was not much mentioned in 1950s modernization theory. While simplistic comparisons of population to GDP and food production that erased both inequality and the political causes of deprivation were present from the start in modernization theory, most theorists focused on stimulating economic growth rather than reducing population, factoring the growth of population and consumption into their projections.[2] While the Rockefeller and Ford Foundations had been pushing population control as a solution to poverty for much of the twentieth century, early waves

of modernization theory assumed that family size would work itself out as nations embarked on their growth trajectories. Into the 1960s, modernizers disavowed the Malthusian thinking that undergirded population control as overly pessimistic, as economist Barbara Ward pithily summed up in a 1963 speech. "Malthus could not look forward to a society so productive that it could afford to let its workers consume," she argued, while "Marx could not look forward to a government sensible enough to insist that they should."[3] The dynamism of capitalism plus the self-serving benevolence of global North states, for Ward as for many other modernization thinkers, rendered population worries as well as Marxism obsolete.

Some US development planners, however, began to ramp up their population rhetoric at the end of the 1950s. As M. Murphy notes, the project of Third World population control was a central impetus cited in the 1959 report that led to the founding of the US Agency for International Development (USAID).[4] The development of the birth control pill, too, as Laura Briggs explains, was driven by experts' concerns about overpopulation in the global South rather than the desire to liberate women in the global North with which it was subsequently associated.[5] However, if population control was moving slowly into the mainstream of development thinking, large-scale interventions of the early 1960s included very little in the way of family planning. Development sociologist and population zealot Joseph Mayone Stycos complained in 1962 that "by far the most frequent [development policy attitude] takes population growth as a given and worries about how to adjust to it," lamenting that the Alliance for Progress showed an "unusual devotion to pure science" and an excessive respect for cultural norms in the area of population.[6] Population limitation only became a central goal of development planning after the obvious and visible failures of Kennedy-era modernization ventures, from the disastrous strategic hamlets in Vietnam to the unworkable combination of austerity and infrastructural development attempted through the Alliance for Progress, as Stycos explains in a 1974 article:

> The 1960s were proclaimed by the United Nations to be the Developmental Decade for the modernizing nations, a theme echoed in the Western Hemisphere by the Alliance for Progress. Both emphasized economic goals and economic measures of success. These were usually expressed in terms of some ratio of product to people, such as "income per capita." Around the

same time, a number of Western economists and demographers began to demonstrate, largely theoretically, some of the more subtle relationships between economic development and population growth in the poorer countries. As the numerators in the economic measures began to evidence disappointingly slow rates of growth, attention began to shift to the denominators, the number of people, as a possible variable to be manipulated. The thesis was adopted by the American foreign aid program and by many United Nations agencies by the latter half of the last decade.[7]

In the late 1960s, as Stycos recounts, earlier ideas of the limitless human future promised by development—the "world without end," envisioned by Basil Wright and Paul Rotha in 1953—had given way to one limited by mathematical parameters. But rather than reevaluating their development ideas and strategies, the United States and its allies in foundations and global governance agencies settled on population and women ("the denominators") as familiar scapegoats for the failures they observed.

As a result, the United States and global governance organizations became more aggressive in their population control efforts. In 1969 Richard Nixon released a presidential message instructing government agency heads "to take steps to enlist the active support of all representatives of the United States abroad . . . to encourage and assist developing nations to recognize and take action to protect against the hazards of unchecked population growth."[8] This was a step further than previous official efforts; the US government since 1965 had warned of a population explosion and assisted nations in administering family planning programs, but largely stopped short of pressuring governments to adopt said plans. Former US Secretary of Defense Robert McNamara took a similarly aggressive approach to population when he became the World Bank's fifth president in 1968, going so far as to express his reluctance to finance health care without an attached population control initiative "because usually health facilities contributed to the decline of the death rate, and thereby to the population explosion."[9]

Policymakers' intense focus on overpopulation was bolstered by Paul Ehrlich's bestselling 1968 book *The Population Bomb*, as well as by films like Blue's, which, despite the reality of declining birth rates in most of the world, ratcheted up the rhetoric about the imminent threat posed by hordes in the global South, supporting the militaristic language employed

at USAID and the World Bank.[10] Development films like *A Few Notes* fueled the overpopulation panic by creating convincing scenes and connections that allowed development experts to seamlessly shift their focus from unused land and underexploited resources to teeming masses swarming cities.[11] Blue's film, completed after months of research interviewing social scientists such as Margaret Mead and John Kenneth Galbraith as well as a number of agricultural experts, conveys a sense of these failures of development, as well as a sense of dread regarding the future, a dread that drove late-1960s population thinking. But *A Few Notes* not only illustrates the consensus of the experts; rather, as its acclaim and awards suggest, it helps to consolidate this sense of dread, positioning Third World men's desire and the resulting births and lifestyle changes as urgent problems.

A Few Notes opens on a wheatfield. Ducks peek out from behind the wheat stalks as a soft, indeterminate buzzing begins. The voice-over, in Blue's characteristic essay-film style, announces, "This film is about a problem which may threaten our lives within the next 20 years." The camera then cuts to men in the field who are harvesting the wheat, their backs to the camera, the rhythmic noise of the thresher echoing the earlier hum. The voice-over continues in Blue's self-conscious essay-film style, at once forging intimacy with audiences and citing the inexorable reality of "statistics":

Statistics say that the world is losing the ability to feed its growing populations.

If nothing is done by the year 1980, the nations of Asia, Africa, and Latin America may see the beginnings of widespread famine.

For the next 40 minutes we are going to move our camera about the earth to show you images which illustrate the problem.

You will see scenes from three continents: the details, the faces will differ but each is a part of the same story happening everywhere.

The ducks, who are revealed to be the source of the buzzing, return. They begin to fill the screen in a frenetic shifting cluster, their quacking and flapping growing louder. The ducks then overflow the screen, moving toward the viewer in a frantic horde, trampling the grain as they go. Just as the sensory assault becomes overwhelming, the film cuts to a stark orange horizon, on which the title is written. The spectacle of birds filling then overspilling

Figure 24. "Statistics say that the world is losing the ability to feed its growing populations," *A Few Notes on Our Food Problem* (dir. Blue, 1968)

the frame echoes Alfred Hitchcock's 1963 film *The Birds,* positioning the global North viewer as menaced by the exponentially growing numbers—a horde, a mass, a throng—that might overwhelm or overthrow the existing social order. This move to make swarming animals represent newly worrying crowds of people had already been taken up by other population films in these years, including mice (in CBS's 1967 "Standing Room Only") and cows (in USAID's 1965 "Brazil: The Gathering Millions"). The ducks overwhelming the grain in *A Few Notes* are a particularly effective visual metaphor for the losing struggle between food production and birth rates.

The film then transports the viewer to the teeming city, first focusing on the crowd of expectant faces accompanied by the announcement, "These are some of the people who may face famine within the next 20 years." These young people who "may face famine," it is revealed, are clamoring for a turn at the mobile cinema truck, which represents the new ways in

which they have learned to "dream of a better life." If the development initiatives of the early 1960s have largely failed, Blue recognizes here that the development film genre has succeeded in enacting a cultural shift— spurred by films like his own, people have realized the inadequacy of their own lives and desire more. However, as the film subtly suggests, capitalist development policies have not lived up to the promises of their propaganda, and thus film as well as policy has shifted its attention to "the denominator," the population that might be limited in the name of quality of life for those who do live. Departing from the optimistic images of collective labor that characterized earlier development films, including Blue's own, *A Few Notes* depicts global South desires for modernity as a source of frustration and dread.

Desire, in *A Few Notes*, is incited by both women's bodies and consumer goods. The third section of the film, shot in Brazil, takes the audience on a journey from the countryside to the city, following the farmers who "stop trying to grow food and move to the city." Panning over the ramshackle dwellings on the steep hillside that make up the Rio de Janeiro favela, Blue asks, "Why do they come? What do they want?," then cuts to a young man "at the top of this slum," "the son of farmer who is also a poet." Blue films him reciting one of his poems: "[H]e was very nervous. It was the first time anyone had ever listened." It turns out to be a love poem, a promise to buy the speaker's beloved "a golden crown," to "have her teeth fixed," and to give her "a silver necklace and a pearl ring," as the camera takes the opportunity to rove over the faces and bodies of the women and girls in the favela. The scene seems to answer the question of what the migrants want, connecting love and sexual desire with consumer desire through the poem's enumeration of all three in relation to the passive, nonlaboring woman's body.

The next scene takes place inside one of the favela dwellings, where the "farmer and his family" discuss the consumer goods they have access to in the city, asserting that they would only move back to the country if they could own their own land. This is one of the only moments in the film where women speak, listing the things they'd like to buy as multiple children cry in their arms, filling the cramped room with noise. The scene embodies the problem of urban overcrowding, which it ascribes to a newly awakened consumer desire rather than rural dispossession or other

structural forces. Next the camera shifts to the outdoor favela steps, lingering on the torso and legs of a visibly pregnant and seemingly injured woman as she ascends with difficulty. Over the faceless pregnant woman's labored climb, the voice-over reiterates the problem of the (male) farmer's desire for a better life: "What does the farmer want? It's very simple. The farmer wants what many other people already have. He wants the money to buy those things which in a modern world bring self-respect and pleasure. If the farmer is to grow more food, he must be given what he needs to earn that money. If he cannot earn that money on the farm, he may leave and go in search of it. This is a force that can develop a nation or it will destroy it." The disjuncture between the woman's pregnant, slowly ascending body and the discussion of the male farmer's desire and underproduction points up the out-of-balance equation that the film is positing: too much desire and reproduction, not enough food. The film makes this even more explicit when it cuts to a still image of the favela on the hillside, as the voice-over explains: "Here is an image. It is the farmer's desire. If we are to get the food we need, the farmer must get the life he wants." The global city slum, then, is positioned as ground zero of desire, and specifically of desire as a problem. But women's bodies are the location where that desire is both incited and problematically sated.

The close of the film visually clinches the argument that "our food problem" is at least in equal measure a population problem. After a visit to an experimental farm that represents hope for food production, the film returns to pitting birth against food production: its culminating scene is a montage cutting between a Brazilian woman giving birth in a squalid room, a giant ship unloading grain, and farmers harvesting it. The grain ship and the birthing woman are positioned to emphasize their visual similarities, suggesting that the food is pouring in while babies pour out at a similar rate. The contrasts between the muscular farmers and the sickly birthing woman suggest something similar: no matter how strong the farmers get, the film suggests, they cannot keep up. Oddly the final moment of the film, after the baby is born and the drawbridge is lowered again, depicts a moment of women's agricultural labor. The script directions read, "FARMER WINNOWING. GRAIN RUNS OUT OF HIS BASKET. HE WALKS AWAY," but at the film's close a silhouetted woman remains in the frame, gathering up the grain from the ground, perhaps

suggesting the film's inchoate awareness that it is capturing women's as well as men's labor and productivity.[12]

Responses to *A Few Notes* were overwhelmingly positive. Bruce Herschensohn, the politically conservative filmmaker who directed the USIA motion picture division from 1968 to 1972, wrote to Blue that USIA's international posts had sent in "excellent" evaluations of the film.[13] Basil Wright, who made *World Without End* with Paul Rotha in 1953, claims in his 1974 memoir that *A Few Notes* stands in a class by itself as the one "outstanding" film among the "productions by the richer nations . . . which explore and explain the urgent needs of those parts of the world which are overpopulated, undereducated, and therefore almost certainly starving." *A Few Notes*, he continues, "has claim, through the force of its message and its cinematic beauty, to be regarded as one of the few really great documentaries." He marvels that Blue possesses "all the facts and statistics and arguments" on population but also cultivates intimacy with the farmers he interviews, commenting that "African villagers shake hands with the camera and therefore with us."[14] Pronouncing the film both a "powerful warning of impending disaster" and "a triumphant assertion of the marvelous potentiality of Man," he closes by praising the US government for its "noble" financing of the film and then musing, "[H]ow it can be reconciled with the devastation of Vietnam is another question."[15]

If the Academy, USIA officials, and British filmmakers were impressed with *A Few Notes*, some critics from countries featured in the film wondered about Blue's depoliticization of "our food problem." Indian filmmaker Anil Srivastava, interviewing Blue in 1971, asked about the "absence of a political stand" in the film, in particular why it had avoided "the overproduction phenomenon in the United States," wondering if Blue had been "inhibited" by USIA. Srivastava, perhaps like others in that period, seemed to associate Blue's avant-garde style with what was presumably a leftist "political stand" or analysis (or in other words, a view of "our food problem" as connected with geopolitics and global capitalism rather than mathematics and technical knowledge), and to assume that the lack of such analysis in the film was due to censorship. He was to be disappointed with Blue, however, who answered that he didn't understand what Srivastava meant by "a political stand," that he "was never inhibited," and that he had ignored US overproduction for fear of boring viewers.[16] Despite his differences with

the US government regarding the Vietnam War and the civil rights move-
ment, Blue remained convinced that overpopulation and underproduction
rather than capitalism were the key causes of food scarcity and malnutri-
tion. The months of research that went into his essay film thus obscure its
oversimplifications, whether they stemmed from ignorance or a desire for
drama or both. But while the assumptions of *A Few Notes* went largely un-
questioned in the global North and continue to shape periodic attempts to
solve world hunger through super-crops like quinoa and genetically modi-
fied "golden rice," some of Blue's arguments have aged less well. In particu-
lar, his difficulty imagining women as anything more than reproductive
vessels and objects of desire for dreaming men was soon challenged in even
the most mainstream development quarters.

BEING AVANT-GARDE: WOMEN IN THE NEW OBSERVATIONAL DOCUMENTARY

Despite the efforts of critics such as Srivastava to introduce geopolitical
forces into the equation, films like *A Few Notes* ensured that world pop-
ulation was understood by experts in the late 1960s and early 1970s as
a simple mathematical calculation in relation to global food production.
However, these same experts acknowledged that the problem of limiting
family size was a trickier task. In the late 1960s, US and international or-
ganizations attempted to address the gap between knowledge and stated
acceptance of family planning and actual use of birth control.[17] As one
report from a 1970 UNESCO conference stated, "Education about family
planning methods is a step that may be dispensed with for those segments
of the population where such knowledge has been found to be widespread.
The task may be instead to overcome resistances to the practice of family
planning or to provide specific information."[18] In developing tactics to
"overcome resistances," media planners seemed to learn from Blue's ex-
ample: in 1969, for example, the Kenyan ministry of health stated that
the Family Planning Association should "be avant-garde in the use of new
media."[19] Part of this "avant-garde" cinematic task, it turned out, would be
to reenvision the happy family and, ultimately, to reconceive of women's
oppression and freedom. If the first task never entirely succeeded—many

audiences continued to understand large families as happy ones, and to suspect that the project of limiting the size of Third World families was racist or anti-feminist or both—the reframing of women and their labor was more successful. Specifically, avant-garde films contributed significantly to the reframing of women's unlimited "productive" (generally meaning waged or commercial agricultural) labor as liberating in this period, as well as the simultaneous cordoning off, naturalizing, and limiting (we might even call it deskilling) of all other kinds of labor.

Beyond the general problems of family planning communication, population controllers also faced mounting opposition to their aims and tactics. Many of these concerns came to a head at the 1974 World Population Conference, held in Romania despite its explicit and aggressive pronatalist national policies. The conference, meant to consolidate the power of the population control movement, instead faced challenges from every side. As Matthew Connelly notes, "An African woman delegate demanded to know why people from rich countries did not 'listen to us for a change,'" and a contingent of feminist attendees denounced the lack of women in leadership as well as the lack of attention to women in population planning policies.[20] Meanwhile another contingent resolved "that population is a cause not a consequence of underdevelopment—and the most effective solution for underdevelopment is the New International [Economic] Order."[21] These challenges won the day, with delegates rejecting a US-backed proposal to recommend reducing family sizes. Even longtime population-control advocate John D. Rockefeller III gave a speech issuing an "urgent call for a deep and probing reappraisal of all that has been done in the population field," including "new and urgent attention to the role of women."[22] Connelly calls the conference the "Waterloo of the population control movement."[23] Although brutally coercive population control efforts would continue in India and elsewhere, and population thinking persisted as a powerful current underlying development initiatives, many development planners backed down from their ambitious dreams of population targets. They returned to economic productivity as a focus, now including women's underrealized productive capacity in their calculations and visions.

Thus while population control was on the slow decline as a credible frame for development in the 1970s, it provided an occasion for women to emerge as central actors and objects in development planning, projects,

and media. The rise of a women in development (WID) framework, which meant women gained new importance for development thinkers and planners, was spurred by Ester Boserup's 1970 book *Woman's Role in Economic Development*. Boserup's book argued strongly that women's "productive work" had been overlooked and devalued by development interventions. Development planners, she argued, had failed to recognize women's central role in farming and commerce, particularly in African countries; as a result, development planners had imposed their own patriarchal logics on rural families, kicking women out of the fields and depriving them of access to technological innovations. Boserup's book contends that for the sake of economic growth, this devaluation of women's "productive function" should be curbed, if not eliminated entirely: "Economic and social development unavoidably entails the disintegration of the division of labour among the two sexes traditionally established in the village. With modernization of agriculture and with migration to the towns, a new sex pattern of productive work must emerge, for better or worse. The obvious danger is, however, that in the course of this transition, women will be deprived of their productive functions, and the whole process of growth will thereby be retarded."[24] Boserup's refrain of "productive," here and throughout her book, itself produces a divide between the different kinds of work women do. "Productive work" is not explicitly defined but seems to be recursively understood as the work that contributes directly to, or might contribute directly to, "the whole process of growth." This distinction, while often difficult to sustain in practice, preserves the boundary earlier development planners drew between work to sustain one's family and community and work that could be remunerated in capitalism; initial development interventions attempted to limit women to performing the former type of work while designating the latter type both more prestigious and the domain of men. Boserup's intervention maintains this divide while attempting to push women over to the other side of it, without a plan or even a recommendation to alleviate or collectivize housework and childcare.

Despite its focus on "productive work," Boserup's book does not entirely leave behind population concerns. Like advocates for population control, Boserup acknowledges earlier development interventions as failures and even acknowledges population growth as a problem. But rather

than controlling population, Boserup asserts that valuing and encouraging women's productive labor is the step that will finally make development interventions successful. She argues that employment outside the home is also "a means of limiting the number of births" because it will lead to women's empowerment.[25] She also, conversely, understands population growth as a reason for the growing necessity of women's waged labor: "Owing to the rapid rise of population in developing countries, combined with a shortage of capital, many countries will probably be unable to solve their agricultural problems exclusively by means of capital-intensive techniques, and therefore the total demand for female labour is likely to increase."[26] Like Blue, Boserup takes for granted the mathematical logic pitting food production against population rather than accounting for either qualitative nutritional value or the political nature of most barriers to adequate food consumption. Here as elsewhere in the book, reproductive labor is explicitly devalued and discounted, as when "the rapid rise of population" is imagined not to entail "female labor" but rather to increase the demand for it. Thus even though Boserup astutely points out the many ways women's work is devalued in modernization and development regimes, her work remains faithful to the economic logic that undergirds development. "In regions with this 'African type' of agriculture," she writes, "it might often be good for the economy of the country if more young villagers stayed at home and more urban jobs were filled by urban women."[27] The "economy of the country" is the beneficiary, while the women are the underused human capital in which resides the potential for economic growth. Her task is emphatically not reducing the burden on women, but rather allowing them to be more involved, trained, and recognized in remunerative work. This orientation constitutes the "women in development" framework that became dominant in the 1970s, as an unquestioned push for women to become more "productive" replaced the previous tendency in development circles to decry the burden placed on women who performed allegedly productive manual and agricultural labor.[28]

Boserup's focus on women spread quickly in development circles. This new interest in women's lives and labor, and the extension of development's productivism to include them, was evident in development films from the early 1970s, including the population films of those years. Women's voices began to be heard in voice-over, displacing the authoritative male voice

by which a development film could up until then be recognized. Perhaps most strikingly, development films in this period began to attribute patriarchal family and community structures to cultures of the global South, disavowing the role (which Boserup highlighted) of very recent development interventions in installing patriarchal social relations. USAID's 1974 population film *Restoring the Balance*, for example, argues that "men holding all the power" in Iran detract from both family planning and general development efforts; films on Latin America, as discussed previously, regularly attribute to machismo the devaluing of women and their work. If these films confidently contrast their own newfound implicit feminism with the draconian patriarchal ways of Third World societies, their feminist vision is narrow, concerned with recovering women's (limited) voice and economic productivity as opposed to revaluing or alleviating women's uncompensated labor or inquiring into their Third World women subjects' ideas about equality or liberation.

The development film's new interest in women's voices and labor coincided with a turn in documentary film away from the didactic and toward the naturalistic and observational, a turn already evident in *A Few Notes*. This new turn toward what was often called the "experiential" reacted against the aggressive voice-overs and general certainties of development films as well as other mid-century propaganda films, but this reaction among global North filmmakers looked and sounded very different than Third Cinema's direct, often fictional, challenges to development narratives and Western authorities. These new ethnographic global North filmmakers, along with the self-reflexive "direct cinema" school, began to eschew voice-over, particularly the authoritative male variety that was characteristic of Griersonian and development films. They reacted against what they perceived as the authoritarianism of these documentary modes by reaching back to and updating the observational traditions of Robert Flaherty and Frances Flaherty, inviting viewers to spend what seemed like unstructured time with their subjects.

Scott MacDonald has argued that this new type of documentary, many of whose practitioners were based in Cambridge, Massachusetts, at either Harvard or MIT, differed in important ways from the Flahertys' "ideological" ethnographic work. The purpose of this new documentary style, MacDonald claims, was not to lead audiences to particular inferences but

rather to "record lived experience as it unfolded and to provide cinematic experiences from which audiences must draw their own conclusions." These new forms of the 1970s, MacDonald elaborates, "attempt to cinematically observe and reconstitute real experience so that the filmmakers and their audiences can come to understand the process of human life more completely."[29] This new trend in documentary filmmaking is exemplified by the films of Documentary Educational Resources (DER), a Cambridge-based production company that both pioneered this experiential style and became a highly successful distributor of ethnographic films. DER began, MacDonald explains, with one family—arms conglomerate Raytheon's founder Laurence Marshall, his wife Lorna, and their son John—and their expeditions over the course of the 1950s making films about the !Kung San people of the Kalahari desert. The new observational style associated with DER was inaugurated, MacDonald argues, by the Marshalls' 1951 film *First Film*, in which Lorna Marshall does the voice-over, highlighting her own subjective position with comments such as, "We observed no theft nor aggression; we observed impressive honesty, cooperation, and integration among this far away and independent group." This film, according to MacDonald, is impressive in its avoidance of "many of the problems of conventional documentary voice-overs" and its attention to gender relations, both of which demonstrate a respect and intimacy for subjects heretofore unexpressed in ethnographic documentary. For MacDonald "the voice-over commentary in *First Film* reveals not merely Lorna Marshall's familiarity with the people gathered at Gautscha, but her unpretentious empathy with them, as a parent."[30]

"Unpretentious empathy" was the watchword for this new mode of ethnographic documentary. If they were not less deliberately crafted than previous ethnographic films, new experiential documentaries did seek an intimacy and immediacy that previous development films had not, and, as Blue had begun to with *A Few Notes*, attempted to give voice to their subjects. Of course scholars since the 1980s, most famously Gayatri Spivak but also film scholar Bill Nichols in his classic 1983 essay on voice in documentary, have viewed with suspicion this desire to "give voice," characterizing it as a naive fantasy of unmediated access to the consciousness of an oppressed person (for Spivak) or a documentary subject (for Nichols).[31] And we might well be suspicious of any claim to empathy—much less the

patronizing observation of "neither theft nor aggression"—by a white American arms manufacturer family gazing at Black indigenous subjects living under apartheid rule. But this story about *First Film* also reveals how observational filmmaking in the 1970s dovetailed with the rise of the WID framework. DER's capacity for cultivating intimacy between film-maker, subjects, and viewer meant that it claimed to know women's experience and convey it honestly, unpretentiously, and empathetically to viewers who could then, according to the open yet intimate logic of the films, decide for themselves about what they saw and heard. Because in its claim to naturalness it already disavowed the labor of participants on both sides of the camera, the experiential "Cambridge school" style was particularly well placed to disavow other kinds of affective and communicative labor.

Andean Women, a 1974 DER film directed by Norman Miller, adheres to the observational, intimate style pioneered by the Marshalls in the 1950s. Although it contains a few interviews with its subjects at the beginning, most of the film records the titular women's conversation, in Aymara with subtitles, as they sit outdoors in a circle and shuck corn. The subtitles create intimacy between the women and the viewer, breaking the convention of previous development films, which had often depicted indigenous people talking inaudibly. The film also cultivates intimacy with its subjects in other ways: through its close-ups, its casual outdoor settings, and its sequencing of the topics the women discuss. Chatting together in a way that allows viewers to imagine that this is their everyday conversation, the women move from labor and education ("If there had been 'going to school' [when we were growing up]—wow! We would know how to read and write!") to marriage to childbirth and family relations. When the conversation arrives at these more personal topics, it feels like the viewer has built trust with the subjects.

If the film centers these titular Andean women's domestic relationships and childbearing practices and beliefs, its clearest message is conveyed in the contrast between the agricultural and household labor women perform and the community's consensus that women do not work very hard. The film opens on a woman gutting a lamb carcass by hand while her family looks on, and then distributing the entrails to various animals around the farm; she walks barefoot with a child running after her. The

film then cuts to an interview with a man who asserts that butchery is men's work, that "women's obligations are to spin and weave," and that they only "help" in farming rather than plowing the land themselves. Although the women similarly report that because they are weak, they refrain from hard work and only help the men, the film visually refutes these assertions, depicting the same women engaged in all manner of hard labor, agricultural and otherwise. The film returns again and again to the corn-shucking circle, where the women's careworn faces and industrious bodies counter their assertions of their own inferiority and weakness. In this way the new intimate, observational ethnographic style seems to answer calls for Third World women's increased visibility and voice. The film seems to echo Boserup in arguing that women's agricultural labor should be seen, recognized, and publicly esteemed, while their reproductive capacity should be both distinguished from "productive" labor and stemmed to facilitate their productivity.

Women in a Changing World, another DER film, which reuses the footage from *Andean Women* and to which Blue contributed footage of Kenya, offers a further visualization of Boserup's arguments. The film, featuring an authoritative (though female) voice-over but also scenes that look casual and unstaged, equates women's public visibility and hard physical labor with power and freedom. It begins with a claim that although the idea that women are entitled to equal rights is "nothing new," "discrimination continues," as an Afghan woman, face covered, carries a baby through a courtyard and a dark doorway. This opening efficiently sets up several equations: the problem of women's rights is framed as one of "discrimination" rather than one of exploitation, and the problem of "discrimination" is framed, at least in part, as one of invisibility. Cutting to a Bolivian weaver, the voice-over explains that "many professions and occupations are still denied to women." Here the film's diagnosis and prescription for the problem of women's oppression takes Boserup's work a step further: it argues that women's labor, and the increased acknowledgment and monetization of the labor they already perform, is not only good for the economy but also liberatory for women.

In this film, as in *Andean Women*, Bolivia is one of the places that exemplifies a discriminatory environment. As the camera focuses on an Aymara woman sowing seeds in front of an ox-drawn plow that a man

steers behind her, the voice-over explains, "As if living were not difficult enough, and the day's meal hard-won, machismo only serves to make things worse." The voice-over then goes on to define machismo, suggesting to viewers that the "male attitude of being the privileged ruler of the family" is both characteristically Latin American and entirely foreign to the global North. As the voice-over continues in an extended definition of machismo, the camera captures a man and a woman working together, planting potatoes in a way that looks harmoniously coordinated. It is only the voice-over's explanation that machismo is when a man "keeps his womenfolk toiling in the fields" that makes the scene legible as one of excessive rather than appropriate women's labor.

While the focus of *Women in a Changing World* is women's agricultural and economic labor, which it takes pains to separate from reproductive labor, population concerns pervade the film. The women sitting in the circle explain that "those with large families are respected," and that "those with large families can finish work more quickly . . . but if we have too many children, we're unhappy, and then there's never enough food." Later the voice-over asserts, "These girls will grow up to swell the numbers of the world's illiterate, the vast majority of whom are women" as the camera pans over Bolivian schoolchildren doing a call-and-response exercise with their teacher (the voice-over has told us that "school is difficult for Indian children"). The echo of the population movement's fear of the "swelling ranks" of the illiterate comes through clearly, despite the visible efforts of the students to remove themselves from those ranks.

Women in a Changing World contrasts its Bolivian scenes, which imply that little there has changed for women in recent history, with scenes from the Hong Kong Islands. As women clear stones from the beach and hoist heavy baskets of sand and shells, doing work that looks as arduous as the potato-planting that viewers have just seen, the voice-over announces that these women, in contrast with the Bolivians, are beneficiaries of recent progress: "The lives of women both on and off the islands have changed dramatically. They now have full political rights, and some of the worst aspects of male domination have ended. Women's contributions to economic life are acknowledged and highly valued. They are more than mere producers of children. The women of Hong Kong have learned that economic well-being may involve controlling their fertility. Most of them

know about family planning." As she washes clothing by hand, with a baby next to her held by in an ingenious contraption made of two wicker chairs, a woman recounts that she tried the pill and it upset her stomach, then tried the "safety period method," which led to her baby's birth, then had a tubal ligation. While other women fear tubal ligations because they worry they will not be able to work afterward, the woman explains, she thinks their fear is unfounded; after a few months' rest, she can now carry "up to 170 pounds." The film then cuts to a montage of women doing various forms of hard labor: close-ups of a pair of women grinding and sifting flour, then the mud-covered legs of a woman hoeing a field, then an aerial view of a woman carrying heaped baskets on a carrying pole over her shoulders. The voice-over proclaims that "the women of these islands are no longer bound into servitude or destined to become concubines. They have won some sort of equality." The aerial view of the weighed-down women, meant to illustrate the equality celebrated in the voice-over, closes out the Hong Kong section, the only one in which the film strongly argues that the "changing world" has brought benefits for women. It is also the only section that depicts a colonized population, though the film makes no mention of British rule, referring only to the "Hong Kong government." The film's observational style and focus on women's voices facilitate this elision, the intimate camerawork allowing for the jettisoning of explicit geopolitics.

Next the film returns to what it characterizes as its most "unfree area": Afghanistan. Most of this section takes place in a courtyard where women sit together calmly, chatting and shaping loaves of bread. The voice-over, however, asserts that these women are considered chattel, and that in Afghanistan, "economic power and freedom of all kinds are exclusively male." The camera cuts to the market, where men are buying and selling. "Even the food the women cook is bought by men." Here the ideology of the films is laid bare: hard labor and public buying and selling of goods are equated with "freedom of all kinds." The work the Afghan women do looks considerably less arduous than that performed by women in the Hong Kong Islands, but this has no bearing on whether they are free or not. The all-women worlds of Hong Kong, necessitated by the economic demands placed on its fishing communities, represent freedom, while the "cloistered worlds" of Afghanistan, dictated by religion, represent servitude and

inequality. Thus *Women in a Changing World* does not just instruct viewers about how different cultures work, but also provides a lesson in how to incorporate a certain type of liberal feminism into development thinking, teaching audiences to understand hard physical labor and unmediated access to the marketplace as freedom. The film's patient, observational, and participatory style, the illusion that very little work for either filmmakers or participants has gone into staging its scenes, makes its claims, which in fact are relatively new to development discourse, all the more compelling.

THE THIRD WORLD WOMAN, THE TESTIMONIO FORM, AND THE BEGINNINGS OF FEMINISM

The opening credits of Helena Solberg's 1975 film *The Double Day* depict Solberg and the other members of her film collective, the International Women's Film Project (IWFP), riding in a jeep together over a rough dirt road on the Bolivian Altiplano. They stop, get out, set up their equipment, and confer together over what to film and how, as heavily laden indigenous women walk by. Toward the end of the scene, sound mixer Lisa Jackson, tall and blonde, approaches one of the indigenous women, seemingly testing out the microphone as the woman looks at her with a quizzical smile. Critics have characterized this scene as a moment of self-reflective solidarity, in which the filmmakers cast their creative labor as part of the larger feminist struggle in which the film's woman-worker subjects also engage.[32] They argue, too, that the scene showcases the IWFP as an international collective made up of mostly women, a rarity for filmmaking in this era despite the proliferation of film collectives in various Latin American national contexts.[33] The scene also places the film in the self-reflexive avant-garde category in which the 1970s feminist documentary scene was generally interested. The collective of filmmakers becomes part of the film's story from the beginning; the filmmakers are divested of some of their authority but perhaps also marked as thoughtful and trustworthy by being seen conferring together about their own practices and eliciting intimate smiles from their subjects.

Crucially, this scene is also one of development, that is of middle-class, urban white people giving technological assistance to deprived

Figure 25. Opening credits of *The Double Day* (dir. Solberg, 1975)

and isolated rural indigenous ones. The credit scene begins with the female voice-over reciting facts about Latin America: "[W]ith a population of over 325 million and a geographic area twice the size of Europe, Latin America includes some of the most sparsely populated regions of the world." While the voice-over goes on to describe Latin America's status as the "producer of raw materials for the industrialized world" and to note the concentration of wealth in the hands of a few, the visual scene is one of emptiness, of the lack of industrial growth rather than of exploitation. The structure of the film, too, recalls other development films: as Solberg in an interview explains, the film follows "the progression from most underdeveloped to most developed" areas.[34] Thus even though the opening establishes both a participatory style and an approach to geopolitics inflected by dependency theory, *Double Day* enforces principles of capitalist development, both visually depicting underdevelopment and moving temporally along development's trajectory. The film homogenizes

the experiences of poor and working people, suggesting that their general problem of deprivation, stagnation, and exclusion can be ameliorated (if not eliminated) by various kinds of technical assistance, most prominently that of the filmmakers who will help them tell their story.

Solberg's film stages, in other words, the entanglement of transnational feminism and international development in the global 1970s: it reveals how the individualistic ideas of voice and visibility in the new ethnographic documentary, as well as a newer focus on increasing women's "productivity" in development thinking, influenced transnational feminist knowledge and aesthetic production. Recent accounts of development in the global 1970s have attempted to recuperate it as a time of possibility, a time when both feminist concerns and a "basic needs" approach began to shape development interventions—or, as Joanne Meyerowitz writes, a time when development experts both "moved to the left" and began to put women's experiences at the center of their theories and interventions.[35] It is true that downward resource redistribution, both at the macro level of the New International Economic Order and the micro level of "basic needs" anti-poverty thinking, was seriously discussed in those years.[36] Feminism, too, as Meyerowitz observes and as illustrated earlier, changed development's focus, with women quickly becoming the preferred objects of development interventions. But the inverse was also true: if development was shaped by feminism and to some degree leftism in the 1970s, development also shaped feminism, particularly global and academic feminist visions. In the capitalist world, this meant that development, rather than reparations, solidarity, or redistribution, was the way feminist theory and thought, even when it was purportedly leftist or Marxist, imagined the world from the beginning.

In making this observation and exploring its implications, I build on the work of Kelly Coogan-Gehr, whose book on the role of private foundations in the early years of the journal *Signs* provides a new genealogy of feminist scholarship. Coogan-Gehr finds that the Rockefeller and Ford Foundations dictated *Signs*'s agenda in the years after its 1975 founding. In particular, the Rockefeller Foundation refused the *Signs* collective's request in 1981 to hold a conference on women in socialist countries, instead suggesting and ultimately funding a conference at Stanford on "communities of women" that posited private property (in the tradition of Virginia

Woolf's essay "A Room of One's Own") as the key condition for women's autonomy.[37] The direction of 1970s and 1980s feminist scholarship was thus shaped by Cold War capitalist imperatives: this near-total exclusion of existing socialist examples left "global" feminism unable to say or envision socialism even when its critiques were Marxist or Marxism inflected. This absence, Coogan-Gehr argues, created a body of feminist scholarship that both oversimplified Marxism and focused on "identity and multiculturalism as organizing rubrics of politics and knowledge" rather than on collective transformation.[38]

If Coogan-Gehr's case study demonstrates how private foundations shaped the direction of feminist scholarship, documentary film was another key site of knowledge production for both development and feminism during the Cold War. The story of US feminism is often told as one of institutionalization; that is, of the radical groups of the 1970s making their way into the academy in the 1980s.[39] While institutionalization was certainly one of the processes at play, feminist films like *Double Day* illuminate the kind of cross-pollination that was happening in the 1970s, in which artists and academics and political figures were talking to one another and together attempting to explain how gender and other forms of difference were connected and what exactly women everywhere had in common. Films from this period offer insight into the substance and impact of these dialogues: they reveal how social scientists' confrontations with feminists and the global Left, and feminists' relationships with development institutions, ideas, and aesthetics, produced influential visions of what kind of women's labor was valuable and desirable. These visions united liberal WID visions with more radical Marxist-feminist ones; if their stated analysis of women's oppression was different, their visions of deprivation and empowerment looked more similar.

The Double Day is a key text for understanding how 1970s international feminist thought and aesthetics were influenced by both the WID productivism advocated by Boserup and the Cambridge School's experiential emphasis on giving voice to women. The film is generally considered to be the first Latin American feminist documentary; it also establishes Bolivian labor activist Domitila Barrios de Chungara as an international symbol of both Third World women's radicalism and the emerging testimonio form. Through footage of women's labor and intimate interviews with

working-class women in Bolivia, Mexico, and Argentina, the film compiles stories of women's oppression over various parts of the continent. However, the film does not juxtapose these stories in a way that produces an analysis of the structural causes of women's oppression, nor does it offer possible alternative visions of women's liberation through economic and social transformation. Thus *The Double Day* ultimately echoes earlier development films in both its depiction of a trajectory toward modernization and its imagining of democratic speech as a solution to exploitation. It concludes by highlighting the resistant capacity of Chungara, whose discovery of her voice in response to her government's brutal attacks on her mining community becomes the solution both offered and further facilitated by the film.

Helena Solberg grew up in Brazil but lived in the United States for much of the 1970s. Solberg and her friends from the Catholic University of Rio de Janeiro began making films in the 1960s; some of her friends went on to form the second wave of that country's radical Cinema Novo movement, a movement in which scholars sometimes place her.[40] Solberg's pre–*Double Day* films, the feminist documentary *A entrevista* (1966) and the neorealist fiction *Meio-dia* (1970), feel more like Cinema Novo films in their radical politics and surprise endings that break the fourth wall, in the first case, and invert power relations in the second. However, if she first worked out her aesthetic with her Brazilian peers, some of whom would go on in the late 1960s and early 1970s to make wildly satirical and carnivalesque anticolonial fiction films, Solberg was also influenced by US documentary culture. During her stays in the United States, first in Cambridge, Massachusetts, from 1961 to 1963 (accompanying her first husband) and then in her longer stay in Washington, D.C., beginning in 1970, Solberg was drawn to the documentary scene. She mused in a 2020 interview, "I always thought that if I'd stayed in Brazil, I might have gone straight to working with fiction, but in the United States the documentary was so strong, direct cinema was so alive and so important."[41]

Solberg was also drawn to feminism during her time in the United States. With a group of historians and artists, she founded a film collective in 1974, soon to be called the International Women's Film Project. That collective drew on their historical knowledge to make *The Emerging Woman*, a thoroughly researched and stylistically straightforward

narrative account of the history of US and to a lesser degree British feminism. Solberg says Betty Friedan's work made her want to make the film, and that she subsequently "looked for women who were studying history" to get a sense of the feminist history the film recounts.[42] The film, made on a very low budget, only breaks from its mode of propulsive didactic voice-over over historical stills near the end, for a montage of doll heads and other eerie artifacts of femininity accompanied by a recitation of Sylvia Plath's poem "The Applicant." *The Emerging Woman*, one of the first films to piece together the history of US women's rights and feminism, was selected as an official film of the American Bicentennial Commission and, Solberg recalls, "purchased by nearly all libraries in the US." It earned Solberg attention and more filmmaking opportunities as a "Latina" and Latin America expert in the United States.[43]

The success of *The Emerging Woman* marked Solberg's arrival on the scene of the US feminist documentary movement. Often making use of portable 16 mm cameras and building on the experiential aesthetics of cinema verité, feminist documentary filmmakers together created a recognizable aesthetic characterized by the "talking head" giving personal testimony. Barbara Halpern Martineau explains that "early women's liberation cinema used images of women talking in close-up to validate the concept of self-expression, a crucial concept for women used to being objectified, interpreted, eroticized, and generally discounted by the mass media."[44] Julia Lesage, writing in the late 1970s, characterizes this aesthetic similarly, as one of "biography, simplicity, trust between woman filmmaker and woman subject, a linear narrative structure, and little self-consciousness about the flexibility of the cinematic medium."[45] Lesage elaborates on the nature of the interviews in these films, often likened by scholars to consciousness raising: "The sound track of the feminist documentary film often consists almost entirely of women's self-conscious, heightened, intellectual discussion of roles and sexual politics. The film gives voice to that which had in the media been spoken for women by patriarchy. Received notions about women give way to an outpouring of real desires, contradictions, decisions, and social analyses."[46] Yet even as these feminist documentaries seem to capture the ethos of consciousness raising, their politics are, as Lesage notes, sometimes limited by their interview form: "[T]he films' very strength, the emphasis on the experiential,

can sometimes be a political limitation, especially when the film limits itself to the individual and offers little or no analysis or sense of collective process leading to social change."[47] Both the strengths and the weaknesses Lesage identifies are perhaps magnified in ethnographic development films, whose emphasis on the experiences of "others" can allow global North viewers to connect with global South characters' individual experiences but which, because of this emphasis, are unlikely to be able to depict the systems that oppress those characters.[48]

The Double Day, the film Solberg and the IWFP made after *The Emerging Woman*, embodies the experiential focus of US 1970s feminist documentary culture, but also the productivist and individualist orientation of "women in development." The film's political concerns, Solberg notes, somewhat naturally followed from those of *The Emerging Woman*, even as the differences between the two films indicate the developmentalist view that Latin America has no feminist history. The film was funded by the US government's Interamerican Foundation, an agency created by Nixon's administration and exemplifying his approach of encouraging private-public partnerships; the Foundation focused on development and funded, as Nixon explained, "innovative ideas and programs, particularly from non-governmental sources."[49] In practice, however, Solberg remembers the Foundation being run by "a group of religious liberals" who were enthusiastic about the IWFP's feminist work and radical ideas.[50] In preparation for *The Double Day*, Solberg attended a two-week workshop in Cuernavaca, Mexico, run by Marxist feminist anthropologist Helen Safa; there she met women from around Latin America and began to formulate the film, which she would characterize as "Marxist in method, not ideology."[51] After the workshop, Solberg and the IWFP crew traveled for three months, meeting and filming women in Argentina, Bolivia, Mexico, and Venezuela; they attempted to film in Brazil, but the military government confiscated their equipment and refused them permission.

The Double Day was made quickly, in preparation for the Mexico City International Women's Year conference. The film was screened at the conference, which motivated Bolivian labor activist Domitila Barrios de Chungara to attend; Solberg told Chungara about the conference and helped her travel to Mexico. At the conference, Chungara was a singularly memorable presence, engaging in a famous confrontation with bourgeois

feminist activists that is often remembered incorrectly as a confrontation
with Betty Friedan. This apocryphal scene, Jocelyn Olcott points out, is
perfectly emblematic of the dynamics of the conference, in which global
North feminists wanted to focus on the shared concerns of women across
class while global South working-class women like Chungara demanded
a broader global justice agenda that did not necessarily foreground or
even include feminism.[52] In 1977 Chungara, in collaboration with Bra-
zilian sociologist Moema Vizzier, whom she had also met at the Mexico
City conference, published the testimonial memoir *Si me permiten hablar*,
translated ("rather gracelessly," as Doris Sommer remarks) into English
as *Let Me Speak!*[53] It became the most widely translated and distributed
Bolivian book of all time.[54] *The Double Day* played a key role in making
Chungara and her testimonial style iconic, paving the way for the even
greater success of Guatemalan Mayan activist Rigoberta Menchú's subse-
quent testimonial memoir *I, Rigoberta Menchú*, as well as a wave of other
testimonial novels and memoirs from Latin American revolutionary and
activist women, upon which scholars have noted Chungara's influence.[55]
Chungara herself collaborated on other testimonios in both written and
cinematic forms throughout the 1980s, which together constituted what
Isabel Seguí calls "a transmedia cultural and educational product."[56] *Dou-
ble Day* thus had a significant role in the construction of the testimonio
boom and ultimately helped global North audiences equate leftist radical-
ism with a lone subaltern woman speaking.

The Double Day, unlike *Emerging Woman* but in the tradition of de-
velopment films, presents women's position in Latin America as largely
outside recent history. *Emerging Woman's* precise historical accounts of
global North women's struggles for rights are replaced in *Double Day*
by scenes of Latin American women working and testimony from those
women about their work experiences. As Solberg indicates, the film moves
from Bolivia to Mexico to Argentina, identifying neither the women de-
picted nor the countries in which the scenes are filmed. However, in each
unidentified geographical location, the film alternates between scenes
of women talking, mainly in groups, filmed in close-up, and scenes of
women laboring in factories or fields. In the close-up scenes, the women
reflect on their work lives with seeming frankness, explaining the various
difficulties and forms of discrimination they face. "We work a double day,

and we're not happy about it," says one of the Bolivian women, giving the film its name. Despite the starkly different settings for the rural and urban women, the film homogenizes rather than differentiates the women's experiences across geography and social conditions. By cutting between the groups being interviewed with eyeline-match shots, the film encourages viewers to see similarities in the scenes and imagine that the women in different places are talking to one another.

Across its settings, the film constructs wage work as empowering. The opening moments of the film depict not women working but rather women looking for work. Visually counterposed to men in orderly lines energetically emerging from a factory, the women stand in a disorganized throng, frustrated, explaining that they've "gone from factory to factory" in Buenos Aires without success and have ended up searching for work as maids instead. A group of men nearby contradict them, saying there are plenty of jobs in factories. Although the women's conversation moves on to the difficult working conditions of domestic workers, this initial contrast between the men who can find "productive work" (sketched here exclusively as factory work) and the women who cannot and must turn to domestic work is echoed throughout the remainder of the film. From the Argentine scene, the film moves seamlessly to a Bolivian scene, similarly staged: women outdoors, filling the frame, talking one by one about their moves to the city and difficulties finding work. This time the interviewees are Bolivian *cholas*, urbanized indigenous women who wear distinctive full skirts and bowler hats: "We're not allowed in the factories," they explain, adding that "women have never been considered important." Again the women move on to discuss their education levels and working conditions, but it is the condition of being barred from factory work with which they open, and which seems to take precedence.

Later, over footage of rural Bolivian women cleaning and preparing offal outdoors, a baby perched beside one of them, the voice-over echoes Boserup's contention that the problem with development is that it has deprived women of "productive" (seemingly here meaning commercial-agricultural) work opportunities. "In the past, women participated just as much as men and children in the task of production. In weaving, agriculture, and the care of animals, she was much more involved in production than she is today. . . . [T]he home and the place of work for the

entire family were one." Being "involved in production" is positioned here
as an unquestioned good; it is cordoned off from the domestic and even
the sales work the women perform onscreen. The film's constant desire for
women to be "more involved in production" is not well explained in the
film and seems at odds with the constant labor they perform onscreen. It
also feels painfully ironic in retrospect, given the intertwined processes
of the offshoring and feminization of manufacturing that were underway
even as the film was being made.

The film begins to mount a stronger feminist critique in interviews
with managerial types, who give accounts of their exploitation of women
that are both callous and ridiculous. An Argentine factory manager, for
example, explains that he gives women the most tedious jobs because "in
general, men are more restless than women, and this type of work tires
and bores them easily." Likewise a school official gives Solberg an inco-
herent account of why he must separate children by gender for lunch and
sports activities—he cites size and the necessity of separating older from
younger children. Solberg pushes him further to explain the gendered sep-
arations ("but here is by sex, not by size") until he gets confused. "I don't
understand," he says, and her retort of "neither do I" is a perfect revelation
of the senselessness of the gendering process. In a later scene, a blonde
Argentine middle-class woman, drinking at a café, says confidently that
"women would have fewer conflicts and more success if they tried to look
attractive for men, and used their feminine wiles," completely missing and
misunderstanding the struggles of the poor and working-class women the
film has just showcased.

But if the film makes some points effectively, locating its critique in its
ironic portrayal of the silly, self-justifying comments of a few middle-class
individuals, this strategy cements the film's individualism: the ideology
of the middle class can be mocked, but a systemic analysis is not built
from this mockery, much less a plan for liberation. The film also ignores
historical and contemporary attempts at gender equality, even in Latin
America. In her history of the International Women's Year conference, Ol-
cott observes that media coverage of the conference entirely ignored the
Family Code that had just been passed in Cuba, giving men and women
equal rights in the home. Olcott notes that journalists lumped speaker
Vilma Espín in with the other "wifey poos"—attendees who were wives

of important political figures with little political experience of their own; Espín was the wife of Raúl Castro but also a revolutionary and politician in her own right.[57] Solberg, too, despite its relevance to the film's subject matter, ignores Cuba and the Family Code, most likely because the Interamerican Foundation funding did not extend to projects there.[58]

Helen Safa, on whose feminist anthropological work Solberg drew in order to formulate the film, also remarks on the elision of Cuba in her review of *Double Day*, noting that it is the one place in Latin America "where the organization of women has been consciously undertaken by the state." Safa also worries in the review that despite "the articulateness and even militancy of the Latin American women in this film," the film neither depicts solutions nor develops "the link between sexual oppression, class oppression, and capitalism."[59] Other reviews noted more positively the film's substitution of personal testimony for analysis: Nora Jacquez Wieser was impressed with how the film lets "poor and working-class women in Latin America speak for themselves about their lives. Their style is not one of declamation or proclamation. They simply talk and the viewer is left with a positive respect for the strength and endurance which has meant these women's survival throughout history."[60]

Thus rather than building a particular line of anti-capitalist feminist analysis or presenting alternative ways of organizing gender and labor, *Double Day* emphasizes the voices of individual women, and of Chungara in particular. While she is unnamed, Chungara is the star and focal point of the film: she is the only subject whose interview recurs throughout the film, and the only woman-worker subject interviewed alone, with no one else in the frame. Unlike many of the other women, who appear shy or contemplative or angry, she stands confidently, shoulders back in threefourths profile to the camera, well-lit and sturdy and smiling, gesturing as she speaks. Over the course of the film, Chungara discusses how women in mining communities are disrespected rather than esteemed by men— "Why don't they get respect in their own homes?"—and describes how, by "getting organized," they earned men's trust and confidence: "Now we speak and the men listen."

In her final scene that also comprises the ending of *Double Day*, Chungara speaks for longer than any other participant in the film, giving a graphic account of the 1967 San Juan massacre, when the Bolivian

military attacked her mining community on a festival night. Standing tall, a small smile on her face, she describes the mutilated bodies of women and children, not expressing overt shock or sadness at the details. Surviving the massacre, in her words, pushed her, finally, to speak in public and denounce the military: "[F]or the first time I got up and spoke what I really thought," she says. "We had picked up so many dead that I felt courage and rage." As she recounts the events, Solberg prods her to give an account of her personal feelings, asking, "Was this the first time you spoke in public?" and "Weren't you scared?" in stark contrast with her analytical approach to her middle-class subjects earlier in the film. For its part, the camera zooms in on Chungara's face, moving closer and closer over the course of her testimony. Chungara, however, stays focused on events, continuing to smile a little as she recounts her four stints in prison, losing a pregnancy, and being accused with her fellow women activists of being "agitators, conspirators, everything." At this point, her testimony abruptly stops, the neo-folk song "Mujer" by Gloria Martín sounds, and the final credits montage begins.

This ending, in which Chungara powerfully recounts the discovery of her voice after surviving a horrific attack, but not any sort of organizing or transformative social process that comes afterward nor even the issues around which she was organizing, reflects what David William Foster calls "the potential slippage in *Double Day* between Solberg's subtle socialist perspective and the liberal feminism within which it is inserted."[61] Foster identifies this ambivalent stance, which we might understand more precisely as the militancy of Solberg's interlocutors contrasted with the women-in-development frame that emphasized their individual visibility, voice, and productive potential, as the reason "*Double Day* enjoys virtually no prominence in either the filmography of feminist movements in the United States or in filmmaking registries for Latin America."[62] There is evidence the film was shown in Latin America beyond the Mexico City conference: Solberg recounts that while in Bolivia doing research for a subsequent film, a rural activist mentioned *Double Day* without knowing Solberg had made it, revealed that she "knew the film really well," and said it was "a film they used in the union"; Solberg also suggests that the titular term, "doble jornada" in Spanish, became widely used in Latin America as a result of the film.[63] However, Foster is correct that the film did not

achieve critical acclaim, nor did it attain the ubiquity in libraries that *The Emerging Woman* had.

The film's most conspicuous accomplishment, overlooked by Foster, was introducing Chungara to the world and helping to bring about the subsequent testimonio boom that followed. It is difficult to know what Chungara herself thought of her own testimony, its effects, or her appearance in Solberg's film. This is mainly because she so clearly thought of her testimonios as representing collective concerns rather than her individual experience. She starts her second testimonio, compiled by David Acebey in 1985, referring not at all to herself: "There are many reasons to do this second book. For example reporting what one has seen in exile, or being accountable to those whose activities have been realized. But in this case, it is principally to repay the solidarity other peoples have shown with Bolivia."[64] Here, and elsewhere, she effaces herself, demonstrating what Sommer terms the "plural self" of the testimonio form.[65] But the testimonio boom Chungara can be said to have inspired, in retrospect, produced an odd effect: if the subjects of testimonio were always speaking for a collective, they still produced the act of witnessing and telling as the most conspicuous end point of action. As Segui points out, the "transmedia . . . product" that was Chungara's aggregated collection of testimonios "contributed significantly to the creation of a usable counter-public sphere for organized working class and peasant women."[66] However, it could also quite easily be used for developmentalist ends, as when a USAID-funded curriculum used Chungara's testimony to formulate a lesson on "how a miner's wife spends her day."[67] Because USAID and the Latin American working class, not least its members in Bolivian mining communities, were so often at violent odds, it is worth considering the flexibility of Chungara's testimony: how some might read it as a manual for insurgency while others might understand its constant moves toward plural selfhood simply as indicative of Chungara's status as a typical miner's wife.

The story of *Double Day* points to how 1970s experiential feminist documentary and the kinds of witnessing it produced, particularly when tied to developmentalist frames and funders that precluded imagining more communitarian solutions to exploitation, anticipated the documentary form that would come to characterize neoliberalism. For Daniel Worden, documentary is "the art and literature of our [neoliberal] age," because it

"produces a way of thinking everyday life's relation to economic and social structures" while also being characterized by "irresolution" and emphasizing the partial quality of individuals' stories.[68] While Worden does not discuss feminism or feminist documentary in his genealogy of neoliberal documentary aesthetics, the project he names was of course shared with feminism and embodied by its "personal-is-political" ethos, and the testimonial aesthetics he examines were developed in part by feminist filmmakers. This is, perhaps, a dubious honor, akin to noticing that *Double Day*'s pro-factory stance might feed into the "feminization" of manufacturing work that was already beginning to accompany the globalizing neoliberal economy in 1975. But if neoliberal documentary culture learned from feminist documentary's focus on the personal, the funding and ideas of development are also an important part of the story, suggesting that feminist documentary, and global feminism itself, did not have to be the way it was.

CONCLUSION

In the 1970s, development filmmakers finally cast aside the deep-voiced, omniscient, didactic male voice-over that had been a staple of the development film. Subjects of development films were suddenly encouraged to express the intimate realities of their lives and the hardships they faced. If the refrain in early development films was that the ignorance and lethargy of traditional societies was holding them back from the rapid modernization they needed to undergo, James Blue's exhortation in *A Few Notes* to "trust the farmer" and his doubts about the speed of modernization revealed cracks in what had seemed just a few years before like orthodoxies. Women, too, after Blue's film, were finally given a chance to be more than symbols of recalcitrant or tragic tradition; development films began to give voice to women as the true subjects of development, a shift that also seemed to provide a new and more nuanced picture of social transformation.

But even as the development film morphed into something subtler and more aesthetically complex, its core precepts remained. Films like *Women in a Changing World* and *Andean Women* use their sophisticated

observational style to naturalize while slightly revising the existing story of development; the films newly celebrate bringing women into "productive work" while pretending that this inclusion has been a long-standing development objective. Development also shaped the aesthetics and practices of global feminism. This is clear in a feminist documentary like *The Double Day*, which might have disagreements with some development logics but inherits the form of the development film in ways that make the possibility of hemispheric feminist solidarity difficult. The film's focus on individual experience; its hopeful, insistent close-ups of Chungara; its relentless productivism made audible by clacking factory machinery and out-of-work women's complaints; and its difficulty explaining or analyzing exploitative processes make it difficult to imagine what women should do beyond telling stories and letting development take its course.

Yet there is a different film peeking out of *Double Day* that does not quite cohere, one visible in the more grotesque moments like the offal sequence, as well as in Chungara's repeated references to gruesomely interrupted pregnancies in her final monologue. Such moments not only call attention to "unproductive" reproductive labor but also threaten to sever the naturalizing logic of development and hint at a more general breakdown of, or even a refusal to reproduce, the existing system. Despite the film's reduction of Chungara's politics to an affective talking head (the withholding of her politics from the frame), these moments point the way to a politics of collective struggle that neither the film nor its development-inflected transnational feminism can quite encompass.

Epilogue

The development film does not exist anymore. Its scenes, viewed now, seem archaic and clichéd; we've seen them before, but we don't know where. However, development as an ideology has persisted long after the media that naturalized it became outmoded. As the development film's rapid shift to center women and feminism discussed in chapter 6 makes clear, development's aesthetics and imperatives were malleable; development would later accommodate the withdrawal of state funding and even, allegedly, environmental sustainability, which had previously seemed to be its polar opposite. But if development shifted with the times, the productive and extractive ethos at its core was nonnegotiable: whatever else it was, development in the postwar era conflated economic growth with the good life, imagining more extraction and production everywhere as the only path to eventual, long-deferred freedom. The development film cemented this link between capitalist extraction and collective hope for the future, juxtaposing close-ups of rural children's expectant faces with scenes of drilling, smelting, bulldozing, and assembly-line production.

As the development film declined, so did state-run development. Latin American governments cut and privatized even the most basic services in what Lesley Gill calls an "armed retreat"; this neoliberal order was eventually

imposed on the rest of the world, often with the coercive guidance of the International Monetary Fund and the World Bank.[1] After the imposition of these austerity measures, networks of nongovernmental organizations remained, providing basic services to the newly dispossessed in the wake of brutal cuts while also co-opting the leaders of activist groups making demands on the state.[2] In those years, development was financialized and feminized as much as privatized: microlenders capitalized on women's capacity for self-sacrifice, reframing this capacity as a criterion for a good investment.[3] This search for "good investments" continued into the 1990s, when girls, rather than women, emerged as ideal targets for development interventions. "[I]nvest in a girl," exhorted a Nike video in 2008, as part of its Girl Effect campaign, "and she will do the rest."[4] The Girl Effect campaign emerged during the brief counterinsurgency era of the War on Terror, complementing short-lived efforts by the US government and NATO to build schools for girls in war zones in Pakistan and Afghanistan.[5]

The Girl Effect campaign is a good example of how the media apparatus of development, now called *development communications*, has evolved in the neoliberal period. While the development films of the era of state-administered development purported to depict and promote self-help projects, in the neoliberal era development media itself constitutes the development intervention. Girl Effect does not produce documentary media touting its efforts to help girls; rather, its videos and "award-winning sexual health chatbots" are themselves imagined to be development projects.[6] Another popular development media innovation of recent decades is Kiva .org, which combines the profile-match features of a dating app with a format that calls upon global North lenders to judge the creditworthiness of potential global South borrowers, based on the borrowers' confident, resilient self-portraits, which showcase abundance and potential rather than scarcity and abjection. This interaction, however, only goes one way: borrowers, mainly women, are often unaware their photos are on the site; they borrow not from these global North lenders seeking altruistic connection but from Kiva's "partner" banks, which often charge predatory interest rates.[7] These financialized development media initiatives, although they have laundered Nike's reputation (in the case of the Girl Effect) and made lenders in the global North feel good (in the case of Kiva), have not alleviated global poverty and hunger: the world failed to meet the

Millennium Development Goals proposed by the United Nations, which in 2015 became the Sustainable Development Goals.[8]

This diminution, privatization, and financialization of the development world set the stage for the dismantling of US-led international development in 2025. Donald Trump arrived on the political scene in 2016 as a symptom of the end of US hegemony, but his second term revealed him to be a catalyst for hastening that end. One of his second administration's many initial shakeups was the destruction of USAID by Trump's unelected deputy Elon Musk, who boasted of "feeding USAID into the wood chipper."[9] As Laura Robson points out, decades of privatization paved the way for the gutting of USAID: its many corporate and nonprofit contractors, often on missions to privatize basic services overseas, were easy targets for layoffs.[10] These massive cuts to USAID thus will have reverberations for international development as an industry and a field, given that the United States has financed so many of the organizations, banks, and corporations engaged in development efforts worldwide, ranging from fomenting regime change in Cuba (which was rescued from the woodchipper) to clinical trials for experimental drugs (which were not).[11] Many development workers lamented that the death of USAID would tank an entire industry, and indeed, as Robson points out, the most poignant and credible stories of devastation after the AID cuts focused on the uncertain fate of development workers themselves, rather than the people they were meant to be assisting.[12] Robson's sense of the self-serving recursiveness of the development world resonates with the story this book has told, in which the most reliable consumers and beneficiaries of development films were the very organizations and experts that had commissioned the films in the first place.

This destruction of the financialized neoliberal development sector by far-right tech lords, much like the destruction of the rest of the so-called liberal international order cemented by the United States and Europe's effective sponsorship of Israel's live-streamed genocide in Gaza, creates an uncomfortable place for anyone attempting to revive or newly imagine a left internationalism. As Musk gleefully slashed USAID, its former head Andrew Natsios sputtered indignantly in an interview that "AID is the most pro-business and pro-market of all aid agencies in the world, I can tell you that categorically."[13] He added that Musk and the "young

kids" working for him "don't know anything about the global South," an odd statement given Musk's upbringing in South Africa but also one that hints at the most salient divide between these two fanatically capitalist factions: Trump and Musk, unlike Natsios, are avowed proponents of biological racism and thus reject any sort of hypothetical developmental logic that might continue to hold out the hope of the global South one day attaining modernity. The destruction of USAID illuminates a larger dispute between white supremacist smash-and-grab tech lords and ostensibly anti-racist internationalists who attempt to maintain US hegemony by promoting US and capitalist interests abroad. While some liberal scholars have come down on one side or the other of this divide, expressing nostalgia for an era when financialized modernization constituted a perpetually unrealized future or imagining a degrowth or communitarian agenda underlying Trump's chaotic protectionism, we might heed Quinn Slobodian's caution that disputes such as the one between Natsios and Musk are simply "family feuds" within neoliberal globalism.[14] For any sort of left project to be viable, it will have to reject both these visions.

CULTURE IN THE GREEN TRANSITION

In his 1967 short documentary *Por primera vez* (*For the First Time*), Octavio Cortázar accompanies a mobile film unit to the remote Cuban village of Los Mulos, hoping to encounter villagers who have never seen a film before and document their first cinematic experience. Upon arrival Cortázar asks around, trying to find villagers who have not seen a film. First a young girl in a laughing group of children identifies a man, Ovidio, who she thinks has never seen a film, then the camera cuts to Ovidio standing in a field, explaining that the girl is wrong and that he has seen films, but that there are lots of peasants in the area who have not; after he speaks, the camera follows his gesture, panning over the beautiful tranquil hillsides around him. Cortázar finally finds a few women who have never seen a film—they cite caring responsibilities as well as rural isolation as the reasons—and asks them what they imagine cinema to be. "It must be a beautiful thing, a thing of importance," says one woman, holding a toddler; another, also holding a child, imagines "snakes, pretty

girls, weddings, cavalry, war and everything." A third envisions "a party, a dance." The documentary culminates in a film screening: the audience of adults and children bring chairs and torches outdoors and watch intently as the technicians set up the projector. Their faces light up with smiles as the music starts, and then the crowd begins to point and laugh. The choice of film is finally revealed: it is *Modern Times*, Charlie Chaplin's 1936 satire of factory work and industrial capitalist modernity. As the mechanical feeding machine goes off the rails, raucous laughter rings out; the camera then returns to the audience, who laugh, point, comment, and exclaim to each other, expressions of pure joy on their faces. The film ends with close-ups of the children, who fight to keep their eyes open, then fall asleep one by one.

Por primera vez is not a development film. It does, in the manner of those films, feature lingering close-ups of the faces of rural villagers, including many children, and it does treat the same broad themes as development films: isolation, technological change, the relationship of the urban to the rural and of the global North to the global South. However, *Por primera vez* depicts these elements in a markedly different way. There are the interviews with rural villagers, rare in development films, in which first the small girl and Ovidio play a kind of displacement game, pointing to more isolated others who are less likely to have seen a film, and then the women offer lovely and remarkably accurate conjectures about what cinema is that refute any idea of their isolation. Then there is the screening itself, in which the joyful laughter of the villagers demonstrates the ease with which they understand the Chaplin film, an ease that perhaps derives from its universal message or perhaps from this particular audience's capacity to critique capitalism. Finally, there is the collective dozing off, which frames moviegoing not as an opportunity for self-improvement but rather as a respite from difficult lives that already contain sufficient, really too much, work.

The choice of *Modern Times* to inaugurate the audience's film viewing feels a bit unexpected in 1967 Cuba, given the hope industrial development held for the socialist world in that period. If in development ideology, industrialization constituted the national path toward the good life, *Por primera vez* questions that path: villagers laugh uproariously at Chaplin's sendup of mechanized production and the bodily deformations

it causes. What is the use of a higher income and modern conveniences, the juxtaposed films ask, if you will just be forced to bend your body to the will of machines? The energetically laughing and then contentedly dreaming bodies of the audience seem to ask, too, what else could we demand? *Por primera vez* not only questions the logic of capitalist development, but also helps audiences glimpse a world in which rural people might casually acquire a critical cosmopolitan sensibility without giving up their local knowledge, and in which publicly provided technology might be a source of shared leisure and entertainment (a true quality-of-life improvement!) rather than enveloping and transforming every aspect of work and life.

I bring in this example to initiate a discussion of what has been and might be imagined beyond development. Cortázar, a Prague-trained, Cuban-state-supported filmmaker, made *Por primera vez* at a moment when Fidel Castro's regime was attempting to mobilize the entire population to speed up sugar production. Cortázar, famously, was not free to make art as he liked; Castro's 1961 "Words to the Intellectuals" speech decreed: "within the revolution, everything; against the revolution, nothing."[15] But Cortázar nonetheless was free to let his impoverished rural subjects speak their minds on camera, and ultimately to make a film whose labor politics diverged from the modernizing imperatives of the Cuban government. *Por primera vez* was not merely permitted but became iconic; to this day it is cited as an inspiration to filmmakers in Cuba and elsewhere.[16] Despite the revolution's constraints on his art making, Cortázar was thus freer than many of his counterparts in the capitalist world, who made formulaic films either at the behest of their funders or because they could not think of anything else.

This failure of imagination in capitalism, the catastrophic fixation on economic growth above all things, preoccupies the cluster of climate manifestos produced in the past decade, perhaps the places where we might most expect to see challenges to development's imperatives. The authors of these manifestos agree, more or less, on how humanity could save itself from the total collapse that will inevitably accompany continuing unmitigated carbon emissions. Whether imagining a future that is communist, social democratic, or decentralized and vaguely anarchist, they call for a program of slowed economic growth, less productive work, more economic equality, and more mass transit and public goods and services, an

end to imperialism, and a new official respect for indigenous knowledge and nonhuman life. They differ on exactly how we might arrive at these ends: Naomi Klein argues for "planning and banning"; Kohei Saito advocates for worker cooperatives and local control over energy production; and Jason Hickel calls for ending planned obsolescence, cutting advertising, and forgiving all debt.[17] Such measures could, these writers argue, benefit humanity in ways far beyond disaster mitigation: we could end (or at least stem the excesses of) capitalism and colonialism and save ourselves while finding meaning in community and social relationships instead of overconsumption. All agree that if there is any hope for planetary survival, it necessarily entails humans finding a "new imaginary," a new, nonpropertizing relationship between themselves and the rest of the planet.

For this new imaginary and new way of living, these scholars often look to Latin America. Naomi Klein begins her book *This Changes Everything* by relaying a 2009 conversation with Bolivian diplomat Angélica Navarro Llanos, which led her finally to face the reality of climate change; Hickel points to Costa Rica as an exemplar of leaving growth principles behind and embracing state-run social services and "meaning" beyond consumerism; and Saito points to the Zapatistas and Via Campesina as groups leading the way in the fight for local sovereignty and against global capitalism and what he calls "the imperial mode of life."[18] In their manifesto *Half-Earth Socialism*, Troy Vettese and Drew Pendergrass take this tendency to look to Latin America to its logical conclusion: in the book's fictional sketch of a 2047 revolutionary carbon-neutral society, the world's resource extraction, distribution, and use is planned from a Havana supercomputer, while the "world parliament" meets in La Paz.[19]

But despite these sources of inspiration, and despite how the Latin American thinkers and governments they cite have so often foregrounded the struggle to either do development differently or move beyond it, these thinkers consistently affirm the ideals and assumptions of development. They do not recount efforts by Latin American governments, intellectuals, and indigenous movements to throw off development's constraints and promises, such as when Andean countries attempted for a time to adopt the principle of *buen vivir* (an idea of the good life drawn from Aymara and Quechua concepts that encompass plenitude as well as living

harmoniously with one's community and the nonhuman world) in order to oppose development and shed the principle of growth at its core.[20] Rather, even as these thinkers boldly imagine that degrowth will "change everything," they remain committed to development, which for so long has given growthism its moral force.[21]

The lack of interest in challenging development in these degrowth manifestos is matched by their lack of attention to culture. Despite their overwhelming belief in the importance of popular imaginations and "imagining otherwise," these thinkers leave to others the task of sketching the cultural transformations that would be necessary to "change everything" or "slow down." This is fine, of course; these thinkers cannot do everything on their own. But one thing I hope this book has demonstrated is that speeding up the world was not easy, and that this speedup was a cultural task as much as an economic one. Artists played key roles in convincing the world that it could be transformed; their photographs and films taught audiences to see race as mutable, to value workers and work differently, and to see mechanization as friendly and helpful rather than terrifying and impersonal. These artists both drew on and tempered anti-fascist and revolutionary traditions, using the intimacy of their camerawork to fabricate a sense that rural indigenous people had been isolated and hostile for centuries, and that they were now experiencing liberation through hard physical labor and everyday contact with capitalism and the state. At the behest of governments and oil companies, they also celebrated the saturation of oil into postwar life, positioning both the drilling and consumption of petroleum as honorable and inevitable progress. It was possible to make a living making noncommercial art in the postwar period on the condition that this art support the projects of petro-capitalist expansion and US Cold War empire. Artists, in other words, helped get us into this mess; it stands to reason that maybe they could help get us out again.

What would allow artists the space to produce new visions that might lead the world out of economic growth and development? One place where cultural programming is currently accompanying redistributive and green industrial policy is Mexico. President Claudia Sheinbaum's multi-tiered plan for a post-neoliberal "Mexican Humanism" that would extend the "fourth transformation" promised by her Morena Party—consisting

of nationalizing natural resources, reshoring manufacturing, producing green technology, and establishing a raft of new public services—also includes infusing money into "national artistic education."[22] At a time when many wealthier countries are cutting education in the arts and humanities, Mexico is expanding its educational programming, as well as its support for indigenous artists and the works they create.[23] Sheinbaum explains, "We aim to create a truly integrated system of artistic education—one that brings together formal and informal education in a way that supports both artistic development and community engagement."[24]

Beyond this exhortation to "community engagement," however, there seem to be no strictures: artists are given free training (and, in the case of indigenous artists, financial support) but are free to create without state constraints. Despite her science background, Sheinbaum intuits the importance of support and training for artists, not just for their own fulfillment or national prestige, but also to find "new observations and meanings," as Raymond Williams puts it.[25] Such support for artists seems crucial if we are to move beyond the present impasse, in which the nightmare of neoliberal entrepreneurial sloganeering is opposed only by racist border walls and wealth hoarding. For Sheinbaum this inclusion of art in the "fourth transformation" harkens back to the Mexican revolutionary era (for Morena, the third transformation), a time when, as Stephanie J. Smith argues, "art transcended abstract notions of beauty and concretely shaped many topics of political discussion, especially in areas such as education and foreign affairs."[26] Art, that is, might just push the state to recover, invent, and popularize more humane ways of relating to one another and to the planet.

While we do not yet know where this iteration of Mexico's fourth transformation might lead, the combination of state support and freedom Sheinbaum's government imagines for its artists is important. Many of the talented artists whose stories I tell here were constrained by the forms in which they were allowed to work and the scenes they were allowed to show. The actor-subjects—Trini, Sebastiana, Flávio, Domitila— also had ideas of their own, visions of a better life that the development film, and development itself, could not include, and which its hierarchies did not allow them to articulate. What would these artists have made together if they had not been constrained by private foundations, oil

companies, belligerent media outlets, international organizations, modernizing states, and imperialist government agencies? What if instead they'd been supported and been able to make anything they wanted? What if they had been given the space to collaborate on equal footing? What visions of a good life might they have given the world?

Notes

INTRODUCTION

1. *The Forgotten Village* (dir. Herbert Kline, 1941); *The Unending Struggle* (dir. Lee Bobker, 1965).

2. *The Bridge* (dir. Willard Van Dyke, 1944).

3. "So That Men Are Free" (dir. Willard Van Dyke, 1962).

4. Films containing many of these elements that are not discussed in this book include *Doña Julia* (dir. Skip Faust, 1959), *A Village Is Waiting* (dir. Erica Anderson, 1963), *Miracle in San José* (Movius/Peru, 1964), "Brazil: The Take-Off Point" (dir. Warren Wallace, 1964), *A Future for Ram* (dir. Dr. and Mrs. Philips Foster, 1969), *Auto-ayuda comunal: llave al progreso* (Audiovisual Productions South America, 1965), *Fomento: Organizing for Progress* (USAID, 1965), and *New Girl at Tororo* (USIA, 1965).

5. *United in Progress* (dir. Charles Guggenheim and Richard Heffron, 1963).

6. James C. Scott, *Seeing Like a State: How Certain Schemes to Improve the Human Condition have Failed* (Yale University Press, 1998); Arturo Escobar, *Encountering Development: The Making and Unmaking of the Third World* (Princeton University Press, 1995), 134; Nick Cullather, *The Hungry World: America's Cold War Battle Against Poverty in Asia* (Harvard University Press, 2010). For some of the many "development showcase" claims made by scholars, see José Itzigsohn, *Developing Poverty: The State, Labor Market Deregulation and the Informal Economy in Costa Rica and the Dominican Republic* (UPenn

Press, 2000), 54, about Costa Rica; Robert Karl, "From 'Showcase' to 'Failure': Democracy and the Colombian Developmental State in the 1960s," in *State and Nation Making in Latin America and Spain: The Rise and Fall of the Developmental State*, ed. Miguel A. Centeno and Agustín E. Ferraro (Cambridge University Press, 2019), 73–104; Dennis Merrill, *Negotiating Paradise: US Tourism and Empire in 20th Century Latin America* (University of North Carolina Press, 2009).

7. While the modernity thesis is attributed to Siegfried Kracauer's essay "The Cult of Distraction: On Berlin's Picture Palaces" (trans. Thomas Y. Levin [1926], *New German Critique* 40 [Winter 1987]: 91–96) and Walter Benjamin's subsequent essays "On Some Motifs in Baudelaire" and "The Work of Art in the Age of Mechanical Reproduction" in *Illuminations* (trans. Harry Zohn, Schocken Books [1936, 1968], 155–200 and 217–251), Ben Singer demonstrates that "the association between urban modernity and vivid entertainments was a stock intellectual motif by the time Kracauer and Benjamin elaborated it." *Melodrama and Modernity: Early Sensational Cinema and Its Contexts* (Columbia University Press, 2001), 97; also 101–130.

8. See, for example, Jacqueline Stewart, *Migrating to the Movies: Cinema and Black Urban Modernity* (University of California Press, 2005); Allyson Nadia Field, *Uplift Cinema: The Emergence of African American Film and the Possibility of Black Modernity* (Duke University Press, 2015); Camila Gatica Mizala, *Modernity at the Movies: Cinema-Going in Buenos Aires and Santiago, 1915–1945* (University of Pittsburgh Press, 2023); Maite Conde, *Foundational Films: Early Cinema and Modernity in Brazil* (University of California Press, 2018); and Ana M. López, "Early Cinema and Modernity in Latin America," *Cinema Journal* 40, no. 1 (2000): 48–78.

9. Lee Grieveson, *Cinema and the Wealth of Nations: Media, Capital, and the Liberal World System* (University of California Press, 2017), 1.

10. Johannes Fabian, *Time and the Other: How Anthropology Makes Its Object* (Columbia University Press, 1983), 31.

11. Gilbert Rist, *The History of Development: From Western Origins to Global Faith* (Zed Books, 1997).

12. Stephen Macekura, *The Mismeasure of Progress: Economic Growth and Its Critics* (University of Chicago Press, 2020), 32. See also Matthias Schmelzer, *The Hegemony of Growth: The OECD and the Making of the Economic Growth Paradigm* (Cambridge University Press, 2016).

13. Stephen Macekura, "Development and Economic Growth," in *History of the Future of Economic Growth: Historical Roots of Current Debates on Sustainable Degrowth*, ed. Matthias Schmelzer and Iris Boroway (Routledge, 2017), 118–119.

14. Walt Rostow, *Stages of Economic Growth: A Non-Communist Manifesto* (Cambridge University Press, 1960).

15. See Michael Omi and Howard Winant, *Racial Formation in the United States: From the 1960s to the Present* (Routledge, 1991); Jodi Melamed, *Represent and Destroy: Rationalizing Violence in the New Racial Capitalism* (University of Minnesota Press, 2011); David Luis-Brown, *Waves of Decolonization: Discourses of Race and Hemispheric Citizenship in Cuba and the United States* (Duke University Press, 2008); Charles King, *Gods of the Upper Air: How a Circle of Renegade Anthropologists Reinvented Race, Sex, and Gender in the Twentieth Century* (Doubleday, 2019); Sebastián Gil-Riaño, *The Remnants of Race: UNESCO and Economic Development and the Global South* (Columbia University Press, 2023); and Sonali Thakkar, *The Reeducation of Race: Jewishness and the Politics of Antiracism in Postcolonial Thought* (Stanford University Press, 2023).

16. See Michelle Brattain, "Race, Racism, and Antiracism: The Problems of Presenting Science to the Postwar Public," *American Historical Review* (December 2007): 1386–1413; UNESCO, "Statement on the Nature of Race and Race Differences," in *Unesco: Four Statements on the Race Question* (Paris, 1969), 36–43.

17. Scholars approach the relationship between capitalist and socialist development in various ways. David Engerman traces how US modernization theorists looked admiringly to Soviet planning, particularly Stalin's first five-year plan, despite the cost to Soviet populations, while Susan Buck-Morss argues that Soviet and US planning and cultural efforts shared a common modernizing drive from the start. Stephen Macekura traces how growth ideas shaped Soviet measures of progress, while James C. Scott considers how socialist modernization disregarded the well-being of ordinary people in pursuing state legibility. Finally, María Josefina Saldaña-Portillo reads militant leftists' memoirs from the Americas to demonstrate how modernization theory's vision of throwing over one's feminized, community-oriented self in favor of a nationalistic masculine one infiltrated the Latin American Left. Engerman, *Modernization from the Other Shore: American Intellectuals and the Romance of American Development* (Harvard University Press, 2003); Buck-Morss, *Dreamworld and Catastrophe: The Passing of Mass Utopia in East and West* (MIT Press, 2000); Macekura, *Mismeasure of Progress*; Scott, *Seeing Like a State*; Saldaña-Portillo, *The Revolutionary Imagination in the Americas and the Age of Development* (Duke University Press, 2003).

18. James Ferguson, *Give a Man a Fish: Reflections on the New Politics of Distribution* (Duke University Press, 2015).

19. Much less, of course, could development respect the life of the fish.

20. See Amy Offner, *Sorting Out the Mixed Economy: The Rise and Fall of Welfare and Developmental States in the Americas* (Princeton University Press, 2019); Christy Thornton, *Revolution in Development: Mexico and the Governance of the Global Economy* (University of California Press, 2021); and Tore Olsson, *Agrarian Crossings: Reformers and the Remaking of the US and Mexican*

Countryside (Princeton University Press, 2017). Scholars who have traced development's roots in the labor struggles around African decolonization in the 1930s and 1940s have noted a similar narrowing of visions of development. See Frederick Cooper and Randall Packard, eds., *International Development and the Social Sciences: Essays on the History and Politics of Knowledge* (University of California Press, 1998); and Mark Mazower, *Governing the World: The History of an Idea* (Penguin, 2012).

21. Rosaleen Smyth, "Film as Instrument of Modernization and Social Change in Africa: The Long View," in *Modernization as Spectacle in Africa*, ed. Peter J. Bloom, Stephan F. Miescher, and Takyiwaa Manuh (Indiana University Press, 2014), 65; Peter Sutoris, *Visions of Development: The Films Division of India and the Imagination of Progress, 1948–75* (Hurst, 2016). See also Tom Rice, *Films for the Colonies: Cinema and the Preservation of the British Empire* (University of California Press, 2019); James Burns, "Watching Africans Watch Films: Theories of Spectatorship in British Colonial Africa," *Historical Journal of Film, Radio and Television* 20, no. 2 (2000): 197–211; Scott Anthony and James G. Mansell, eds., *The Projection of Britain: A History of the GPO Film Unit* (Palgrave Macmillan, 2011); Colin MacCabe and Lee Grieveson, eds., *Film and the End of Empire* (Palgrave Macmillan, 2011); Alexander Fisher, "Funding, Ideology and the Aesthetics of the Development Film in Postcolonial Zimbabwe," *Journal of African Cinemas* 2, no. 2 (2010): 111–120; and, in a different way, Christina Klein, *Cold War Orientalism: Asia in the Middlebrow Imagination, 1945–1961* (University of California Press, 2003), esp. 191–222.

22. For works that treat World War II and Cold War hemispheric culture without mentioning development films or centering development, see Darlene Sadlier, *Americans All: Good Neighbor Cultural Diplomacy in World War II* (University of Texas Press, 2012); Adrián Pérez Melgosa, *Cinema and Inter-American Relations: Tracking Transnational Affect* (Routledge, 2012); Claire Fox, *Making Art Panamerican: Cultural Policy and the Cold War* (University of Minnesota Press, 2013); Patrick Iber, *Neither Peace Nor Freedom: The Cultural Cold War in Latin America* (Harvard University Press, 2015); Laura Belmonte, *Selling the American Way: US Propaganda and the Cold War* (University of Pennsylvania Press, 2008); and Nicholas Cull, *The Cold War and the United States Information Agency: American Propaganda and Public Diplomacy, 1945–1989* (Cambridge University Press, 2008). Works that have identified development as a theme (but generally not the central focus) in films made in the Americas include Adela Pineda Franco, *The Mexican Revolution on the World Stage: Intellectuals and Film in the Twentieth Century* (State University of New York Press, 2019); Seth Fein, "Everyday Forms of Transnational Collaboration: US Film Propaganda in Cold War Mexico," in *Close Encounters of Empire: Writing the Cultural History of US-Latin American Relations*, ed. Emily Rosenberg et al. (Duke University Press, 1998), 400–450; Ben Nobbs-Thiessen, *Landscape of Migration:*

Mobility and Environmental Change on Bolivia's Tropical Frontier, 1952 to the Present (University of North Carolina Press, 2019), 26–64; Zoe Druick, "Visualising the World: The British Documentary at UNESCO," in *The Projection of Britain*, ed. Scott Anthony and James G. Mansell (Bloomsbury, 2019), 272–280; and Zoe Druick, "UNESCO, Film, and Education: Mediating Postwar Paradigms of Communication," in *Useful Cinema*, ed. Charles R. Acland and Haidee Wasson (Duke University Press, 2011), 81–102. Druick also frames her book on Canada's National Film Board as a story of media "putting into practice the modernizing policies of industrial societies." *Projecting Canada: Government Policy and Documentary Film at the National Film Board* (McGill-Queens, 2007), 9.

23. See Thomas Field, *From Development to Dictatorship: Bolivia and the Alliance for Progress in the Kennedy Era* (Cornell University Press, 2014); Carlota McAllister, "Rural Markets, Revolutionary Souls, and Rebellious Women in Cold War Guatemala," in *In from the Cold: Latin America's New Encounter with the Cold War*, ed. Gil Joseph and Daniela Spenser (Duke University Press, 2008).

24. In its unity of purpose and form, the development film fits with Rick Altman's description of genre as "cohering both semantically and syntactically." I am also guided by literary theorist Michael McKeon, who argues, "Genre provides a conceptual framework for the mediation (if not the 'solution') of intractable problems, a method for rendering such problems intelligible." See Altman, "A Semantic-Syntactic Approach to Film Genre," *Cinema Journal* 23, no. 3 (Spring 1984): 6–18; and McKeon, *The Origins of the English Novel, 1640–1700* (Johns Hopkins University Press, 1987), 20.

25. John Grierson, "Flaherty's Poetic *Moana*," *New York Sun*, February 8, 1926.

26. Donna Haraway, "Teddy Bear Patriarchy: Taxidermy in the Garden of Eden, New York City, 1908–1936," *Social Text* 11 (Winter 1984–1985): 20–64; Fatimah Tobing Rony, *The Third Eye: Race, Cinema, and Ethnographic Spectacle* (Duke University Press, 1996). See also Jeffrey Geiger, *Facing the Pacific: Polynesia and the US Imperial Imagination* (University of Hawai'i Press, 2007); Brian Hochman, *Savage Preservation: The Ethnographic Origins of Modern Media Technology* (University of Minnesota Press, 2015).

27. See, for example, the satisfying igloo-building scene in *Nanook of the North*, beautifully described by Salomé Aguilera Skvirsky in *The Process Genre: Race and the Aesthetic of Labor* (Duke University Press, 2020).

28. "So That Men Are Free" (dir. Willard Van Dyke, 1962).

29. David Ekbladh, *The Great American Mission: Modernization and the Construction of an American World Order* (Princeton University Press, 2009), 3–4. This book follows Ekbladh in finding continuity between New Deal ideals and the Cold War development regime.

30. See Paula Rabinowitz, *They Must Be Represented: The Politics of Documentary* (Verso, 1994); John Tagg, *The Disciplinary Frame: Photographic Truths and the Capture of Meaning* (University of Minnesota Press, 2008);

William Alexander, *Film on the Left: American Documentary Film from 1931 to 1942* (Princeton University Press, 1981); and Maren Stange, *Symbols of Ideal Life: Social Documentary Photography in America, 1890–1950* (Cambridge University Press, 1989).

31. See Michael Denning, *The Cultural Front: The Laboring of American Culture in the Twentieth Century* (Verso, 1996).

32. Brian Winston argues similarly that John Grierson drew on and tempered Soviet avant-garde techniques, which he considered too radically destabilizing, in order to create a film tradition that supported the state and the status quo. Bill Nichols, *Speaking Truth with Films: Evidence, Ethics, Politics in Documentary* (University of California Press, 2016); Winston, *Claiming the Real: The Documentary Film Revisited* (British Film Institute, 1995).

33. Rabinowitz, *They Must Be Represented*, 26.

34. See Singer, *Melodrama and Modernity*, 53.

35. Marisol de la Cadena, "'Women Are More Indian': Ethnicity and Gender in a Community Near Cuzco," in *Ethnicity, Markets, and Migration in the Andes: At the Crossroads of History and Anthropology*, ed. Brooke Larson and Olivia Harris (Duke University Press, 1995), 343.

36. Linda Williams, *Playing the Race Card: Melodramas of Black and White from Uncle Tom to O. J. Simpson* (Princeton University Press, 2002).

37. *Vuelve Sebastiana* (dir. Jorge Ruiz, 1953) and "So That Men Are Free" (dir. Willard Van Dyke, 1962) both begin this way.

38. Julianne Burton, "Democratizing Documentary: Modes of Address in the New Latin American Cinema, 1958–1972," in *The Social Documentary in Latin America*, ed. Burton (University of Pittsburgh Press, 1990), 49.

39. Burton, "Democratizing Documentary," 49. See also Zuzana Pick, *The New Latin American Cinema: A Continental Project* (University of Texas Press, 1993); John King, *Magical Reels: A History of Cinema in Latin America* (Verso, 2000); and Paul Schroeder Rodrigues, *Latin American Cinema: A Comparative History* (University of California Press, 2016).

40. Karen Schwartzman, "An Interview with Margot Benacerraf: Reverón, Araya, and the Institutionalization of Cinema in Venezuela," *Journal of Film and Video* 44, no. 3 (1992–1993): 63. See Druick, "UNESCO, Film, and Education"; and Molly Geidel, "Sowing Death in Our Women's Wombs: Modernization and Indigenous Nationalism in the 1960s Peace Corps and Jorge Sanjinés' *Yawar Mallku*," *American Quarterly* 62, no. 3 (2010): 63–86.

41. For recent and ongoing efforts in this direction, see Hadi Gharabaghi and Bret Vukoder, "The Motion Pictures of the United States Information Agency: Studying a Global Film and Television Operation," *Journal of E-media Studies* 6, no. 1 (2022): 1–37.

42. See Katie Day Good, *Bring the World to the Child: Technologies of Global Citizenship in American Education* (MIT Press, 2020); and Kristen Ostherr,

"Health Films, the Cold War, and the Production of Patriotic Audiences," in *Useful Cinema*, ed. Charles Acland and Haidee Wasson (Duke University Press, 2011), 103–124.

43. Herbert Kline, "On John Steinbeck," *Steinbeck Quarterly* (Summer 1971): 80–88.

44. Fein, "Everyday Forms," 421.

45. Steven Larner, "Remembering James Blue," in *James Blue: Scripts and Interviews*, ed. John Minkowsky (Rice Universtiy/SWAMP, 2002), 7.

46. Nino Gandarilla Guardia, *Cine y Televisión en Santa Cruz* (Universidad Autónoma Gabriel René Moreno, 2011), 265–266.

47. Ostherr, "Health Films," 104.

48. See Brian McKenzie, *Remaking France: Americanization, Public Diplomacy and the Marshall Plan* (Berghahn Books, 2005), 165; and Druick, "Visualising the World," 273.

49. Nils Gilman, *Mandarins of the Future: Modernization in Cold War America* (Johns Hopkins University Press, 2007), 7.

50. See David Armstrong, "The True Believer: Walt Whitman Rostow and the Path to Vietnam" (PhD diss., University of Texas at Austin, 2000), 53, 87, 381.

51. See Arthur M. Schlesinger Jr., Personal Papers, John F. Kennedy Library (hereafter JFKL); For his review of James Blue's USIA film *The March*, see Arthur Schlesinger Jr., "Washington: Fantasy and Reality," *Show*, April 1964, 41.

52. Edward Shils, "Mass Society and Its Culture," *Daedalus* 89, no. 2 (Spring 1960): 313, and "Daydreams and Nightmares: Reflections on the Criticism of Mass Culture," *Sewanee Review* 65, no. 4 (1957): 587–608; Gilman, *Mandarins of the Future*, 54. Prof. Lucas Ortiz B. to Werner J. Blanchard, May 2, 1955, Apoyo Técnico 40-455/1955/C-8/E-F3, CREFAL; David E. Apter, "Africa and the Social Scientist," *World Politics* 6, no. 4 (July 1954): 538–548; Lucian W. Pye, *Communication and Political Development* (Princeton University Press, 1963); Harold Lasswell, "The Structure and Function of Communication in Society," in *The Communication of Ideas*, ed. L. Bryson (Harper and Bros., 1948), 37–51; Ithiel de Sola Pool, *Handbook of Communication* (Rand McNally, 1973).

53. Daniel Lerner, *The Passing of Traditional Society: Modernizing the Middle East* (Free Press, 1958), 54.

54. Lerner, *Passing of Traditional Society*, 54.

55. In the account, the only scene of film spectatorship recounted in his many extant writings and interviews, Van Dyke recalls that he was "affected greatly" by what he calls the "realism" of the film. His experience with *Birth of a Nation* was not unique: schoolchildren around the United States were taken to see Griffith's film when it was released in 1915, and the film was included on school library viewing lists as an educational film at least through the 1940s. See Willard Van Dyke, unpublished memoir, 10–12, Center for Creative Photography (hereafter CCP), Tucson, AZ; and Melvyn Stokes, *D.W. Griffith's "The Birth of a Nation"*:

A History of the Most Controversial Motion Picture of All Time (Oxford University Press, 2008).

56. See Eithne Quinn, *A Piece of the Action: Race and Labor in Post–Civil Rights Hollywood* (Columbia University Press, 2019); Pooja Rangan, *Immediations: The Humanitarian Impulse in Documentary* (Duke University Press, 2017); and Erin Hill, *Never Done: A History of Women's Work in Media Production* (Rutgers University Press, 2016).

57. Rony, *Third Eye*, 104.

58. "So That Men Are Free" (dir. Willard Van Dyke, 1962).

59. See Naomi Klein, *The Shock Doctrine: The Rise of Disaster Capitalism* (Penguin, 2007); James Petras, "Imperialism and NGOs in Latin America," *Monthly Review*, December 1, 1997, https://monthlyreview.org/1997/12/01/imperialism-and-ngos-in-latin-america/; and Lesley Gill, *Teetering on the Rim: Global Restructuring, Daily Life, and the Armed Retreat of the Bolivian State* (Columbia University Press, 2000).

60. See Dani Rodrik, "Premature Deindustrialization," *Journal of Economic Growth* 21 (2016): 1–33.

61. "Israel's War on Gaza Has Set Development Back by 69 Years, UN Says," *Al-Jazeera*, October 22, 2024, https://www.aljazeera.com/news/2024/10/22/israels-war-on-gaza-has-set-development-back-69-years-un-says; US Department of State, "How Does Relief and Development Coherence Apply in Situations of Forced Displacement?," https://www.state.gov/other-policy-issues/relief-and-development-coherence/. The framing of development as a response to environmental crisis ("sustainable development") is even more ubiquitous.

CHAPTER 1. FROM THE POPULAR FRONT TO THE MODERNIZATION MISSION

1. Michael Szalay, *New Deal Modernism: American Literature and the Invention of the Welfare State* (Duke University Press, 2000), 166. For accounts of the worker solidarity ethos of Popular Front culture, see Michael Denning, *The Cultural Front: The Laboring of American Culture in the Twentieth Century* (Verso, 1996); for an account of US documentary film culture in that period see William Alexander, *Film on the Left: American Documentary Film from 1931 to 1942* (Princeton University Press, 1981).

2. See Bill Nichols, "Documentary Film and the Modernist Avant Garde," *Critical Inquiry* 24, no. 4 (Summer 2001): 580–610; and Fatimah Tobing Rony, *The Third Eye: Race, Cinema and Ethnographic Spectacle* (Duke University Press, 1996).

3. On the village as privileged object of modernization theory and development interventions, see Nicole Sackley, "The Village as Cold War Site: Experts, Development, and the History of Rural Reconstruction," *Journal of Global*

History 6 (2011): 481–504; and Arturo Escobar, *Encountering Development: The Making and Unmaking of the Third World* (Princeton University Press, 1995).

4. John Steinbeck, *A Life in Letters* (Viking, 1975), 185–188.

5. Steinbeck, *Life in Letters*, 194.

6. See Denning, *Cultural Front*; Benjamin Balthasar, *Anti-Imperialist Modernism: Race and Transnational Radical Culture from the Great Depression to the Cold War* (University of Michigan Press, 2016). Steinbeck went further in rejecting leftism in his script for the 1952 Hollywood film *Viva Zapata!*, directed by notorious anti-communist Elia Kazan. Pineda Franco details how Kazan connected the film's portrayal of Emiliano Zapata as a lone, defiant tragic hero to his own decision to name names to the House Un-American Activities Committee. Steinbeck too wrote that he understood Zapata as "a symbol of the individual standing out against collectivization" from both the "extreme right" and the "extreme left." Steinbeck later aggressively supported the US war in Vietnam. See Adela Pineda Franco, *The Mexican Revolution on the World Stage: Intellectuals and Film in the Twentieth Century* (State University of New York Press, 2019), 64; and Thomas E. Barden, ed., *Steinbeck in Vietnam: Dispatches from the War* (University of Virginia Press, 2012).

7. For their worries about fascism, see Herbert Kline to John Steinbeck, May 13, 1940, John Steinbeck Personal Papers (hereafter JSPP), Department of Special Collections and University Archives, Stanford University Libraries (hereafter DSCUA-SUL). See also Kline's reference, writing in 1942 to Steinbeck's agent Annie Laurie Williams, to "all the anti-fascist preachments we made in our films." Kline to Annie Laurie Williams and Elizabeth Otis, April 13, 1942, box 117, folder 4, Annie Laurie Williams Papers (hereafter ALWP), Columbia University, Rare Book and Manuscript Library (hereafter CU-RBML).

8. Chris Vials, *Haunted by Hitler: Liberals, the Left, and the Fight Against Communism in the United States* (University of Massachusetts Press, 2014), 88. For other useful accounts of fascism in connection with visual and film culture, see Julia Adeney Thomas and Geoff Eley, *Visualizing Fascism: The Twentieth Century Rise of the Global Right* (Duke University Press, 2020); Jennifer Lynde Barker, *The Aesthetics of Antifascist Film: Radical Projection* (Routledge, 2013).

9. Jackson J. Benson, *The True Adventures of John Steinbeck, Writer* (Viking Press, 1984), 452–453.

10. John Steinbeck to Herbert Kline [ca. March 1940], box M1350, folder 1, JSPP, DSCUA-SUL. *Ejidos* are the communal lands historically shared by indigenous Mexicans, which were usurped by the government in the 1850s and then reallocated to peasants who petitioned for them after the revolution, mostly during the Cárdenas years (1934–1940).

11. Steinbeck to Kline [ca. March 1940], box M1350, folder 1, JSPP, DSCUA-SUL.

12. Herbert Kline, "Diary of a Document: Some Highlights of the Steinbeck-Kline Motion Picture Expedition in Mexico," *New York Times*, March 23, 1941,

184. For reviewers who read the film as a product of the filmmakers' real-life encounters see, among others, The Cinemaid, "'Forgotten Village' at Clay Is Rated Classic," *San Francisco Call/Bulletin*, February 17, 1942; K. W., "Clay Presents Classic Film, 'Forgotten Village," *San Francisco Examiner*, February 16, 1942; Edwin Schallert, "'Forgotten Village' Human Moving Documentary Opus," *Los Angeles Times*, February 21, 1942; and Sara Hamilton, "Film Reveals Simplicity of Mexican Life," *Los Angeles Examiner*, February 21, 1942. Adela Pineda Franco similarly argues that film's shift to implicate tradition happened because of real-life events: that the filmmakers were prepared to film conflict in the streets over the 1940 election, but because this conflict never came to pass, "the documentary came to represent a more indirect attack on fascism." Pineda Franco, *Mexican Revolution on the World Stage*, 40.

13. Philip K. Scheuer, "Town Called Hollywood," *Los Angeles Times*, February 9, 1941, C3.

14. John Steinbeck, *Log from the Sea of Cortez* (1941; Lowe and Brydone, 1958) 74, 99.

15. Steinbeck, *Life in Letters*, 201.

16. John Steinbeck to Herbert Kline [ca. June 1940], box M1350, folder 1, JSPP, DSCUA-SUL.

17. Steinbeck to Herbert Kline [ca. June 1940], JSPP.

18. Steinbeck, *Life in Letters*, 208.

19. Steinbeck, *Life in Letters*, 210. Steinbeck suggested to Kline that maybe the OCIAA was a result of his entreaties. John Steinbeck to Herbert Kline, ["Wednesday," ca. late summer 1940], box M1350, folder 1, JSPP, DSCUA-SUL.

20. Almazán lost the 1940 election to Cárdenas's successor Manuel Ávila Camacho, whose policies, however, signaled a sea change from Cárdenas's redistributive ones. As Karin Alejandra Rosemblatt writes, beginning with Ávila Camacho, "demands for improved access to land would be met by technological fixes aimed at enhancing efficiency." Rosemblatt, *The Science and Politics of Race in Mexico and the United States, 1910–1950* (University of North Carolina Press, 2018), 100.

21. Herbert Kline, "Down Mexico Way: Report from a Documentary Unit Now Filming Below the Border," *New York Times*, July 21, 1941.

22. *Forgotten Village*'s erasure of political conflict is especially evident if we compare it with the Fred Zinnemann and Emilio Gómez Muriel coproduction *Redes/The Wave* from 1936, which learns from Soviet montage and ethnography to depict the exploitation of its fishermen protagonists and their escalating confrontation with their bosses.

23. John Steinbeck to Harry Moore, March 1936, Papers of John Steinbeck, University of Virginia Library (hereafter UVAL).

24. See Jeffrey Geiger, *Facing the Pacific: Polynesia and the US Imperial Imagination* (University of Hawai'i Press, 2007).

25. Travis Workman, *Political Moods: Film Melodrama in the Two Koreas* (University of California Press, 2023), 6. For an account of the formal conventions of American melodrama, to which *Forgotten Village* most closely adheres, see Linda Williams, "Melodrama Revised," in *Refiguring American Film Genres: History and Theory*, ed. Nick Browne (University of California Press, 1998), 42–88.

26. Workman, *Political Moods*, 7.

27. Eisler was hired in late 1940 after the film's original composer, *Redes* score composer Silvestre Revueltas, died during the film's production stage. Because his leftism meant he had difficulty maintaining his US visa status, Eisler had lived and taught in Mexico by the time he took the job scoring *Forgotten Village*. In preparation for writing the film's score, he returned to Mexico for three weeks to listen to Mexican musicians, a process rendered exotic in a *New York Times* interview with Theodore Strauss, in which Eisler discussed the "age-old Indian music" that was "a little frightening." Pineda Franco notes that despite the score's assimilation of Mexican sounds and instruments, Eisler's music has a "distancing" effect, "clashing with the internal logic of diegetic sound" at important moments. Theodore Strauss, "Musical Marathon: In the Score for 'Forgotten Village,' Hanns Eisler Sets a Record of Sorts," *New York Times*, November 23, 1941; Caleb Boyd, "'They Called Me an Alien': Hanns Eisler's American Years, 1935–1948" (MA thesis, University of Arizona, 2013), 97; Pineda Franco, *Mexican Revolution on the World Stage*, 75–76.

28. Williams, "Melodrama Revised," 65.

29. John Steinbeck, *The Forgotten Village: Life in a Mexican Village* (Viking, 1941), 1.

30. Szalay, *New Deal Modernism*, 167; Daniel Lerner, *The Passing of Traditional Society: Modernizing the Middle East* (Free Press, 1958).

31. In an early plan for the film, Steinbeck writes that "opposition [to the doctor] must develop from some source . . . mainly witch doctor, politicos, pulqueria. A leader of old conservatives in village can be Juan Diego's grandfather." See "El Pueblo Olvidado," undated, p. 11, box 117, folder 4, ALWP, CU-RBML.

32. Herbert Kline, "Diary of a Document," *New York Times*, March 23, 1941.

33. Kline, "Diary of a Document."

34. *Forgotten Village* production stills, box M1350, folder 5, JSPP, DSCUA-SUL.

35. John Steinbeck, memo, box M1350, folder 4, JSPP, DSCUA-SUL

36. "John Steinbeck's Mexican Village," *New York Times Book Review* 91, June 1, 1948, 8.

37. Philip K. Scheuer, "A Town Called Hollywood," *Los Angeles Times*, February 9, 1941.

38. Bosley Crowther, "The Forgotten Village," *New York Times*, November 19, 1941.

39. "Cinema," *Time*, December 8, 1941; Paul Speegle, "'The Forgotten Village' Is a Sincere Achievement," *San Francisco Chronicle*, February 16, 1942.

40. Archer Winstein, "The Seventeen and One Half Best Pictures of 1941," *New York Post*, December 18, 1941; "*Kane* Selected as Year's Best," *Hollywood Reporter*, December 22, 1941.

41. James Ferguson, *The Anti-Politics Machine: Development, Depoliticization and Bureaucratic Culture in Lesotho* (University of Minnesota Press, 1994). For an account of women's marginalization in development ventures, see Florence Babb, "Women and Men at Vicos, Peru: A Case of Unequal Development," in *Women's Place in the Andes: Engaging Decolonial Feminist Anthropology*, ed. Florence Babb (University of California Press, 2018).

42. "Herbert Kline, Filmmaker, 89; Recorded Crises in 1930s Europe," *New York Times*, February 17, 1999, C23.

43. Herbert Kline, "On John Steinbeck," *Steinbeck Quarterly* (Summer 1971): 80–88.

44. Herbert Rosener to Joseph Burstyn, April 8, 1942, box 117, folder 4, ALWP, CU-RBML. See also Herbert Kline to Annie Laurie Williams, December 25, 1946, box 117, folder 4, ALWP, CU-RBML.

45. Herbert Kline to Annie Laurie Williams and Elizabeth Otis, May 17, 1944, 3, box 117 Folder 4, ALWP, CU-RBML

46. Robert Redfield, "*The Forgotten Village*," *American Sociological Review* 7, no. 1 (February 1942): 131–132. On Sackley's contributions to modernization theory, see Nicole Sackley, "Cosmopolitanism and the Uses of Tradition: Robert Redfield and Alternative Visions of Modernization During the Cold War," *Modern Intellectual History* 9, no. 3 (2012): 265–295.

47. "The Disputed 'Village' Letter to the Editor by Alvin Johnson," *New York Times*, October 12, 1941; Steinbeck, *Life in Letters*, 235.

48. See Pineda Franco, *Mexican Revolution on the World Stage*, 54.

49. Mariam Colón Pizarro, "Poetic Pragmatism: The Puerto Rican Division of Community Education (DIVEDCO) and the Politics of Cultural Production, 1949–1968" (PhD diss., University of Michigan, 2011), 263; Phillips Ruopp to John Steinbeck, March 10, 1952, box 117, folder 4, ALWP, CU-RBML

50. Fernando de Moral González, *Cine Documental en Pátzcuaro* (Centro de Cooperación Regional para la Educación, 2007), 31.

51. See "Films for Church Use," *International Journal of Religious Education* 19 (1942): 33.

52. Norman D. Humphrey, "The Generic Folk Culture of Mexico," *Rural Sociology* (December 1, 1943): 372.

53. Barker Fairley, "Books of the Month: Symbolisms," *Canadian Forum* 21 (August 1941): 153–154.

54. Edward Ricketts, "Thesis and Materials for a Script on Mexico," in *Breaking Through: Essays, Journals, and Travelogues of Edward Ricketts*, ed. Edward Ricketts and Katharine A. Rodger (University of California Press, 2006), 206–7.

55. Francisco Castillo Nájera to Arthur Mayer, September 13, 1941, box M1350, folder 10, JSPP, DSCUA-SUL.

56. See Alan Knight, "Popular Culture and the Revolutionary State in Mexico, 1910–1940," *Hispanic American Historical Review* 74, no. 3 (1994): 395.

57. Francisco Castillo Nájera to Arthur Mayer, September 13, 1941, box M1350, folder 10, JSPP, DSCUA-SUL.

58. Herbert Kline, "Films Without Make Believe," *Magazine of Art*, February 1942, 155.

59. Kline, "Films Without Make Believe," 148.

60. Darlene Sadlier, *Americans All: Good Neighbor Cultural Diplomacy in World War II* (University of Texas Press, 2012), 2, 62.

61. Seth Fein, "Everyday Forms of Transnational Collaboration: US Film Propaganda in Cold War Mexico," in *Close Encounters of Empire: Writing the Cultural History of US-Latin American Relations*, ed. Gil Joseph, Catherine LeGrand, and Ricardo Salvatore (Duke University Press, 1998), 404.

62. Darlene Rivas, *Missionary Capitalist: Nelson Rockefeller in Venezuela* (University of North Carolina Press, 2002), 39–40.

63. Nelson A. Rockefeller, "Hemisphere Economic Policy," June 1940, Nelson Rockefeller Personal Papers, box 6, folder 44, Rockefeller Archive Center (hereafter RAC).

64. Rivas, *Missionary Capitalist*, 39–45.

65. See Greg Grandin, "Your Americanism and Mine: Americanism and Anti-Americanism in the Americas," *American Historical Review* 111, no. 4 (2006): 1042–1066.

66. There are also limits to what Good Neighbor films can express, particularly in terms of labor and anti-racist solidarity, as Catherine Benamou explores in her account of Orson Welles's unfinished Good Neighbor film. See Benamou, *It's All True: Orson Welles' Panamerican Odyssey* (University of California Press, 2007).

67. Denning, *Cultural Front*, 58; Willard Van Dyke, interview with Russell Campbell, October 15, 1976, interviews 1973–1976, Willard Van Dyke Personal Papers (hereafter WVDPP), CCP.

68. Julius Lobo, "Documentary Poetry and American Modernism from the Depression to World War 2" (PhD diss., Pennsylvania State University, 2011), 135.

69. Willard Van Dyke, unpublished autobiography, 64, WVDPP, CCP.

70. Van Dyke, unpublished autobiography, 64.

71. Willard Van Dyke to Edward Weston, 1935, in *The Letters Between Edward Weston and Willard Van Dyke*, ed. Leslie Squyres Calmes (University of Arizona Press, 1992), 28.

72. Van Dyke, interview with Russell Campbell, October 15, 1976, interviews 1973–1976, 10, WVDPP, CCP.

73. Van Dyke, unpublished autobiography, 141, WVDPP, CCP.

74. Dan Streible, "The Failure of the NYU Educational Film Institute," in *Learning with the Lights Off: Educational Film in the United States*, ed. Devin Orgeron, Marsha Orgeron, and Dan Streible (Oxford University Press, 2012), 272.

75. Streible, "Failure of the NYU Educational Film Institute," 273.

76. Van Dyke, unpublished autobiography, 144–146, WVDPP, CCP.

77. Charles Wolfe attributes the formal experimentalism and political radicalism of the film to Maddow and Blitzstein. Wolfe, "Straight Shots and Crooked Plots: Social Documentary and the Avant-Garde in the 1930s," in *The Documentary Film Reader: History, Theory, Criticism*, ed. Jonathan Kahana (1995; Oxford University Press, 2016), 241–242.

78. Van Dyke, unpublished autobiography, 156, WVDPP, CCP.

79. Van Dyke, unpublished autobiography, 129.

80. Iris Barry, "Observations on the American Documentary Film in Wartime," 1946, 2, Rockefeller Foundation Projects, RG 1.1, box 246, folder 2943, RAC.

81. David Farber, *Sloan Rules: Alfred P. Sloan and the Triumph of General Motors* (University of Chicago Press, 2002), 230–231.

82. Eunice Fuller Barnard to Willard Van Dyke, August 31, 1942, box 11, folder 21, WVDPP, CCP.

83. Harold Sloan to Willard Van Dyke, February 24, 1942, box 11, folder 21, WVDPP, CCP.

84. Van Dyke, unpublished autobiography, 169, WVDPP, CCP. *The Bridge* uses melodramatic devices rather than constituting melodrama itself. Linda Williams is helpful here in characterizing melodrama as a mode, arguing that "supposedly realist cinematic *effects*—whether of setting, action or narrative motivation—most often operate in the service of melodramatic *affects*." Williams, "Melodrama Revised," 42.

85. The pop-ups and litany of products seem to be the result of Harold Sloan's further intervention in the film. Sloan liked the triangular trade sequence and pushed Van Dyke to embellish it by adding the drawings of "definite products." See Eunice Fuller Barnard to Willard Van Dyke, August 13, 1942, "Documentary Film Productions: *The Bridge*," WVDPP, CCP.

86. Ben Maddow, March 26 1942 entry, p. 3, and "Further Notes for Log," in "Writings by Others: Ben Maddow Notes 1942, South American trip with WVD for 'The Bridge,'" WVDPP, CCP.

87. Van Dyke, unpublished autobiography, 175–176, WVDPP, CCP.

88. Van Dyke, unpublished autobiography, 170–171.

89. See Seth Garfield, *In Search of the Amazon: Brazil, The United States, and the Nature of a Region* (Duke University Press, 2013).

90. See Godfrey Hodgson, *America in Our Time: From World War II to Nixon—What Happened and Why* (Princeton University Press, 1976); and Iwan Morgan and Robert Mason, *The Liberal Consensus Reconsidered: American Politics and Society in the Postwar Era* (University of Florida Press, 2017). See

also Jodi Melamed's conception of racial liberalism in *Represent and Destroy: Rationalizing Violence in the New Racial Capitalism* (University of Minnesota Press, 2011).

91. Van Dyke, unpublished autobiography, 224–225, WVDPP, CCP.

92. Dick Vosburgh, "Obituary: Ben Maddow," *The Independent*, October 13, 1992; Van Dyke, unpublished autobiography, 232, WVDPP, CCP.

93. Howard Thompson, "Current Screen Entries in 16 mm," *New York Times*, March 11, 1962, x7.

94. William C. Cobb to Leslie Olson, February 18, 1966, Rockefeller Foundation Records 3.2 (admin. program and policy), series 923 (agriculture), box 2, folder 7, RAC.

95. William C. Cobb to Bertha Valenzuela, June 6, 1966, Rockefeller Foundation Records 3.2 (admin. program and policy), series 923 (agriculture), box 2, folder 7, RAC; William C. Cobb to Francisco Darquea Moreno, February 1, 1963, Rockefeller Foundation Records 3.2 (admin. program and policy), series 923 (agriculture), box 1, folder 6, RAC; William S. Abbot to Becky Sanford, February 20, 1963,William S. Abbot to the Rockefeller Foundation, January 11, 1963, and William C. Cobb to William S. Abbot, January 24, 1963, all in Rockefeller Foundation Records 3.2 (admin. program and policy), series 923 (agriculture), box 2, folder 7, RAC.

96. While *Rice* was removed from its TV distribution (with McGraw-Hill) in 1966, it continued to be available for rent from the Museum of Modern Art; a Rockefeller Foundation report in 1967 quoted a MoMA source saying demand for the film was "still good." "Status of the Films," February 14, 1967, Rockefeller Foundation Records, box R1996, folder "Films," RAC.

97. Eugene I. Knez, "Rice," *American Anthropologist* 68, no. 5 (October 1966): 1328–1329. Rockefeller Foundation staffers, on the other hand, criticized Van Dyke for focusing on "rice paddies in the rain" rather than the scientific work of the Rockefeller experts. See Henry Romney to William C. Cobb, October 17, 1963, Rockefeller Foundation Records, box 7, folder 64, RAC.

98. The Harvard students mainly rated *Rice* in the "A" range and praised its photography and educational value, though a substantial minority felt it lacked sufficient scientific information. See Harvard University, "Comments by Members of Biology 104, 'Plants and Human Affairs,' on the Rice Film," February 26, 1964, Rockefeller Foundation Records, box 8, folder 65, RAC.

99. Denning, *Cultural Front*.

100. It has been difficult to determine whether and how much the actors in *Forgotten Village* were paid. The film's budget lists only "living expenses, including crew and cast" ($7300.84) and "salaries, Mex. crew and Hollywood cutters" ($6452.88); this suggests that the Mexican actors, unlike the Mexican and American production crew members, were compensated only with "living expenses" rather than salaries. "Preliminary Report: Pan-American Films inc., Production of 'The Forgotten Village,'" December 1941, box 117, folder 4, ALWP, CU-RBML.

CHAPTER 2. DISPOSSESSION AS DEVELOPMENT
IN US INFORMATION AGENCY PROPAGANDA,
PETRODOCUMENTARY, AND PUERTO RICAN
COMMUNITY EDUCATION FILMMAKING

1. Quoted in Arturo Escobar, *Encountering Development: The Making and Unmaking of the Third World* (Princeton University Press, 1995), 3.

2. Andre Gunder Frank, "The Development of Underdevelopment," *Monthly Review* 18, no. 4 (September 1966): 37–51; Walter Rodney, *How Europe Underdeveloped Africa* (Bogle/L'Overture Publications, 1972).

3. Cedric Robinson, "Capitalism, Slavery and Bourgeois Historiography," *History Workshop Journal* 23, no. 1 (Spring 1987): 136.

4. The key work here is Louis Hartz, *The Liberal Tradition in America* (Harcourt, 1955).

5. Nils Gilman, *Mandarins of the Future: Modernization Theory in Cold War America* (Johns Hopkins University Press, 2007), 66.

6. See Walt Rostow, "The Making of Modern America, 1776–1940: An Essay on Three Themes," Working Paper for the Center for International Studies, MIT (Center for International Studies, 1960).

7. Banks Murray, "American Films for Turkish Villagers," *The Record* 7–8 (1949): 26. Murray's piece was also included in the 1950 and 1951 editions of the US State Department's *The Record*.

8. Kenneth Osgood, *Total Cold War: Eisenhower's Secret Propaganda Battle at Home and Abroad* (University of Kansas Press, 2006).

9. Original USIA films in this category include *In Search of Lincoln* (1956); the *Scenes from American History* series (*A New World, To Freedom, A Nation Sets Its Course,* and *Coast to Coast*); the animated short *Tom Schuler, Cobbler Statesman* (1953); and *Pilgrimage of Liberty* (1958). Other US history films distributed by USIA in the 1950s include *Decision at Williamsburg; Abraham Lincoln: A Background Study; The Face of Lincoln; Benjamin Franklin; Changing Cotton Land: Westward Flow; Growing Americans; The Growing Years; The American Cowboy;* and *Jefferson: The Architect.* See *Departments of State and Justice, the Judiciary, and Related Agencies Appropriations for 1957, Hearings Before the Subcommittee of the Committee on Appropriations, House of* Representatives, 84th Cong. 210–217 (1957) ("United States Information Agency Film List," February 7, 1956); and USIA film scripts and film evaluations, National Archives and Records Administration (hereafter NARA).

10. See Osgood, *Total Cold War,* 146–148; and Jason Parker, *Hearts, Minds, Voices: US Cold War Public Diplomacy and the Formation of the Third World* (Oxford University Press, 2016), 71–79.

11. See, for example, the Australian Institute of Public Affairs report "*Film . . .* Productivity, Key to Plenty" (1951), 54–55, https://ipa.org.au/wp-content/uploads/archive/1229569278_document_5-2_film.pdf.

12. Brian A. McKenzie, *Remaking France: Americanization, Public Diplomacy, and the Marshall Plan* (Berghahn Books, 2008), 166.

13. See Eric Lott, *Love and Theft: Blackface Minstrelsy and the American Working Class* (Oxford University Press, 1993).

14. "Productivity: Key to Plenty; Pre-release Evaluations," May 31, 1954, 1, USIA Microfilm Files, 1954, folder 34, Roosevelt Study Centre, Middelburg, Netherlands (hereafter RSC).

15. See Irving Molofsky, "U.S. Is Offering Record Amount in Sex-Bias Suit," *New York Times*, March 23, 2000.

16. "Productivity: Key to Plenty; Pre-release Evaluations," May 31 1954, 1, USIA Microfilm Files, 1954, folder 34, RSC. These objections seem to have been partially addressed by the French voice-over, which assured audiences that "one can remain attached to moral values which give a precise meaning to existence without neglecting the material factors which contribute to the good things in life." McKenzie, *Remaking France*, 166.

17. "Productivity: Key to Plenty: Pre-release Evaluations," May 31 1954, 1, USIA Microfilm Files, 1954, folder 34, RSC.

18. "Productivity: Key to Plenty," USIA files, RG 306, box 2, folder S-21-53, NARA.

19. Harold Orleans, "Preview Film Evaluation of 'A Nation Sets Its Course'" (October 15, 1953), 24, Microfilm Papers of the Institute for Research in Human Relations, RSC.

20. Matthew Huber, *Lifeblood: Oil, Freedom, and the Forces of Capital* (University of Minnesota Press, 2013), 58.

21. Timothy Mitchell, *Carbon Democracy: Political Power in the Age of Oil* (Verso, 2011), 42.

22. Huber, *Lifeblood*, 59.

23. See C. P. Trussel, "Deception Is Laid to Standard Oil," *New York Times*, June 1, 1942; "US Firms Fueled Germany for War," *New York Times*, October 19, 1945, 9; and "I.G. Farben Linked to US Companies," *New York Times*, December 12, 1945, 3. See also Anthony Sampson, *The Seven Sisters: The Great Oil Companies and the World They Made* (Viking, 1975).

24. See Steven W. Plattner, *Roy Stryker: USA, 1943–1950* (University of Texas Press, 1983), 12–13; and Miguel Tinker Salas, *The Enduring Legacy: Oil, Culture, and Society in Venezuela* (Duke University Press, 2009), 191–192.

25. Plattner, *Roy Stryker*, 20.

26. See Michael Poindexter, "Oil, Space, and National Imaginaries: Discursive Productions by Standard Oil New Jersey Post WWII" (MA thesis, University of Louisville, 2017), 93–105.

27. Richard Doud, "Oral History Interview with Roy Stryker," Archives of American Art, Smithsonian Institution, October 17, 1963, www.aaa.si.edu/collections/interviews/oral-history-interview-royemerson-stryker-12480#transcript.

28. Doud, "Oral History Interview with Roy Stryker."

29. "Oiltown USA: A Picture Story," *Coronet Magazine*, April 1946, 100.

30. Poindexter, "Oil, Space, and National Imaginaries," 41.

31. Wallace Scot MacFarlane, "Oil on the Farm: The East Texas Oil Boom and the Origins of an Energy Economy," *Journal of Southern History* 83 (2017): 872, 874.

32. See Frederick Buell, "A Short History of Oil Cultures: or, the Marriage of Catastrophe and Exuberance," *Journal of American Studies* 46 (2012): 290.

33. Fernando Coronil, *The Magical State: Nature, Money, and Modernity in Venezuela* (University of Chicago Press, 1997), 134.

34. Gordon Parks, *To Smile in Autumn* (W. W. Norton, 1979), 24.

35. Gordon Parks, *Voices in the Mirror* (Bantam Doubleday Dell, 1990), 96.

36. Richard K. Doud, "Interview with John Collier," January 18, 1965, www .americansuburbx.com/2011/10/interview-interview-with-john-collier-1965.html.

37. See Jason Pribilsky, "Developing Selves: Photography, Cold War Science, and 'Backwards' People in the Peruvian Andes, 1951–1966," *Visual Studies* 30, no. 2 (2015): 131–150.

38. John Collier Jr. and Malcolm Collier, *Visual Anthropology: Photography as Research Method* (University of New Mexico Press, 1986), 30–39.

39. Mitchell, *Carbon Democracy*.

40. Collier and Collier, *Visual Anthropology*, 47.

41. Doud, "Oral History Interview with Roy Stryker."

42. Paul Rotha, *Robert J. Flaherty* (University of Pennsylvania Press, 1984), 237.

43. Michael Watts, "Oil Frontiers: The Niger Delta and the Gulf of Mexico," in *Oil Culture*, ed. Ross Barrett and Daniel Worden (University of Minnesota Press, 2014), 202.

44. Frances Hubbard Flaherty, *The Odyssey of a Filmmaker: Robert Flaherty's Story* (Arno Press, 1972), 35.

45. Huber, *Lifeblood*, 27–59; Mitchell, *Carbon Democracy*, esp. 43–65. For a history of the role of oil in US wars, see Andrew Bacevich, *America's War for the Greater Middle East: A Military History* (Random House, 2016).

46. Flaherty, *Odyssey*, 36.

47. Ross Barrett, "Picturing a Crude Past: Primitivism, Public Art, and Corporate Oil Promotion in the United States," in *Oil Culture*, ed. Ross Barrett and Daniel Worden (University of Minnesota Press, 2014), 60.

48. Helen Van Dongen, *Filming Robert Flaherty's "Louisiana Story": The Helen Van Dongen Diary* (Museum of Modern Art, 1998), 57.

49. Stephanie LeMenager, *Living Oil: Petroleum Culture in the American Century* (Oxford University Press, 2014), 66.

50. Van Dongen, *Filming*, 58.

51. Van Dongen, *Filming*, 58.

52. Richard Leacock, "The Making of *Louisiana Story*," *Southern Quarterly* 23, no. 1 (Fall 1984): 58.

53. Barbara Eckstein, *Sustaining New Orleans: Literature, Local Memory and the Fate of a City* (Routledge, 2006), 238; Rotha, *Robert J. Flaherty*, 260–261.

54. Gregory A. Waller, "The American Petroleum Institute: Sponsored Motion Pictures in the Service of Public Relations," in *Petrocinema: Sponsored Film and the Oil Industry*, ed. Marina Dahlquist and Patrick Vondereau (Bloomsbury, 2021), 137.

55. Waller, "American Petroleum Institute," 150.

56. Waller, "American Petroleum Institute," 154.

57. See Kenneth Jackson, *Crabgrass Frontier: The Suburbanization of the United States* (Oxford University Press, 1985).

58. Vojislava Filipcevic, "Urban Planning and the Spaces of Democracy: New York of the Great Depression in *42nd Street, Dead End*, and *The City*," *Culture, Theory & Critique* 51, no. 1 (2010): 86.

59. MacFarlane, "Oil on the Farm," 868.

60. María Josefina Saldaña Portillo, *Indian Given: Racial Geographies across Mexico and the United States* (Duke University Press, 2016), 57–62.

61. Harry Franqui-Rivera, "War Among All Puerto Ricans: The Nationalist Revolt and the Creation of the Estado Libre Asociado of Puerto Rico (Part 2)," *US Studies Online* (June 2015), https://usso.uk/2015/06/war-among-all-puerto -ricans-the-nationalist-revolt-and-the-creation-of-the-estado-libre-asociado-of -puerto-rico-part-two/.

62. Rafael Cabrera Collazo, "Iconografía de la modernidad: La División de Educación a la Comunidad y la política cultural en el Puerto Rico de los cinquenta," in *Metodologías de análisis del film*, ed. Javier Marzal Felici and Francisco Javier Gómez-Tarín (Edipo, 2007), 15. (My translation, as are all translations in this book unless otherwise indicated.)

63. Richard Doud, "Oral History Interview with Jack and Irene Delano," June 12, 1965, https://www.aaa.si.edu/collections/interviews/oral-history-interview -jack-and-irene-delano-13026.

64. Elmer Davis to Jack Delano, July 13 1943, Jack Delano Personal Papers (hereafter JDPP), Library of Congress (hereafter LoC).

65. See Alphonse Daudet, "The Last Class: The Story of a Little Alsatian," *New York Times*, August 23, 1914, M5.

66. Jack Delano to Roy Stryker, [ca. 1946], JDPP, LoC.

67. Cati Marsh Kennerley, "Cultural Negotiations: Puerto Rican Intellectuals in a State-Sponsored Community Education Project, 1948–1968," *Harvard Educational Review* 73, no. 3 (Fall 2003): 430.

68. Willard Van Dyke, interview with Sol Worth, in *A Personal History of Documentary Film* (1973), 129, CCP.

69. Willard Van Dyke to Edward Weston, January 16, 1956, in Van Dyke and Weston, *The Letters Between Willard Van Dyke and Edward Weston* (University of Arizona/Center for Creative Photography, 1992), 50.

70. Marsh Kennerley, "Cultural Negotiations," 433.

71. Cabrera Collazo, "Iconografía de la modernidad," 15.

72. Rene Marqués, "Writing for a Community Education Programme," *UNESCO Reports and Papers on Mass Communication* 24 (November 1957): 5–11.

73. Luis Ramiro Beltrán, *Mis primeros 25 años* (Editorial de la Buena Memoria, 2010).

CHAPTER 3. EXPERIMENTS IN FUNDAMENTAL
EDUCATION FILMMAKING AND LATIN AMERICAN
REGIONALISM AT PÁTZCUARO

1. Burger had made *Crisis* (1939) with Kline and *Death Mills* (1945) with Wilder. For one characterization of Mexican melodramatic style that emphasizes pathos, rural settings, and music, see Elena Lahr-Vivaz, *Mexican Melodrama from the Golden Age to the New Wave* (University of Arizona Press, 2016), esp. 14–15.

2. Suzanne Langlois, "And Action! UN and UNESCO Coordinating Information Films, 1945–1951," in *A History of UNESCO: Global Actions and Impacts*, ed. Pohl Duedahl (Palgrave Macmillan, 2016), 85.

3. "1,000 Million Illiterates," *UNESCO Courier* 6, no. 6 (1951), http://unesdoc.unesco.org/images/0007/000735/073557eo.pdf#nameddest=73557.

4. Charles Dorn and Kristen Ghodsee argue similarly that the weakness of the capitalist world's nebulous rationale for literacy is demonstrated by the comparative success of Cuba's literacy programs, which were accompanied by land reform. Dorn and Ghodsee, "The Cold War Politicization of Literacy: Communism, UNESCO, and the World Bank," *Diplomatic History* 36, no. 2 (April 2012): 373–398.

5. Denise Ferreira da Silva, *Toward a Global Idea of Race* (University of Minnesota Press, 2007), 130–131.

6. UNESCO, "The Race Question," Paris, 1950, 8, UNESDOC digital library.

7. Michelle Brattain, "Race, Racism, and Antiracism: the Problems of Presenting Science to the Postwar Public," *American Historical Review* (December 2007): 1386–1413; Sebastián Gil-Riaño, "Relocating Anti-Racist Science: The 1950 UNESCO Statement on Race and Economic Development in the Global South," *British Journal for the History of Science* 51, no. 2 (2018): 1–23.

8. Glenda Sluga, "UNESCO and the (One) World of Julian Huxley," *Journal of World History* 21, no. 3 (2010): 403.

9. Zoe Druick, "'Before Education, Good Food, and Health': World Citizenship and Biopolitics in UNESCO's Post-War Literacy Films," in *Body, Capital, and Screens: Visual Media and the Healthy Self in the Twentieth Century*, ed. Christian Bonah and Anja Laukötter (Amsterdam University Press, 2020), 254.

10. Joseph Watras, "The New Education Fellowship and UNESCO's Programme of Fundamental Education," *Paedagogica Historica* 47, nos. 1–2 (2011): 194. See UNESCO, *Fundamental Education: Common Ground for All Peoples* (UNESCO, 1947).

11. UNESCO, *Fundamental Education: A Description and Programme*, Monographs on Education, no. 1 (UNESCO, 1949), 9.

12. UNESCO, *Fundamental Education: A Description*, 14.

13. UNESCO, *Fundamental Education: A Description*, 16.

14. See Chantalle Verna, *Haiti and the Uses of America: Post–US Occupation Promises* (Rutgers University Press, 2017), esp. 122–147.

15. Anabella Abarzua Cutroni, "The First UNESGO Experts on Latin America (1946–58)," in *The Politics of Academic Autonomy in Latin America*, ed. Fernanda Beigel et al. (Routledge, 2013), 47–64. See Lloyd H. Hughes, "Fieldworkers: Keystone of CREFAL's Training Program," *Community Development Bulletin* 9, no. 4 (September 1958): 87–95.

16. Federico Lazarín Miranda, "México, la UNESCO, y el Proyecto de Educación Fundamental para América Latina, 1945–1951," *Signos Históricos* 16, no. 31 (January–June 2014): 89–113; Carla Irina Villanueva, "The Politics of Repressive Education Reform: The Institutional Relationship Between the *Secretaría de Educación Pública* and *Escuelas Normales Rurales* in Mexico During the Cold War" (PhD diss., University of Notre Dame, 2020), 96.

17. See Lloyd H. Hughes, *The Mexican Cultural Mission Programme* (UNESCO, 1950), 30.

18. "Síntesis de las actividades de la división audiovisual del CREFAL," 1953, Apoyo Técnico, folder 40-470/1953/c-5/e-2, and "Proposición de un Plan Coordinado de Producción de Materiales," August 1955, Apoyo Técnico, Programa del Cine, folder 40-45/1955, Archive of the Regional Center for Fundamental Education in Latin America (hereafter CREFAL).

19. Jennifer Jolly, *Creating Pátzcuaro, Creating Mexico: Art, Tourism and Nation Building Under Lázaro Cárdenas* (University of Texas Press, 2018).

20. Hughes, "Fieldworkers," 87.

21. Hughes, "Fieldworkers," 89.

22. "Audiovisual Expert Sees World," *US National Commission for UNESCO Newsletter* 9, no. 11 (1962): 3.

23. Karen Schwartzman, "An Interview with Margot Benacerraf," *Journal of Film and Video* 44, no. 34 (1993): 62–63.

24. Tom Rice, *Films for the Colonies: Cinema and the Preservation of the British Empire* (University of California Press, 2019), 19.

25. Rice, *Films for the Colonies*, 1–12.

26. Rosaleen Smyth, "Grierson, the British Documentary Movement, and Colonial Cinema in British Colonial Africa," *Film History* 25, no. 4 (2013): 82–113.

27. Smyth, "British Documentary Movement."

28. Tim Boon, *Films of Fact: A History of Science Documentary on Film and Television* (Wallflower Press, 2008), 44.

29. Boon, *Films of Fact*, 55.

30. Charlotte Lydia Riley, "'The Winds of Change Are Blowing Economically': The Labour Party and British Overseas Development, 1940s–1960s," in *Britain, France and the Decolonization of Africa: Future Imperfect?*, ed. Andrew W. M. Smith and Chris Jeppesen (University College London, 2017), 50.

31. Riley, "'Winds of Change,'" 51.

32. Herbert G. Luft, "Rotha and the World," *Quarterly of Film Radio and Television* 10, no. 1 (Autumn 1955): 95.

33. Smyth, "British Documentary Movement," 95.

34. Zoe Druick, "Visualising the World: The British Documentary at UNESCO," in *The Projection of Britain: A History of the GPO Film Unit*, ed. James Mansell and Scott Anthony (BFI Publishing, 2011), 275.

35. See Druick, "Visualising the World"; and Richard MacDonald, "Evasive Enlightenment: World Without End and the Internationalism of Postwar Documentary," *Journal of British Cinema and Television* 10, no. 3 (2013): 452–474.

36. Cecile Starr, "One World," *Saturday Review* 37 (February 13, 1954): 54.

37. J. R. C., "World Without End," n.d., box 77, folder 10d, p. 16, Paul Rotha Personal Papers (hereafter PRPP), UCLA Library Special Collections (hereafter UCLA).

38. Siegfried Kracauer, *Theory of Film: The Redemption of Physical Reality* (Oxford University Press, 1960), 205.

39. MacDonald, "Evasive Enlightenment," 469; David M. J. Wood, "Docudrama for the Emerging Post-war Order: Documentary Film, Internationalism and Indigenous Subjects in 1950s Mexico," *Studies in Spanish and Latin American Cinemas* 17, no. 2 (2020): 200.

40. Paul Rotha to Lucas Ortiz, September 10, 1952, box 77, folder 10f, PRPP, UCLA.

41. Paul Rotha to Ross McLean, November 3, 1952, box 77, folder 10e, PRPP, UCLA.

42. Rotha to McLean, November 3, 1952, PRPP.

43. See Paul Rotha, *Robert J. Flaherty: A Biography* (University of Pennsylvania Press, 1983).

44. Paul Rotha to Basil Wright, November 5, 1952, box 77, folder 10d, PRPP, UCLA.

45. Rotha to Wright, November 5, 1952, PRPP.

46. Agustín Campos, Prudenciano Flores, and Margarita Castañeda Pasaye to the leader of Film Mex S.A., April 8, 1951, Dirección General, AHD/DG/DG/1951/Abril/32, CREFAL.

47. Paul Rotha to R. Hawker, Esq., October 22, 1952, 1, box 77, folder 10e, PRPP, UCLA.

48. Paul Rotha to Margot Rose Perkins, November 2, 1952, 3, box 77, folder 10b, PRPP, UCLA; Paul Rotha to Margot Rose Perkins, December 5, 1952, 3, box 77, folder 10a, PRPP, UCLA.

49. Paul Rotha to Margot Rose Perkins, November 24, 1952, 1, box 77, folder 10a, PRPP, UCLA.

50. Hagen Hasselbach to Paul Rotha, July 15, 1952, 2, box 77, folder 10, PRPP, UCLA.

51. Rotha to Perkins, December 5, 1952, 4, PRPP.

52. Amalia Ribi Forclaz, "From Reconstruction to Development: The Early Years of the Food and Agriculture Organization (FAO) and the Conceptualization of Rural Welfare, 1945–1955," *International History Review* 41, no. 2 (2019): 363.

53. Rotha to Perkins, November 24, 1952, 6, PRPP.

54. Rotha to Perkins, November 24, 1952, 6, PRPP.

55. Paul Rotha to Margot Rose Perkins, October 26, 1952, 5, box 77, folder 10a, PRPP, UCLA.

56. Rotha papers, box 12, folder 1 (back of photo), PRPP, UCLA.

57. Rotha to Perkins, November 24, 1952, 1, PRPP.

58. Rotha to Perkins, December 5, 1952, 4, PRPP.

59. Rotha to Perkins, December 5, 1952, 3, PRPP.

60. Apart from *Tzintzuntzan,* see *Camino a la vida* (CREFAL, 1958) and *Nunca es demasiado tarde* (dir. Henry Cassirer, 1961).

61. "Training in Audio-Visual Production: Report on the Short Course Conducted at CREFAL from 3 June to 30 August 1957," 20, Apoyo Técnico, 43-451/1957/C-10/E-1, CREFAL

62. Gabriel Anzola Gómez, *Como llegar hasta los campesinos por medio de la educación* (Ministerio de la educación, 1962), 281.

63. Anzola, *Como llegar hasta los campesinos,* 280.

64. Rice, *Films for the Colonies,* 31.

65. UNESCO, *The Use of Mobile Cinema and Radio Vans in Fundamental Education* (UNESCO, 1949).

66. UNESCO, *The Use of Mobile Cinema,* 161–162.

67. Lucien Parizeau, "Training in Audio-Visual," 27, Apoyo Técnico, 43/451/1957/C-10/E-1, CREFAL.

68. Parizeau, "Training in Audio-Visual," 26.

69. Parizeau, "Training in Audio-Visual," 26–28.

70. "Comentarios sobre películas de agricultura, 1961," Apoyo Técnico 421/1961/6-14/6-3 (entire folder), CREFAL.

71. "Unos sugerencias sobre la producción, uso, y evaluación de los materiales audiovisuales durante la segunda época," folder 40-455/1955/C-8/E-3, CREFAL.

72. H. G. Ogden, "Training in Audio-Visual Materials," 12, Apoyo Técnico 43-451/1957/C-10/E-1, CREFAL.

73. J. Ernesto Rosales Urbino, untitled report, August 22, 1953, Apoyo Técnico, folder 40-470/1953/C-5/E-2, CREFAL.

74. Rosales Urbino, untitled report, CREFAL.

75. Florita Botts, *Journeys for a Witness: My Work as a Photographer for the United Nations, 1960s–1980s* (Viella, 2020), 14.

76. Botts, *Journeys for a Witness*, 15.

77. Watras, "New Education Fellowship," 203.

78. Lloyd H. Hughes, "Crefal: Training Centre for Community Development for Latin America," *International Review of Education/Internationale Zeitschrift für Erziehungswissenschaft/Revue Internationale de l'Education* 9, no. 2 (1963): 226–235; Fernando de Moral Gonzales, *Cine Documental en Pátzcuaro* (Centro de Cooperación Regional para la Educación de Adultos en América Latina y el Caribe, 2007), 72.

79. Ross McLean to Julio Castro, December 23, 1953, Apoyo Técnico, folder 40-470/1953/C-5/E-2, CREFAL.

CHAPTER 4. PERFECTING THE DEVELOPMENT FILM FORM IN REVOLUTIONARY BOLIVIA

1. José Sánchez H., *The Art and Politics of Bolivian Cinema* (Scarecrow Press, 1999), 60; José Antonio Valdivia, *Testigo de la realidad: Jorge Ruiz, memorias del cine boliviano* (Plural, 1998), 64–65. The interview seems to be the one reported by the *New York Herald Tribune* as a "filmed message, delivered in English," in which "Mr. Paz Estenssoro emphasized that his regime is not anti-capitalist." "Bolivia Wants Profits of Tin Used for Nation: President Explains," *New York Herald Tribune*, April 19, 1952, 3.

2. See James Malloy, *Bolivia: The Uncompleted Revolution* (University of Pittsburgh Press, 1970), 176–177.

3. Carlos Mesa, *La aventura del cine Boliviano, 1952–1980* (Editorial Gisbert, 1985), 2.

4. "Bolivian President to Resign," *Al Jazeera*, March 7, 2005, https://www.aljazeera.com/news/2005/3/7/bolivian-president-to-resign-2.

5. See Edward A. Morrow, "Deep Split Is Seen in Bolivia's Cabinet," *New York Times*, May 3, 1952, 10.

6. Nicole Trofimov, "The Alliance for Progress: A Comparative Analysis of Bolivia, Colombia, and Venezuela; What Factors Explain the Different Levels of Aid Given to these Countries Between 1961 to 1963?," *Webster Review* 1, no. 1 (2021): 70; Thomas Field, *From Development to Dictatorship: Bolivia and the Alliance for Progress in the Kennedy Era* (Cornell University Press, 2014); Molly Geidel, *Peace Corps Fantasies: How Development Shaped the Global Sixties* (University of Minnesota Press, 2015), esp. ch. 5, and "*Life* and the Pedagogy of Counterinsurgency, 1961–64," *Photography and Culture* 9, no. 3 (2016): 219–238.

7. See Roberto Pareja, "'Los embrujos secretos del trópico': Frontera amazónica y producción del espacio estatal en la obra cinematográfica de Jorge Ruiz," *Bolivian Studies Journal* 20 (2014): 70–89; Ben Nobbs-Thiessen, *Landscape of Migration: Mobility and Environmental Change on Bolivia's Tropical Frontier, 1952 to the Present* (University of North Carolina Press, 2020); Doris Sommer, *Foundational Fictions: The National Romances of Latin America* (University of California Press, 1991).

8. See Joshua Malitsky, *Post-Revolution Nonfiction Film: Building the Soviet and Cuban Nations* (Indiana University Press, 2013). A few newsreels and newsreel-like films released in the immediate wake of the revolution are the exception. See Mikel Luis Rodríguez, "El ICB: el primer organismo cinematográfico institucional en Bolivia (1952–1967)," *Secuencias* 10 (1999): 27.

9. See *Los que nunca fueron* (Ruiz, 1954), *Los Ximul* (Ruiz, 1956), *Policía rural* (Ruiz, 1963), and *So That Men Are Free* (Van Dyke, 1962, with cinematography by Ruiz).

10. Jeffrey Himpele, *Circuits of Culture: Media, Politics, and Indigenous Identity in the Andes* (University of Minnesota Press, 2007), 120.

11. Instituto Cinematographico Boliviano, "Estadistica: Cines de Bolivia," *Wara Wara*, 1954, National Film Archive (AFNB).

12. Alber Quispe Escobar, "Un corte cinematográfico: Notas sobre la producción fílmica en Cochabamba, 1951–1964," *Punto Cero* 14, no. 18 (2009), http://www.scielo.org.bo/scielo.php?pid=S1815-02762009000100008&script=sci_arttext.

13. Nino Gandarilla describes a tradition in Santa Cruz established by the 1970s of jeering and whistling at latecomers who continued arriving throughout the short film and the trailers. Gandarilla Guardia, *Cine y televisión en Santa Cruz* (Universidad Autónoma Gabriel René Moreno, 2011), 265–266.

14. Waldo Cerruto, "Editorial," *Wara Wara*, 1954, AFNB.

15. Valdivia, *Testigo de la realidad*, 40.

16. Valdivia, *Testigo de la realidad*, 41.

17. Valdivia, *Testigo de la realidad*, 41.

18. See Fatimah Tobing Rony, *The Third Eye: Race, Cinema, and Ethnographic Spectacle* (Duke University Press, 1996).

19. Valdivia, *Testigo de la realidad*, 41.

20. Alfonso Gumucio Dagrón, "Breve historia del cine boliviano," *La palabra y el hombre* 24 (1977): 16–17.

21. Valdivia, *Testigo de la realidad*, 49.

22. *Vuelve Sebastiana* won prizes at the Santa Margherita and Bilbao festival, as well as at the 1956 SODRE festival in Ecuador.

23. See Mariano Mestman and María Luisa Ortega, "Cruces de miradas en la transición del cine documental: John Grierson en Sudamérica," *Cine documental* 18 (2018): 192.

24. Luis Ramiro Beltrán, *Mis primeros 25 años* (Editorial de la Buena Memoria, 2010).

25. Beltrán, *Mis primeros 25 años*, 169–187.

26. Beltrán, *Mis primeros 25 años*, 158–173.

27. Alfred Métraux, "Un mundo perdido," *Sur* 1, no. 3 (1931): 108–9.

28. Beltrán, *Mis primeros 25 años*; Valdivia, *Testigo de la realidad*, 53.

29. Verónica Cordova S., "Cine Boliviano: Del indigenismo a la globalización," *Nuestra America* 3 (2007): 138.

30. Valdivia, *Testigo de la realidad*; Laura Gotkowitz, *A Revolution for Our Rights: Indigenous Struggles for Land and Justice in Bolivia, 1880–1952* (Duke University Press, 2008); Carmen Soliz, *Fields of Revolution: Agrarian Reform and State Formation in Bolivia, 1935–1964* (University of Pittsburgh Press, 2021). Critics, noting this timing, have generally read *Vuelve Sebastiana* as asserting the filmmaker's and the Bolivian state's total mastery over Bolivian land and rural indigenous populations through the all-encompassing camera work and the consciousness-hopping voice-over. See Cordova, "Cine Boliviano," 134–135; Jeffrey Himpele, *Circuits of Culture: Media, Politics, and Indigenous Identity in the Andes* (University of Minnesota Press, 2007), 121; Pareja, "Los embrujos secretos del trópico," 79; and Jaime Salinas Zabalaga, "The Other Side of Bolivian Modernity: *Vuelve Sebastiana* and the Reconfiguration of Space-Time Coordinates to Think the Nation," *Bolivian Studies Journal* 23–24 (2017–2018): 1074–2247.

31. See Silvia Rivera Cusicanqui, "Liberal Democracy and Ayllu Democracy in Bolivia: The Case of Northern Potosí," *Journal of Development Studies* 26, no. 4 (1990): 97–121; Waskar Ari, *Earth Politics: Religion, Decolonization and Bolivia's Indigenous Intellectuals* (Duke University Press, 2014), 135–170.

32. See Silvia Rivera Cusicanqui, *Oprimidos pero no vencidos luchas del campesinado aymara y qhechwa de Bolivia, 1900–1980* (HISBOL, 1984).

33. Silvia Rivera Cusicanqui, "The Notion of 'Rights' and the Paradoxes of Postcolonial Modernity," *Qui Parle* 18, no. 2 (2010): 29–54; Marisol de la Cadena, "Women Are More Indian: Ethnicity and Gender in a Community Near Cuzco," in *Ethnicity, Markets, and Migration in the Andes: At the Crossroads of History and Anthropology*, ed. Brooke Larson and Olivia Harris (Duke University Press, 1995).

34. Rivera Cusicanqui, "Notion of 'Rights.'"

35. Rony, *Third Eye*.

36. Elena Lahr-Vivaz argues that *Maria Candelaria*'s filmmakers "offer an allegorical paean to Mexico's indigenous populations even as they signal the need to eradicate the barbarism of the pre-Revolutionary past in the name of the modernity assuredly still to come." *Mexican Melodrama from the Golden Age to the New Wave* (University of Arizona Press, 2016), 37.

37. Valdivia, *Testigo de la realidad*, 60–61.

38. Manuel Chaparro Escudero, *Memorias Chipayas* (MEDIA, 2009), 47.

39. Ruiz notes in his memoir that Sebastiana's community "rebaptized" her Come Back Sebastiana after the film. Valdivia, *Testigo de la realidad*, 53.

40. Film historian turned politician Mesa, who praised *Vuelve Sebastiana* in the 1980s as a precursor to Bolivia's original indigenist radical film traditions,

invoked the film in 2013 for a very different purpose: to discredit the plurina-tional government of Bolivia's first indigenous president, Evo Morales. In an op-ed entitled "The Pariahs of the Plurinational State," he describes a march by Urus and Chipayas demanding the preservation of their land; although Morales's government ended up partially conceding to their demands, Mesa invokes the film to link the march to ongoing Aymara domination of the Uru-Chipayas. "As the masterwork of filmmaker Jorge Ruiz *Vuelve Sebastiana* beautifully recounts, the Uru-Chipayas have always been surrounded and scorned by the Aymaras, who consider them their enemies." This invocation of the film, in another period when indigenous unity seemed possible, was not quite accurate: what the film depicts beautifully is Chipaya-Aymara friendship. See Carlos Mesa, "Los parias del estado plurinacional," March 18, 2013, https://carlosdmesa.com/2013/03/18/los-parias-del-estado-plurinacional/.

41. Valdivia, *Testigo de la realidad*, 37.

42. Kevin Young, *Blood of the Earth: Resource Nationalism, Revolution, and Empire in Bolivia* (University of Texas Press, 2017).

43. Young, *Blood of the Earth*, 73.

44. Anne McClintock, *Imperial Leather: Race, Gender, and Sexuality in the Colonial Contest* (Routledge, 1995), 22.

45. See Susan Eckstein, "Transformation of a 'Revolution from Below'—Bolivia and International Capital," *Comparative Studies in Society and History* 25, no. 1 (January 1983): 105–135.

46. Valdivia, *Testigo de la realidad*, 80.

47. See Linda Williams, *Playing the Race Card: Melodramas of Black and White from Uncle Tom to O. J. Simpson* (Princeton University Press, 2003).

48. Seth Fein, "The United States and the Mexican Film Industry After World War II," Texas Papers on Mexico, Mexican Center, Institute of Latin American Studies, University of Texas at Austin, 1993, 1.

49. Oscar Soria, "Cine," *Presencia*, August 6, 1975, 500.

50. Ben Singer, *Melodrama and Modernity: Early Sensational Cinema and Its Context* (Columbia University Press, 20010, 46.

51. See Young, *Blood of the Earth*, 35–58.

52. "Remarks of the Newly Appointed Ambassador of Bolivia, Dr. Enrique Sánchez De Lozada, April 24, 1963," 1966 Correspondence Folder, Archivo de Relaciones Exteriores (hereafter ARE).

53. Elizabeth Cobbs argues that in the 1950s, the United States did not con-sider Latin America important enough to assist in building welfare states there, and thus "Latin America was expected to observe the normal liberal trade pol-icies which the US government recognized as too risky for Western Europe and Japan." See Cobbs, *The Rich Neighbor Policy: Rockefeller and Kaiser in Brazil* (Yale University Press, 1992), 19–20.

54. While *Our Daily Bread* appears to promote frontier-nostalgic self-sufficiency, an early draft of the script saw the commune saved by President

Franklin D. Roosevelt, and even the final version of the film was imagined by Vidor to express the philosophy of the New Deal. See Colin Schindler, *Hollywood in Crisis: Cinema and American Society 1929–1939* (Taylor and Francis, 2005).

55. Soria, "Cine"; Valdivia, *Testigo de la realidad*, 78.

56. ICA/W, "Film: La Vertiente," October 13, 1960, Films, Filmstrips and Slides, NARA.

57. Valdivia, *Testigo de la realidad*, 82. *Las montañas no cambian* won prizes at festivals in Karlovy Vary, Berlin, and Bilbao.

58. Field, *From Development to Dictatorship*, 15–22.

59. Field, *From Development to Dictatorship*, 15–22.

60. Claudia Arteaga, *"Las montañas no cambian* y la mise-en-scène del desarrollismo boliviano en los años sesenta," *Artefacto Visual* 2, no. 2 (2017): 122–153.

61. Marco Arnez Cuellar, "Estéticas indigenistas: revolución nacional y desarrollo en la cinematografía de Jorge Ruíz (1952–1962)" (PhD thesis, Universidad Mayor de San Andrés, 2013).

62. María Josefina Saldaña-Portillo, building on Ileana Rodriguez's work, describes this move to occupy both the feminine and masculine positions as key to the work of both development and revolution in the Americas. See Saldaña-Portillo, *The Revolutionary Imagination in the Americas and the Age of Development* (Duke University Press, 2003); and Rodriguez, *Women Guerrillas, and Love: Understanding War in Central America* (University of Minnesota Press, 1996).

63. Valdivia, *Testigo de la realidad*, 83.

64. Ruiz claims the USSR, Czechoslovakia, and the People's Republic of China all purchased copies of the film. Valdivia, *Testigo de la realidad*, 81.

65. See Amy Offner, *Sorting Out the Mixed Economy: The Rise and Fall of Welfare and Developmental States in the Americas* (Princeton University Press, 2019), 30–78.

66. Nobbs-Thiessen, *Landscape of Migration*, 55.

67. "The Universal Magic of the Movies: From Zululand to Music Hall," *Life*, December 20, 1963, 23.

68. See Mary Weismantel, *Cholas and Pishtacos: Stories of Race and Sex in the Andes* (University of Chicago Press, 2003).

69. See Geidel, *Peace Corps Fantasies*, ch. 6.

70. Geidel, *Peace Corps Fantasies*.

CHAPTER 5. BRUTAL PEDAGOGY IN THE KENNEDY YEARS

1. See Jeffrey Taffet, *Foreign Aid as Foreign Policy: The Alliance for Progress in Latin America* (Routledge, 2007); and Stephen Rabe, *The Most Dangerous*

Area in the World: John F. Kennedy Confronts Communist Revolution in Latin America (University of North Carolina Press, 1999).

2. USAID's plan for 1963 stated, for example, that "in the field of education expanded facilities in the form of classrooms, trained teachers and material are needed on a massive scale. Human resources can best be improved through education; its contribution to economic growth has no parallel." USAID, *Proposed Program for Fiscal Year 1963* (USAID, 1963), 68.

3. See Thomas Field, *From Development to Dictatorship: Bolivia and the Alliance for Progress in the Kennedy Era* (Cornell University Press, 2014); and John Bedan, "The Price of Progress: Guatemala and the United States during the Alliance for Progress Era" (PhD diss., University of Oregon, September 2018).

4. For Ruiz's account of shooting "So That Men Are Free," see José Antonio Valdivia, *Testigo de la realidad: Jorge Ruiz, memorias del cine documental Boliviano* (Plural, 1998), 129. See Geoff Alexander, *Films You Saw in School: A Critical Review of 1,153 Classroom Educational Films (1958–1985) in 74 Subject Categories* (McFarland, 2013).

5. The reference to the Inca civilization indicates the indigenist ideas that influenced the Vicos project, which did not, however, call for the preservation of indigenous lifeways. See Jason Pribilsky, "Development and the 'Indian Problem' in the Cold War Andes: *Indigenismo*, Science, and Modernization in the Making of the Cornell-Peru Project at Vicos," *Diplomatic History* 33, no. 3 (2009): 405–426.

6. Burton Benjamin to Charles Kuralt, May 15, 1962, and Charles Kuralt to Burton Benjamin, July 10, 1962, box 53, folder 698, Charles Kuralt Collection, Wilson Library, UNC-Chapel Hill (hereafter WLUNC).

7. Burton Benjamin to Charles Kuralt, September 13, 1962, and "So That Men Are Free," *Show*, August 1963, box 53, folder 698, Charles Kuralt Collection, WLUNC.

8. Geoff Alexander includes the film in his book cataloging "the most commonly distributed films in North American Classrooms" and claims it was "one of the first films seen in classrooms dealing with the enmity between Andean Indian groups and their mestizo overseers and landlords"; the film is only one of two CBS *20th Century* programs included in his book. See Alexander, *Films You Saw in School*, 8, 48.

9. "USIA Flap Over Negro Film," *Variety*, September 4, 1963, 1. George Stevens Jr. confirmed that he thought *Variety*'s account of this was accurate in personal correspondence (email to author, July 10, 2022).

10. Willard Van Dyke to Mrs. E. T. Wilcox, June 4, 1971, WVDPP, CCP.

11. Michael Latham, *Modernization as Ideolog: American Social Science and "Nation Building" in the Kennedy* Era (University of North Carolina Press, 2000), 186–189.

12. Willard Van Dyke, unpublished memoir, 295, WVDPP, CCP.

13. James L. Enyeart, *Willard Van Dyke: Changing the World Through Photography and Film* (University of New Mexico Press, 2008), 272–273.

14. Willard Van Dyke, "Interview with Sol Worth," 1973, 68, folder 2, WVDPP, CCP.

15. Willard Van Dyke, "Statement for Filmmakers' Cinematheque Showing of 'The City'" folder, [ca. 1965], "Writings, Articles," 196, WVDPP, CCP.

16. "Prisoners of Our Geography," *Life*, June 28, 1961, 38–51.

17. "The Races and the Terrain—A Mixed-Up Inheritance," *Life*, July 28, 1961, 40–52.

18. Andrew St. George, "The Menacing Spread of Castroism," *Life*, June 2, 1961, 2.

19. Robert Coughlan, "The Staggering Problem," *Life*, July 28, 1961, 57.

20. Coughlan, "Staggering Problem," 59.

21. Coughlan, "Staggering Problem," 59.

22. Gordon Parks, "Freedom's Fearful Foe: Poverty," *Life*, June 16, 1961, 86–98.

23. See Gordon Parks, *A Choice of Weapons* (Harper and Row, 1966).

24. Parks's title had changed by 1961 from staff photographer to contributing photographer. See Paul Roth, "Saving Flávio: A Photographic Essay in Context," in Parks, *The Flávio Story* (Stedl, 2018), 88–131.

25. See Alan Brinkley, *The Publisher: Henry Luce and his American Century* (Knopf, 2010).

26. Gordon Parks, *Flavio* (W. W. Norton, 1978), 58.

27. Parks, *Flavio*, 58.

28. Parks, *Flavio*.

29. Parks, *Flavio*, 14.

30. Parks, *Flavio*, 14.

31. Parks, *Flavio*, 14.

32. Parks, *Flavio*, 20–21.

33. Parks, *Flavio*, 62.

34. Tad Szulc, "Rusk Calls Poverty 'Real Issue' in Western Hemisphere," *New York Times*, May 5, 1961, 1.

35. Gordon Parks, "Freedom's Fearful Foe: Poverty," *Life*, June 16, 1961.

36. See Parks, *Flávio Story*, 52.

37. Parks, *Flavio*, 79–89.

38. "Flavio's Rescue," *Life*, July 21, 1961.

39. Parks, *Flavio*, 78.

40. Jay Prosser, *Light in the Dark Room: Photography and Loss* (University of Minnesota Press, 2004), 89–122.

41. Lewis Bernstein, "Interim Psychological Test Evaluation," 1961, box 36, folder 8, Flavio File, Gordon Parks Papers (hereafter GPP), LoC.

42. Israel Friedman to José Gallo, September 6, 1961, Flavio file, GPP, LoC.

43. Parks, *Flavio*, 143.

44. Parks, *Flavio*, 159.

45. See Parks, *Flávio Story*, esp. 283–293.

46. "Interview with Flávio da Silva," December 10–12, 2016, in Parks, *Flávio Story*.

47. James Ferguson, *Expectations of Modernity: Myths and Meanings of Life on the Zambian Copperbelt* (University of California Press, 1999), 236.

48. Parks, *Flavio*, 40.

49. Parks, *Flavio*, 7.

50. Parks, *Flavio*, 198.

51. Parks, *Flavio*, 197.

52. Parks, *Flavio*, 142.

53. A 1963 memo states: "No longer is USIA handed a policy and told to make the best of it. The Agency's counsel is now sought whenever national policies with foreign implications are being formulated. The Director participates actively in all meetings of the National Security Council and its executive committee." USIA, "Some Changes in USIA since March, 1961," October 28, 1963, USIA, box 2, folder 2, JFKL.

54. In October 1964, USIA reflected that "in its efforts to provide USIA posts with documentary films of quality and effectiveness," it had "been calling upon the nation's best film talents, including an impressive number of outstanding young filmmakers with outstanding reputations," listing Hershensohn, Guggenheim, Seltzer, Kent MacKenzie, Morton Heilig, Robert K. Sharpe, Edward Speigel, Gary Goldsmith, Terry Sanders, William Jersey, Nicholas Webster, William Greaves, Tibor Hirsch, Curtis Harrington, Ed Emshwiller, Paul Cohen, and Hillary Harris. "IMS Notes for July 1964," 1–4, USIA, BH 18.310, Bruce Herschensohn Collection, Pepperdine University Special Collections (hereafter PUSC).

55. George Stevens Jr., speech from 1965, quoted in Katherine Lynne Jackson, "Tangled Up in James Blue: A Committed Filmmaker's Journey Through Independent and Commercial Filmmaking, Propaganda, Documentary, Observational Cinema and Alternative Media" (PhD diss., New York University, 1992), 209.

56. Murrow introduced the five themes in July 1961. See USIA files, box 2, folder 2, July 24, 1961, NARA.

57. Nicholas Cull, *The Cold War and the United States Information Agency: American Propaganda and Public Diplomacy, 1945–1989* (Cambridge University Press, 2009), 209.

58. "Memorandum of Agreement between International Information Administration and Technical Cooperation Administration," April 7, 1952, USIA Motion Pictures Subject File, box 153, folder 9, "Motion Pictures, 1952," NARA.

59. This general sense of Blue's politics was affirmed by his brother Richard Blue in personal correspondence with the author, July 2020.

60. Mary Batten, "Interview with James Blue," *Film Comment* 1, no. 5 (Summer 1963): 7.

61. Jackson, "Tangled Up," 138.

62. George Stevens Jr., *My Place in the Sun: Life in the Golden Age of Hollywood and Washington* (University Press of Kentucky, 2022), 158.

63. Jackson, "Tangled Up," 231.

64. Colombia was also imagined as particularly congenial to development because of its twentieth-century history of development initiatives by state agencies and the private sector. See Arturo Escobar, *Encountering Development: The Making and Unmaking of the Third World* (Princeton University Press, 1995); and more recently Amy Offner, *Sorting Out the Mixed Economy: The Rise and Fall of Welfare and Developmental States in the Americas* (Princeton University Press, 2019); and Susana Romero Sánchez, "Ruralizing Urbanization: Credit, Housing, and Modernization in Colombia, 1920–1948" (PhD diss., Cornell University, 2015).

65. Taffet, *Foreign Aid*, 150.

66. Edward R. Murrow to Chester Bowles, August 24, 1962, USIA files, JFKL. Bowles had suggested on August 7 that "the Alliance is not in Good Shape. It desperately needs a success story. Colombia can provide it." Chester Bowles, "Setting the Pace for the Alliance for Progress in Colombia," August 7, 1962, Arthur Schlesinger Jr. Personal Papers, box Wh2, folder 1, JFKL.

67. Jackson, "Tangled Up," 238.

68. George Stevens Jr. to James Blue, c/o Georges Derocles, Paris, TLS, 2 May 1963, quoted in Jackson, "Tangled Up," 242.

69. Willard Van Dyke, "Statement Cheered," *New York Times*, "Movie Opinions," November 3, 1963, X8. Blue also told an interviewer in 1968 that "his French friends who make films admire *Rincon Santo* least of all his work." See Robert LaRue, "James Blue/Documentary," *Old Oregon*, May–June 1968, 36.

70. Jim Wood to James Blue, July 21, 1963, box 82, folder 82, James Blue Personal Papers (hereafter JBPP), Special Collections at the University of Oregon (hereafter SCUO).

71. George Stevens, "Remarks to American Film Festival Luncheon, April 22, 1965," 7, box 6, folder 49, JBPP, SCUO.

72. Steven Larner, "Remembering James Blue," in *James Blue: Scripts and Interviews*, ed. John Minkowsky (Rice University/SWAMP, 2002), 7.

73. Jennifer Horne, "Experiments in Propaganda: Reintroducing James Blue's Colombian Trilogy," *The Moving Image* 9, no. 1 (Spring 2009).

74. Letter to Hearst Metrotone News from USIA, September 10, 1963, USIA Rights and Permission Files, box 54, folder 3 (*The March*), NARA.

75. See Nicholas Cull, "Auteurs of Ideology: USIA Documentary Film Propaganda in the Kennedy Era as Seen Through Bruce Herschensohn's *Five Cities of June* (1963) and James Blue's *The March* (1964)," *Film History* 10 (1998): 306–307.

76. Jackson, "Tangled Up," 298.

77. Cull, "Auteurs of Ideology," 307.

78. Jackson, "Tangled Up," 317.

79. See Gordon Hitchens, "People We Like," *Film Comment* 17, no. 1 (January/February 1981): 69–70.

80. James Blue Notebook, 1967, box 11, folder 58, JBPP, SCUO; James Blue Memo to Bob Butler, USIA, Washington, January 20, 1967, box 6, folder 14, JBPP, SCUO.

81. Peter Lunenfeld, "There Are People in the Streets Who Have Never Had a Chance to Speak: James Blue and the Complex Documentary," *Journal of Film and Video* 46, no. 1 (Spring 1994): 24.

82. See Cull, *Cold War*, 296–297. This rejection of "nation building" was a subject of USIA staff debates; see Michael P. Canning to USIA Staff (1970), subject files, box 154, folder 6, and Canning to USIA staff, February 1971, box 154, folder 6, NARA. Cull affirms the 1970s as the end of the golden age of documentary at USIA. Cull, "Auteurs of Ideology," 308.

83. Andre Gunder Frank, "Rostow's Stages of Economic Growth from Escalation to Nuclear Destruction," 1967, 2, https://historicpittsburgh.org/islandora/object/pitt%3A31735061539908/viewer#page/1/mode/2up.

CHAPTER 6. WOMEN IN DEVELOPMENT
AND THE NEW EXPERIENTIAL DOCUMENTARY

1. See Joanne Meyerowitz, *A War on Global Poverty: The Lost Promise of Redistribution and the Rise of Microcredit* (Princeton University Press, 2021); M. Murphy, *The Economization of Life* (Duke University Press, 2017); Lamia Karim, *Microfinance and Its Discontents: Women in Debt in Bangladesh* (University of Minnesota Press, 2011); and Arturo Escobar, *Encountering Development: The Making and Unmaking of the Third World* (Princeton University Press, 1995).

2. See, for example, Walt Rostow, *Stages of Economic Growth: A Non-Capitalist Manifesto* (Cambridge University Press, 1960), 23. Frank Furedi notes a similar emphasis on economic growth rather than population limitation in modernization theory, with only a few exceptions. See Furedi, *Population and Development: A Critical Introduction* (Polity, 1997) 88–101.

3. Barbara Ward, *Towards a World of Plenty: The Falconer Lectures, University of Toronto, 1963* (University of Toronto Press, 1963), 19.

4. Murphy, *Economization of Life*, 35.

5. Laura Briggs, *Reproducing Empire: Race, Sex and US Imperialism in Puerto Rico* (University of California Press, 2002).

6. Joseph Mayone Stycos, "Population Growth and the Alliance for Progress," *Eugenics Quarterly* 9, no. 4 (1962): 231.

7. Joseph Mayone Stycos, "Some Dimensions of Population and Family Planning," *Journal of Social Issues* 30, no. 4 (1974): 5. This conclusion was also reached

at a 1970 UNESCO conference; see UNESCO, "Principles of Production and Use of Mass Media for Family Planning Programmes," Paris, June 30, 1970, 3.

8. Peter J. Donaldson, "On the Origins of the United States Government's International Population Policy," *Population Studies* 44 (1990): 396.

9. Matthew Connelly, *Fatal Misconception: The Struggle to Control the World's Population* (Harvard University Press, 2008), 263.

10. Paul R. Ehrlich, *The Population Bomb* (Ballantine Books, 1968).

11. See "Brazil: The Gathering Millions," episode of *Population Problems* (1967); CBS, "Standing Room Only," episode of *The Twenty-First Century* (1967); and later films such as *The Problem Is Life* (1969). For a good overview of the 1960s panic and the fallacy of the mathematical approach that divides population by global food production, see Nick Cullather, *The Hungry World: America's Cold War Battle Against Poverty in Asia* (Harvard University Press, 2015).

12. James Blue, "A Few Notes on Our Food Problem," narration and title script, 1968, https://bpb-us-e1.wpmucdn.com/blogs.uoregon.edu/dist/a/6230/files/2014/07/AFewNotesscript-14vxwro.pdf.

13. Bruce Herschensohn to James Blue, September 13, 1968, and Herschenson to Blue, September 27, 1968, box 22, folder 16, JBPP, SCUO.

14. Basil Wright, *The Long View* (Knopf, 1974), 610.

15. Wright, *Long View*, 611.

16. Woody Vasulka and Peter Weibel, *Buffalo Heads: Media Study, Media Practice, Media Pioneers, 1973–1990* (MIT Press, 2008), 657.

17. See Mahmood Mamdani, *The Myth of Population Control: Family, Caste and Class in an Indian Village* (Monthly Review Press, 1972).

18. UNESCO, "Principles of Production," 7–8.

19. UNESCO, "Principles of Production," 7–8.

20. Connelly, *Fatal Misconception*, 314.

21. Furedi, *Population and Development*, 106. On the New International Economic Order, see Adom Getachew, *Worldmaking After Empire: The Rise and Fall of Self-Determination* (Princeton University Press, 2019), esp. 142–175.

22. Connelly, *Fatal Misconception*, 315.

23. Connelly, *Fatal Misconception*, 316.

24. Ester Boserup, *Women's Role in Economic Development* (1970; Earthscan, 2011), xxvii.

25. Boserup, *Women's Role*, 212.

26. Boserup, *Women's Role*, 68.

27. Boserup, *Women's Role*, 187.

28. For one important critique of WID, see Naila Kabeer, *Reversed Realities: Gender Hierarchies in Development Thought* (Verso, 1994).

29. Scott MacDonald, *American Ethnographic Film and Personal Documentary: The Cambridge Turn* (University of California Press, 2013), 8.

30. MacDonald, *American Ethnographic Film*, 22.

31. See Gayatri Spivak, "Can the Subaltern Speak?," in *Marxism and the Interpretation of Culture*, ed. Cary Nelson and Lawrence Grossberg (Macmillan Education, 1988), 271–313; and Bill Nichols, "The Voice of Documentary," *Film Quarterly* 36, no. 3 (Spring 1983): 18.

32. David William Foster, "This Woman Which Is One: Helena Solberg-Ladd's *The Double Day*," *Journal of Iberian and Latin American Research* 18, no. 1 (2012): 55–64.

33. Marina Cavalcanti Tedesco, "The Women's Film Project: An International Collective in the Career of Helena Solberg," *Jump Cut* 61 (Fall 2022), https://www.ejumpcut.org/archive//jc61.2022/MarinaCavalcantiTedesco/text.html.

34. Julianne Burton and Helena Solberg-Ladd, "Helena Solberg-Ladd (Brazil and the United States): A View from the United States," in *Cinema and Social Change in Latin America: Conversations with Filmmakers*, ed. Julianne Burton (University of Texas Press, 2010), 90.

35. Meyerowitz, *War on Global Poverty*, 4.

36. Apart from Getachew, *Worldmaking*, see Nils Gilman, "The New International Economic Order: A Reintroduction," *Humanity* (Spring 2015): 1–16; and Michael Franczak, "Losing the Battle, Winning the War: Neoconservatives vs. the New International Economic Order, 1974–82," *Diplomatic History* 43, no. 5 (November 2019): 867–889.

37. Kelly Coogan-Gehr, *The Geopolitics of the Cold War and Narratives of Inclusion: Excavating a Feminist Archive* (Springer, 2011), 78–80.

38. Coogan-Gehr, *Geopolitics of the Cold War*, 85.

39. See Claire Hemmings, *Why Stories Matter: The Political Grammar of Feminist Theory* (Duke University Press, 2011); and Roderick Ferguson, *The Reorder of Things: The University and Its Pedagogies of Minority Difference* (University of Minnesota Press, 2012).

40. While other scholars associate Solberg with Cinema Novo, Marina Cavalcanti Tedesco argues that her affiliation with the movement is "questionable." See Cavalcanti Tedesco, "Women's Film Project.

41. Helena Solberg, "Helena Solberg Interview las 460/560," September 17, 2018, YouTube, https://www.youtube.com/watch?v=W3HXmWzz2-c&ab_channel=UACenterforLatinAmericanStudies.

42. Mariana Ribeiro Tavares, "Helena Solberg [an Interview]: Latin American Films Made in USA," *Post Script: Essays in Film and the Humanities* 40, nos. 2/3 (Winter/Spring & Summer 2021): 28.

43. Tavares, "Helena Solberg."

44. Barbara Halpern Martineau, "Talking About Our Lives and Experiences: Some Thoughts About Feminism, Documentary, and 'Talking Heads'," in *Show Us Life: Towards a History and Aesthetics of Committed Documentary*, ed. Thomas Waugh (Scarecrow, 1984), 258.

45. Julia Lesage, "The Political Aesthetics of the Feminist Documentary Film," *Quarterly Review of Film Studies* 3, no. 4 (1978): 508.

46. Lesage, "Political Aesthetics," 519.

47. Lesage, "Political Aesthetics," 509.

48. See Paula Rabinowitz, *They Must Be Represented: The Politics of Documentary* (Verso, 1994).

49. Richard Nixon, "Second Annual Report to the Congress on United States Foreign Policy," February 25, 1971, https://www.presidency.ucsb.edu/documents /second-annual-report-the-congress-united-states-foreign-policy.

50. Tavares, "Helena Solberg," 28.

51. Tavares, "Helena Solberg," 29.

52. Jocelyn Olcott, *International Women's Year: The Greatest Consciousness-Raising Event in History* (Princeton University Press, 2017).

53. Doris Sommer, "'Not Just a Personal Story': Women's Testimonios and the Plural Self," in *Life/Lines: Theorizing Women's Autobiography*, ed. Bella Brodzki and Celeste Schenck (Cornell University Press, 1989), 115.

54. "Si me permiten hablar: el libro boliviano más traducido y difundito," https://www.noticiasfides.com/nacional/sociedad/si-me-permiten-hablar-el -libro-boliviano-mas-traducido-y-difundido-183884.

55. Sommer, "'Not Just a Personal Story,'" 122.

56. Isabel Segui, "The Embodied Testimony of Domitila Chungara in *The Courage of the People* (Jorge Sanjinés, 1971)," *Interliteraria* 22, no. 1 (2017): 183.

57. Olcott, *International Women's Year*, 147.

58. See "Presidential Transition Brief: InterAmerican Foundation," IAF.gov, 2020, 1.

59. Helen Safa, "Film: *The Double Day*, 1975, Produced by the International Women's Film Project, Directed by Helena Solberg-Ladd," *American Anthropologist* (September 1977): 746.

60. Nora Jacquez Wieser, "*The Double Day*; *Simplemente Jenny*," *Hispania* 63, no. 2 (May 1980): 453.

61. David William Foster, *Latin American Documentary Filmmaking: Major Works* (University of Arizona Press, 2013), 61.

62. Foster, *Latin American Documentary Filmmaking*, 61.

63. Julianne Burton, *Cinema and Social Change in Latin America* (University of Texas Press, 1986), 89.

64. Domitila Barrios de Chungara, *Aquí también Domitila! Testimonios*, comp. David Acebey (Siglo Veintiuno Editores, 1985), 13.

65. Sommer, "'Not Just a Personal Story,'" 107–130.

66. Segui, "Embodied Testimony of Domitila," 183.

67. Susan Hill Gross and Mary Hill Rojas, *Meeting the Third World Through Women's Perspectives: Contemporary Women in South Asia, Africa, and Latin*

America; A Global Education Unit for Grades Eight Through Twelve, funded by
The U.S. Agency for International Development's Development Education Program (Glenhurst Publications, 1988).

68. Daniel Worden, *Neoliberal Nonfictions: The Documentary Aesthetic from
Joan Didion to Jay-Z* (University of Virginia Press, 2020), 12.

EPILOGUE

1. Lesley Gill, *Teetering on the Rim: Global Restructuring, Daily Life, and the
Armed Retreat of the Bolivian State* (Columbia University Press, 2000).

2. See Naomi Klein, *The Shock Doctrine: The Rise of Disaster Capitalism* (Penguin, 2007); James Petras, "Imperialism and NGOs in Latin America," *Monthly
Review* (December 1, 1997), https://monthlyreview.org/1997/12/01/imperialism
-and-ngos-in-latin-america/.

3. See Lamia Karim, *Microfinance and Its Discontents: Women in Debt in
Bangladesh* (University of Minnesota Press, 2011).

4. "The Girl Effect," https://www.youtube.com/watch?v=WIvmE4_KMNw.

5. The Girl Effect split from Nike in 2015. On these US counterinsurgency
efforts centered on girls' education, see Molly Geidel, "Building the Counterinsurgent Girl," *Feminist Studies* 44, no. 3 (2018): 635–665; and Sonja C. Grover,
Schoolchildren as Propaganda Tools in the War on Terror (Springer, 2011).

6. "Girl Effect," https://girleffect.org/our-impact/.

7. See "How Kiva Works," https://www.kiva.org/about/how#faqs; and Megan
Moodie, "Microfinance and the Gender of Risk: The Case of Kiva.org," *Signs* 38,
no. 2 (Winter 2013): 279–302.

8. Jason Hickel has shown that even the few millennium development goals
the United Nations claimed had been met in 2015 were based on changing the
metrics of poverty and hunger from absolute to proportionate numbers, as well
as moving the international poverty line. In fact, absolute numbers show both
poverty and hunger increasing globally. See Hickel, "The True Extent of Poverty
and Hunger: Questioning the Good News Narrative of the Millennium Development Goals," *Third World Quarterly* (February 5, 2016): 1–19.

9. Elon Musk, "We spent the weekend feeding USAID into the wood chipper. Could gone to some great parties. Did that instead," X, February 3, 2025,
1:54 a.m., https://x.com/elonmusk/status/1886307316804263979?lang=en.

10. Laura Robson, "The End of AID," *Baffler*, March 18 2025, https://thebaffler
.com/latest/the-end-of-aid-robson.

11. Daniel Boguslaw, "While Gutting USAID, Marco Rubio Quietly Saved
Cuban Regime Change Programs," *Prospect*, April 2025, https://prospect.org
/world/2025-04-24-gutting-usaid-marco-rubio-saved-cuban-regime-change

-programs/; Stephanie Nolen, "Abandoned in the Middle of Clinical Trials, Because of a Trump Order," *New York Times*, February 6, 2025, https://www .nytimes.com/2025/02/06/health/usaid-clinical-trials-funding-trump.html.

12. Robson, "End of AID."

13. "Former USAID Administrator Describes Global Impact of Agency's Destruction," *PBS NewsHour*, February 5, 2025, https://www.pbs.org/newshour /show/former-usaid-administrator-describes-global-impact-of-agencys -destruction.

14. Quinn Slobodian, *Hayek's Bastards: Race, Gold, IQ, and the Capitalism of the Far Right* (Zone Books, 2025), 24. See Meyerowitz, *War on Global Poverty*, 229; and Adam Tooze, "Elon's Rockets and Fewer Dolls for 'Baby Girl,'" May 6, 2025, adamtooze.substack.com/p/chartbook-380-trumps-futurism-elons.

15. Fidel Castro, "Palabras a los Intelectuales," June 30, 1961, Biblioteca Nacional de Cuba, available online in translation as Fidel Castro, "Words to the Intellectuals," Castro Speech Database, http://lanic.utexas.edu/project/castro/db /1961/19610630.html.

16. Luis A. Guevara Polanco and Waldo Ramírez made a documentary in 2003, *Como por primera vez*, that pays homage to the film. The film is also included as a special feature in the Criterion Collection DVD/Blu-Ray edition of *Modern Times*, which was restored in 2003 and further updated in 2013. Scholars, too, praise the film. See Julianne Burton, "Democratizing Documentary," in *The Social Documentary in Latin America* ed. Julianne Burton (University of Pittsburgh Press, 1990). See also Michael Chanan, *Cuban Cinema* (University of Minnesota Press, 1985), 25–30.

17. Naomi Klein, *This Changes Everything: Capitalism vs. the Climate* (Penguin, 2014); Kohei Saito, *Slow Down: The Degrowth Manifesto*, trans. Brian Bergstrom (2020; Astra House, 2024); Jason Hickel, *Less Is More: How Degrowth Will Save the World* (Penguin/Random House, 2020).

18. Hickel, *Less Is More*, 182; Klein, *This Changes Everything*, 4–7; Saito, *Slow Down*, 215–216.

19. Troy Vettese and Drew Pendergrass, *Half-Earth Socialism: A Plan to Save the Future from Extinction, Climate Change and Pandemics* (Verso, 2022), 53–54.

20. For an explanation of Buen Vivir, see Unai Villalba, *"Buen Vivir* vs. Development: A Paradigm Shift in the Andes?," *Third World Quarterly* 34, no. 8 (2013): 1427–1442.

21. See Klein, *This Changes Everything*, 5; Hickel, *Less Is More*, 98; Saito, *Slow Down*, 59–63. Klein and Saito mention buen vivir but not as a challenge to development.

22. See David Adler, Vanessa Romero Rocha, and Michael Galant, "The Fourth Transformation," *Phenomenal World*, April 3, 2025, phenomenalworld .org/analysis/the-fourth-transformation/; José Luis Granados Ceja, "We Will

Not Return to the Neoliberal Model," *NACLA Report on the Americas* 57, no. 1 (2025): 12–18.

23. Victor Cisneros, "Presentan avances en el Sistema Nacional de Educación Artística y crecimiento de Original 2025, prometidas por Sheinbaum," *Infobae*, March 14, 2025, https://www.infobae.com/mexico/2025/03/14/presentan-avances-en-el-sistema-nacional-de-educacion-artistica-y-crecimiento-de-original-2025-prometidos-por-sheinbaum/.

24. "Claudia Sheinbaum Unveils Plan to Revitalize Mexico's Artistic Education Schools," *LatinaRepublic*, December 15, 2024.

25. Raymond Williams, "Culture Is Ordinary," in *Raymond Williams on Culture and Society: Essential Writings*, ed. Jim McGuigan (Sage, 2014), 3.

26. Stephanie J. Smith, *The Power and Politics of Art in Postrevolutionary Mexico* (University of North Carolina Press, 2017), 90.

Selected Development Film Filmography

1941

Kline, Herbert, dir. *The Forgotten Village*. Written by John Steinbeck. Pan-American Films, b/w, sound, 67 min.

1944

Van Dyke, Willard, dir. *The Bridge—Connecting South America to the World*. Written by Ben Maddow. Foreign Policy Association/Alfred P. Sloan Foundation, b/w, sound, 30 min.

1948

Flaherty, Robert, and Frances Flaherty, dirs. *Louisiana Story*. US/Standard Oil New Jersey, b/w, sound, 78 min.

1949

Delano, Jack, dir. *Desde las nubes*. Film Unit of the Division of Community Education (DIVEDCO), Puerto Rico, b/w, sound, 37 min.

Delano, Jack, dir. *Una gota de agua*. Comisión de Parques y Recreos Públicos de Puerto Rico/Unidad de Cinema y Gráficas, b/w, sound, 10 min.

Dewhurst, J. Frederic, dir. *Productivity: Key to Plenty*. US/Encylopaedia Britannica Films, 16 mm, b/w, sound, 12 min.

1950

Van Dyke, Willard, dir. *Years of Change*. USIA, b/w.

1951

Delano, Jack, dir. *Los peloteros*. Film Unit of the Division of Community Education (DIVEDCO), Puerto Rico, b/w, sound, 1 hr. 23 min.

Ruiz, Jorge, dir. *Los Urus*. Bolivia Films, color, sound, 18 min.

1952

Tirado, Amilcar, dir. *Una voz en la montaña (A Voice in the Mountains)*. Written by René Marqués. Film Unit of the Division of Community Education (DIVEDCO), b/w, sound, 30 min.

1953

Rotha, Paul, and Basil Wright, dirs. *World Without End*. UNESCO, b/w, sound, 80 min.

Ruiz, Jorge, dir. *Vuelve Sebastiana*. Written by Luis Beltrán. Bolivia Films, color, sound, 28 min.

Scenes from American History, No. 3: A Nation Sets Its Course. USIA, b/w, sound, 30 min.

Van Dyke, Willard, dir. *American Frontier*. US/American Petroleum Institute, b/w, sound, 28 min.

1954

Ruiz, Jorge, dir. *Los que nunca fueron*. Written by Luis Beltrán. Ecuador/BBC, color, sound, 24 min.

Ruiz, Jorge, and Gonzalo Sánchez de Lozada, dirs. *Juanito sabe leer*. Telecine/USIA, b/w, sound, 25 min.

Van Dyke, Willard, Amilcar Tirado, and Luis Maisonet, dirs. *Mayo florido*. Film Unit of the Division of Community Education (DIVEDCO), Puerto Rico, 16 mm, color, sound, 6½ min.

1955

Doniger, Benjamin, dir. *Modesta*. Written by René Marqués. Film Unit of the Division of Community Education (DIVEDCO), Puerto Rico, b/w, sound, 35 min.

Ruiz, Jorge, dir. *Un poquito de diversificación económica*. Written by Oscar Soria. Bolivia ICB, b/w, sound, 38 min.

1956

Girón, Jorge Ramiro, dir. *Eres libre*. Regional Center for Fundamental Education for Latin America (CREFAL), b/w, sound, 10 min.

Ruiz, Jorge, dir. *Los primeros*. Bolivian ICB, b/w, sound, 35 min.

Ruiz, Jorge, dir. *Los Ximul*. Administración de Cooperación Internacional, Guatemala, color, sound, 40 min.

Tirado, Amilcar, dir. *El santero*. Film Unit of the Division of Community Education (DIVEDCO), Puerto Rico, color, sound, 26 min.

1957

CREFAL trainees under the supervision of Lucien Parizeau, dirs. *El primer paso*. Regional Center for Fundamental Education for Latin America (CREFAL), Mexico, b/w, sound, 8 min.

Parizeau, Lucien, and Francine Van De Wiele, dirs. *Tzintzuntzan*. Regional Center for Fundamental Education for Latin America (CREFAL), b/w, sound, 18 min.

Van Dyke, Willard, dir. *El de los cabos blancos*. Film Unit of the Division of Community Education (DIVEDCO), Puerto Rico, b/w, sound, 33 min.

1958

Betancourt, Enrique, dir. *La decisión de José*. Regional Center for Fundamental Education for Latin America (CREFAL), b/w, sound, 12 min.

Camino a la vida. Regional Center for Fundamental Education for Latin America (CREFAL), b/w, sound, 25 min.

Ruiz, Jorge, dir. *La vertiente*. Script by Oscar Soria. El Instituto Cinemagráfico (ICB), Bolivia, b/w, sound, 56 min.

1959

Faust, Skip, dir. *Doña Julia*. Unit of the Division of Community Education (DIVEDCO).

Jacoby, Frank, dir. "The Golden Egg." Dateline UN: Mexico, b/w, sound, 26 min.

Maisonet, Luis, dir. *Juan sin seso*. Film Unit of the Division of Community Education (DIVEDCO), Puerto Rico, b/w, sound, 16 min.

1961

Cassirer, Henry, dir. *Nunca es demasiado tarde*. Regional Center for Fundamental Education for Latin America (CREFAL), b/w, sound, 14 min.

1962

Blue, James, dir. *Evil Wind Out*. United States Information Agency (USIA) Colombia/USA, 35 mm, b/w, sound, 10 min.

Blue, James, dir. *Les Oliviers de la Justice [The Olive Trees of Justice]*. Written by Jean Pélégri. Les Studio Africa/Georges Derocles, Algeria/France, 35 mm, b/w, sound, 78 min.

Blue, James, dir. *A Letter from Colombia*. United States Information Agency
 (USIA), Colombia/USA, 35 mm, b/w, sound, 9:30 min.
Blue, James, dir. *The School at Rincon Santo*. United States Information Agency
 (USIA), Colombia/USA, 35 mm, b/w, sound, 10:40 min.
Land and People. USIA, b/w, sound, 18 min.
Ruiz, Jorge, dir. *Las montañas no cambian*. El Instituto Cinematográfico
 Bolivia (ICB), Bolivia, b/w, sound, 36 min.
Van Dyke, Willard, dir. *Harvest*. Rockefeller Foundation, Mexico, 16 mm, color,
 sound, 30 min.
Van Dyke, Willard, dir. *The Twentieth Century*. Season 6, episode 5, "So That
 Men Are Free." Aired November 25, 1962, on CBS. b/w, sound, 30 min.

1963

Anderson, Erica, dir. *A Village Is Waiting*. Unitarian Service Committee,
 16 mm, color, sound, 30 min.
Guggenheim, Charles, and Richard Heffron, dirs. *United in Progress, March
 1963*. United States Information Agency (USIA), 16 mm, color, sound,
 29 min.
Herschensohn, Bruce, dir. *Bridges of the Barrios*. Narrated by Paul Newman.
 United States Information Agency (USIA), b/w, sound, 11 min.
Ruiz, Jorge, dir. *El policía rural*. USAID/Ecuador, color.

1964

Miracle in San Jose. Movius/Peru, b/w, sound, 21 min.
Parks, Gordon, dir. *Flavio*. b/w, sound, 12 min.
Van Dyke, Willard, with Wheaton Galentine, dirs. *Rice*. Rockefeller Founda-
 tion, color, sound, 26 min.
Wallace, Warren, dir. *Changing World*. Episode "Brazil: The Take-Off Point."
 Aired October 28, 1964, on National Educational Television Network. b/w,
 sound, 57 min.

1965

Auto-ayuda comunal: llave al progreso. Audio-visual Productions South
 America/Peru, b/w, sound, 21 min.
Bobker, Lee, dir. *The Unending Struggle*. US Department of State, b/w, sound,
 30 min.
Fomento! Organizing for Progress. Agency for International Development,
 color, sound, 28 min.
Population Problems. Episode "Brazil: The Gathering Millions." Aired February
 1, 1965, on National Educational Television Network. b/w, sound, 60 min.
Ruiz, Jorge, dir. *Las fuerzas armadas de peru en acción civica*. color, sound,
 30 min.

Van Dyke, Willard, dir. *Taming the Mekong.* b/w, sound, 30 min.

Van Dyke, Willard, dir. *The Twentieth Century.* Season 8, episode 12, "Pop Buell: Hoosier at the Front." Aired March 7, 1965, on CBS. b/w, sound, 30 min.

Van Dyke, Willard (with Roger Barlow), dirs. *The Farmer: Feast of Famine.* b/w, sound, 30 min.

1966

Barrio Action. United States Information Agency (USIA), b/w, sound, 10 min.

Jersey, William, dir. *A Simple Cup of Tea.* USAID, b/w, sound, 28 min.

New Girl at Tororo. United States Information Agency (USIA), b/w, sound, 15 min.

1967

Meyers, Sidney, dir. *The Twenty-First Century.* Season 1, episode 4, "Standing Room Only." Aired May 7, 1967, on CBS. color, sound, 25 min.

1968

Blue, James, dir. *A Few Notes on Our Food Problem.* United States Information Agency (USIA), Taiwan/India/Kenya/Brazil/USA, 35 mm, color, sound, 35 min.

Tomorrow's World: Feeding the Billions. National Broadcasting Company, 16 mm, color, sound, 55 min.

Van der Velde, Wim, dir. *Not Enough.* Organization for Economic Cooperation and Development, color, sound, 30 min.

1969

Hollander, Peter, dir. *The Problem Is Life.* US Broadcasters Committee, color, sound, 28 min.

Phillips, Foster, Dr. and Mrs., dirs. *A Future for Ram.* University of Maryland Department of Agricultural Economics, color, sound, 21 min.

1974

Blue, James (with David MacDougall), dirs. *Kenya Boran, Parts I and II.* Faces of Change collection. Documentary Educational Resources, 16 mm, color, sound, 66 min.

Communicating Family Planning: Speak—They Are Listening. United States Agency for International Development (USAID), 16 mm, sound, color, 33 min.

Miller, Norman/American University Field Staff, dirs. *Andean Women.* Faces of Change collection. Documentary Educational Resources, color, sound, 17 min.

National Family Planning Programs: Restoring the Balance. Airlie Foundation/ USAID Office of Population, color, sound, 28 min.

1975

Miller, Norman N., James Blue, and American Universities Field Staff Films, dirs. *Women in a Changing World*. United States Agency for International Development (USAID), 48 min.

Solberg, Helena/International Women's Film Collective, dirs. *The Double Day*. Sponsored by the InterAmerican Foundation, color, sound, 56 min.

Bibliography

ARCHIVES AND COLLECTIONS

Individual archival items are cited in notes only.

AFNB	National Film Archive, La Paz, Bolivia
ARE	Archivo de Relaciones Exteriores (Foreign Relations Archive), La Paz, Bolivia
CCP	Center for Creative Photography, Tucson, Arizona Willard Van Dyke Personal Papers (WVDPP)
CREFAL	Archive of the Regional Center for Fundamental Education in Latin America, Pátzcuaro, Mexico
CU-RBML	Columbia University Rare Book and Manuscript Library, New York, NY Annie Laurie Williams Papers (ALWP)
DSCUA-SUL	Department of Special Collections and University Archives, Stanford University Libraries, Stanford, CA John Steinbeck Personal Papers (JSPP)
JFKL	John F. Kennedy Library, Boston, MA
LoC	Library of Congress, Washington, DC Gordon Parks Papers (GPP) Jack Delano Personal Papers (JDPP)
NARA	National Archives and Records Administration, College Park, MD

PUSC Pepperdine University Special Collections, Online,
 https://library.pepperdine.edu/collections/special-collections/
RAC Rockefeller Archive Center, Tarrytown, NY
RSC Roosevelt Study Centre, Middelburg, Netherlands
SCUO Special Collections at the University of Oregon, Eugene, OR
 James Blue Personal Papers (JBPP)
UCLA UCLA Library Special Collections, Los Angeles, CA
 Paul Rotha Personal Papers (PRPP)
UVAL University of Virginia Library, Charlottesville, VA
WLUNC Wilson Library, UNC-Chapel Hill, NC

SECONDARY SOURCES

Newspaper and magazine articles are not listed here.

Abarzua Cutroni, Anabella. "The First UNESGO Experts on Latin America
 (1946–58)." In *The Politics of Academic Autonomy in Latin America*, edited
 by Fernanda Beigel. Routledge, 2013.
Alexander, Geoff. *Films You Saw in School: A Critical Review of 1,153 Classroom
 Educational Films (1958–1985) in 74 Subject Categories*. McFarland, 2013.
Alexander, William. *Film on the Left: American Documentary Film from 1931 to
 1942*. Princeton University Press, 1981.
Altman, Rick. "A Semantic-Syntactic Approach to Film Genre." *Cinema
 Journal* 23, no. 3 (Spring 1984): 6–18.
Anthony, Scott, and James G. Mansell, eds. *The Projection of Britain: A History
 of the GPO Film Unit*. Palgrave Macmillan, 2011.
Anzola Gómez, Gabriel. *Como llegar hasta los campesinos por medio de la
 educación*. Ministerio de la educación, 1962.
Apter, David E. "Africa and the Social Scientist." *World Politics* 6, no. 4 (July
 1954): 538–548.
Ari, Waskar. *Earth Politics: Religion, Decolonization and Bolivia's Indigenous
 Intellectuals*. Duke University Press, 2014.
Armstrong, David. "The True Believer: Walt Whitman Rostow and the Path to
 Vietnam." PhD diss., University of Texas at Austin, 2000.
Arnez Cuellar, Marco. "Estéticas indigenistas: Revolución nacional y desarrollo
 en la cinematografía de Jorge Ruiz (1952–1962)." PhD thesis, Universidad
 Mayor de San Andrés, 2013.
Arteaga, Claudia. "*Las montañas no cambian* y la mise-en-scène del desarro-
 llismo boliviano en los años sesenta." *Artefacto visual* 2, no. 2 (2017):
 122–153.
Babb, Florence. "Women and Men at Vicos, Peru: A Case of Unequal Develop-
 ment." In *Women's Place in the Andes: Engaging Decolonial Feminist*

Anthropology, edited by Florence Babb. University of California Press, 2018.

Bacevich, Andrew. *America's War for the Greater Middle East: A Military History*. Random House, 2016.

Balthasar, Benjamin. *Anti-Imperialist Modernism: Race and Transnational Radical Culture from the Great Depression to the Cold War*. University of Michigan Press, 2016.

Barden, Thomas E., ed. *Steinbeck in Vietnam: Dispatches from the War*. University of Virginia Press, 2012.

Barker, Jennifer Lynde. *The Aesthetics of Antifascist Film: Radical Projection*. Routledge, 2013.

Barrett, Ross. "Picturing a Crude Past: Primitivism, Public Art, and Corporate Oil Promotion in the United States." In *Oil Culture*, edited by Ross Barrett and Daniel Worden. University of Minnesota Press, 2014.

Barrios de Chungara, Domitila. *Aquí también Domitila! Testimonios*. Compiled by David Acebey. Siglo Veintiuno Editores, 1985.

Bedan, John. "The Price of Progress: Guatemala and the United States During the Alliance for Progress Era." PhD diss., University of Oregon, September 2018.

Belmonte, Laura. *Selling the American Way: US Propaganda and the Cold War*. University of Pennsylvania Press, 2008.

Beltrán, Luis Ramiro. *Mis primeros 25 años*. Editorial de la Buena Memoria, 2010.

Benamou, Catherine. *It's All True: Orson Welles' Panamerican Odyssey*. University of California Press, 2007.

Benjamin, Walter. *Illuminations*. Translated by Harry Zohn. Schocken Books, 1968.

Boon, Tim. *Films of Fact: A History of Science Documentary on Film and Television*. Wallflower Press, 2008.

Boserup, Ester. *Women's Role in Economic Development*. Earthscan, 2011. Originally published 1970.

Botts, Florita. *Journeys for a Witness: My Work as a Photographer for the United Nations, 1960s–1980s*. Viella, 2020.

Boyd, Caleb. "'They Called Me an Alien': Hanns Eisler's American Years, 1935–1948." MA thesis, University of Arizona, 2013.

Brattain, Michelle. "Race, Racism, and Antiracism: The Problems of Presenting Science to the Postwar Public." *American Historical Review* (December 2007): 1386–1413.

Briggs, Laura. *Reproducing Empire: Race, Sex and US Imperialism in Puerto Rico*. University of California Press, 2002.

Brinkley, Alan. *The Publisher: Henry Luce and His American Century*. Knopf, 2010.

Buck-Morss, Susan. *Dreamworld and Catastrophe: The Passing of Mass Utopia in East and West*. MIT Press, 2000.

Buell, Frederick. "A Short History of Oil Cultures: Or, the Marriage of Catastrophe and Exuberance." *Journal of American Studies* 46 (2012): 273–293.

Burns, James. "Watching Africans Watch Films: Theories of Spectatorship in British Colonial Africa." *Historical Journal of Film, Radio and Television* 20, no. 2 (2000): 197–211.

Burton, Julianne. *Cinema and Social Change in Latin America*. University of Texas Press, 1986.

Burton, Julianne. "Democratizing Documentary: Modes of Address in the New Latin American Cinema, 1958–1972." In *The Social Documentary in Latin America*, edited by Julianne Burton. University of Pittsburgh Press, 1990.

Burton, Julianne, and Helena Solberg-Ladd. "Helena Solberg-Ladd (Brazil and the United States): A View from the United States." In *Cinema and Social Change in Latin America: Conversations with Filmmakers*, edited by Julianne Burton. University of Texas Press, 2010.

Cabrera Collazo, Rafael. "Iconografía de la modernidad: La División de Educación a la Comunidad y la política cultural en el Puerto Rico de los Cinquenta." In *Metodologías de análisis del film*, edited by Javier Marzal Felici and Francisco Javier Gómez-Tarín. Edipo, 2007.

Calmes, Leslie Squyres, ed. *The Letters Between Edward Weston and Willard Van Dyke*. University of Arizona Press, 1992.

Cavalcanti Tedesco, Marina. "The Women's Film Project: An International Collective in the Career of Helena Solberg." *Jump Cut* 61 (Fall 2022). https://www.ejumpcut.org/archive//jc61.2022/MarinaCavalcantiTedesco/index.html.

Chanan, Michael. *Cuban Cinema*. University of Minnesota Press, 1985.

Cobbs, Elizabeth. *The Rich Neighbor Policy: Rockefeller and Kaiser in Brazil*. Yale University Press, 1992.

Collier, John, Jr., and Malcolm Collier. *Visual Anthropology: Photography as Research Method*. University of New Mexico Press, 1986.

Colón Pizarro, Mariam. "Poetic Pragmatism: The Puerto Rican Division of Community Education (DIVEDCO) and the Politics of Cultural Production, 1949–1968." PhD diss., University of Michigan, 2011.

Conde, Maite. *Foundational Films: Early Cinema and Modernity in Brazil*. University of California Press, 2018.

Connelly, Matthew. *Fatal Misconception: The Struggle to Control the World's Population*. Harvard University Press, 2008.

Coogan-Gehr, Kelly. *The Geopolitics of the Cold War and Narratives of Inclusion: Excavating a Feminist Archive*. Springer, 2011.

Cooper, Frederick, and Randall Packard, eds. *International Development and the Social Sciences: Essays on the History and Politics of Knowledge*. University of California Press, 1998.

Córdova S., Verónica. "Cine Boliviano: Del indigenismo a la globalización." *Nuestra America* 3 (2007): 129–145.

Coronil, Fernando. *The Magical State: Nature, Money, and Modernity in Venezuela*. University of Chicago Press, 1997.

Cull, Nicholas. "Auteurs of Ideology: USIA Documentary Film Propaganda in the Kennedy Era as Seen in Bruce Herschensohn's *The Five Cities of June* (1963) and James Blue's *The March* (1964)." *Film History* 10, no. 3 (1998): 295–310.

Cull, Nicholas. *The Cold War and the United States Information Agency: American Propaganda and Public Diplomacy, 1945–1989*. Cambridge University Press, 2008.

Cullather, Nick. *The Hungry World: America's Cold War Battle Against Poverty in Asia*. Harvard University Press, 2010.

de la Cadena, Marisol. "'Women Are More Indian': Ethnicity and Gender in a Community Near Cuzco." In *Ethnicity, Markets, and Migration in the Andes: At the Crossroads of History and Anthropology*, edited by Brooke Larson and Olivia Harris. Duke University Press, 1995.

Denning, Michael. *The Cultural Front: The Laboring of American Culture in the Twentieth Century*. Verso, 1996.

de Sola Pool, Ithiel. *Handbook of Communication*. Rand McNally, 1973.

Donaldson, Peter J. "On the Origins of the United States Government's International Population Policy." *Population Studies* 44 (1990): 385–399.

Dorn, Charles, and Kristen Ghodsee. "The Cold War Politicization of Literacy: Communism, UNESCO, and the World Bank." *Diplomatic History* 36, no. 2 (April 2012): 373–398.

Druick, Zoe. "'Before Education, Good Food, and Health': World Citizenship and Biopolitics in UNESCO's Post-War Literacy Films." In *Body, Capital, and Screens: Visual Media and the Healthy Self in the Twentieth Century*, edited by Christian Bonah and Anja Laukötter. Amsterdam University Press, 2020.

Druick, Zoe. *Projecting Canada: Government Policy and Documentary Film at the National Film Board*. McGill-Queens, 2007.

Druick, Zoe. "UNESCO, Film, and Education: Mediating Postwar Paradigms of Communication." In *Useful Cinema*, edited by Charles R. Acland and Haidee Wasson. Duke University Press, 2011.

Druick, Zoe. "Visualising the World: The British Documentary at UNESCO." In *The Projection of Britain: A History of the GPO Film Unit*, edited by Scott Anthony and James G. Mansell. Palgrave Macmillan, 2011.

Eckstein, Barbara. *Sustaining New Orleans: Literature, Local Memory, and the Fate of a City*. Routledge, 2006.

Eckstein, Susan. "Transformation of a 'Revolution from Below'—Bolivia and International Capital." *Comparative Studies in Society and History* 25, no. 1 (January 1983): 105–135.

Ehrlich, Paul R. *The Population Bomb*. Ballantine Books, 1968.

Ekbladh, David. *The Great American Mission: Modernization and the Construction of an American World Order*. Princeton University Press, 2009.

Engerman, David. *Modernization from the Other Shore: American Intellectuals and the Romance of American Development*. Harvard University Press, 2003.

Enyeart, James L. *Willard Van Dyke: Changing the World Through Photography and Film*. University of New Mexico Press, 2008.

Escobar, Arturo. *Encountering Development: The Making and Unmaking of the Third World*. Princeton University Press, 1995.

Escudero, Manuel Chaparro. *Memorias Chipayas*. MEDIA, 2009.

Fabian, Johannes. *Time and the Other: How Anthropology Makes Its Object*. Columbia University Press, 1983.

Fairley, Barker. "Books of the Month: Symbolisms." *Canadian Forum* 21 (August 1941): 153–54.

Farber, David. *Sloan Rules: Alfred P. Sloan and the Triumph of General Motors*. University of Chicago Press, 2002.

Fein, Seth. "Everyday Forms of Transnational Collaboration: US Film Propaganda in Cold War Mexico." In *Close Encounters of Empire: Writing the Cultural History of US-Latin American Relations*, edited by Gil Joseph, Catherine LeGrand, and Ricardo Salvatore. Duke University Press, 1998.

Fein, Seth. "The United States and the Mexican Film Industry After World War II." Texas Papers on Mexico. Mexican Center, Institute of Latin American Studies, University of Texas at Austin, 1993.

Ferguson, James. *The Anti-Politics Machine: Development, Depoliticization and Bureaucratic Culture in Lesotho*. University of Minnesota Press, 1994.

Ferguson, James. *Expectations of Modernity: Myths and Meanings of Life on the Zambian Copperbelt*. University of California Press, 1999.

Ferguson, James. *Give a Man a Fish: Reflections on the New Politics of Distribution*. Duke University Press, 2015.

Ferguson, Roderick. *The Reorder of Things: The University and Its Pedagogies of Minority Difference*. University of Minnesota Press, 2012.

Ferreira da Silva, Denise. *Toward a Global Idea of Race*. University of Minnesota Press, 2007.

Field, Allyson Nadia. *Uplift Cinema: The Emergence of African American Film and the Possibility of Black Modernity*. Duke University Press, 2015.

Field, Thomas. *From Development to Dictatorship: Bolivia and the Alliance for Progress in the Kennedy Era*. Cornell University Press, 2014.

Filipcevic, Vojislava. "Urban Planning and the Spaces of Democracy: New York of the Great Depression in *42nd Street*, *Dead End*, and *The City*." *Culture, Theory & Critique* 51, no. 1 (2010): 65–91.

"Films for Church Use." *International Journal of Religious Education* 19 (1942): 33–35.

Fisher, Alexander. "Funding, Ideology and the Aesthetics of the Development Film in Postcolonial Zimbabwe." *Journal of African Cinemas* 2, no. 2. (2010): 111–120.

Flaherty, Frances Hubbard. *The Odyssey of a Filmmaker: Robert Flaherty's Story*. Arno Press, 1972.

Forclaz, Amalia Ribi. "From Reconstruction to Development: The Early Years of the Food and Agriculture Organization (FAO) and the Conceptualization of Rural Welfare, 1945–1955." *International History Review* 41, no. 2 (2019): 351–371.

Foster, David William. *Latin American Documentary Filmmaking: Major Works*. University of Arizona Press, 2013.

Foster, David William. "This Woman Which Is One: Helena Solberg-Ladd's *The Double Day*." *Journal of Iberian and Latin American Research* 18, no. 1 (2012): 55–64.

Fox, Claire. *Making Art Panamerican: Cultural Policy and the Cold War*. University of Minnesota Press, 2013.

Franczak, Michael. "Losing the Battle, Winning the War: Neoconservatives vs. the New International Economic Order, 1974–82." *Diplomatic History* 43, no. 5 (November 2019): 867–889.

Frank, Andre Gunder. "The Development of Underdevelopment." *Monthly Review* 18, no. 4 (September 1966): 37–51.

Frank, Andre Gunder. "Rostow's Stages of Economic Growth from Escalation to Nuclear Destruction." 1967. https://historicpittsburgh.org/islandora/object /pitt%3A31735061539908/viewer#page/1/mode/2up.

Franqui-Rivera, Harry. "War Among All Puerto Ricans: The Nationalist Revolt and the Creation of the Estado Libre Asociado of Puerto Rico (Part 2)." *US Studies Online* (June 2015). https://usso.uk/2015/06/war-among-all -puerto-ricans-the-nationalist-revolt-and-the-creation-of-the-estado-libre -asociado-of-puerto-rico-part-two/.

Furedi, Frank. *Population and Development: A Critical Introduction*. Polity, 1997.

Gandarilla Guardia, Nino. *Cine y televisión en Santa Cruz*. Universidad Autónoma Gabriel Rene Moreno, 2011.

Garfield, Seth. *In Search of the Amazon: Brazil, the United States, and the Nature of a Region*. Duke University Press, 2013.

Gatica Mizala, Camila. *Modernity at the Movies: Cinema-Going in Buenos Aires and Santiago, 1915–1945*. University of Pittsburgh Press, 2023.

Geidel, Molly. "Building the Counterinsurgent Girl." *Feminist Studies* 44, no. 3 (2018): 635–665.

Geidel, Molly. "*Life* and the Pedagogy of Counterinsurgency, 1961–64." *Photography and Culture* 9, no. 3 (2016): 219–238.

Geidel, Molly. *Peace Corps Fantasies: How Development Shaped the Global Sixties*. University of Minnesota Press, 2015.

Geidel, Molly. "Sowing Death in Our Women's Wombs: Modernization and Indigenous Nationalism in the 1960s Peace Corps and Jorge Sanjinés' *Yawar Mallku*." *American Quarterly* 62, no. 3 (2010): 63–86.

Geiger, Jeffrey. *Facing the Pacific: Polynesia and the US Imperial Imagination.* University of Hawai'i Press, 2007.

Getachew, Adom. *Worldmaking After Empire: The Rise and Fall of Self-Determination.* Princeton University Press, 2019.

Gharabaghi, Hadi, and Bret Vukoder. "The Motion Pictures of the United States Information Agency: Studying a Global Film and Television Operation." *Journal of E-media Studies* 6, no. 1 (2022): 1–37.

Gil-Riaño, Sebastián. "Relocating Anti-Racist Science: The 1950 UNESCO Statement on Race and Economic Development in the Global South." *British Journal for the History of Science* 51, no. 2 (June 2018): 1–23.

Gil-Riaño, Sebastián. *The Remnants of Race: UNESCO and Economic Development and the Global South.* Columbia University Press, 2023.

Gill, Lesley. *Teetering on the Rim: Global Restructuring, Daily Life, and the Armed Retreat of the Bolivian State.* Columbia University Press, 2000.

Gilman, Nils. *Mandarins of the Future: Modernization in Cold War America.* Johns Hopkins University Press, 2007.

Gilman, Nils. "The New International Economic Order: A Reintroduction." *Humanity* (Spring 2015): 1–16.

González, Fernando de Moral. *Cine documental en Pátzcuaro.* Centro de Cooperación Regional para la Educación, 2007.

Good, Katie Day. *Bring the World to the Child: Technologies of Global Citizenship in American Education.* MIT Press, 2020.

Gotkowitz, Laura. *A Revolution for Our Rights: Indigenous Struggles for Land and Justice in Bolivia, 1880–1952.* Duke University Press, 2008.

Grandin, Greg. "Your Americanism and Mine: Americanism and Anti-Americanism in the Americas." *American Historical Review* 111, no. 4 (2006): 1042–1066.

Grieveson, Lee. *Cinema and the Wealth of Nations: Media, Capital, and the Liberal World System.* University of California Press, 2017.

Grover, Sonja C. *Schoolchildren as Propaganda Tools in the War on Terror.* Springer, 2011.

Gumucio Dagrón, Alfonso. "Breve historia del cine boliviano." *La palabra y el hombre* 24 (1977): 16–17.

Haraway, Donna. "Teddy Bear Patriarchy: Taxidermy in the Garden of Eden, New York City, 1908–1936." *Social Text* 11 (Winter 1984–1985): 20–64.

Hartz, Louis. *The Liberal Tradition in America.* Harcourt, 1955.

Hemmings, Claire. *Why Stories Matter: The Political Grammar of Feminist Theory.* Duke University Press, 2011.

Hickel, Jason. *Less Is More: How Degrowth Will Save the World.* Penguin/Random House, 2020.

Hickel, Jason. "The True Extent of Poverty and Hunger: Questioning the Good News Narrative of the Millennium Development Goals." *Third World Quarterly* (February 5, 2016): 1–19.

Hill, Erin. *Never Done: A History of Women's Work in Media Production*. Rutgers University Press, 2016.

Hill Gross, Susan, and Mary Hill Rojas. *Meeting the Third World Through Women's Perspectives: Contemporary Women in South Asia, Africa, and Latin America; A Global Education Unit for Grades Eight Through Twelve*. Funded by The U.S. Agency for International Development's Development Education Program. Glenhurst Publications, 1988.

Himpele, Jeffrey. *Circuits of Culture: Media, Politics, and Indigenous Identity in the Andes*. University of Minnesota Press, 2007.

Hochman, Brian. *Savage Preservation: The Ethnographic Origins of Modern Media Technology*. University of Minnesota Press, 2015.

Hodgson, Godfrey. *America in Our Time: From World War II to Nixon—What Happened and Why*. Princeton University Press, 1976.

Horne, Jennifer. "Experiments in Propaganda: Reintroducing James Blue's Colombian Trilogy." *Moving Image* 9, no. 1 (Spring 2009): 183–200.

Huber, Matthew. *Lifeblood: Oil, Freedom, and the Forces of Capital*. University of Minnesota Press, 2013.

Hughes, Lloyd H. "Crefal: Training Centre for Community Development for Latin America." *International Review of Education/Internationale Zeitschrift für Erziehungswissenschaft/Revue Internationale de l'Education* 9, no. 2 (1963): 226–235.

Hughes, Lloyd H. "Fieldworkers: Keystone of CREFAL's Training Program." *Community Development Bulletin* 9, no. 4 (September 1958): 87–95.

Hughes, Lloyd H. *The Mexican Cultural Mission Programme*. UNESCO, 1950.

Humphrey, Norman D. "The Generic Folk Culture of Mexico." *Rural Sociology* (December 1, 1943): 364–377.

Iber, Patrick. *Neither Peace nor Freedom: The Cultural Cold War in Latin America*. Harvard University Press, 2015.

Itzigsohn, José. *Developing Poverty: The State, Labor Market Deregulation and the Informal Economy in Costa Rica and the Dominican Republic*. University of Pennsylvania Press, 2000.

Jackson, Katherine Lynne. "Tangled Up in James Blue: A Committed Filmmaker's Journey Through Independent and Commercial Filmmaking, Propaganda, Documentary, Observational Cinema and Alternative Media." PhD diss., New York University, 1992.

Jackson, Kenneth. *Crabgrass Frontier: The Suburbanization of the United States*. Oxford University Press, 1985.

Jolly, Jennifer. *Creating Pátzcuaro, Creating Mexico: Art, Tourism and Nation Building Under Lázaro Cardenas*. University of Texas Press, 2018.

Kabeer, Naila. *Reversed Realities: Gender Hierarchies in Development Thought*. Verso, 1994.

Karim, Lamia. *Microfinance and Its Discontents: Women in Debt in Bangladesh*. University of Minnesota Press, 2011.

Karl, Robert. "From 'Showcase' to 'Failure': Democracy and the Colombian Developmental State in the 1960s." In *State and Nation Making in Latin America and Spain: The Rise and Fall of the Developmental State*, edited by Miguel A. Centeno and Agustín E. Ferraro. Cambridge University Press, 2019.

King, Charles. *Gods of the Upper Air: How a Circle of Renegade Anthropologists Reinvented Race, Sex, and Gender in the Twentieth Century*. Doubleday, 2019.

King, John. *Magical Reels: A History of Cinema in Latin America*. Verso, 2000.

Klein, Christina. *Cold War Orientalism: Asia in the Middlebrow Imagination, 1945-1961*. University of California Press, 2003.

Klein, Naomi. *The Shock Doctrine: The Rise of Disaster Capitalism*. Penguin, 2007.

Klein, Naomi. *This Changes Everything: Capitalism vs. the Climate*. Penguin, 2014.

Kline, Herbert. "On John Steinbeck." *Steinbeck Quarterly* (Summer 1971): 80–88.

Knez, Eugene I. "Rice." *American Anthropologist* 68, no. 5 (October 1966): 1328–1329.

Knight, Alan. "Popular Culture and the Revolutionary State in Mexico, 1910–1940." *Hispanic American Historical Review* 74, no. 3 (1994): 393–444.

Kracauer, Siegfried. "The Cult of Distraction: On Berlin's Picture Palaces." Translated by Thomas Y. Levin. *New German Critique* 40 (Winter 1987): 91–96.

Kracauer, Siegfried. *Theory of Film: The Redemption of Physical Reality*. Oxford University Press, 1960.

Lahr-Vivaz, Elena. *Mexican Melodrama from the Golden Age to the New Wave*. University of Arizona Press, 2016.

Langlois, Suzanne. "And Action! UN and UNESCO Coordinating Information Films, 1945–1951." In *A History of UNESCO: Global Actions and Impacts*, edited by Pohl Duedahl. Palgrave Macmillan, 2016.

Larner, Steven. "Remembering James Blue." In *James Blue: Scripts and Interviews*, edited by John Minkowsky. Rice University/SWAMP, 2002.

Lasswell, Harold. "The Structure and Function of Communication in Society." In *The Communication of Ideas*, edited by L. Bryson. Harper and Bros., 1948.

Latham, Michael. *Modernization as Ideology: American Social Science and "Nation Building" in the Kennedy Era*. University of North Carolina Press, 2000.

Latham, Michael. *The Right Kind of Revolution: Modernization, Development, and U.S. Foreign Policy from the Cold War to the Present*. Cornell University Press, 2011.

Lazarín Miranda, Federico. "México, la UNESCO, y el Proyecto de Educación Fundamental para América Latina, 1945–1951." *Signos Históricos* 16, no. 31 (January–June 2014): 89–113.

Leacock, Richard. "The Making of *Louisiana Story*." *Southern Quarterly* 23, no. 1 (Fall 1984): 52–59.

LeMenager, Stephanie. *Living Oil: Petroleum Culture in the American Century.* Oxford University Press, 2014.

Lerner, Daniel. *The Passing of Traditional Society: Modernizing the Middle East.* Free Press, 1958.

Lesage, Julia. "The Political Aesthetics of the Feminist Documentary Film." *Quarterly Review of Film Studies* 3, no. 4 (1978): 507–523.

Lobo, Julius. "Documentary Poetry and American Modernism from the Depression to World War 2." PhD diss., Pennsylvania State University, 2011.

López, Ana M. "Early Cinema and Modernity in Latin America." *Cinema Journal* 40, no. 1 (2000): 48–78.

Lott, Eric. *Love and Theft: Blackface Minstrelsy and the American Working Class.* Oxford University Press, 1993.

Luft, Herbert G. "Rotha and the World." *Quarterly of Film Radio and Television* 10, no. 1 (Autumn 1955): 89–99.

Luis-Brown, David. *Waves of Decolonization: Discourses of Race and Hemispheric Citizenship in Cuba and the United States.* Duke University Press, 2008.

Lunenfeld, Peter. "There Are People in the Streets Who Never Had a Chance to Speak: James Blue and the Complex Documentary." *Journal of Film and Video* 46, no. 1 (Spring 1994): 21–33.

MacCabe, Colin, and Lee Grieveson, eds. *Film and the End of Empire.* Palgrave Macmillan, 2011.

MacDonald, Richard. "Evasive Enlightenment: World Without End and the Internationalism of Postwar Documentary." *Journal of British Cinema and Television* 10, no. 3 (2013): 452–474.

MacDonald, Scott. *American Ethnographic Film and Personal Documentary: The Cambridge Turn.* University of California Press, 2013.

Macekura, Stephen. "Development and Economic Growth." In *History of the Future of Economic Growth: Historical Roots of Current Debates on Sustainable Degrowth,* edited by Matthias Schmelzer and Iris Boroway. Routledge, 2017.

Macekura, Stephen. *The Mismeasure of Progress: Economic Growth and Its Critics.* University of Chicago Press, 2020.

MacFarlane, Wallace Scot. "Oil on the Farm: The East Texas Oil Boom and the Origins of an Energy Economy." *Journal of Southern History* 83 (2017): 853–888.

Malitsky, Joshua. *Post-Revolution Nonfiction Film: Building the Soviet and Cuban Nations.* Indiana University Press, 2013.

Malloy, James. *Bolivia: The Uncompleted Revolution.* University of Pittsburgh Press, 1970.

Mamdani, Mahmood. *The Myth of Population Control: Family, Caste and Class in an Indian Village.* Monthly Review Press, 1972.

Marqués, Rene. "Writing for a Community Education Programme." *UNESCO Reports and Papers on Mass Communication* 24 (November 1957): 5–11.

Marsh Kennerley, Cati. "Cultural Negotiations: Puerto Rican Intellectuals in a State-Sponsored Community Education Project, 1948–1968." *Harvard Educational Review* 73, no. 3 (Fall 2003): 416–448.

Martineau, Barbara Halpern. "Talking About Our Lives and Experiences: Some Thoughts About Feminism, Documentary, and 'Talking Heads.'" In *Show Us Life: Towards a History and Aesthetics of Committed Documentary*, edited by Thomas Waugh. Scarecrow, 1984.

Mazower, Mark. *Governing the World: The History of an Idea.* Penguin, 2012.

McAllister, Carlota. "Rural Markets, Revolutionary Souls, and Rebellious Women in Cold War Guatemala." In *In from the Cold: Latin America's New Encounter with the Cold War*, edited by Gil Joseph and Daniela Spenser. Duke University Press, 2008.

McClintock, Anne. *Imperial Leather: Race, Gender, and Sexuality in the Colonial Contest.* Routledge, 1995.

McKensie, Brian. *Remaking France: Americanization, Public Diplomacy and the Marshall Plan.* Berghahn Books, 2005.

McKeon, Michael. *The Origins of the English Novel, 1640–1700.* Johns Hopkins University Press, 1987.

Melamed, Jodi. *Represent and Destroy: Rationalizing Violence in the New Racial Capitalism.* University of Minnesota Press, 2011.

Merrill, Dennis. *Negotiating Paradise: US Tourism and Empire in 20th Century Latin America.* University of North Carolina Press, 2009.

Mesa, Carlos. *La aventura del cine Boliviano, 1952–1980.* Editorial Gisbert, 1985.

Mestman, Mariano, and María Luisa Ortega. "Cruces de miradas en la transición del cine documental: John Grierson en Sudamérica." *Cine Documental* 18 (2018): 172–204.

Meyerowitz, Joanne. *A War on Global Poverty: The Lost Promise of Redistribution and the Rise of Microcredit.* Princeton University Press, 2021.

Mitchell, Timothy. *Carbon Democracy: Political Power in the Age of Oil.* Verso, 2011.

Moodie, Megan. "Microfinance and the Gender of Risk: The Case of Kiva.org." *Signs* 38, no. 2 (Winter 2013): 279–302.

Morgan, Iwan, and Robert Mason. *The Liberal Consensus Reconsidered: American Politics and Society in the Postwar Era.* University of Florida Press, 2017.

Murphy, M. *The Economization of Life.* Duke University Press, 2017.

Murray, Banks. "American Films for Turkish Villagers." *The Record* 7–8 (1949): 26–31.

Nichols, Bill. "Documentary Film and the Modernist Avant Garde." *Critical Inquiry* 24, no. 4 (Summer 2001): 580–610.

Nichols, Bill. *Speaking Truth with Films: Evidence, Ethics, Politics in Documentary*. University of California Press, 2016.

Nichols, Bill. "The Voice of Documentary." *Film Quarterly* 36, no. 3 (Spring 1983): 17–30.

Nobbs-Thiessen, Ben. *Landscape of Migration: Mobility and Environmental Change on Bolivia's Tropical Frontier, 1952 to the Present*. University of North Carolina Press, 2019.

Offner, Amy. *Sorting Out the Mixed Economy: The Rise and Fall of Welfare and Developmental States in the Americas*. Princeton University Press, 2019.

Olcott, Jocelyn. *International Women's Year: The Greatest Consciousness-Raising Event in History*. Princeton University Press, 2017.

Olsson, Tore. *Agrarian Crossings: Reformers and the Remaking of the US and Mexican Countryside*. Princeton University Press, 2017.

Omi, Michael, and Howard Winant. *Racial Formation in the United States: From the 1960s to the Present*. Routledge, 1991.

Osgood, Kenneth. *Total Cold War: Eisenhower's Secret Propaganda Battle at Home and Abroad*. University of Kansas Press, 2006.

Ostherr, Kristen. "Health Films, the Cold War, and the Production of Patriotic Audiences." In *Useful Cinema*, edited by Charles Acland and Haidee Wasson. Duke University Press, 2011.

Pareja, Roberto. "'Los embrujos secretos del trópico': Frontera amazónica y producción del espacio estatal en la obra cinematográfica de Jorge Ruiz." *Bolivian Studies Journal* 20 (2014): 70–89.

Parker, Jason. *Hearts, Minds, Voices: US Cold War Public Diplomacy and the Formation of the Third World*. Oxford University Press, 2016.

Parks, Gordon. *A Choice of Weapons*. Harper and Row, 1966.

Parks, Gordon. *Flavio*. W. W. Norton, 1978.

Parks, Gordon. *The Flávio Story*. Stedl, 2018.

Parks, Gordon. *To Smile in Autumn*. W. W. Norton, 1979.

Parks, Gordon. *Voices in the Mirror*. Bantam Doubleday Dell, 1990.

Pérez Melgosa, Adrián. *Cinema and Inter-American Relations: Tracking Transnational Affect*. Routledge, 2012.

Petras, James. "Imperialism and NGOs in Latin America." *Monthly Review*, December 1, 1997. https://monthlyreview.org/1997/12/01/imperialism-and-ngos-in-latin-america/.

Pick, Zuzana. *The New Latin American Cinema: A Continental Project*. University of Texas Press, 1993.

Pineda Franco, Adela. *The Mexican Revolution on the World Stage: Intellectuals and Film in the Twentieth Century*. State University of New York Press, 2019.

Pineda Franco, Adela. *Steinbeck y México: Una mirada cinematográfica en la era de la hegemonía estadounidense*. Bonilla Artigas Editores, 2018.

Plattner, Steven W. *Roy Stryker: USA, 1943–1950*. University of Texas Press, 1983.

Poindexter, Michael. "Oil, Space, and National Imaginaries: Discursive Productions by Standard Oil New Jersey Post WWII." MA thesis, University of Louisville, 2017.

Pribilsky, Jason. "Developing Selves: Photography, Cold War Science, and 'Backwards' People in the Peruvian Andes, 1951–1966." *Visual Studies* 30, no. 2 (2015): 131–150.

Pribilsky, Jason. "Development and the 'Indian Problem' in the Cold War Andes: *Indigenismo*, Science, and Modernization in the Making of the Cornell-Peru Project at Vicos." *Diplomatic History* 33, no. 3 (2009): 405–426.

Prosser, Jay. *Light in the Dark Room: Photography and Loss*. University of Minnesota Press, 2004.

Pye, Lucian W. *Communication and Political Development*. Princeton University Press, 1963.

Quinn, Eithne. *A Piece of the Action: Race and Labor in Post–Civil Rights Hollywood*. Columbia University Press, 2019.

Quispe Escobar, Alber. "Un corte cinematográfico: Notas sobre la producción fílmica en Cochabamba, 1951–1964." *Punto Cero* 14, no. 18 (2009). http://www.scielo.org.bo/scielo.php?pid=S1815-02762009000100008&script=sci_arttext.

Rabe, Stephen. *The Most Dangerous Area in the World: John F. Kennedy Confronts Communist Revolution in Latin America*. University of North Carolina Press, 1999.

Rabinowitz, Paula. *They Must Be Represented: The Politics of Documentary*. Verso, 1994.

Rangan, Pooja. *Immediations: The Humanitarian Impulse in Documentary*. Duke University Press, 2017.

Redfield, Robert. "*The Forgotten Village*." *American Sociological Review* 7, no. 1 (February 1942): 131–132.

Rice, Tom. *Films for the Colonies: Cinema and the Preservation of the British Empire*. University of California Press, 2019.

Ricketts, Edward. "Thesis and Materials for a Script on Mexico." In *Breaking Through: Essays, Journals, and Travelogues of Edward Ricketts*, edited by Edward Ricketts and Katharine A. Rodger. University of California Press, 2006.

Riley, Charlotte Lydia. "'The Winds of Change Are Blowing Economically': The Labour Party and British Overseas Development, 1940s–1960s." In *Britain, France and the Decolonization of Africa: Future Imperfect?*, edited by Andrew W. M. Smith and Chris Jeppesen. University College London, 2017.

Rist, Gilbert. *The History of Development: From Western Origins to Global Faith*. Zed Books, 1997.

Rivas, Darlene. *Missionary Capitalist: Nelson Rockefeller in Venezuela*. University of North Carolina Press, 2002.

Rivera Cusicanqui, Silvia. "Liberal Democracy and Ayllu Democracy in Bolivia: The Case of Northern Potosí." *Journal of Development Studies* 26, no. 4 (1990): 97–121.

Rivera Cusicanqui, Silvia. "The Notion of 'Rights' and the Paradoxes of Post-colonial Modernity." *Qui Parle* 18, no. 2 (2010): 29–54.

Rivera Cusicanqui, Silvia. *Oprimidos pero no vencidos luchas del campesinado aymara y qhechwa de Bolivia, 1900–1980*. HISBOL, 1984.

Robinson, Cedric. "Capitalism, Slavery and Bourgeois Historiography." *History Workshop Journal* 23, no. 1 (Spring 1987): 122–140.

Robson, Laura. "The End of AID." *Baffler*, March 18, 2025. https://thebaffler .com/latest/the-end-of-aid-robson.

Rodney, Walter. *How Europe Underdeveloped Africa*. Bogle/L'Overture Publications, 1972.

Rodriguez, Ileana. *Women Guerrillas, and Love: Understanding War in Central America*. University of Minnesota Press, 1996.

Rodríguez, Mikel Luis. "El ICB: El primer organismo cinematográfico institucional en Bolivia (1952–1967)." *Secuencias* 10 (1999): 23–37.

Romero Sánchez, Susana. "Ruralizing Urbanization: Credit, Housing, and Modernization in Colombia, 1920–1948." PhD diss., Cornell University, 2015.

Rony, Fatimah Tobing. *The Third Eye: Race, Cinema, and Ethnographic Spectacle*. Duke University Press, 1996.

Rosemblatt, Karin Alejandra. *The Science and Politics of Race in Mexico and the United States, 1910–1950*. University of North Carolina Press, 2018.

Rostow, Walt. "The Making of Modern America, 1776–1940: An Essay on Three Themes." Working Paper for the Center for International Studies, MIT. Center for International Studies, 1960.

Rostow, Walt. *Stages of Economic Growth: A Non-Communist Manifesto*. Cambridge University Press, 1960.

Rotha, Paul. *Robert J. Flaherty: A Biography*. University of Pennsylvania Press, 1983.

Sackley, Nicole. "Cosmopolitanism and the Uses of Tradition: Robert Redfield and Alternative Visions of Modernization During the Cold War." *Modern Intellectual History* 9, no. 3 (2012): 265–295.

Sackley, Nicole. "The Village as Cold War Site: Experts, Development, and the History of Rural Reconstruction." *Journal of Global History* 6 (2011): 481–504.

Sadlier, Darlene. *Americans All: Good Neighbor Cultural Diplomacy in World War II*. University of Texas Press, 2012.

Safa, Helen. "Film: *The Double Day*, 1975, Produced by the International Women's Film Project, Directed by Helena Solberg-Ladd." *American Anthropologist* (September 1977): 746–747.

Saito, Kohei. *Slow Down: The Degrowth Manifesto*. Translated by Brian Bergstrom. Astra House, 2024. Originally published 2020.

Saldaña-Portillo, María Josefina. *Indian Given: Racial Geographies Across Mexico and the United States*. Duke University Press, 2016.

Saldaña-Portillo, María Josefina. *The Revolutionary Imagination in the Americas and the Age of Development*. Duke University Press, 2003.

Salinas Zabalaga, Jaime. "The Other Side of Bolivian Modernity: *Vuelve Sebastiana* and the Reconfiguration of Space-Time Coordinates to Think the Nation." *Bolivian Studies Journal* 23–24 (2017–2018): 1074–2247.

Sampson, Anthony. *The Seven Sisters: The Great Oil Companies and the World They Made*. Viking, 1975.

Sánchez-H., José. *The Art and Politics of Bolivian Cinema*. Scarecrow Press, 1999.

Schindler, Colin. *Hollywood in Crisis: Cinema and American Society 1929–1939*. Taylor and Francis, 2005.

Schmelzer, Matthias. *The Hegemony of Growth: The OECD and the Making of the Economic Growth Paradigm*. Cambridge University Press, 2016.

Schmelzer, Matthias, and Iris Boroway. *History of the Future of Economic Growth: Historical Roots of Current Debates on Sustainable Degrowth*. Routledge, 2017.

Schroeder Rodrigues, Paul. *Latin American Cinema: A Comparative History*. University of California Press, 2016.

Schwartzman, Karen. "An Interview with Margot Benacerraf: Reverón, Araya, and the Institutionalization of Cinema in Venezuela." *Journal of Film and Video* 44, no. 3 (1992–1993): 51–75.

Scott, James C. *Seeing Like a State: How Certain Schemes to Improve the Human Condition Have Failed*. Yale University Press, 1998.

Segui, Isabel. "The Embodied Testimony of Domitila Chungara in *The Courage of the People* (Jorge Sanjinés, 1971)." *Interliteraria* 22, no. 1 (2017): 180–193.

Shils, Edward. "Daydreams and Nightmares: Reflections on the Criticism of Mass Culture." *Sewanee Review* 65, no. 4 (1957): 587–608.

Shils, Edward. "Mass Society and Its Culture." *Daedalus* 89, no. 2 (Spring 1960): 288–314.

Singer, Ben. *Melodrama and Modernity: Early Sensational Cinema and Its Context*. Columbia University Press, 2001.

Skvirsky, Sálome Aguilera. *The Process Genre: Race and the Aesthetic of Labor*. Duke University Press, 2020.

Slobodian, Quinn. *Hayek's Bastards: Race, Gold, IQ, and the Capitalism of the Far Right*. Zone Books, 2025.

Sluga, Glenda. "UNESCO and the (One) World of Julian Huxley." *Journal of World History* 21, no. 3 (2010): 393–418.

Smith, Stephanie J. *The Power and Politics of Art in Postrevolutionary Mexico*. University of North Carolina Press, 2017.

Smyth, Rosaleen. "Film as Instrument of Modernization and Social Change in Africa: The Long View." In *Modernization as Spectacle in Africa*, edited by Peter J. Bloom, Stephan F. Miescher, and Takyiwaa Manuh. Indiana University Press, 2014.

Smyth, Rosaleen. "Grierson, the British Documentary Movement, and Colonial Cinema in British Colonial Africa." *Film History* 25, no. 4 (2013): 82–113.

Soliz, Carmen. *Fields of Revolution: Agrarian Reform and State Formation in Bolivia, 1935–1964*. University of Pittsburgh Press, 2021.

Sommer, Doris. *Foundational Fictions: The National Romances of Latin America*. University of California Press, 1991.

Sommer, Doris. "'Not Just a Personal Story': Women's Testimonios and the Plural Self." In *Life/Lines: Theorizing Women's Autobiography*, edited by Bella Brodzki and Celeste Schenck. Cornell University Press, 1989.

Spivak, Gayatri. "Can the Subaltern Speak?" In *Marxism and the Interpretation of Culture*, edited by Cary Nelson and Lawrence Grossberg. Macmillan Education, 1988.

Stange, Maren. *Symbols of Ideal Life: Social Documentary Photography in America, 1890–1950*. Cambridge University Press, 1989.

Steinbeck, John. *The Forgotten Village: Life in a Mexican Village*. Viking, 1941.

Steinbeck, John. *A Life in Letters*. Viking, 1975.

Steinbeck, John. *Log from the Sea of Cortez*. Lowe and Brydone, 1958. Originally published 1941.

Stevens, George, Jr. *My Place in the Sun: Life in the Golden Age of Hollywood and Washington*. University Press of Kentucky, 2022.

Stewart, Jacqueline. *Migrating to the Movies: Cinema and Black Urban Modernity*. University of California Press, 2005.

Stokes, Melvyn. *D. W. Griffith's "The Birth of a Nation": A History of the Most Controversial Motion Picture of All Time*. Oxford University Press, 2008.

Streible, Dan. "The Failure of the NYU Educational Film Institute." In *Learning with the Lights Off: Educational Film in the United States*, edited by Devin Orgeron, Marsha Orgeron, and Dan Streible. Oxford University Press, 2012.

Stycos, Joseph Mayone. "Population Growth and the Alliance for Progress." *Eugenics Quarterly* 9, no. 4 (1962): 231–236.

Stycos, Joseph Mayone. "Some Dimensions of Population and Family Planning." *Journal of Social Issues* 30, no. 4 (1974): 1–29.

Sutoris, Peter. *Visions of Development: The Films Division of India and the Imagination of Progress, 1948–75*. Hurst, 2016.

Szalay, Michael. *New Deal Modernism: American Literature and the Invention of the Welfare State*. Duke University Press, 2000.

Taffet, Jeffrey. *Foreign Aid as Foreign Policy: The Alliance for Progress in Latin America*. Routledge, 2007.

Tagg, John. *The Disciplinary Frame: Photographic Truths and the Capture of Meaning*. University of Minnesota Press, 2008.

Tavares, Mariana Ribeiro. "Helena Solberg [an Interview]: Latin American Films Made in USA." *Post Script: Essays in Film and the Humanities* 40, nos. 2/3 (Winter/Spring & Summer 2021): 27–37.

Thakkar, Sonali. *The Reeducation of Race: Jewishness and the Politics of Antiracism in Postcolonial Thought*. Stanford University Press, 2023.

Thomas, Julia Adeney, and Geoff Eley. *Visualizing Fascism: The Twentieth Century Rise of the Global Right.* Duke University Press, 2020.

Thornton, Christy. *Revolution in Development: Mexico and the Governance of the Global Economy.* University of California Press, 2021.

Tinker Salas, Miguel. *The Enduring Legacy: Oil, Culture, and Society in Venezuela.* Duke University Press, 2009.

Trofimov, Nicole. "The Alliance for Progress: A Comparative Analysis of Bolivia, Colombia, and Venezuela; What Factors Explain the Different Levels of Aid Given to These Countries Between 1961 to 1963?" *Webster Review* 1, no. 1 (2021).

UNESCO. *Fundamental Education: Common Ground for All Peoples.* UNESCO, 1947.

UNESCO. *Fundamental Education: A Description and Programme.* Monographs on Education, no. 1. UNESCO, 1949.

UNESCO. "Principles of Production and Use of Mass Media for Family Planning Programmes." Paris, June 30, 1970. https://unesdoc.unesco.org/ark: /48223/pf0000000447.

UNESCO. "Statement on the Nature of Race and Race Differences." In *Unesco: Four Statements on the Race Question.* UNESCO, 1969.

UNESCO. *The Use of Mobile Cinema and Radio Vans in Fundamental Education.* UNESCO, 1949.

USAID. *Proposed Program for Fiscal Year 1963.* USAID, 1963.

Valdivia, José Antonio. *Testigo de la realidad: Jorge Ruiz, memorias del cine boliviano.* Plural, 1998.

Van Dongen, Helen. *Filming Robert Flaherty's "Louisiana Story": The Helen Van Dongen Diary.* Museum of Modern Art, 1998.

Van Dyke, Willard, and Edward Weston. *The Letters Between Willard Van Dyke and Edward Weston.* University of Arizona/Center for Creative Photography, 1992.

Vasulka, Woody, and Peter Weibel. *Buffalo Heads: Media Study, Media Practice, Media Pioneers, 1973–1990.* MIT Press, 2008.

Verna, Chantalle. *Haiti and the Uses of America: Post–US Occupation Promises.* Rutgers University Press, 2017.

Vettese, Troy, and Drew Pendergrass. *Half-Earth Socialism: A Plan to Save the Future from Extinction, Climate Change and Pandemics.* Verso, 2022.

Vials, Chris. *Haunted by Hitler: Liberals, the Left, and the Fight Against Communism in the United States.* University of Massachusetts Press, 2014.

Villanueva, Carla Irina. "The Politics of Repressive Education Reform: The Institutional Relationship Between the *Secretaría de Educación Pública* and *Escuelas Normales Rurales* in Mexico During the Cold War." PhD diss., University of Notre Dame, 2020.

Waller, Gregory A. "The American Petroleum Institute: Sponsored Motion Pictures in the Service of Public Relations." In *Petrocinema: Sponsored Film*

and the Oil Industry, edited by Marina Dahlquist and Patrick Vondereau. Bloomsbury, 2021.

Ward, Barbara. *Towards a World of Plenty: The Falconer Lectures, University of Toronto, 1963*. University of Toronto Press, 1963.

Watras, Joseph. "The New Education Fellowship and UNESCO's Programme of Fundamental Education." *Paedagogica Historica* 47, nos. 1–2 (2011): 191–205.

Watts, Michael. "Oil Frontiers: The Niger Delta and the Gulf of Mexico." In *Oil Culture*, edited by Ross Barrett and Daniel Worden. University of Minnesota Press, 2014.

Weismantel, Mary. *Cholas and Pishtacos: Stories of Race and Sex in the Andes*. University of Chicago Press, 2003.

Wieser, Nora Jacquez. "*The Double Day*; *Simplemente Jenny*." *Hispania* 63, no. 2 (May 1980): 452–456.

Williams, Linda. "Melodrama Revised." In *Refiguring American Film Genres: History and Theory*, edited by Nick Browne. University of California Press, 1998.

Williams, Linda. *Playing the Race Card: Melodramas of Black and White from Uncle Tom to O. J. Simpson*. Princeton University Press, 2002.

Williams, Raymond. "Culture Is Ordinary." In *Raymond Williams on Culture and Society: Essential Writings*, edited by Jim McGuigan. Sage, 2014.

Winston, Brian. *Claiming the Real: The Documentary Film Revisited*. British Film Institute, 1995.

Wolfe, Charles. "Straight Shots and Crooked Plots: Social Documentary and the Avant-Garde in the 1930s." In *The Documentary Film Reader: History, Theory, Criticism*, edited by Jonathan Kahana. Oxford University Press, 2016. First published 1995.

Wood, David M. J. "Docudrama for the Emerging Post-War Order: Documentary Film, Internationalism and Indigenous Subjects in 1950s Mexico." *Studies in Spanish and Latin American Cinemas* 17, no. 2 (2020): 193–208.

Worden, Daniel. *Neoliberal Nonfictions: The Documentary Aesthetic from Joan Didion to Jay-Z*. University of Virginia Press, 2020.

Workman, Travis. *Political Moods: Film Melodrama in the Two Koreas*. University of California Press, 2023.

Wright, Basil. *The Long View*. Knopf, 1974.

Young, Kevin. *Blood of the Earth: Resource Nationalism, Revolution, and Empire in Bolivia*. University of Texas Press, 2017.

Index

Founded in 1893,
UNIVERSITY OF CALIFORNIA PRESS
publishes bold, progressive books and journals
on topics in the arts, humanities, social sciences,
and natural sciences—with a focus on social
justice issues—that inspire thought and action
among readers worldwide.

The UC PRESS FOUNDATION
raises funds to uphold the press's vital role
as an independent, nonprofit publisher, and
receives philanthropic support from a wide
range of individuals and institutions—and from
committed readers like you. To learn more, visit
ucpress.edu/supportus.